The Collected Essays of
RUDOLF
WITTKOWER

IDEA AND IMAGE

1 Rudolf Wittkower in 1960

RUDOLF WITTKOWER

IDEA AND IMAGE

STUDIES IN THE ITALIAN RENAISSANCE

with 272 illustrations

THAMES AND HUDSON

Library of Congress Catalog card number 78-62804

Text filmset and printed in Great Britain by BAS Printers Limited,
Over Wallop, Hampshire.

CONTENTS

FOREWORD

THIS VOLUME concludes 'The Collected Essays of Rudolf Wittkower' with a selection from the author's writings and lectures on Renaissance topics. It will, I hope, serve to illustrate his own approach to art history which was to him, in his own words,[1] 'first and foremost the *history* of artists and styles, of subject matter (i.e. iconography) and techniques; and the *history* of ideas and concepts underlying the works of art'. But because 'the objects on which art historical studies are focused are different from all other historical records', an art historian should be conversant also with 'the allied fields of antiquarianism, art criticism, art theory, and connoisseurship'. Moreover, 'he needs the support of philosophy, semantics, psychology, and social studies. He will have to concern himself with minute facts as much as with the problems of methodology and terminology.'

But methodology and terminology may be dangerous tools. In my recollection, the only time that my husband entered into a controversy in print he did so to attack the fallacy of authoritarian principles. 'In this discussion', he wrote,[2] 'I have not merely been concerned with the correction of details, but have wished also to point out how dangerous it can be if, in face of the infinite varieties and possibilities of research, a dogmatist claims absolute validity of his methods.'

Nor was he a believer in the rigid periodization of history. On the contrary. For him[3] 'stylistic terms, rather than establishing water-tight classifications,' were 'merely signposts that facilitate communication. . . . Generic terms such as Gothic, Renaissance, Baroque, convey an idea of what art historians are talking about', but their 'value is extremely limited' and 'qualifying determinants such as "early, high, and late" are no more than useful crutches.'

This caution against the validity of stylistic terms may surprise the reader of the essay on *Michelangelo's Biblioteca Laurenziana* in which the author is much concerned with proving the existence of a 'Mannerist' style in architecture (the term had previously been used almost exclusively for painting and sculpture). But in this way he taught a generation of young art historians to *see* the hallmarks of a distinctive period – no longer 'Renaissance' and not yet 'Baroque'. Today the epithet 'Mannerist' has gone out of fashion in some quarters, but the stylistic phenomenon remains.

The essay is here reprinted with some modifications of the original translation by Joan Yeo and with the elimination of certain repetitions which

the author obviously felt necessary in order to drive home his point, but which now seem superfluous. I may add that the study of the Laurenziana was preceded by a briefer and more general paper on *Das Problem manieristischer Architektur*. This was set in galley proofs (now incomplete) but there the matter rested: because of the political situation in Germany the essay never appeared in print. In 1933 the typescript was incorporated in the unpublished *Festschrift für Walter Friedlaender* and is now lost.

The lecture on *Michelangelo's Dome of St Peter's* is a concise summary of studies which appeared first in German as *Miscellen zur Peterskuppel Michelangelos* (1933) and then, revised and enlarged, in Italian as *La cupola di San Pietro di Michelangelo* (1962 and 1964).

The talk on *The 'Menicantonio' Sketchbook in the Paul Mellon Collection*, here printed in the original English text, was given in Italian translation at the Bramante Congress of 1970 in Rome. The address to the President, the organizers and members of the Congress, and a brief summary of Menicantonio's activities, have been omitted. So has a tentative counter-proposal to the previous reading of the faded and fragmentary signature inside the cover of the sketchbook; that is because Professor C. L. Frommel, one of the few scholars who had studied this signature, came to my husband after the lecture to explain his own and most probably correct reading of the cryptic letters. According to him they prove that Domenico da Varignano and not Domenico di Chiarellis, i.e. Menicantonio, was the author of the book.

The publication of the proceedings of the Congress dragged on for several years for reasons beyond the control of the Committee. By the time it was possible to go into print, my husband was no longer alive, and the decision to hand over the manuscript was left to me. I felt, however, that I had first to ask Professor Frommel whether his reading of the signature invalidated in any way my husband's argument. Professor Frommel very kindly read the manuscript and assured me that the question of authorship had no bearing on the chief aim of the paper, namely the analysis of a selected number of drawings with a view to ascertaining the artist's intention in assembling the sketchbook.

My attempts at further correspondence with the Bramante Committee seem to have fallen victim to the erratic Italian postal conditions at the time, and the talk on Paul Mellon's treasure could not be included in the publication of the Congress – to everyone's regret. Following Professor Frommel's advice I have replaced the name of Menicantonio by the more general terms 'the author' or 'the artist' in the text here printed.

I can be brief about the other essays in this volume. *Giorgione and Arcady* and *'Sacred Mountains' in the Italian Alps* are the original English texts for the respective Italian and French translations. *The Changing Concept of Proportion* merges two closely related papers by omitting the last paragraph from the 'Systems of Proportion' (*Architects' Year Book*) and three and a half pages from the beginning of 'The Changing Concept of Proportion' (*Daedalus*). The last paper here reprinted, *The Painters of Verona*, is actually the first one Rudolf Wittkower ever published. It has been included not only for the reasons stated in the note on p. 249, but also because

it seemed to me to have a certain biographical interest. It exemplifies for the first time a working procedure which the author was to broaden and refine but never to abandon – that is, first and foremost to *look* at the work of art, then to see it in its historical context and so to arrive at an understanding of the artist's intention, whether he was a minor provincial painter or one of the giants in the history of art. The only editing in the translation from the German text consists in the suppression of some sub-headings and one or two small cuts.

I wish to express my gratitude to all who have given their consent to republish the essays in this volume, especially to the National Gallery, Washington D.C., for permitting the reprint of Desiderio's 'St Jerome in the Desert', and to Mr Paul Mellon whose hospitality made it possible to study the 'Menicantonio' sketch-book in his collection at Upperville, and whose generosity allowed the entire book to be photographed for the first time. I am also grateful to the staff of the Warburg Institute who, as always, helped to provide some missing illustrations and to Dr Peter Cannon-Brookes for lending us some photographs of the 'Sacri Monti'. I am deeply obliged to Professor David Rosand for his advice on *The Painters of Verona* and to Professor C. L. Frommel for the trouble he has taken over the 'Menicantonio' manuscript. Lastly I wish to put it on record that the unflagging help of all those at Thames and Hudson who were concerned with the production of these volumes was a source of encouragement and pleasure throughout.

New York, December 1977 MARGOT WITTKOWER

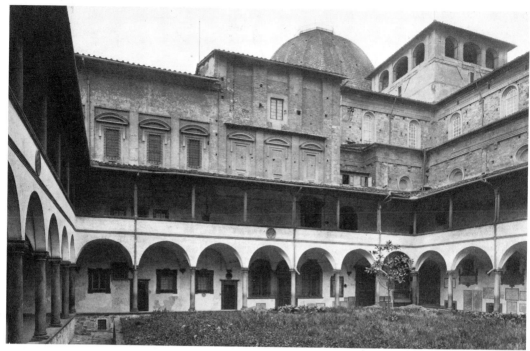

2 The north end of the Biblioteca Laurenziana as it appeared before 1900

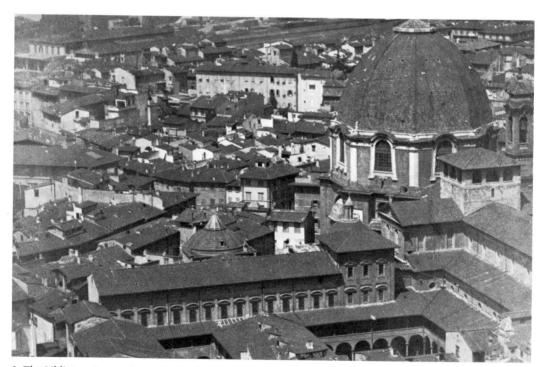

3 The Biblioteca Laurenziana as it is today. On the right is the church of S. Lorenzo with the domed Cappella dei Principi beyond it. The small dome behind the Library itself is Poccianti's Rotonda of 1822

10

I

MICHELANGELO'S BIBLIOTECA LAURENZIANA

THE Biblioteca Laurenziana must surely be the most important and influential Italian secular building of the whole 16th century, and it is therefore very remarkable that no exhaustive account of its architectural history exists. The present essay is an attempt to fill that gap, based both on the surviving drawings and documents and on a close examination of the building itself. But, instead of pursuing a strictly chronological approach, it seems best to begin by establishing and explaining the major break that occurred in its construction, a break which serves to clarify a great deal of both previous and subsequent developments.

The heightening of the Vestibule

Today's visitor to the cloister of S. Lorenzo sees on its west side, above the loggia of the first floor, the long building of the Laurentian Library. The single row of windows ends on the right with a higher, two-storeyed block, three windows wide, which contains the entrance lobby of the Library – the famous Vestibule. The present façade of the Vestibule is of recent date; Michelangelo completed only the windows and pilaster-strips of the lower floor, leaving the whole upper floor in the rough. The modern completion, together with some slight alterations to the interior, was carried out around the turn of the century and finished in 1904.[1]

The condition of the Vestibule façade before its modern completion tells us a great deal about Michelangelo's original intentions, and therefore makes an excellent starting point for our study. No one involved in the restoration, however, seems to have left any record of what was done, so that for our information we have to depend upon only two reliable sources, a description by Geymüller published in 1904,[2]

and two old photographs by Brogi.[3] Using these, let us look closely at certain details of the façade as they appeared before the renovation (see Appendix I).

To begin with two rather puzzling observations. First: in the middle of the south pilaster strip of the Vestibule façade, at the height of the Library cornice, a stumpy stone projects well beyond the surface of the pilaster strip. The height at which this stone is introduced, its breadth (which corresponds exactly to that of the Library consoles), and finally its distance from the last console of the Library cornice (exactly that between the consoles of the cornice) make it impossible to doubt that this is the upper scroll-shaped part of a console. Second: the opposite, northern corner of the Vestibule wall is furnished with twenty quoins from the roof of the cloister upwards. They do not go up as far as the roof of the Vestibule, however, but stop about two-thirds of the way up; above that the corner is built up just with bricks. It cannot be mere chance that the quoins should be employed exactly to the height of the Library cornice. Combining the two pieces of evidence, we are surely right to conclude that the cornice of the Library was originally to have been continued across the front of the Vestibule, and that at a time when the building was already well advanced the wall of the Vestibule was intended to go no higher than that of the Library. Library and Vestibule would have appeared as a single block under a single cornice and roof.[4]

Why was the quoining not continued above the level of the cornice when the Vestibule was heightened? Surely because the quoining only had meaning for Michelangelo as long as he intended to treat the Library and Vestibule façade as one unit. At that stage he planned to

11

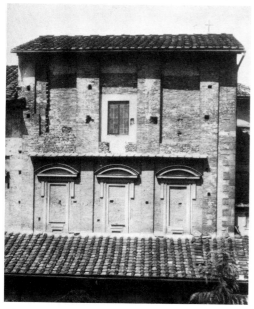

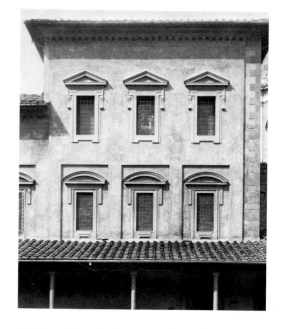

4, 5 The unfinished façade of the Vestibule before 1900 and (right) the façade as it is today

6 The south-east corner of the Library showing remains of quoining

bind together the long complex of the façade with quoining at each end, in the manner of normal palace fronts. If this is correct, we should expect to find remains of quoining also at 6 the southern corner of the Library – and so we do.[5] The change of plan that heightened the Vestibule and gave it the effect of a separate block made the quoining senseless. The extra height of the north corner was simply bricked, and the quoins that remained from the first scheme were meant to disappear under plaster.

No one seems to have pointed out that there is no rational justification, as the building stands today, for carrying the Library windows across the front of the Vestibule in a row of identical 7 but sham windows. At the time of building, the Vestibule interior made no more allowance for window *openings* than it does now, and the articulation of the exterior is completely inde- 8 pendent of that of the interior. The only explanation for this renunciation of 'truth' must have been a desire to unify the Library and Vestibule façades.[6] But in the new scheme, the box-shaped Vestibule block was sharply differentiated from the long, lower, Library building, and the contrast between the two at once became conspicuous. Two blocks of such different heights could never have been made to look like a single block, and if Michelangelo had intended the difference from the beginning he

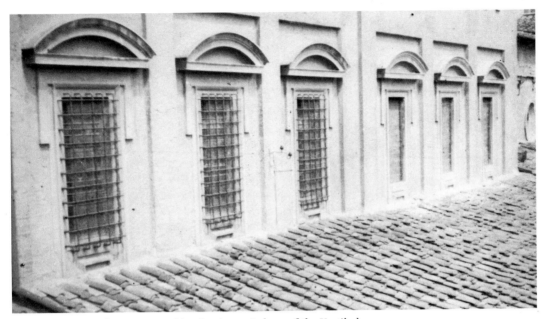

7 The Library windows continued by the sham windows of the Vestibule

8 Section through the Library and Vestibule (after Geymüller)

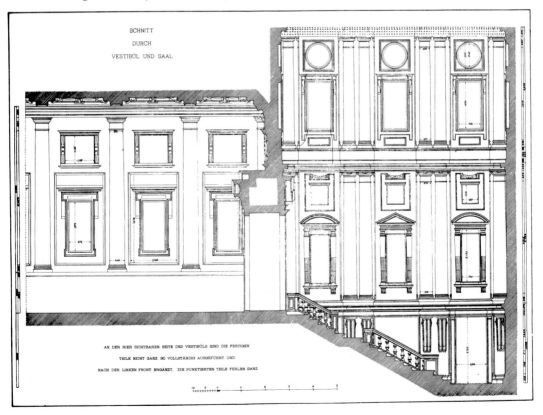

SCHNITT
DURCH
VESTIBÜL UND SAAL

AN DER HIER SICHTBAREN SEITE DES VESTIBÜLS SIND DIE FERTIGEN

TEILE NICHT GANZ SO VOLLSTÄNDIG AUSGEFÜHRT UND

NACH DER LINKEN FRONT ERGÄNZT. DIE PUNKTIERTEN TEILE FEHLEN GANZ

9 Back (west) side of the Library showing the new wall built on the old

10 The Biblioteca Laurenziana in relation to its surroundings (after Limburger)

would doubtless have expressed it somehow on the façade. The acceptance of the three sham windows in the final scheme can only be seen as a compromise – a vestige from the earlier scheme which had been based on quite other principles.

Other considerations point to the same conclusion. The Library was to be built over the old monks' living quarters, and the new walls were to be set upon the old to save money. Lengthy examinations and consultations were necessary to assure the stability of the new walls 9 (see Appendix I). The entrance to the Vestibule is at first-floor level, while the Library is one floor higher, extending over the living rooms which are entered from the first floor. Even with the Library and Vestibule under a single roof the total height of the Vestibule would have been three metres more than that of the Library. On purely technical grounds, therefore, Michelangelo would have been reluctant to raise the Vestibule walls any more than was absolutely necessary – i.e. higher than the Library roof. Only very weighty reasons could have induced him to make the decision.

The present interior shape of the Vestibule, moreover, can hardly be looked upon as the natural starting point of a design. The relation of ground area to height is so unusual that it is difficult either to accept it without question or to see it as the result of a free artistic choice. Is it conceivable that Michelangelo should have deliberately chosen to build a room 14·60 m high on a ground-plan measuring 9·51 × 10·31 m? Surely the obvious intention must have been the original one, with the Vestibule and the main hall of the Library sharing a common roof height.

Again: aesthetic considerations would have dictated the union of the two blocks as seen from outside. The surrounding buildings are a series of regular horizontals; it was clearly desirable to match the line of the church nave on the north with a similarly homogeneous line on the west, harmonizing with the regular arcades of the cloister. The peace of the cloister as a whole could only be shattered by the introduction of blocks of buildings that were different in height and differently articulated.

Everything seems to support the conclusion that the Vestibule was originally to have been no higher than the Library, and that the change was made only after the basic structure of the

building was well advanced. Why then did Michelangelo at the last minute abandon a plan that seems to have been the most reasonable statically, spatially and topographically?

The argument so far would not, perhaps, be absolutely conclusive in the absence of documentary evidence. Fortunately such evidence does exist. A drawing has been preserved that exactly represents the interior wall elevation of the original scheme as I have tried to reconstruct it. It shows the Vestibule wall opposite the entrance. It is divided not into three storeys as it is today but into four; above the high base with its two doors is the main storey, above this an attic, and finally the vault.[7] In spite of the fact that it has been correctly identified as the Vestibule, this drawing has not hitherto been properly understood. Let us start with the articulation of the main storey. The tabernacled bays are framed by pilasters[8] and a continuous entablature and, as in the existing building, pairs of columns stand in recesses between them. In the Vestibule as built, however, the pilasters were omitted, and the tabernacle bays are simply narrow sections of wall. The drawing therefore includes three pairs of pilasters that were not actually executed, and each of these pilasters is shown with a cross measurement equal to the diameter of a column. Two conclusions are possible: either the ground-plan as represented in the drawing is bigger than the actual dimension of the building by 6 × 54 cm (the diameter of the columns); or, taking the ground-plan of the Vestibule as fixed, all the members shown in the drawing are smaller than those actually executed.

The first alternative is clearly untenable. The width of the room from east to west was fixed from the beginning at 10·31 m, since the east and west walls were to be built upon those of the monks' range. If we suppose the larger dimensions for the east and west walls (12·75 m instead of 9·51) we arrive at a completely differently shaped room, in which the north and south walls are 2·44 m *shorter* than the east and west, instead of 1·20 m *longer*. Obviously the same system could not be used to articulate both. Moreover ground-plans that are certainly prior to the date of this drawing show an approximately square area. There is no need to argue the case further. The supposed measurements of the individual members of the drawing

must be calculated according to the present dimension of the wall: 9·51 m.

Of course, free-hand sketches like the drawing we have been discussing are not drawn exactly to scale, and indeed it can be shown that in this case an unintended change of scale took place during the very process of drawing (see Appendix II). Michelangelo seems first to have drawn a boundary line to the left and right. The two doors, which were put in before the detailing of the main and attic storeys, are equidistant from these lines. But on the other levels the bounding line is exceeded on the right. Without this enlargement of scale the axis of the right-hand tabernacle would have lain over the axis of the door just as the left-hand one does. Michelangelo did not bother to correct it, since it is self-evident that the door was to be axially placed.[9] Nor does the change in scale materially affect the conclusions that follow.

The width, being fixed, can be used to establish a scale from which the total height and the individual measurements can be approximately deduced, although it varies a little according to the point where one takes the measurement. Starting from the original, inner, bounding lines (see Appendix II), the total height comes to 12·25 m; from the later, outer line it comes to 11·50. The width, reckoning from outer column to outer column, comes to 11·00 m. The Vestibule as actually executed is, with the (modern) cornice, 14·63 m high, a measurement that is not reflected at all in this drawing.

The floor of the Library is, and had to be, about 3·00 m (3·039 m to be precise) above that of the Vestibule. The total height of the Library is 8·43 m. If the Vestibule roof were continuous with that of the Library, the Vestibule would therefore be 11·47 m high (3·04 + 8·43). There is no doubt that this is the vertical measurement presupposed in our drawing, particularly as it is almost exactly the one deducible from the outer bounding line. The drawing therefore illustrates the interior wall articulation of the first scheme.

It seems highly probable, too, that it illustrates not merely an interim stage of the first scheme, but its final form. From this system of articulation to that actually executed there is a clearly marked and unmistakeable line of development. When Michelangelo, for reasons which have yet to be investigated, decided to

15

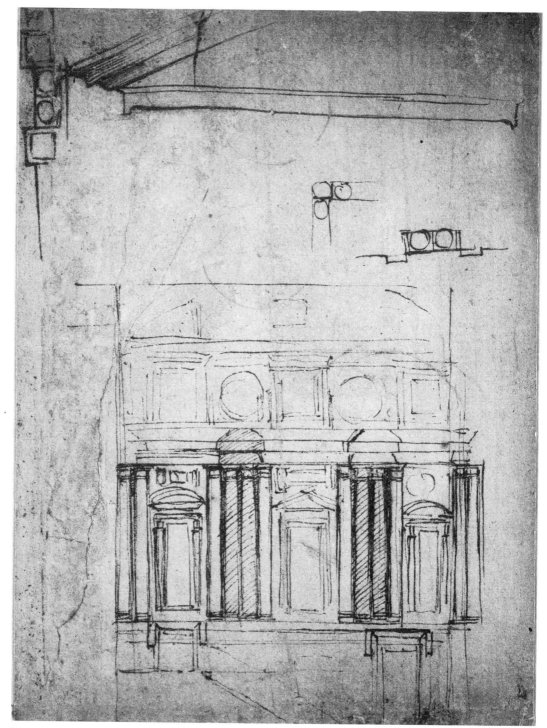

11 MICHELANGELO. Interior elevation of the Vestibule: final stage of the first scheme (Casa Buonarroti 48)

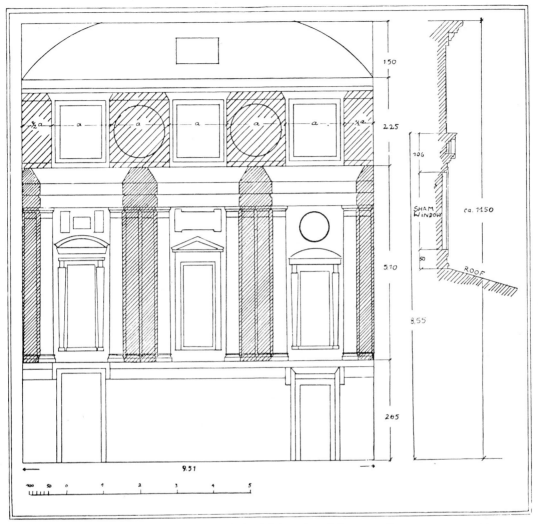

12 The drawing opposite redrawn to scale, with (at right) section of the east wall

heighten the Vestibule, it became necessary to re-articulate the walls according to the new proportions. The introduction of a second high storey did not suffice; the main storey and the one below it also had to be heightened. To heighten the individual members entailed widening them too and this in turn involved a corresponding reduction elsewhere. Heightening the columns by about 1·35 m (from about 4·10 to 5·46 m) meant enlarging their diameters, so the space occupied by the tabernacle bays had to become narrower. The pilasters enclosing the tabernacles were discarded. Or rather, not completely discarded: they were turned at an

angle of 90° and placed within the depth of the wall, at right angles to the outer surface of the tabernacles, facing each other across the recessed paired columns. The result was a transposition of the old design into a new dimension.

It is not only the fact that the Vestibule as built follows the general lines of the drawing so closely that identifies it as the final version of the first scheme; individual members too are shown very much as they actually exist. The doors at the bottom, for instance, are topped by a rectilinear hood-motif exactly like that used on the outside of the Library windows under- 2

17

neath the pediment. These windows were already partially built at the time of the drawing, and Michelangelo simply adapted an external motif for internal use. In the case of the tabernacles, too, the sketchy indication of the drawing clearly reflects what is basically their present form. The component parts are recognizable particularly in the left-hand tabernacle: the inner, box-shaped niche, the herm-like pillars at the side with deeply recessed capitals, the shelf-like floor of the niche, the crowning segmental pediment, and the alternation of segmental and triangular pediments – all are fixed. The attic storey in the drawing again appears in the final version by way of a remarkable but logical transposition. The square panels of the earlier attic are incorporated into the new main storey – actually they almost retain their original position, for by the heightening of the base and main storey the tabernacle bays rise to the height of the square panels. And the circular panels which alternate with the square ones in a recessed plane of the old attic are – though only after various experiments – transferred to above the window of the actual second storey. No element that appears in the drawing is sacrificed; they all recur, logically transposed, in the building that actually exists.

It must be admitted that the drawing is in many respects different from the final conception. In the drawing, the richly articulated main storey rests upon a plain, uniform base, and the advancing and receding planes of the main storey are not continued vertically into the attic; in fact the parts of the attic lying above the pilasters of the tabernacle bays are pushed back to a recessed position.[10] In the actual building the same vertical articulation runs through all three storeys. In the drawing the horizontals are dominant: from floor to ceiling the advancing and receding wall planes keep the same vertical positions. This change, however, is the logical result of the introduction of a second storey, and the second storey is the result of the heightening. If the two upper storeys were to be visually integrated, it was only logical to include the lowest storey as well.

The heightening of the base and main storey in connection with the introduction of the tall second storey not only led to this complete rearrangement of the wall articulation but had a drastic effect on the staircase plan, to be dealt with in more detail later. In the first scheme, as shown in the drawing, the distance from the floor of the Vestibule to the bottom of the tabernacle is 3·00 m – that is, the tabernacle recess was to begin exactly at the height of the Library door, an idea decisive for the wall articulation at this stage. But with the heightening of all the storeys, the idea of a correspondence between door and tabernacle had to be abandoned. The door now has no relation to the tabernacles at their new height. What repercussions this change had from a stylistic point of view I shall try to explore later.

All the far-reaching changes that we have been discussing go back to the idea of heightening the Vestibule, and it is now time to investigate the reasons why this was done. In our analysis of the first scheme one question of cardinal importance has not so far been asked: how was the Vestibule to be lit?[11] A rectangular window, nearly 1·00 × 0·65 m is indicated in the wall of the vault. Such a window could have been placed in only two of the four walls, the west wall (shown in the drawing) and the north wall adjoining the church. The south wall abuts the Library and the east wall had to remain unbroken in order to maintain its uniformity with that of the Library. Two windows of this size would hardly suffice for the lighting of the Vestibule. Some information about Michelangelo's ideas for lighting during this phase can be gleaned from letters, and it is necessary to understand them if we are to discover the reason for the heightening.

Michelangelo intended to light the Vestibule from above. This is made clear in letters to him from Fattucci on 29 November 1525, and P. P. Marzi on 23 December 1525.[12] A particular passage in Marzi's letter leaves no doubt that it is neither the 'piccola libreria' nor the Library itself that is being referred to,[13] but the Vestibule. Before trying to interpret it, it will be as well to give this difficult passage in a literal translation:[14] 'The present is to let you know that His Holiness received your letter of the 7th[15] enclosing the drawing of the library some days ago. . . . He says that the roundels shown therein as lights can be looked upon as very beautiful, but he does not know whether the dust that will fall on them will not be stronger than the light they will be able to transmit? And

whether the walls will bear the weight or[16] whether the structure will be damaged, if the walls are heightened two *braccia* to make windows, as you propose, since part of the roof is already in position and must now be taken down and the beams moved?'

Skylights, in other words, are intended for a section of the building whose roof is already in process of being built; to abandon them for ordinary wall windows will mean demolishing what has been begun and heightening the surrounding walls.[17] This cannot refer to the Library, since its windows had already been started in April 1525,[18] nor to the 'piccola libreria', since this was never started at all (see below, p. 44). It must refer to the Vestibule, and its meaning becomes clear only in the light of the change of plan that has just been analyzed. As a corollary, there could be no clearer explanation of that change of plan than this letter.

For a complete understanding of Marzi's letter we must try to reconstruct the whole discussion between the pope and Michelangelo. The passage in Fattucci's letter of 29 November runs: 'His Holiness was very pleased to learn from your letter that you are preparing to make the Vestibule, as you were requested. Now as to the window over the roof with the glass lights in the ceiling, His Holiness says that it seems to him very fine and novel; there is nothing to prevent your doing it, but he says that you would have to pay two Gesuati friars who would do nothing but clean up the dust.'[19] From this it is clear that, shortly before, Michelangelo had decided to start on the Vestibule. It must be presumed that at that time most of the walls were already standing and that by 'making' the Vestibule, it is the decoration of the walls that is meant.[20] Now, at the eleventh hour, Fattucci writes to say that the pope has turned against the construction of skylights. In his reply to this letter Michelangelo must have explained that ordinary windows would necessitate the heightening of the walls – the stability of which he would not guarantee – and the demolition of the Vestibule roof, which was already in place. That letter is lost, but Marzi's of 23 December must be the answer to it. Here both solutions are commented upon, though the final decision seems to be left to Michelangelo. But the affair was evidently not settled. It was apparently with great reluctance, and only after further detailed

correspondence with the pope, that he was persuaded to drop the idea of skylights. Not until 23 February 1526 do we at last hear that the Vestibule is to be built in the proposed manner, 'in modo avisata'.[21] It was thus a full two months after Marzi's letter before the final heightened form was agreed upon in detail.

The date of the drawing that we have been discussing must be after 12 April 1525, since it shows the flight of steps as detached from the wall (see below, p. 35), and before 29 November, since that marks the beginning of the proposal to heighten the Vestibule. The drawing itself is consistent with the idea of a flat vault containing skylights (*occhi*). It is clear from the documents we have quoted, and from the corresponding clues contained in the building itself, that Michelangelo decided upon the change of plan very unwillingly. Pope Clement's demand for proper windows rather than skylights was clearly based on practical rather than aesthetic considerations, and he was not able to follow Michelangelo's daring and unorthodox ideas. As far as I know, these would have been the first skylights in any modern secular building.

At first the whole inner logic of Michelangelo's ideas resisted the pope's demand. Eventually, it is true, they provided the starting point for a completely new concept, but that needed a 'creative pause' of several months, to crystallize the thoughts that were taking vague shape below the surface. Before this inner process of change set in, Michelangelo tried a compromise, quickly abandoned.

This compromise can be deduced from Marzi's letter. Attempting to save as much as possible of the original scheme, Michelangelo proposed to heighten the Vestibule by two *braccia* (1·15 m). His intentions are not far to seek. The main storey of the original scheme was 5·10 m high; the wall space above it was 3·75 m. By adding another 1·15 m he arrived at a total of 4·90 m. This would have to contain the new windows, and would therefore have to be articulated as one storey, but its height would remain slightly less than that of the main storey.

This intermediate stage, with its preservation of the main storey as shown in the drawing on the one hand, and its introduction of a second storey almost as high on the other, may have been a necessary stage in the development of the

11

Vestibule's final plan, but could not be a final solution for the problem. Taking all the relevant factors into consideration, the vertical measurement of the window opening could not have been more than 1·50 m – hardly enough to provide adequate light. Moreover, the window would have to be uncomfortably high up in the second storey – 2·25 m from its base. Such a distance would have been difficult to accommodate artistically, and the compressed window shape equally difficult to relate to any rectangular frame around it or to the tabernacles of the main storey. By a further heightening of the Vestibule, involving a heightening also of the base and main storeys, these problems are avoidable.

Another factor, however, was decisive against the intermediate plan. We have seen that Michelangelo was worried about the stability of

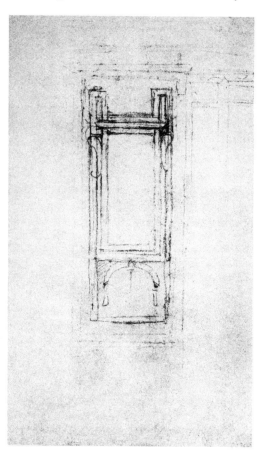

13 MICHELANGELO. Sketch for a window and twin pilasters (Casa Buonarroti 3)

the walls if they were raised higher than his first scheme. In fact this anxiety must have related only to the east (façade) wall: the north wall abutted the church, the south was shared with the Library, the west (back) wall could easily have been strengthened. Now it seems certain Michelangelo believed that window openings endangered the stability of walls, a belief that seems absurd to us today but which is confirmed by the authority of the 18th-century architect G. I. Rossi[22] who had been reared in the Florentine tradition. The great drawback of the intermediate scheme was that it made windows in both east and west walls unavoidable. The south wall could not be used for them because it abutted the Library, the north because it abutted a chapel of the south transept of S. Lorenzo. If, however, he were to raise the walls higher still – so high that windows became possible in the north wall – he could dispense with them in the east. That this was indeed one of his preoccupations is very strongly suggested by the fact that before the modern renovation the east façade was windowless.

Traces of the intermediate plan can, I think, be found in some sketches of windows now in the Casa Buonarroti. One shows a window frame 13 with twin pilasters next to it on the right. The final scale must be assumed, but the position of the window is still too high. Others[23] show the final form of the windows, but with no relation to the surrounding architecture.[24] It may seem rash to base such an elaborate reconstruction of the intermediate scheme merely on the brief note about the wall heightening of two braccia. Yet Michelangelo would not have made the proposal without very concrete reasons. There must be a meaning behind it, and there seems to be no interpretation other than the one here proposed.

Having traced the building history of the Vestibule as far as we can, we should ask: has the unfinished façade been correctly completed? The façade of the first scheme can unequivocally be reconstructed as a continuation of the Library façade as it now stands, but Michelangelo's ideas for the façade of the final scheme are very problematic. It is nevertheless possible to see certain faults in the way it was restored around 1900.

These faults spring fundamentally from the restorers' mistake in seeing the unfinished

façade as a homogeneous scheme instead of a half-way stage between one scheme and another. The first problem was the south wall of the Vestibule above the Library roof. It was just at this point that disturbing the unity of Library and Vestibule created the greatest difficulty. In the original scheme the wall dividing the Library from the Vestibule would have been unmarked on the exterior. In the new scheme it was clearly visible, and therefore demanded to be carried down to the ground in its own right, not merely as a pilaster-strip of the Library. Michelangelo left no indication of how he proposed to get over this difficulty. A second problem was the north corner of the Vestibule façade with its quoining, and here the master left us in no doubt about his intention. The quoining was to disappear under the plaster; in other words, the corner was to be played down, not emphasized as in the first scheme. The modern reconstruction carries the quoining senselessly up to the roof, and the problem of the south wall of the Vestibule above the Library roof is left completely unsolved. The restorers seem merely to have wanted to distract attention from it and therefore did not give it the cornice which appears on the east front. They treated the north wall in the same way, for the sake of consistency, but by thus limiting the cornice to the façade face they succeeded only in giving the building a very flat, stage-scenery effect, with the emphatic quoining of the northern corner standing out as an inorganic intrusion. The idea of excluding these north and south walls from the scheme of the façade was obviously meant to give it homogeneity, but all it does is to make the roof appear disjointed.

The restorers' next step – completely unjustified by the condition of the wall as it then stood – was to open three windows in the east façade and give them frames which are a pastiche made up from interior and exterior Library windows. The windows themselves are at least consistent with Michelangelo's intentions, but the way they are handled contradicts some of the building's most fundamental principles. The window openings outside were heightened by 30 cm above those inside. The building is 1·60 m higher than it was when Michelangelo left it, and it is this which gives the upper storey of today so marked a preponderance over the lower. The modern height-

ening was intended to increase the distance between the pediments over the windows and the cornice; it thus emphasizes the distinction between the box-like Vestibule block and the Library. The new shape of the roof has the same effect. Michelangelo left a simple gabled roof over the rough walls of the Vestibule, set at the same angle as that over the Library, a clear indication that the two blocks belonged together. The new roof is pyramidal (that is, centralized), making the separation more pronounced. Such a roof form is ill suited to asymmetrical layouts and for that reason alone should never have been used here.

Nevertheless, it must be admitted that the modern completion of the façade has succeeded better than such restorations commonly do. Indeed several erudite scholars have taken it to be the original.[25]

To sum up: the façade before its modern restoration was the result of two (or, counting the intermediate stage, three) different schemes. What the final design was to be, the building offers no clue. Some changes would certainly have had to be made in the fabric before a final design could have been achieved. The quoining would have been obliterated and the south wall of the Vestibule redesigned. The retention of the uniform row of (sham) windows continuing those of the Library represents a compromise. But did Michelangelo at heart really want to complete the façade? Literary sources and drawings are both silent on that point. On 18 February 1559, Ammanati wrote to Cosimo I saying that he was hoping to receive a model of the façade from Michelangelo.[26] We do not know whether the aged master ever made up his mind.

The evolution of the Library and Vestibule

The early disputes between the pope and Michelangelo over the choice of the site and the beginning of building are well documented (see Appendix III). More important, the few surviving drawings can be used as I have used them in the previous section, to throw new light on the development of his artistic conceptions.

Pl. 14 is an elevation in the Casa Buonarroti. Frey and Thode[27] believed that it was for the

Vestibule; Tolnay,[28] on the other hand, thought it was a sketch for the interior of the Library. Tolnay is certainly correct; it is in fact one of the earliest schemes for the Library, dating from a time before anything had been decided about the Vestibule.[29] But the interpretation of this sketch is complicated by one detail which should not be overlooked. The original drawing was in red chalk, and Michelangelo went over it with a pen, but not completely. He disregarded the continuation of the design on the right – the next sham window is visible in the red only – and he ignored a third storey, indicated on the extreme left. Horizontally, further pen outlining was unnecessary, as the design simply repeated itself. And since only two storeys were redrawn in ink, we are, I think, justified in regarding the faint red outline of the third storey as no more than a passing idea, abandoned in the process of drawing.[30] Indeed, it is only by discounting this third storey that we can connect the drawing with the Library at all, for it is inconceivable that Michelangelo could seriously have contemplated a three-storey interior elevation. Apart from aesthetic considerations, structural reasons along obliged him to keep the height of the Library within certain limits.

We must therefore begin our interpretation of this drawing with a hypothesis: we must take the assumed height of that part of the drawing traced with a pen to be the present height of the Library, and see whether the elevation then holds good. The main storey corresponds quite closely with the drawing for the Vestibule that we were discussing earlier. The windows at the bottom are sham (indicated by pen shading). Real windows are proposed only for the upper storey. Taking the base and parapet together, the sham windows are set at a height of approximately 1·50 m. In fact, the position of the cloister roof dictates that real windows could not be inserted at less than 2·50 m from the floor of the Library. This would account for the windows in the drawing being sham ones, and increases the likelihood that it does indeed relate to the Library.

It can, moreover, be shown that Michelangelo's first ideas for the articulation of the Library must have lain in this direction. In the scheme under consideration the height of the base is about 75 cm. This low base, together with the forward and backward movement of the wall articulation, would have made it impossible to place desks against the wall, as they were eventually placed. Michelangelo must, therefore, have intended the spaces next to the walls to be open passage-ways, with another one down the middle. A letter from Fattucci of 3 April 1526 says that the pope wants the ceiling to be divided so as to match the divisions of the floor, and indeed 'just as there will be three paths on the ground, separating the two rows of desks, so there should be three on the ceiling.'[31] At the date of this letter, however, the final form of the Library had already been decided upon for a long time – nearly two years – and it is a decisive feature of the final programme that the passage-ways beside the windows could be abandoned.

A word must be said about the interior wall articulation. In the actual building Michelangelo separated off a plain neutral base 1·49 m high all round the Library (with the exception of the door frames at either end). Above this neutral zone the orders begin. This base could only have been conceived in conjunction with a

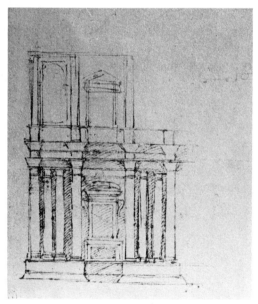

14 MICHELANGELO. First scheme for the Library interior (Casa Buonarroti 42). The light underdrawing in red chalk is not visible in the photograph

scheme for putting the desks against the wall. How does the whole scheme work? Entering the Library today the visitor sees the whole height of the room from the floor of the central aisle in which he stands. But he registers the upper surface of the desks, which he sees in sharp foreshortening, as a sort of second floor from which the orders rise. In this way it became possible to place the windows 2·50 m from the floor, which is as low as the cloister roof allows, without any feeling of visual discomfort. A single giant order could then be employed to give the room the uniform, severe character which seemed desirable for the calm of a Library, without thereby making it appear unduly long, for from the central aisle one is always aware of its real height. Finally, by the elimination of the side passage-ways Michelangelo gained space for the accommodation of books – always a prime consideration in every discussion.

The ingenious way in which the Library satisfies both practical and aesthetic demands was certainly the result of prolonged thought on Michelangelo's part. Clearly he must have allowed for the placing of the desks when he was designing the architecture, but the pope's letter of 3 April 1526 shows that his intentions were not fully understood in Rome. When the pope speaks of two rows of desks between three passage-ways, he was thinking of a scheme which Michelangelo had already abandoned in April 1524.

Pl. 14 must show the decisive elements that went to make up the first phase of the Library design. Further investigation will enable us to place it more accurately in sequence, but from this point on we have to rely on inference rather than deduction because no other internal elevations of the Library have survived.

The next drawing chronologically, a sheet 15 preserved at Haarlem, shows the wall articulation of the Vestibule. Its authenticity has been disputed by Tolnay,[32] but I think this problem will solve itself when we have correctly identified what it represents, something which has not been seriously attempted hitherto.

What is important for this purpose is the left-hand side of the sheet only, not the ground-plans on the right which must have been done

15 MICHELANGELO. First scheme for the Vestibule (Haarlem, Teyler Museum)

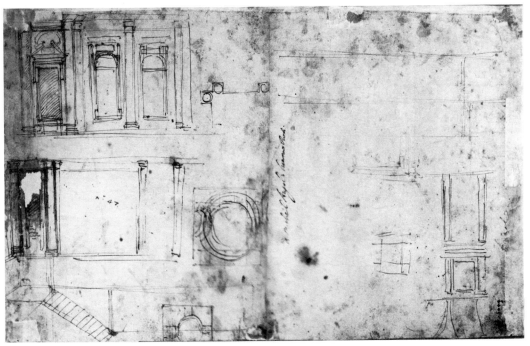

later. There are two parts to this left-hand side. The lower one consists of three elements: at the bottom, a base with staircase; above it, an intermediate section which functions as another, shorter base; and finally a storey divided by orders. This storey is repeated above on a rather larger scale, so that the fourth frame on the right – a repetition of the one on the extreme left – is not drawn again. Assuming that the width for the lower elevation is the actual width of 9·51 m, this gives a height of 2·50 m for the base, which corresponds roughly with that arrived at in the case of the Casa Buonarroti drawing analyzed earlier. This height fits the staircase also; it has thirteen steps, each 19 cm high and 29 cm wide. In spite of its sketchiness, the same scale is adhered to throughout – evidently the draftsman had the *sesto nell' occhio*. The height of the intermediate section can be given as 1·80–2·00 m, and the distance from the bottom of the main storey to the bottom of the window openings (taken from the upper, more detailed drawing) is about 1·00 m. The total distance from the floor to the bottom of the windows is thus between 5·30 and 5·50 m.

Now 5·50 m is exactly the minimum height at which the Library windows could be placed. This cannot be a coincidence. It must prove that Michelangelo's first intention was to give the Vestibule proper windows at the same height as those of the Library. The idea of articulating the Vestibule interior and exterior with those of the Library is a natural one from which to start.

If this is the case, we should be able to infer Michelangelo's scheme for the Library at this stage from the articulation of the Haarlem sketch for the Vestibule. The reason for raising the Vestibule windows so impractically high could only have been to align them with those of the Library. At this time, therefore, the Library windows already must have been planned in their final position: 2·50 m above the Library floor, and we may assume, in the light of our earlier conclusions, that the elevation was already divided into a neutral lower zone and a giant order above.

What we may *not* assume, however, is that the present uniform arrangement of the Library elevation was already decided upon. On the contrary, the Haarlem sketch indicates an intermediate stage between the first scheme (Pl. 14) and the final one. That first scheme, it

will be remembered, showed at the upper level an *a-b-a-b*-rhythm of window frames (one taller and ending in a semi-circle, the other shorter and crowned with a pediment). At the stage represented by the Haarlem sketch (and assuming that the same scheme was to apply to the Library and the Vestibule) this has been changed to an *a-bb-a-bb* rhythm. The two outer bays stand forward of the two inner ones. The latter are bound together by columns and separated from the outer bays, which are enclosed by pilasters.[33] The outer bays, too, have a straight top with a broken pediment and a framework resembling those on the exterior of the Library as built; the inner ones have semi-circular pediments and a vertical projection of the framework.[34] In other words, virtually the same two types of window articulation as those of the first scheme have been re-arranged in a different rhythm.

If Michelangelo were attempting to articulate the Vestibule in such a way as to give the windows the same level and the same rhythm as the Library, the construction of the two lower sections shown in the Haarlem sketch becomes automatically necessary. To unite both into a single storey of about 4·50 m was impossible because of the requirements of the doors, the staircase and the proportions of the walls. But this scheme, logical as it seemed to be, was not destined to be executed. Possibly, indeed, it represents an experiment which convinced the master that the problems of the Library and the Vestibule were so different that unity between them was unattainable. It must have made him realize that the Vestibule windows could not be built on the same level as those of the Library, and that if the unity of the exterior was to be preserved he would have inevitably to submit to a total separation of the inner and outer elevations of the Vestibule.

It is important to ascertain the date at which Michelangelo arrived at the temporary solution of the Library problem represented by the Haarlem sketch. On 29 April 1524, Fattucci writes from Rome: 'As to the staircase, he [the pope] very much likes the idea of a double staircase' (see below, p. 27).[35] This gives us an *ante ₎ quem* date for the Haarlem drawing. Michelangelo's first plan for the Library arrived in Rome on 21 January 1524 (see Appendix III). The receipt of further plans was acknowledged

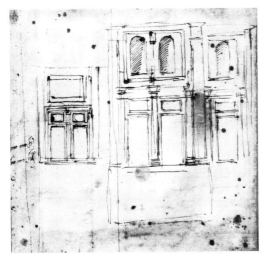

16 MICHELANGELO. Second scheme for the Vestibule (Casa Buonarroti 89)

from Rome on 10 March and 13 April 1524. The sketch of the first Library scheme, assuming that it was done for the pope, must have been among these, to be followed before long by the Haarlem drawing.

On the basis of the Haarlem sketch, another drawing in the Casa Buonarroti can be identified as relating to the wall articulation of the Vestibule (and, conversely, helps to prove the genuineness of the Haarlem sketch). It is evidence for the decisive step towards the separation of interior and exterior elevations, though elements from the Haarlem scheme are clearly recognizable.

In both cases the wall consists of four bays; the left-hand bay is not drawn, but has to be assumed to match that on the right. The result is that not a window (or more accurately, a niche) but a column comes in the centre of the wall. This highly unusual feature led Geymüller to believe that the Casa Buonarroti sketch was a design by Michelangelo for the façade of S. Spirito. That is clearly seen to be a mistake as soon as one understands its relationship with the Haarlem design.[36] The second is quite clearly developed from the first. The intermediate storey of the Haarlem sketch, between the top of the stairs and the columns, is now incorporated, logically, in the main storey,[37] so that the order now rests directly on the base against which the staircase is placed.

Giant pilasters bind the new main storey together vertically, but its great height – more than 7·00 m – needed horizontal articulation too. The columns occupy about four-sevenths of the whole height, leaving space above them for an arrangement of niches which becomes almost a second storey.[38]

As in the Haarlem scheme, the two middle bays are united by the pilasters, but whereas in that scheme the outer bays were brought forward, here they are recessed behind the projecting centre. Only this interpretation explains why all the horizontals of the outer bays (or, to be strictly accurate, of the right-hand bay, which is the only one actually drawn) are a few millimetres lower than those of the centre. A rectangular base below the two centre bays indicates that the two giant pilasters belong with the projecting section.[39] Each bay is the same width, as they are in the Haarlem scheme, so that the projecting centre is just twice the width of each side bay.

All these features connect the two schemes closely together. But the Casa Buonarroti scheme does contain some completely new elements. For example, there are no windows. The openings indicated in the two central bays, beneath the round-headed niches,[40] are doors. In his sketches for the Vestibule Michelangelo usually shows the west wall, but on this occasion he shows the south, the wall dividing the Library and the Vestibule. On a four-bay plan, the axis of the Library would align with a section of wall, not an opening. So *double* doors have to open from the Vestibule into the Library. These double doors are drawn out again on a smaller scale on the left. This contains faint indications of further ideas for giving them a special character by placing circular motifs inside the panels above them, or by surmounting them with round arches. The rectangle at the top was probably to be filled with an inscription. The fact that there were no windows made possible a wall articulation that would not have been feasible at the stage of the Haarlem scheme. The height of both doors and windows was then fixed, and it was impossible to bring them into a harmonious relation with each other. Now the door opening not only determines the height of the base storey but its height of 3·00 m fixes that of the niches on either side, which follow the form of the doors.[41]

25

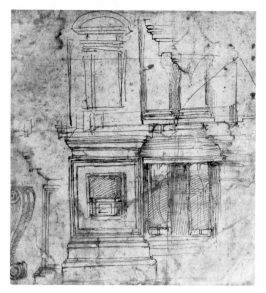

17 MICHELANGELO. Detailed design for the lowest level of the Vestibule elevation (British Museum 1895-9-15-508)

The idea of making the niches correspond with the doors in level and in height was a decisive step towards the final scheme.[42]

There is no indication of windows in the wall in the Casa Buonarroti scheme, nor are they possible. We must conclude, therefore, that skylighting is already envisaged. Between the Haarlem elevation and this one two radical and mutually complementary innovations have been decided upon: independence of interior articulation from the façade and the lighting of the interior by skylights. We have reached the final version of the first plan with which I started this essay. From the Haarlem scheme, Michelangelo developed the scheme we have just been analyzing. With the freedom thus gained he evolved the scheme illustrated in Pl. 11 adapting a design from one originally planned for the Library, with some characteristic modifications.[43] This scheme was his final design until he was obliged to heighten the Vestibule at the pope's bidding.

An approximate date for the Casa Buonarroti drawing can be deduced from the following evidence. The *post quem* date must be 29 April 1524. From then until April 1525 the problems of the Vestibule receded into the background, to become prominent again only in connection with the staircase. Since the Haarlem sketch does not constitute a practical solution, the Casa Buonarroti design must belong to the spring or summer of 1525. With it, the stage is set for the separation of Library and Vestibule schemes, though it does not itself stress that separation. What the sequence proposed here reveals is a progressive clarification of themes, leading to the final version of the first plan.

The transition from this final form of the first scheme to the scheme actually carried out is traceable not only in the studies of window details for the upper storey already referred to, but also in a sheet of drawings now in the British Museum showing an important phase in the design of the base storey. There are drawings on both sides of the sheet. The main one is not the sketch of a first idea but the detailed working-out of an idea that has already taken definite shape. On the back of the sheet are two other sets of drawings, one done before the drawing on the front, the other after it. The first shows seven variations for the moulding at the bottom of the base (upper centre and right-hand side). The second shows five different sketches for the moulding at the base of the columns of the main storey (upper left and right, left border, lower middle).[44] Between the drawing on the front and the actual building the only difference is the notion of placing niches in the base below the tabernacles – an idea that was later abandoned. The sketches on this London sheet are datable exactly to the time of the change of plan, the end of February 1526. To this period also belong the large profile drawings of the base in the Casa Buonarroti. These were added to sheets that Michelangelo had already used to draw out the stair design of April 1525.[45] This brings us to the end of the drawings illustrating the development of the Library and Vestibule.[46]

The staircase

In discussions of the Biblioteca Laurenziana, the main focus of interest has always been the staircase. Panofsky's work[47] has solved important problems about its later history; but so many questions remain that it will be well to restate the whole sequence of events.

Stage 1. In the design sent to Rome and acknowledged by Fattucci on 10 March 1524[48]

Michelangelo had apparently left it uncertain how he intended to deal with the difference in floor level between the Vestibule and Library, and apparently promised to send a drawing later showing the steps.

Stage 2. This drawing was asked for on 3 April 1524 and its receipt was acknowledged on 29 April.[49] The staircase shown in it had two wings, 'la salita di dua scale', and we can, with Tolnay,[50] recognize it in a sketch in the Archivio Buonarroti. The staircase in the Haarlem sketch is, I think, also demonstrably the same one, since the two coincide almost exactly in their measurements of landing, length of stair and free space at the foot of the stairs.[51]

The form which Michelangelo adopts here is the traditional one for the east end of a church: twin stairways placed left and right against the walls leading to a raised choir, and embracing the entrance to a crypt.[52] This similarity to a church setting is made even more marked in later drawings by the insertion of a doorway between the two flights of stairs. Buontalenti's staircase for SS. Trinita (now in S. Stefano, Florence) was derived from Michelangelo's Laurentian plans and shows that it could indeed fit very well into a church setting.

Stage 3. For nearly a year – from 29 April 1524 to the beginning of April 1525 – the problems of the staircase remain in the background, while the contract is settled, foundations laid, the basic structure built and work begins on the details of the Library. Then, on 12 April 1525, Fattucci writes to Michelangelo that the pope wishes to give up the idea of a twin staircase and instead to have a single flight of stairs taking up the whole width of the Vestibule.[53] This renewed interest in the staircase on the part of the pope is probably due to Michelangelo's having just sent some new proposals of his own, embodying ideas that have been maturing in his mind over the past year. There are in fact two stair drawings that fall very plausibly into the period shortly before Fattucci's letter: the Vestibule ground-plan, Casa Buonarroti 89, and the elevation that goes with it, Casa Buonarroti 92. The case for dating them at this point is strengthened by their close connection with other sketches for the staircase which can only have been made shortly after 12 April,[54] and by the fact that another drawing on the same sheet (Casa Buonarroti 89) showing an oblong room

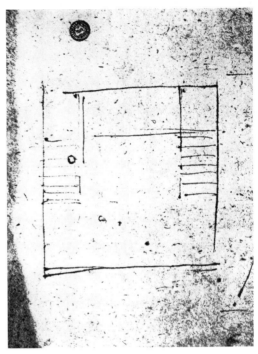

18 MICHELANGELO. Sketch of staircase, Stage 2 (Archivio Buonarroti)

19 MICHELANGELO. Plan of the Vestibule with stairs against the walls. The plan top left is for the so-called 'chapel' at the opposite end of the Library (Casa Buonarroti 89)

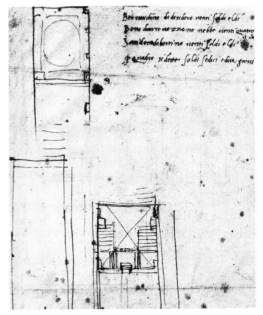

with pillars in the corners can be proved to have been done shortly before then (see p. 44).

In these two drawings no essential alteration has been made to the stairs contemplated in the spring of 1524. The twin stairs against the wall remain, but are made more monumental.[55] The width of each flight is now between 2·50 and 3·00 m, compared to the earlier 2·00 m. Each tread has to be correspondingly deeper. The big landing, wider than that planned in the spring of 1524, is now divided into three, with the centre section, in front of the Library door, raised by three or four steps above those at the top of each flight of stairs. The total number of steps up to this point is twelve or thirteen. It can hardly be doubted that this takes us to the level of the cornice crowning the basement storey of
19 the Vestibule. The plan also shows three smaller steps up from this landing to the actual Library door. The big middle landing must therefore be something less than 3·00 m from the ground, since this is the difference between the ground levels of the Vestibule and the Library.

The drawing reproduced here as Pl. 16 is on the other side of the same sheet, and Tolnay believed that plan and elevation related to the same scheme. This cannot be so. The ground-plan shows only one door into the Library; the elevation, as we have seen, two. Nor can the length of the staircase in the plan be brought to agree with the way the elevation is articulated.[56] It has also been shown that the elevation must date from the summer of 1524. The elevation that corresponds much more closely with this
11 ground plan is Casa Buonarroti 48, which has the five-fold wall division that the ground-plan presupposes, and a base storey whose height agrees very well with the landing height posited for the plan.

Stage 4. A ground-plan that fulfils the pope's demand for a stair taking up the whole width of
21 the Vestibule is on the verso of Casa Buonarroti 92, middle left.[57] This is clearly connected with the ground-plan we have been discussing. The only difference is that here the space between the two flights of stairs is filled with a concave staircase. Its corresponding elevation is to be
20 found on the recto of the same sheet, right at the bottom,[58] where not only concave but convex steps too are provisionally indicated. The concave steps would have presented intractable difficulties in joining them to the landing.[59]

Stage 5. These were experiments. Now Michelangelo began to tackle the problem in quite a new way. Out of the idea of twin stairs along the walls he proceeded to develop twin stairs that were free-standing and projected into the room. This is first visible on Casa Buonarroti 92 recto, 2 near the middle. The flights of stairs standing against the wall are now turned inwards so that they converge; the bottom steps still touch, or nearly touch, the wall, but the top ones are now only 2·00 m apart instead of 4·00 m.[60] This is evidently a new attempt to meet the pope's wishes and make the stairs occupy the whole width of the room.

But this solution proved to be no more practical than the previous one. Not only were awkward spaces left in the corners between the stairs and the wall, but the junction between the lower outer landings and the higher central one would have been very difficult to manage.[61] This whole group of stair designs is closely interconnected, and the first form of free-standing staircase grows directly out of the earlier schemes for twin flights of stairs against the walls, with a triple landing.

Stage 6. Only in the drawing at the bottom of Casa Buonarroti 92 verso does Michelangelo for 2 the first time free himself entirely from the idea of placing the stairs against the walls. This sketch shows the triple, free-standing staircase as a viable possibility. The whole problem of the triple arrangement consists in the relation of the side flights to the central one. Somehow all three elements have to be welded into a unity, and Michelangelo achieves this by starting the side flights two steps forward of the middle one. At any particular point the side steps will thus be two steps higher than the corresponding middle one. The junction of middle and side is marked by rectangular blocks of the same dimensions as a step. This arrangement determines that of the top of the staircase. The last step of the centre flight connects with the rectangular blocks flanking the one below, forming a straight-sided U in plan, while the last step of both side flights is extended to three times its normal depth and joined together across the top to become part of the landing.[62] Upon this landing are two steps forming a single flight leading to the Library door.

Such a scheme is still closely associated with the earlier stages. As before, the side flights are

28

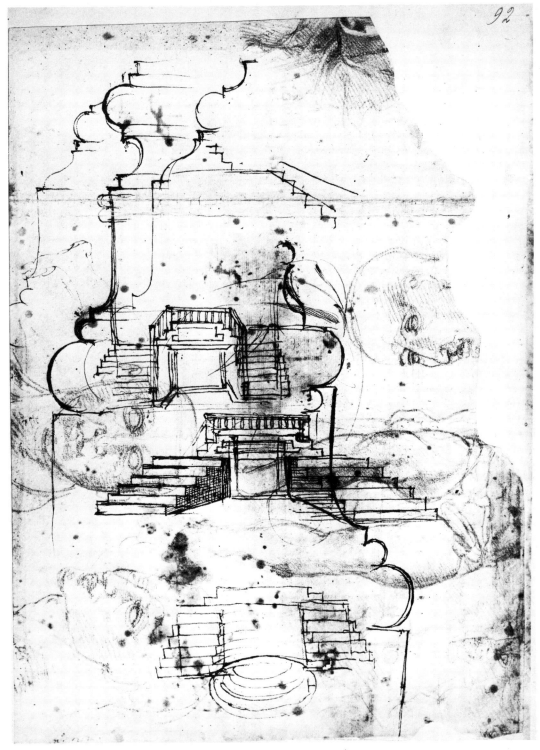

20 MICHELANGELO. Sketches for the staircase (Casa Buonarroti 92 recto)

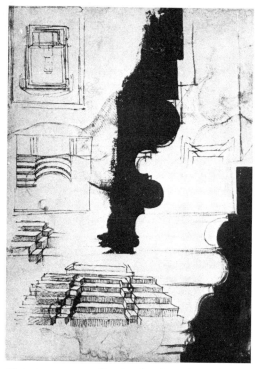

21 MICHELANGELO. Sketches for the staircase (Casa Buonarroti 92 verso)

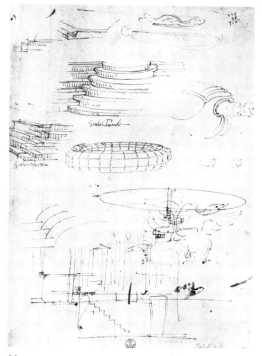

22 ANTONIO DA SANGALLO. Copy of sketches by Michelangelo for the staircase (Uffizi Dis. Arch. 1464)

the determining element; they enclose the central flight as if with a pair of tongs. The recessed central flight is a variant of the experiment with concave steps. This particular sketch has been the subject of considerable misunderstanding. Thode[63] believed that since six steps are shown in the left-hand flight and only five on the right, Michelangelo was offering two alternatives. Actually, the drawing of the left-hand staircase is finished, the right-hand unfinished: the bottom step is not drawn at all and the one above it only lightly indicated. Tolnay too is mistaken in saying that 'the central flight is one step lower than its neighbours': it is two steps lower. These mistakes in observation lead to mistakes in interpretation. According to Tolnay, the deep central stairs were to ascend slowly and majestically, the side ones faster and less impressively. But in fact, as we have shown, the emphasis began by being on the side flights and only later focused on the central one.

Stage 7. For the next stage we depend on a single small sketch of a ground-plan on the same sheet (Casa Buonarroti 92 verso upper right). Enigmatic as this is, however, it connects with certain copies made after Michelangelo by Antonio da Sangallo the Younger, and by these means we can elucidate this stage of the staircase.

Sangallo's copies consist of three sheets now in the Uffizi (Dis. Arch. 816, 817 and 1464); under one of them he wrote 'Staircase of the Library which Michelangelo designed.'[64] Taken together they illustrate two variants of the same stage of development: (a) one project has a central flight of convex steps converging on the Library door; (b) the other shows a rectangular central flight extending in front of the side flights. The similarities between the two are greater than the differences, which concern only the shape of the central flight. Both versions attempt to arrange the junction of middle and side flights in a manner similar to, but more complicated than, that of Stage 6. A written note on sheet 816 relates to the plan with convex central steps (a), and gives an extremely precise description of the new treatment: 'He who goes up the middle flight' – he could have said the side flights too – 'climbs $\frac{1}{3}$ *braccio* at a time, he who goes up the corners climbs $\frac{1}{6}$ *braccio*. All the steps are the same height except the bottom step of the middle flight, which is $\frac{1}{6}$ *braccio* less.'[65]

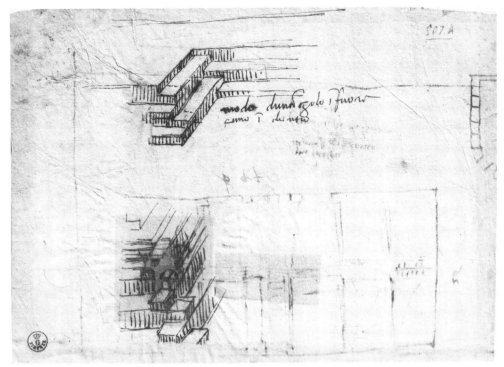

23 ANTONIO DA SANGALLO. Copy of sketches by Michelangelo for the staircase (Uffizi Dis. Arch. 817)

24 ANTONIO DA SANGALLO. Copy of sketches by Michelangelo for the staircase (Uffizi Dis. Arch. 816)

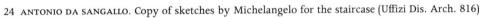

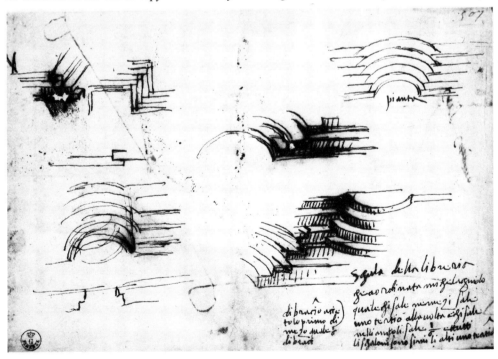

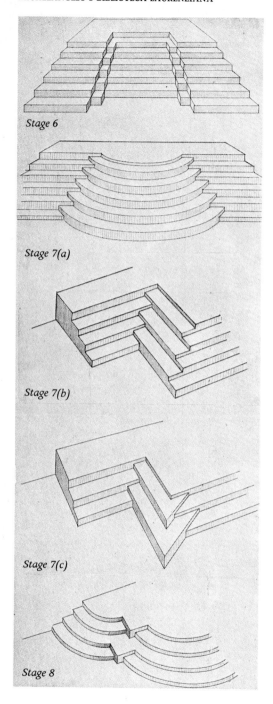

Stage 6

Stage 7(a)

Stage 7(b)

Stage 7(c)

Stage 8

25 Reconstructions of Michelangelo's ideas for the staircase, Stages 6–8

This dovetailing of the middle and side flights, with one always half a step above the other, is represented exactly as described, and as clearly as could be desired, in another of the sketches, near the top of sheet 1464. 2

The arrangement with the projecting rectangular central flight (b) is more complicated. As one can see in the sketch at the top of sheet 817, the lateral steps are to be half a step higher 2 than the central ones and the two dovetail in just the same way as version (a). The drawing shows how this happens at both front and back corners, and the intention is made doubly clear by the inscription: 'modo d'un angolo fuoro come dentro', i.e. the shape of the corner outside and in.

Sheet 816 gives us the ground-plans of the 2 two versions – (a) top right and (b) top left.[66] Part of the ground-plan of (a) appears on the left of sheet 1464. But at this point we must go back 2 to the rather obscure fragment (upper right of Casa Buonarroti 92) which is all that remains of 2 Michelangelo's original for this stage. The type of dovetailing is clearly the same, and confirms the accuracy of Sangallo's copies. But when one draws out a perspective of this plan, one realizes that it represents a more complicated variant (c) of the rectangular projecting centre, of which the simpler version (b) is that shown in the sketch on sheet 817. 2

In (c) the accent is shifted from the plain rectangular form to the complicated shaping of the corners. The intention seems to be to create re-entrant angles not only at the back but at the front too, and this can only be done by bringing forward the sides to a point in front of the projecting centre and making them features in their own right. This complicated solution necessarily presupposes a simple rectangular centre.

The dovetailing in all three variations, (a), (b) and (c), follows the same principles, and the evolution from the convex middle flight (a), through the rectangular centre (b) to the projecting acute angles (c) can be seen as a continuous process of development: (a) has only one dovetail; (b) separates the sides and front of the rectangle; (c) achieves a double dovetail. All three variations show one significant feature compared to the earlier plans: the depreciation of the side flights to give greater dominance to the centre.

Stage 8. From these three schemes with the ingenious dovetailing emerges yet another which retains the same system but introduces two new elements. This scheme too is preserved only in a copy, in the sketchbook of Oreste Vannocci in the Biblioteca Comunale in Siena.[67] Michelangelo here returns to the convex central flight of sheet 1464, but in place of the formerly straight side flights – the last vestiges of the original flights along the walls – there is now a repetition of the central convex shape. In all the variant forms of Stage 7 the outer edges of the side flights are at right angles to the back wall, but here the steps run right into the back wall. With this idea, the last vestige of the original wall flights is eliminated. A new kind of stair has been evolved, one which springs from the back wall and which is in direct relation to the door.

There is a further significant element. The separation of middle and side flights is eliminated and the whole structure unified. Every second step is carried unbroken round the whole staircase. Instead of three separate flights, one is aware of a single geometrical pattern: basically a square whose sides are intersected by segments of a circle.

It is very instructive to look back over the whole process that has led up to this point. In the first practicable plan for a free-standing stair (Stage 6), the middle flight, in spite of the cubes inserted between it and the side flights, remained essentially separate; one can imagine it being taken out and put back again without disturbing the sides. The separateness is eliminated in the next Stage 7(a), where side and middle flights interlock, an effect achieved by making them rise at different levels. In Stage 7(b), Michelangelo retains this interlocking technique but makes the side and middle flights rise by equal steps – only the straight sides of the central rectangle now perform the linking function previously performed by the convex centre. In the sequel, Stage 7(c), the fracture between sides and front of this central rectangle is healed by turning the sides into a sort of clamp, holding both parts of the staircase together. Now the problem is essentially solved. The rather bizarre shape of the staircase is the necessary result of a logical process. One can even imagine the side and middle steps meeting beneath the clamp. In the last Stage, 8, this is made explicit, and at the same time the 'clamps'

26 ORESTE VANNOCCI. Copy of a sketch by Michelangelo for the staircase (Siena, Biblioteca Comunale)

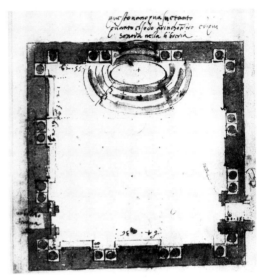

27 BATTISTA DA SANGALLO. Scale plan of the Vestibule, with staircase based on a Michelangelo drawing inserted (Lille, Musée Wicar)

which had had the effect of an extraneous feature, become an integral part of the whole staircase. In this solution, the dovetailing is retained but sides and middle ascend by equal steps, and no separate rhythm is required for the points where the dovetailing takes place.

Stage 9. That is not quite the end of this particular story, however. The union of middle and side flights is, as we have seen, brought to a point where it is the overall effect, not the individual flights, that is the important thing. But the flights are still distinct entities; the three segments, if all were completed, would be at right angles to each other. So one can imagine a final step towards unification, in which all division between the flights is eliminated. And Michelangelo did in fact take that step. Again, it is recorded only in copies: on a page of Battista 27 da Sangallo's sketchbook at Lille, and in a

drawing corresponding to this in another detail from Oreste Vannocci's sketchbook.[68] Here the whole staircase has now become a unified whole in the shape of an oval, though even here the idea of a break between middle and sides is not, apparently, entirely abandoned.[69] It is the most mature solution to the problem of making the stairs centre upon the door, and the logical completion of a movement to bring staircase, landing and door into one organic and inseparable whole.[70]

Now that this aspect of the problem has been brought to its natural conclusion, it is time to examine another. In Stages 8 and 9 we have to assume a landing halfway up the stairs – that is after about seven steps.[71] Above the landing the stairs continue in a single flight. This arrange-

27 ment is clearly seen in the Lille sketch. The stairs in Stages 8 and 9 can have only this form, for the following reason: as the *sides* of the staircase, and not just the middle, are made of steps, the more steps there are, the more the base of the staircase has to expand *laterally*, as well as out into the room. Thus, a staircase with two lateral flights, each of fourteen steps 30 cm deep, would need a base width of twice 14×30 cm, plus the width of the door, say $2 \cdot 00$ m: i.e. $10 \cdot 40$ m – which is wider than the whole Vestibule! On the other hand, assuming a landing halfway up the stairs (after the seventh step) and above that one flight only, as wide as the door, we get a minimum base width of twice 7×30 cm plus $2 \cdot 00$ m: $6 \cdot 20$ m. If to this we add something to allow for a landing a little wider than the door, we arrive at a figure quite close to the existing structure: $6 \cdot 55$ m.

The idea of the halfway landing has its own history. Even if Michelangelo was careless, as he often was, about indicating the exact number of steps in his sketches, there must be a reason for the fact that they are invariably so few. As soon as he began to consider the idea of a free-standing stair he clearly reckoned on a break after the sixth or seventh step, and its continuation in a single flight above the landing. Moreover the landing on the section of Casa

11 Buonarroti 48 is marked exactly halfway up; and, finally, the landing of the stage we shall be examining next (Stage 10) can be reconstructed at half height.

True, at earlier stages Michelangelo had contemplated taking all three flights together to the Library door. Look, for instance, at Stage 7(a) in Uffizi 816, lower left: here the convex central flight runs together with the side flights up to a broad landing in front of the Library door. Another instance is the outer section of the staircase in Casa Buonarroti 48.[72] And we shall see that even as late as Stage 12 Michelangelo was still ready to consider three flights running right through without a landing.

I have already shown how the development of ideas for the staircase falls into two phases, separated by nearly a year. Stage 2 belongs to a period shortly before 29 April 1524. Stages 3–9 must belong relatively close together shortly before or after 12 April 1525. Proof of this lies in the fact that the two last stages (8 and 9) presuppose a wall whose lowest storey is a homogeneous, unbroken surface. They will not work if that storey is given any articulation. And as we have seen this unbroken surface was retained only up to the final version of the first scheme (Casa Buonarroti 48), which has to be dated before 29 November 1525. To this argument there is one apparently grave objection: the very last ground-plan with the oval stair (the Lille sketchbook) shows the final form of the Vestibule and not its first stage. But is this a faithful copy of a Michelangelo original? Heydenreich thought it was, and explained the complete agreement between Battista da Sangallo's and Vannocci's drawings by assuming that they had a common original. But I think not. It is very odd that Michelangelo should indicate the staircase in so summary a manner on a ground-plan drawn in such detail. Instead of the necessary fourteen or fifteen steps, only nine can be counted here. And the size of the staircase in relation to that of the room is completely wrong: the stair is much too small. On the scale of the ground-plan of the room, the whole stair, apart from the landing, comes to considerably less than $3 \cdot 00$ m. The depth of each step would have to be at most 20 cm, a quite inconceivable dimension. A stair roughly sketched like this into a ground-plan carefully drawn to scale can have been no more than an attempt to clarify the relation of staircase to room, and it is in this relationship that we notice the discrepancy in scale. In view of these observations, it is surely impossible that both the sketch and the scale drawing go back to a single Michelangelo original. It is much more

likely that one of Michelangelo's mere sketch plans for the stair has been inserted into a scale plan of the Vestibule without considering that this sketch was for a quite differently articulated room. Only this hypothesis can explain the combination of elements differing in scale and meaning. And it follows that Vannocci must somehow have seen and made use of Sangallo's sketchbook.[73]

Stage 10. The adoption of the final Vestibule scheme with its carefully articulated base necessitated a complete revision of the stair project. Stairs placed against the Library wall were incompatible with such a base. Michelangelo was compelled to return once more to the idea of a free-standing stair.

That decision, together with the general change of plan, must have been taken at the beginning of 1526. But in the second half of that year work came to a halt for lack of money, with the staircase problem unresolved. Nothing happened for seven years, and it was not until 1533 that building was resumed. On 20 August of that year a contract was drawn up between Michelangelo and five stonemasons, Antonio and Simone di Jacopo di Berto, Francesco d'Andrea Luchesini, and the latter's nephews Michele and Leonardo di Giovanni Luchesini, for providing two doors and the staircase for the Library. Work was to be completed by the end of March 1534. The stair was to be made 'according to the method, shape and size not so much of the drawings kept in the cloister but according to the small terracotta model made by Michelangelo, which each of the above named masters has seen. It is expressly stated that the steps of the staircase shall be fourteen, each to be of one piece, particularly the first seven with the *rivolte*, without any joint being visible.'[74] The last sentence seems to contradict itself, but no doubt some self-evident premise is meant to be understood: each step was to be of one piece, but if that were impracticable, the first seven steps must in any case be of one piece, while in the others no joint must be visible.

In the text the lower seven steps are distinguished from the upper by the term *rivolte*.[75] This can be understood only in its original sense of 'turning round' or 'turning back',[76] and must refer to the curves that we now see at either end of each step of the central flight.[77] Without a break of some sort, steps

with curved ends could not be continued in steps with none. Halfway up the flight, therefore, a landing is to be assumed.

This scheme is identical neither to any of the earlier schemes nor to the project of twenty-five years later, but it has connections with both. The halfway landing occurs in early schemes but not in the later ones. The steps with *rivolte* are not found in any early project, but only in the executed scheme. Here, admittedly, they include the whole length of the middle flight, not just the steps to the landing – but I shall show later that the scheme of 1533 was apparently revised in the same year so that all the middle steps did after all receive them. The shape of the steps between the *rivolte* was presumably convex. We can hardly go wrong in assuming that the seven middle steps with *rivolte* were bordered by straight flights accompanying the middle flight to the landing, and further that above the landing the middle flight alone continued in a simple convex form. So with the highest degree of probability a scheme can be reconstructed which looks back to Stage 7(a). This scheme of 1533 is moreover of decisive importance, for a number of the steps in the existing staircase were actually made during this phase of building (see below, p. 41).

The convex steps with *rivolte* reveal a combination of ideas from earlier schemes. In Stage 6, the top step of the middle flight connects with the corner blocks in an essentially similar way. But now two members originally introduced for functional reasons are fused and given a purely aesthetic role in a setting based on the convex curves of Stage 7(a).[78]

Stage 11. Between 1533, the year of the contract, and 1559, when the staircase was actually completed, there was one abortive attempt to finish it.[79] This was made by the sculptor Nicolò Tribolo, and is in several respects revealing. Vasari gives a full account of it – in fact two conflicting accounts, one in the Life of Michelangelo and the other in the Life of Tribolo. In the first,[80] we are told that Tribolo was sent by Cosimo I to Rome during the pontificate of Paul III (1534–50) in order to persuade Michelangelo to return to Florence. Having failed to do so, Tribolo at least tried to learn what Michelangelo's final intentions were with regard to the staircase, since even the drawings and terracotta models that were available did

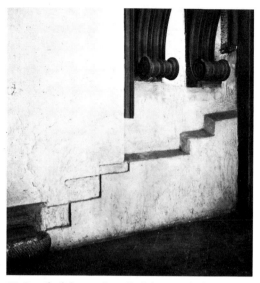

28 Detail of the south wall of the Vestibule
showing the marks of Tribulo's stairs

not make clear 'la propria ed ultima risoluzione'.
Michelangelo answered that he remembered
nothing about it. In the Life of Tribolo, the story
is slightly different.[81] Tribolo had been en-
trusted by Duke Cosimo with the task of
completing the stair. Having put four steps in
position, he did not know how to proceed, and
was sent by the Duke to Rome to get information
from Michelangelo and to persuade him to come
back to Florence. Michelangelo refused to make
the journey and as regards the staircase he
declared: 'I no longer remember either the
measurements or anything else.'

This second account seems the most likely,
for Vasari would hardly have reported the
remarkable fact of the placing of the four steps
unless it had actually happened. He should
anyway have been especially well qualified to
speak about the whole episode, for not only was
he living in Florence at the time, but a few years
later actually worked on the staircase himself.
He gives no exact date for Tribolo's abortive
efforts, but these can be accurately dated from
two other documents. On 20 January 1550, Lelio
Torelli writes to Cosimo's majordomo Pier
Francesco Riccio: since the stair 'which has now
been designed is not going forward', he, Torelli,
was sending for consideration a letter written
by Michelangelo to Fattucci on the subject of the

stair, and which he had obtained from Fat-
tucci.[82] This (missing) letter may not have been
of recent date; it may even go back to the 1520s,
when Fattucci represented Michelangelo's in-
terests in Rome, and the two were in constant
correspondence over the affairs of the Library.
The second document is of the summer of 1550.
After Tribolo's failure in Rome, various at-
tempts seem to have been made to get some
information out of Michelangelo about the
staircase, and one of his close friends, Donato
Giannotti, writes to ask him for a drawing of the
stair.[83] Though Tribolo's name is mentioned
neither in Giannotti's letter nor in Torelli's, they
must be connected with this phase of the stair
building. So 1549 seems to be the year of
Tribolo's efforts, and his journey to Rome
probably took place at the end of that year or the
beginning of 1550.[84]

The details of Tribolo's attempt to complete
the stair would be of small interest were it not
the key to a hitherto unexplained chapter in the
stair's history. On the back wall, on either side
of the present staircase, are distinct signs of 2
stairs having once been built there. The grey
macigno, which is used for the ornamental parts
of the Vestibule, has been removed in three
places – the horizontal base from a distance of
some 1·20 m from the corner, and two vertical
mouldings on either side of the consoles, one to a
height of a little more than 1·00 m from the
floor, the other to a height of 1·77 m,[85] and even
some parts of the brackets have been sawn off.
The condition of the wall shows that the facing
was once complete and has been forcibly
removed. On the surface thus exposed are the
marks of steps: the lowest 20·5 cm high, the
second 22 cm high and 32 cm deep; and above
that two more steps are imprinted.[86] All this
makes it clear that twin flights of stairs were to
have been built against this wall, leading up to
the middle.

It has been shown that after it had been
decided to articulate the lowest storey of the
Vestibule, only a free-standing stair could be
installed. Yet the marks we have been examin-
ing are irrefutable evidence of a plan with steps
against the wall. The combination of the final
base mouldings with such a stair could never
have been undertaken under Michelangelo's
supervision. The mistake can only have hap-
pened because he was not there and nobody

understood his intentions. It could not have arisen during the final building period, so Tribolo alone must be held responsible for it. The inevitable conclusion is that the marks of steps on the wall are to be connected with Vasari's description of the four steps built by Tribolo. This accounts not only for the appearance of the wall but also for Tribolo's actions. The mouldings and consoles in the wall made the continuation of his staircase impossible. He therefore betook himself to Rome, explained the situation to the master and received . . . not a word of help. Michelangelo had not forgotten all about it: years later he could remember his original ideas perfectly well. His obstinate silence was due to anger at Tribolo's ill-considered procedure. Tribolo could make no further progress and died a few months later, at the beginning of September 1550.

Tribolo's misunderstanding is readily explicable in the light of our earlier discussion. He thought of the final stage of the first plan, with the steps placed against the back wall, as Michelangelo's last word. He was presumably led to this conclusion by the existence of Michelangelo's exact drawings. It is not impossible that these were the 'drawings kept in the cloister' referred to in the 1533 contract which were *not* to be used; a model was to be used instead. If so, they belonged to an earlier stage of development.[87]

7 The copies by Battista da Sangallo and Vannocci after Michelangelo's oval plan (Stages 8 and 9) and Tribolo's undertaking mutually support one another. The latter strengthens our belief that the copies do, in fact, reproduce plans by Michelangelo, and the copies confirm that Tribolo had such plans to refer to (though not, of course, the same ones). What both the copyists and Tribolo overlooked was that Michelangelo had prepared various plans for the stair to fit various elevations. This alone explains how Tribolo could blindly embark on a scheme which only made sense if one assumed a completely different wall articulation for the Vestibule.

When work on the stair was resumed ten years later, the steps built by Tribolo had to be removed. At that time no attempt was made to repair the damaged wall, and the steps, which had no further use, were left simply lying in the Vestibule. Their subsequent fate can be followed through nearly three hundred years. Bottari writes of them (*c.* 1759) in his edition of Vasari.[88] He found a number of completely worked steps in the Vestibule, and expressly affirms that these belonged to the step marks on the wall; his quite casual conclusions from this require neither discussion nor refutation here. Domenico Moreni,[89] writing in 1816, also knew about the steps, and believed, like Bottari, that they had been placed in that position under Michelangelo's direction; he reports that they were removed from the Vestibule on 21 March 1811, broken in pieces and used for the foundations of a building in Poggio Imperiale. Such was the inglorious end of Tribolo's contribution.

Stage 12. Five years after the Tribolo affair a new effort was made to get Michelangelo to say what his final intentions were – and this time successfully. Duke Cosimo entrusted Vasari with the mission of persuading him to speak. And Vasari received from Michelangelo that famous letter of 28 September 1555, which was for so long wrongly interpreted.[90] The riddle was finally solved by Panofsky.[91] To reconstruct the stair project of 1555 Panofsky went to the rough draft of the letter in the Codex Vaticanus and drew attention to two insignificant little sketches in the margin. In view 29 of Panofsky's conclusive proofs, it will suffice here merely to describe the nature of this scheme: three flights – the central with oval 30 steps, the lateral with straight ones – meet in front of the door at a common landing. The top step of the middle flight has the same width as the door, but the flight broadens as it goes down. The landing forms a bridge between the wall and the staircase proper – that is to say there is a free passage underneath it, leaving the base of the wall undisturbed throughout. Michelangelo's express instruction that the base of this wall should be left untouched[92] obviously rules out Tribolo's solution.

Michelangelo says that he does not think he is describing his old plan: 'ma non credo che sia apunto quello che io pensai allora.' Which old plan is he thinking of? Doubtless that of 1533. The 1555 scheme agrees very largely with that of 1533. It differs in two points only: instead of pausing at a halfway landing, the stairs rise all the way without a break; and instead of the

29 MICHELANGELO. Sketches in the margin of a letter to Vasari, 28 September 1555 (Codex Vaticanus 3211, f 87v)

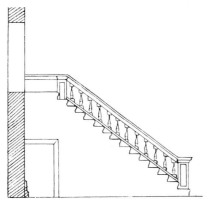

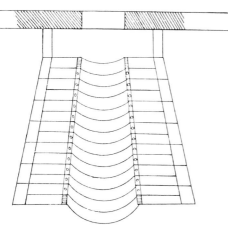

30 Reconstruction of the staircase plan of 1555, Stage 12 (after Panofsky)

upper part above the landing being a single flight, the side flights run the whole way up.

In the remark quoted above Michelangelo seems to be mixing up his 1533 scheme with an earlier series of ideas. As we have seen (p. 34), in the stair schemes of 1525 he was considering both a stair with a landing break and an undivided stair running all the way up. The section shown on Casa Buonarroti 48 could indicate either possibility. The undivided stair, however, was practicable only with an un-articulated lower wall: otherwise it would come into conflict with the consoles.[93] This dilemma perhaps accounts for the long delay in actually building the stair.

Stage 13. Another three years passed, and then in December 1558 the discussion was renewed.[94] Ammanati was now in charge of the work. In January 1559 Michelangelo sent a small ter-racotta model in a box and an explanatory letter. As in his letter of 1555, he refers critically to Tribolo's efforts, and tries to explain what had been in his mind at that time. He remembers, he says, that in his original scheme – he is no doubt still thinking of his 1533 scheme[95] – a single flight only is brought up to the door, by which he means a single flight above a big landing. This fundamentally important fact, and Michelangelo's further observation that only the middle flight is to have banisters, while the side flights are to have a place to sit down ('un sedere') at every other step, clearly point to the staircase as we have it today. The execution of all details the master leaves to the discretion of the supervising architect.

Panofsky has solved the difficulties of interpreting the texts; he has explained the relation of the plan of 1558/9 to that of 1555, and the general conformity of the existing stair with Michelangelo's final intentions. What I add here, by way of completion to his researches, is an exact description and analysis of the stair itself. These observations have hitherto been neither recorded nor appreciated.

1 The middle steps are all 18·5 cm high, the side steps 17 cm.

31 Section comparing steps of the middle flight (broken line) and side flights (solid line)

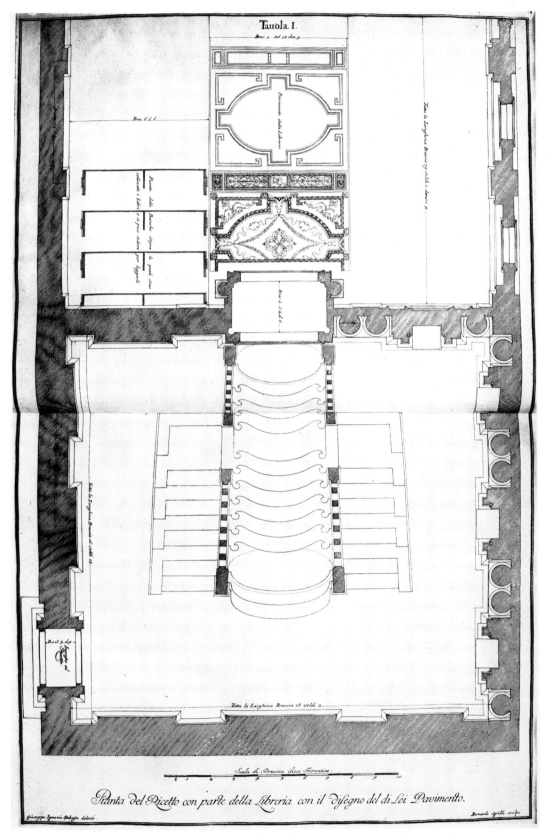

32 Plan of the Vestibule, staircase and part of the Library, from G. I. Rossi's *La Libreria Mediceo Laurenziana*, 1739

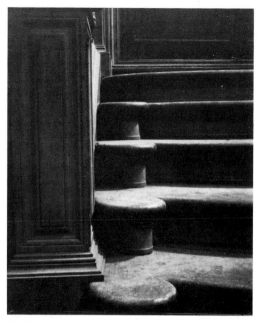

33 Banisters cutting into the steps of the middle flight

34 Tenth step, between middle and side flights

2 The middle steps are between 41·8 and 43 cm deep (mostly 42 cm), the side steps 43·44 cm.

3 The middle steps all have a moulding at the bottom 2 cm high and ·3 cm deep; none of the side steps have this.

4 The middle steps are shaped at the side in such a way that they cannot be brought into an organic connection with the base mouldings of the banisters or those of the square newel posts with which the banisters begin and end.

5 The middle steps are forced to fit against these mouldings by the following means:

> (a) On the three lowest steps small pieces have been cut out at the point of connection with the newel post (the curve of the lowest step is flattened).
> (b) At the eighth step a piece 5·5 cm broad is cut away in order to make room for the projecting base of the upper newel post.
> (c) The ninth step is also slightly cut by about 1 cm on either side.
> (d) At the eleventh step, the first of the upper flight, 4·4 cm is covered by the newel post above the landing.
> (e) On the top oval step 4·5 cm is cut into on either side by the top newel posts; on the left the step is sawn out, on the right it is overlaid in front, cut away at the back.

6 The tenth step of the side flights, which is turned at right angles to join the side landings to the middle landing, shows the following peculiarities:

> (a) Its height is 18·5 cm, i.e. the height of the middle, not of the other side, steps.
> (b) It has a bottom moulding like the middle steps (see 3, above).
> (c) Its front edge projects a little beyond the newel post and its rough, unpolished surface at this point shows it to have been cut from a longer step to fit into its present position.

7 The third step forms an almost complete oval, and round it runs a groove 2·5 mm deep and 6·5 cm from the edge. The groove stops at the back, leaving a distance of 1·325 m ungrooved. The fact that this step is an almost complete oval, functioning as a sort of subsidiary landing, means that a small triangle is left on either side between its back edge, the bottom of the next stair and the base of the banister; this triangle has been filled with pieces of white marble, contrasting with the grey-green *macigno* of the rest.

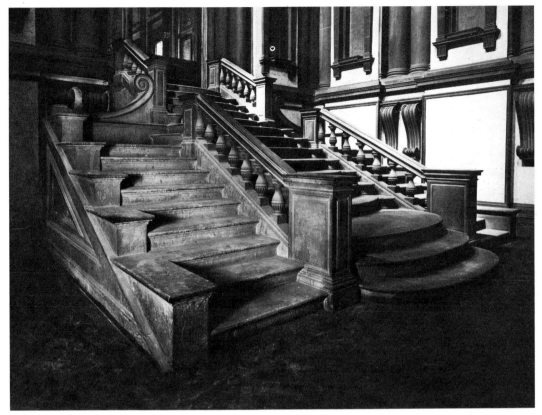

35 The staircase, seen from the Vestibule entrance

8 The fourth and fifth middle steps (the first and second with *rivolte*) have snail-shaped engravings inside the *rivolte*. These do not appear elsewhere.

9 Between the top oval step and the door are patches of white marble similar to those of the third step (see 7, above).

Taken together, these observations lead me to the following conclusions:

I. The middle steps are older than the steps of the side flights. This can be inferred from the fact that the side steps are less high and deeper than the middle ones (1, above), representing a historically later stage of development. Furthermore the side steps, including the banisters and the newel posts, are only with difficulty fitted round the middle steps. (4, 5)

II. The older middle steps are not now in the setting which their form seems to require. (4, 7, 9)

III. The middle steps are clearly not quite finished. Probably only the fourth and fifth steps, with their snail-engraving (8) can be considered complete. Presumably too, the groove on the third step (7) was to have been cut in the other three oval steps.

IV. The steps of the side flights were made for the present staircase, but to connect them with the middle flight, one step of the old material was used on each side and cut to fit its new position. (6)

V. The above argument is perfectly consistent with the hitherto disregarded reports of Vasari and others that at the time of the construction of the staircase a great number of ready-hewn steps were available in the Vestibule.[96]

VI. It is clear that the present steps belong to two periods. All the middle steps must be of 1533/34; they must therefore have been made according to Michelangelo's detailed instructions,[97] although these are just the parts whose authenticity has been most doubted. Had

41

this scheme been built the staircase as a whole would have projected less than the present one; it would have been steeper and more compact. We cannot be sure whether the idea of turning the third step into a landing goes back to Michelangelo. It is easy to understand that after twenty-five years he did not have every detail in his head. He seems to have forgotten that some steps had actually been made – at all events he did not plan to make use of them; he even proposed to make the staircase of wood. Ammanati, however, did use them, and it was no easy task that faced him. He had to fit the old steps into a completely new setting. Hence the marble-filled angles of the oval steps. Hence all the other complications that I have set out in detail. And now the extent of Ammanati's contribution can be accurately assessed: the banisters are his, the newel posts are his,[98] and the decorative scrolls which lead the eye inwards at the top of the side flights are his.

Those who have followed this account of the development of Michelangelo's ideas for the staircase will see elements of every stage in the completed structure. The idea of the free-standing triple stair was evolved in April 1525 (Stage 6), and retained through all subsequent phases. The triple landing, which was at first built against the back wall and ran across the whole breadth of the room (Stage 3), led via the impracticable Stage 5 to the present landing. Oval steps for the centre, stretching further into the room than the side flights, appear first as a vague idea in Stage 4 and after Stage 7 the idea of projecting the middle beyond the sides remains constant. The continuation of the stair in a single flight above the landing exists *in nuce* already in Stage 3. After Stage 6 the landing lies about halfway up, but the idea of a triple stair running right up to the door still remained a possibility (Stage 12). The origin of the *rivolte* in Stage 6 has been discussed. All these motifs, reaching far back in their origins and springing from different conceptions of the staircase, were finally blended into a magnificent whole.

A highly interesting chapter could be written on the subsequent influence of the staircase. Here all that can be said is that the stages leading up to the final solution were richer in influence than the final solution itself. In the designs of Buontalenti in particular the earlier stages of the Vestibule stair recur again and again as a

36
37

36 Staircase by Buontalenti in S. Stefano, Florence

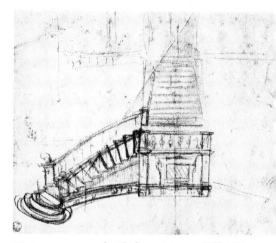

37 BUONTALENTI. Sketch for a staircase (Uffizi Dis. Arch. 2309)

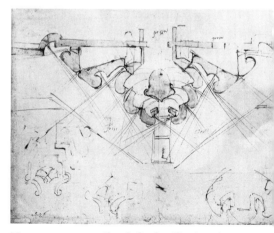

38 MICHELANGELO. Sketch for fortifications (Casa Buonarroti 22a recto)

starting point. Even more revealing are cases where Michelangelo himself reverts unconsciously to ideas formed during the evolution of the staircase. The most remarkable and unexpected phases of that evolution are Stages 7 and 8 in which purely practical considerations fall more and more under the domination of compelling abstract ideas pursued for their own sake. The same hankering after complicated geometrical shapes and abstruse forms comes through in plans that he did in the same year but for completely different purposes – fortifications. In 1529 he was put in charge of the defences of Florence, and in planning the bastions his guiding principle was that of providing mutual cover for the various lines of fire. Some of the designs that he produced can only be compared to the staircase designs. Here and there actually identical forms appear, e.g. the acute angles of Stage 7(c) and variations of the *rivolte* of the middle steps. Sometimes the similarity is so close that without other evidence one could not tell which was which. It is no accident that the same forms should be found in such widely different architectural categories as stairs and fortifications. Nowhere else is such a degree of abstract thought possible without completely negating the building's function. Yet in both cases Michelangelo was able to use these abstract forms as the starting point for new forms adapted to specific practical ends.

Plans for a supplementary reading room

The idea of having some small rooms separated off from the main Library to house its most precious treasures and to serve as quiet places for study had been present from the very beginning of the whole enterprise. Between 1524 and 1526 it went through a series of vicissitudes which can still be reconstructed; no part was ever realized.

A plan was already in existence as early as 10 March 1524. In his letter to Michelangelo, Fattucci writes as follows: 'I am sending back to you the plan of the Library, which is to be executed, and at the head of the Library are shown two little studies, which have the window in the middle which is opposite the entrance to the Library; and in these studies he [the pope] wishes to put certain of the more precious books; and also he wishes to make use

of others which will have the door in the middle.'[99] So the 'studies' will have the window at the head of the hall and the door of the entrance wall 'in the middle'. This can only mean that from either end of the long rectangle of the hall two small rooms were to be cut off – i.e. four altogether, one at each corner – which would give the room the shape of a Greek cross (though the arms would have been so much thicker than the long axis that this would not have been very apparent). The length of the hall, according to the same letter of 10 March, is 96 *braccia* (55·68 m), while from another letter, of 3 April 1524, it appears that the 'studies' were to be each only 6 *braccia* (3·45 m) long.[100]

That plan was clearly abandoned as early as the first days of April 1524, in favour of the idea of a *crociera*, or cruciform plan. This appears in a drawing by Michelangelo mentioned in a letter of 13 April from Fattucci in Rome.[101] For four months the cruciform plan remained an integral part of the scheme. But, on 2 August 1524, Fattucci wrote on the pope's behalf: 'For the time being, he does not wish you to carry out the *crociera*, but leave it so that when the work starts it can still be done.'[102] In fact this meant the end of the cruciform plan.

The material that survives is not sufficient for a reconstruction of the cruciform plan. It is touched on only in Michelangelo's memorandum of a date prior to 3 April 1525 (possibly summer 1524) in the words: 'the cross to have eighteen *braccia* [10·44 m] in every direction and the space on each side of the same height and size as the main wall.'[103] This 'cross' must presumably be imagined not, as Carl Frey[104] maintained, in the middle of the hall, but attached to the end opposite the entrance. One can appreciate this point if one looks at Poccianti's circular building of 1821, which breaks the long wall of the Library, as would the arm of a cross, and so badly disturbs the effect of continuity. And the thesis is supported by the fact that the idea of the *crociera* was followed by that of the 'piccola libreria', which was, without any doubt, to be attached to the end of the Library opposite the entrance.

The third stage is announced in a letter from Fattucci of 12 April 1525, in which he says: 'As to the chapel at the head of the Library, he [the pope] does not want chapels, but wishes that it should be a secret Library, to hold certain books

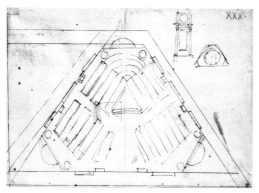

39 MICHELANGELO. Sketch for the 'piccola libreria' (Casa Buonarroti 79)

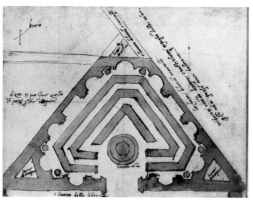

40 MICHELANGELO. Sketch for the 'piccola libreria' (Casa Buonarroti 79)

more precious than the others.'[105] So before 12 April 1525, there was in Rome a plan of Michelangelo's in which the short south wall of the Library opened into a room which was called a 'chapel', but the pope wanted a 'libreria secreta' instead.

A vestige of the chapel scheme is preserved in a sketch by Michelangelo. In the top left-hand corner of Casa Buonarroti 89 is the ground-plan of an oblong room articulated with pilasters and corner pillars, very much like what we should call a 'chapel'. Previous critics have been unable to agree about the meaning of this plan,[106] but the continuation of the lines at the bottom strongly suggest the walls of the Library. This suggestion is confirmed by the fact that both the other plans on the sheet repeat the same walls: the one on the right shows the Vestibule with the northern part of the Library, the one on the left the same area but without

19

marking the division between Vestibule and Library.[107] As the oblong plan at the top cannot be the Vestibule, it must be the other end of the Library. The sheet therefore shows the whole ensemble as planned at the beginning of April 1525. All three plans obviously belong together in time, since they show the same surrounding walls repeated three times on more or less the same scale. (This argument, incidentally, enables us to date the whole sheet – a key document in the history of the staircase – to before 12 April 1525, since after that date Michelangelo was obliged to revise the plan for the rectangular chapel.)

The final scheme for the 'piccola libreria' must have been made after 12 April but before 10 November 1525, for on that date Fattucci informed Michelangelo: 'I have received a letter from Giovanni Spina with certain designs of the little library, which I showed to His Holiness, who said that he wished it to be made as you have designed it.'[108] This scheme may be recognized in two sheets in the Casa Buonarroti showing a room in the shape of an isosceles triangle. It can hardly be doubted that this room was to be built off the short south end of the large hall because: (1) the 'capella' that has just been described was to be 'in capo della libreria'; (2) one of the ground-plans shows a doorway from the 'piccola libreria' into the main hall and the beginning of the east and west walls, with the words 'e'l vano della libreria' written there by Michelangelo; (3) the braccia scale top left of the same plan tells us that the width of the room is about 17 braccia (9·86 m), which is almost exactly the width of the Library.[109]

The question which of the two plans is the earlier can be answered both from the degree of their finish and from the nature of their internal arrangements. The more sketchy plan is in fact the earlier, for the following reasons. The sides of the triangle are each divided by two pilasters into three flat niches. The middle niche is somewhat wider than the side ones, so that a subtle a-b-a rhythm is created. The simplicity of the articulation brings it into harmony with the large hall. The idea of making the book desks part of the total design is also taken over from the large hall; they are so arranged as to form passage-ways focusing on the central niche, which is in line with the axis of the main Library. The 'piccola libreria' is thus conceived

as a natural extension of the large hall, whose long axis finds its logical climax in the point of the triangle.

But, just as we have seen in the Vestibule, a conception that began as an organic unity developed in such a way as to produce differentiation and separation of parts. This next, and probably final, stage is shown in the more finished drawing.[110] Comparing it to the earlier sketch, one can see three elements that have been transformed. The rich, plastic articulation of the wall now stands in very noticeable contrast to the wall treatment of the large hall; the furniture, though still in line with the walls, pays no heed to their articulation; and finally the idea of axial continuity has been replaced by that of an independent, self-contained, centralized room. Entering it from the main Library one is no longer drawn forward along an uninterrupted axial line; one comes straight up against the round desk ('banco tondo') in the middle, which brings the axis to an abrupt stop and insists instead on the idea of centrality. In the earlier design, each side of the triangle could be read as a separate entity; the semicircular niches rounding off the angles are clearly dissociated from the sides, and the one opposite the entrance exerts a sort of magnetic 'pull' along the main axis. In the later version the sides are given niches like those of the corners, making it impossible to read them separately.

Of the proposed wall elevations we know very little. There exists only, for the earlier scheme, the small sketch of one corner bay in the top right-hand corner of the sheet. This design is a clear counterpart to the final form of the first plan for the Vestibule, which can likewise be dated after 12 April 1525. Above the niche of the main storey, framed by projecting orders, there is, as in the Vestibule scheme, a high attic with a circular opening. Here, as there, indirect lighting is contemplated: the small triangular spaces cutting off the angles of the big triangle were to serve as light sources. The writing in the angles of the later plan, 'lume per di sopra', shows that the ceilings of these diminutive spaces were to be glazed. The light would pass through the circular openings above the niches into the room. But, as another inscription on the same sheet shows, there was also to be a large glazed 'occhio' in the middle of the ceiling.

From both practical and artistic points of view, the 'piccola libreria' would have formed the culmination of the whole Library complex. The Vestibule with its staircase led into the official Library, and from there one would have proceeded into the private study. The sequence of shapes – square, oblong, triangle – would have formed a geometrical progression. Two small rooms with strong wall relief would have held the large, relatively unstressed room between them. The articulation of the roughly square Vestibule is based on the concentration of each wall on its own centre (a-b-a, a-b'-a, a-b-a). The large oblong hall, in contrast, has a simple alternation that could be repeated to infinity. Finally, in the centralized 'piccola libreria' all three walls would have been brought together in a continuous alternation without end or beginning (a-b-a-c-a-b-a-c-a-b).

The 'piccola libreria' was never built. In the spring of 1526, during the building of the Vestibule, Michelangelo obtained once more the pope's *placet* for it, to which Clement VII had already agreed on 10 November 1525. But on 3 April 1526 Fattucci informed Michelangelo that the pope would like the 'piccola libreria' to be taken in hand only after the completion of the Vestibule.[111] This postponement soon turned into complete abandonment. For already in the summer, funds for the Library were considerably reduced. At the end of the year began the long period of the cessation of all work.[112] When it started again, only the completion of what had been begun was considered, and no mention was made of the pope's wish for a private study. The need for such a room nevertheless remained, to be satisfied eventually by the circular building erected by Poccianti at the beginning of the 19th century. By then the tradition had certainly died; Poccianti had no idea of Michelangelo's intentions.

One mute witness to the 'piccola libreria' may be said to survive. Notes on the second of our two plans record that its west wall would be formed by the wall of 'the house of Ilarione Martelli'.[113] It was this house in fact which dictated that the library should be triangular since it cut diagonally across the site. The wall is still standing today – eloquent testimony of conditions that could not be avoided, of arbitrary necessity transformed by phenomenal mental agility into architectural logic.

45

41 MICHELANGELO. Sketch for the entrance door to the Library, Vestibule side (British Museum 1859-6-25-550)

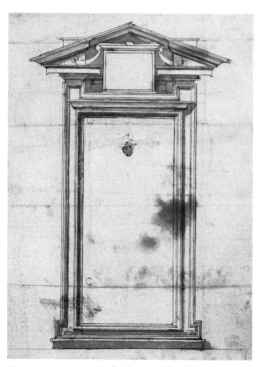

42 MICHELANGELO. Scale drawing for the entrance door to the Library, Vestibule side (Casa Buonarroti 98)

Doors, ceiling, desks, floor

From 23 February 1525 onwards work on the Vestibule proceeded according to Michelangelo's final plans. This meant that all the remaining details had to be worked out and decided upon at once.

Doors. There are two main doors: one from the cloister to the Vestibule, the other between the Vestibule and the Library. To give the latter its final form on the Library side, Michelangelo had to know what sort of room was going to face it at the other end of the hall. After 3 April 1526, when he received a firm assurance about the 'piccola libreria',[114] he could begin to design the communicating door. From a letter of Fattucci we learn that Michelangelo's drawing for the door reached Rome on 17 April. This probably showed the Vestibule side only, the side that was to carry the inscription. The pope expressed himself as delighted with the design, but there was to be further correspondence about the tablet for the inscription. On 6 June Michelangelo received the drawing back from Rome with the question of the inscription still not quite settled.[115] In the autumn of 1526 work stopped, with the door not even begun. So things stood until 1533. The contract quoted above (p. 35), concluded on 20 August of that year between Michelangelo and Simone di Jacopo di Berto and the various Luchesini, mentions two doors to be executed by March 1534.[116] These were undoubtedly the two doors that we are considering here, but only one, the door into the Library, was actually carried out at the time.

For this door there exist various small preparatory sketches by Michelangelo, plus complete working drawings for both its sides. All these drawings belong not to the contract year, 1533, but to the early scheme of 1526. This can be proved by some profile drawings in the Casa Buonarroti (Casa Buonarroti 53). On this sheet the following profile drawings are to be found for the Library side of the door: (1) on the left of the recto and at the bottom of the verso are almost identical profiles for the outer corners of the triangular pediment down to the cornice; (2) on the right of the recto a section through the

actual door frame; (3) at the top of the verso a section through the segmental pediment. The profiles drawn for the triangular pediment and the door frames agree with the actual construction.[117] Only the profile for the segmental pediment is different. The drawing is very close to the corresponding profile of the windows immediately below the vault of the Medici Chapel, and from this an idea can be formed of the rich moulding originally planned for this pediment; it was later considerably simplified. A note from Michelangelo's hand on Casa Buonarroti 53 recto says that these profile drawings were to be given to Ceccone as models. Francesco di Corbignano, called Il Ceccone, was working as Michelangelo's stonemason during the 1520s, especially in the Medici Chapel, but he is not among the masons under contract for the doors in 1533.

So the door executed in 1533 had been designed in 1526. What are its special characteristics? On a sheet of sketches now in London Michelangelo showed both sides of the door. On the recto are four experiments for the Vestibule side,[118] on the verso an advanced drawing for the Library side. Clearly the intention from the beginning had been to make both sides contrast with their respective rooms – the Vestibule side was to have a flat, band-like surround contrasting with the columns, the Library side strong, column-like features contrasting with the pilasters. But on both sides he extends the door frame vertically between the lintel and pediment to form motifs which one could call 'turned-up ears'. On the Vestibule side these remain dominant; on the Library side they appear again in the scale drawing, but have vanished by the time the door is actually built.

The original sketch of the Vestibule side very largely anticipates the scale drawing (Casa Buonarroti 98), and this in turn is very close to the actual construction.[119] The differences, though trivial, should however be noticed. The outer frame of the drawing has a considerably broader profile than that executed. The surface between outer and inner frame is thus actually broader and more effective than that shown in the drawing. This has a particular significance. The door frame has its own narrow chamfered cornice, the general effect of which is to separate inner and outer frame. In the actual construction the separation is increased by making

43 Entrance door to the Library, Vestibule side

47

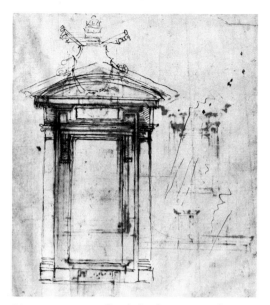

44 MICHELANGELO. Sketch for the entrance door to the Library, Library side (British Museum 1859-6-25-550)

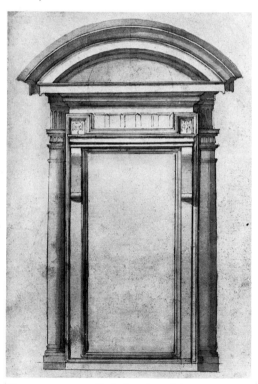

45 MICHELANGELO. Scale drawing of the entrance door to the Library, Library side (Casa Buonarroti 111)

the outer moulding very fine instead of equal to the inner one. The function of the surface bounded by these mouldings becomes clear only in the actual construction. As we have seen, it is given a dynamic upward impulse by its 'turned-up ears'; above those, still defined by the moulding, rests the pediment, but their flat surfaces effectually prevent any union between two parts which properly belong together – door frame and pediment.

The connection between the London sketch of the Library side and the scale drawing of the same side in Casa Buonarroti[120] has not hitherto been recognized. In the drawing, as in the sketch, the door frame, with big brackets and 'turned-up ears', is placed against a recessed aedicule of columns. In the sketch a double pediment is already indicated, the segmental inside the triangular. The scale drawing shows only the segmental pediment, while in the actual construction the triangular is placed inside the segmental. Instead of the 'harmonious' combination of the sketch, we have a reversal, suggesting conflict.

The actual door frame on the Library side agrees fundamentally with the scale drawing, but has developed beyond it in several ways. The present door frame is made up of the following four layers or planes: (a) a column aedicule with segmental pediment; (b) in front of this and partly covering the columns is a massive block which may be conceived as filling the whole space between the pediment and the floor; (c) on the upper part of this block is a section of cornice, not quite as wide as the block and therefore not organically connected with it. The triangular pediment above it does not appear to be resting on the cornice, but rather the cornice to be hanging from the pediment; (d) the door-opening, with narrow frame, breaks through the block. The first three layers, (a), (b) and (c), are tied together by a moulding on the underside of the pediment, which is carried round the corners of each layer. Layers (b) and (d), the block and the door-opening, are tied together as follows: a vertical, panel-like depression in the block, rising to the lintel, merges with the inner door frame to form a broad moulding and reveals its 'true' character only just above the lintel, where instead of completing itself in a horizontal it comes to an abrupt termination.

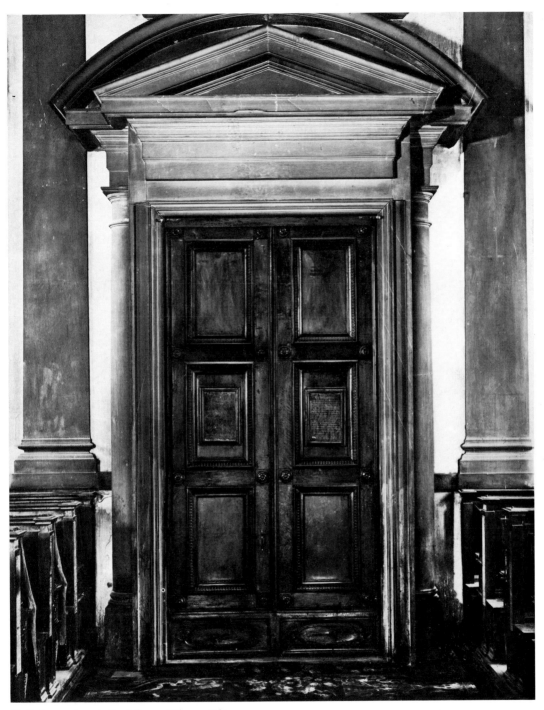

46 Entrance door to the Library, Library side

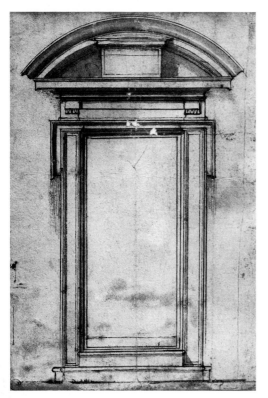

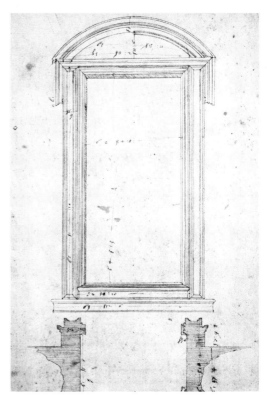

47 MICHELANGELO. Scale drawing of the entrance door to the Vestibule (Casa Buonarroti 95)

49 Parts for the entrance door to the Vestibule, from G. I. Rossi's *La Libreria Mediceo Laurenziana*, 1739

48 G. A. DOSIO. Scale drawing of the entrance door to the Vestibule, reconstructed from the worked pieces (Uffizi Dis. Arch. 1925)

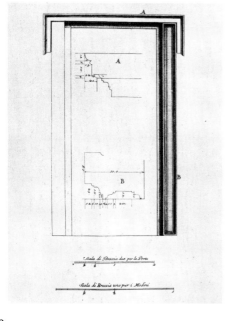

The separation of outer and inner frames, which is a feature of both scale drawings and which is carried out on the Vestibule side in a more extreme form, is effected on the Library side too but by different means: the narrow outer door frame appears at the same time above the lintel as of one piece with the block in which the door is placed. The idea of a separation between the frames appears again in the small, nearly square niches above the tabernacles of the Vestibule's main storey, thus establishing a vital relationship between the door and the tabernacle bays.[121]

The entrance door to the Vestibule from the cloister was also supposed to have been executed in accordance with the contract of 20 August 1533, but was not. The inside door frame had been completed along with the rest of the interior of the lowest storey (see below), but the outside one makes a remarkable story, which can be fully reconstructed. The sources,

arranged chronologically, are as follows: (a) Scale drawing by Michelangelo, Casa Buonarroti 95, datable to spring or summer 1526.[122] (b) Scale drawing in the Uffizi, Dis. Arch. 1925, definitely attributable on grounds of technique to G. A. Dosio and datable to about 1550.[123] (c) Drawing and text by the architect G. B. Nelli in a voluminous collection of measured drawings of the Vestibule in the Uffizi, Dis. Arch. 3696–3739, the title of which runs: 'Opere d'Architettura di Michelangelo Buonarroti fatte per S. Lorenzo di Firenze misurate e desegnate da Giovan Batista Nelli al Serenissimo Ferdinando Principe di Toscana,' with a dedication on folio 5 dated 10 April 1687.[124] (d) Part of Giuseppe Ignazio Rossi's *La Libreria Mediceo Laurenziana, architettura di Michelagnolo Buonarruoti*, Florence, 1739 (text on p. 31, and plates XX–XXII).[125]

From these sources, the development of the framing of the outer door can be accurately traced. The component parts of the frame were for the most part worked in accordance with the contract of 1533, but were never put in position, and remained lying in the Vestibule. The agreement of the Dosio drawing and Rossi's Pl. XXII with the scale drawing in Casa Buonarroti indicates that the scale drawing represented Michelangelo's settled intention. By 1687 nothing had yet been done. Shortly after that date, however, the architect Pier Maria Baldi was commissioned by Duke Cosimo III (1670–1723) to finish the door.[126] For some mysterious reason Baldi availed himself neither of the ready-worked materials nor of the drawing in the possession of the Buonarroti family, but in the dullest way simply copied the frame of the inside door and crowned it with a segmental pediment. After Baldi's completion, the worked parts of 1533 were found, according to Ricci, still in the Vestibule. Perhaps they shared the fate of Tribolo's steps and were also carted away to Poggio Imperiale in 1811 (see above, p. 37).

Nelli and Rossi, who were well acquainted with Michelangelo's style, justly condemn this copy, which is in direct contradiction to his desire for differentiation and indeed an insult to his inexhaustible imagination. The form of the door shown in the Casa Buonarotti drawing is closely related to that of the windows of the façade. In both, the dominant motif is a heavy hood-moulding which encloses the upper part

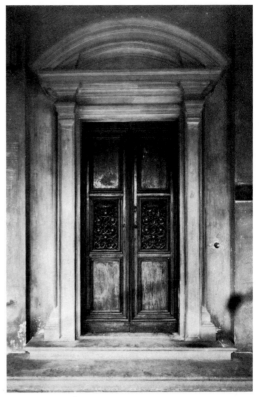

50 Entrance door to the Vestibule, exterior; executed by G. M. Baldi, *c.* 1700

51 Entrance door to the Vestibule, interior

51

of the frame in an inverted U-shape – a particularly impressive manner of separating the frame proper from the pediment. It contrasts with both sides of the Library door, where the unity of frame and pediment had been broken on one side (the Vestibule) by a powerful upward thrust, and on the other (the Library) by a neutral zone. Here, in the entrance door, the decisive factor is the pediment, whose crushing weight is caught and deflected by the isolating vice-like hood. And in spite of its fundamental conformity to the window design, it contains not only new elements that express its particular function (pilasters, steps, inscription table), but also elements that display a development of ideas beyond the stage of the windows. In the windows, which were already complete in the spring of 1525, at least a year before the probable date of the door drawing, the window frames, hoods and pediments had been absolutely separate entities, resulting in a tendency to divide into horizontal layers. In the door, on the other hand, the projection of the hood over the pilasters leads to a vertical fusion and a new kind of conflict.

As we have seen, Michelangelo at one time considered using the inverted U-shaped
7 hood of the Library windows for the interior doors in the lowest storey of the Vestibule. It is
11 found in the final version of the first scheme, completed between the spring and autumn of 1525. Later he developed a different line of
51 thought. The doors are organically related to the articulation of the basement storey and of the tabernacles (the capitals, for instance, are identical), but they introduce the idea of a separation between inner and outer frames (already noted in connection with the Library door and the panels above the tabernacles) in an
43 entirely new way. In the Library door he had placed a narrow chamfered cornice between the two frames to emphasize the separation. In the door that we are now examining a similar effect of separation is achieved by the vertical pilasters on either side of the door. They have burst through the frame and forced the inner and outer mouldings apart. The cornice of the Library door and the pilasters of this one perform the same function. Take away either and the conflict disappears; each door frame becomes an organic whole. Retain them, and the two doors gain a fundamental relationship.

When Baldi simply re-used the inside door frame on the outside, he reversed the whole process of Michelangelo's creative thought. Our analysis of the inside door has shown how carefully it was worked out in relation to the rest of the Vestibule. To transfer it to the outside, and with the addition of an arbitrary segmental pediment, is to render it completely meaningless.

Ceiling. The large hall of the Library owes 5 much of its splendour to the wonderfully carved wooden ceiling. This has its own history. From the very beginning, before the plans were settled in detail, the pope demanded a special and novel ceiling. He did not want the normal coffering, but 'qualche fantasia nuova'.[127] This wish, expressed on 10 March 1524, and repeated on 3 April, must have been immediately complied with, for on 13 April Fattucci announced that the drawing for the ceiling had pleased the pope.[128] Exactly a year later, at a time when the Library building was already well advanced, the question of the ceiling arose again. As before, Clement asked for a very beautiful ceiling in low relief. If no new scheme had been prepared, the old one was to be sent back again.[129] Then follows another interval of a year. On 3 April 1526 the pope once more made his wishes known.[130] In June we learn that the ceiling would have been started, but the lime wood was not seasoned.[131] But then in the middle of July expenditure was drastically cut back, and with the general interruption of work in the autumn of 1526 all thought of the construction of the ceiling ceased before it had even been begun.[132] Not until 23 August 1533 did news come from Sebastiano del Piombo in Rome that the pope now wished the ceiling and desks to be put in hand.[133] So 1533 can be fixed as the date *post quem*, but the ceiling itself shows features suggesting an even later date.

Each of its large central panels contains an 5 oval frame with four ibex skulls joined to one another by garlands. Outside the oval, filling the corners between it and a larger rectangle, are decorative pairs of dolphins. The ibex skulls and dolphins are the dominant elements of the ceiling decoration and, predictably, they have a symbolic meaning: they are the emblems of Duke Cosimo I, whose reign began in 1537. The *post quem* date must accordingly be moved forward four years.[134] The idea of giving the

ceiling a symbolic significance was Clement VII's ('qualche sua fantasia overo Livrea'),[135] but after his death it obviously remained alive and it is not surprising that the arms of Cosimo I should replace those of the pope.

This being so, how much of the design goes back to Michelangelo? He left Florence for Rome in 1534 and never returned. Vasari[136] says that the ceiling was executed by the Florentine carvers Carota and del Tasso[137] from Michelangelo's designs. One such design from his hand, in red chalk and partly outlined in pencil, has in fact been preserved in the Casa Buonarroti. It shows a preliminary stage but provides conclusive proof that the form of the present ceiling was to a very great extent the one fixed by Michelangelo. The design, however, differs from the actual ceiling in certain details. Instead of dolphins in the corners there are rectangular framed panels, taking up again the theme of the niches between the windows. And, far more important, it gives the whole ceiling completely different proportions. Two designs are contained within a frame drawn in with a ruler, so that one of the side panels and the centre one are represented, with the strips in between, the other side panel being understood below it.[138] But in this scheme the central panel, instead of being a lateral or horizontal oblong as in the actual ceiling, is almost square and in fact rather longer in the longitudinal direction. The borders are broader, and the side panels contain three instead of the later two similar decorative features. It is hardly possible to bring this arrangement into harmony with that of the side walls. Assuming – as we surely must – that the width of the side and middle panels correspond to the triple articulation of the short end walls of the Library,[139] then their depth is about half as big again as each bay of the long side walls. According to the system of the drawing the rhythm of the ceiling panels would correspond to that of the architecture only at the ends of the room. It was a decisive step to change these proportions and bring the ceiling into harmony with the rhythm of the long walls as well. The ceiling as constructed forms a complete unity with the architecture – something that had scarcely ever been done before. Traditional coffered ceilings had simply covered the room regardless of its articulation, and the sketch, with its strongly emphasized framing

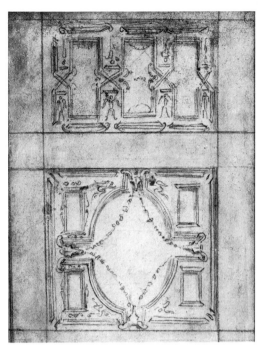

52 MICHELANGELO. Sketch for the central panel and one side panel of the Library ceiling (Casa Buonarroti 126)

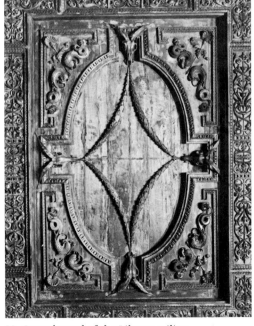

53 Central panel of the Library ceiling

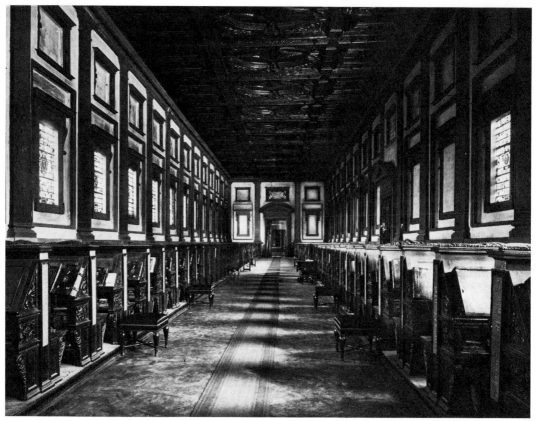

54 Interior of the Library, seen from the Vestibule door

system, its almost square central panels and its dissociation from the long walls, belongs to a world considerably nearer to that tradition than does the ceiling actually erected.[140]

It remains to determine how long after 1537 the ceiling was built. In discussing the staircase we noted that after an interval beginning in 1537, work was not resumed until 1549–50. We also know (see below) that the floor of the Library was not laid until some time between 1547 and 1554. So the end of the 1540s certainly saw a resumption of activity, and this seems a likely period for the construction of the ceiling.[141] It must have been shortly before the laying of the floor, not only for practical reasons, but mainly because the terracotta inlay of the floor almost exactly repeats the design of the middle panels of the ceiling.

Desks. To the same period – say about 1550 – 54 we may attribute the desks, made by the

otherwise little known Battista del Cinque and Ciapino.[142] The desks too have a long history. As early as 2 September 1524[143] the pope was asking how many desks the Library would hold and how many books would go into each desk. He advises the Library of S. Marco as a guide to the distance between the one desk and another. In the spring of 1526,[144] when the ceiling was also under active consideration, the pope asked that the wood used for the desks should be walnut. On 6 June of that year[145] the wood lay ready seasoning – but it was limewood and pine, not walnut. Again on 17 July 1533,[146] after the seven-year interval, Sebastiano del Piombo conveyed Clement's wish that selected walnut should be used, and on 23 August came the order, through Sebastiano, that work on the desks should begin.[147] The contract was perhaps concluded but work can hardly have started until the end of 1534.

I have said that the close connection of the desks with the architecture of the Library is among the happiest ideas of the whole building. This idea was already fully formed at the beginning of 1524, but no drawings have been preserved from the early stages. An original design for the side elevation of a desk does exist, however, showing the general scheme of the present desks.[148] Only unimportant changes were made in the execution. The carving of the fronts of the benches is poor in conception and not too high in quality.[149] Apparently the desks, unlike the ceiling, were not entrusted to the very best craftsmen available.

Floor. The area to be decorated was clearly determined after the positions of the desks had been fixed, and the investigations of A. Marquand[150] have definitely dated the inlaid floor to a period between 1547 and 1554. The work was mainly in the hands of Santi di Buglione who, according to Vasari,[151] was following designs by Tribolo. Its pattern is a reflection of the ceiling, somewhat enriched. In the middle, enclosed by laurel garlands, are the intertwined Medici rings; ribbons dangle from the ibex heads; and others of Cosimo's emblems are arranged in the borders.[152]

Glass. The completion of the Library included the windows, which incorporate various emblems of Cosimo I and Clement VII in stained glass – lightly distributed, delicate and pale in colour. They bear the date 1568. Giovanni da Udine has been held responsible for the design of the glass, but although close in type to his work, it is surely too poor to be by him.[153]

Since all the component parts of the Library had been brought to completion on the initiative of Cosimo I, and as far as was possible in accordance with the wishes of the absent master, the Duke could justifiably hand down a record of his work to posterity in an inscription over the entrance door. And this he did, though in a scroll typical of the 'modern' taste of 1570 – the sole element in the room to disturb the absolute dominion of Michelangelo's conception of form:

BIBLIOTHECAM HANC
COS: MED: TUSCORUM
MAGNUS DUX I
PERFICIENDAM CURAVIT
AN: DNI MDLXXI III ID: IUN

Modern additions and alterations

In 1571 a solemn ceremony proclaimed the Library open to the public. On the same day a medal was struck with the image of Duke Cosimo I on one side and on the other a door – the entrance door to the Library – with the motto PUBBLICAE UTILITATI.

As we saw at the beginning of this essay, the Vestibule façade remained in the rough until the end of the 19th century, and of the interior elevations only that of the south side, against the Library, was complete up to the top. At the time of the opening, moreover, the Vestibule was filled with a mass of hewn stones, which were only removed in 1811.

Early in the 19th century, Duke Ferdinand III seriously intended to complete the unfinished parts of the Vestibule. Scaffolding was erected and the necessary stone assembled, but the enterprise had to be abandoned owing to unfavourable times.[154] Nearly a hundred years passed before the work was eventually carried out, and the not altogether happy results on the façade have already been examined.

Two points about the work of 1904 need to be mentioned. The interior south wall of the Vestibule, the only one finished by Michelangelo, had no cornice. Rossi[155] explains in his text that no design existed for the crowning cornice, but supposes that it was to have been similar to that of the Library. Geymüller[156] thought that the missing cornice had been completed 'from fragments perserved in the Vestibule, which had not been removed', but this was a mistake. The present cornice is modern, though fairly successful. It is a free combination of the Library cornice and that above the first storey of the Vestibule. It contains the integral parts of Michelangelo's cornice – the same main profiles connected by the same small mouldings. The new cornice was tried out in wood, and a photograph was taken by the Soprintendenza for their records. It was then constructed according to the model. The ceiling still remained unfinished. For this no directions of Michelangelo are extant. They were lacking already at the time of building. Ammanati in 1559 had hoped to obtain drawings from Michelangelo for both the ceiling of the Vestibule and the façade.[157] Whether he succeeded or not is unknown. Today, instead of a solid

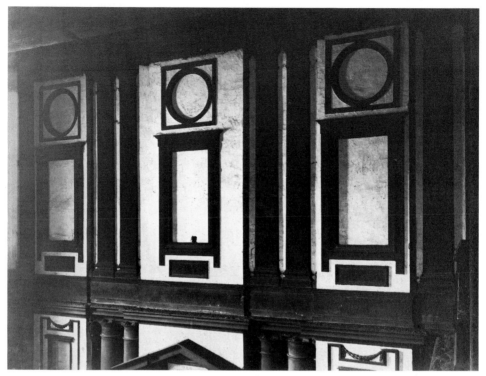

55 Upper part of the south wall of the Vestibule, the only wall completed by Michelangelo

56 North-west corner of the Vestibule before the modern completion

ceiling there is a painted reproduction of the Library ceiling on canvas – a flimsy subterfuge that materially diminishes the energetic effect of the architecture.

We must now look at the additional buildings that have grown up around those of Michelangelo. Already at an early date there was apparently an idea for enlarging the Library. In the north-east corner of the cloister, about opposite the entrance to the Vestibule, there is a *macigno* door frame at the top of three steps, clearly connected in style with the Vestibule. Ruggiero[158] illustrated it in his book with the caption 'Architectura di Michelangelo Buonarroti.'

To anyone familiar with Michelangelo's style it is at once obvious that this door does not express his ideas. Somebody has simply taken over the tabernacle design of the interior and simplified it; the clear-cut mouldings are translated into a soft, rounded style. All this suggests an architect from among Michelangelo's followers.

There is a drawing of this door in the Uffizi,[159] certainly attributable from the style

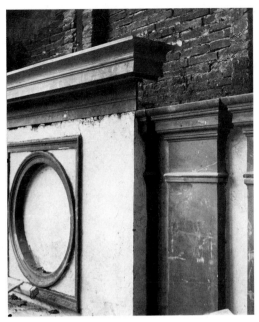

57 Model cornice of wood, erected about 1904 as an experiment before the present cornice was built

58 Door in the north-east corner of the cloister, by G. A. Dosio

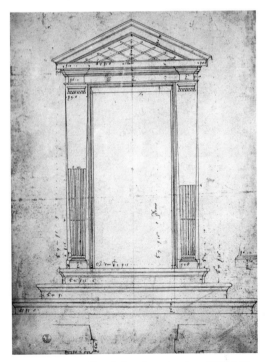

59 G. A. DOSIO. Sketch for the same door (Uffizi Dis. Arch. 1946)

and handwriting to Dosio. Dosio did many drawings of parts of the Vestibule, but in this case what we have is not simply a representation of what is there but an alternative project. The fluting of the pilaster on the left runs more than halfway up, as in the tabernacles of the Vestibule; that on the right considerably less. The conclusion is inescapable that the door was designed and executed by Dosio, and it seems not unreasonable to attribute to him also the whole scheme of which the door forms a part. The door is the entrance to a staircase hall with broad, clearly worked *macigno* steps. This hall was evidently not completed and work on it was soon abandoned. What conceivable purpose can this rather pompous hall have been intended to serve? Our bird's-eye view of the whole complex of buildings provides the answer. Above this corner of the cloister is a structure which can only be the beginning of a complete additional storey to run the length of the east side. Clearly, in the second half of the 16th century Dosio was to erect another Library parallel to Michelangelo's on the other side of the cloister.

An enlargement of the Library became indispensable in 1792 when Count Angioli d'Elci presented his collection of 8000 volumes to Ferdinand III. It was not until thirty years later, however, that Pasquale Poccianti was entrusted with the task of building the present Rotonda, which opens off the middle of the long wall of the Library on the western side. This actually represents only a small part of Poccianti's project, the minimum space necessary for housing the d'Elci collection. His more grandiose scheme provided for another parallel Library where Dosio's was to have been, also with a Rotonda opening from its long wall, and a block across the middle of the cloister connecting the two Rotondas.[160]

Excellent as Poccianti's building is in itself, it bears no relation to Michelangelo's original scheme. The line of pilasters along the wall of the Library brooks absolutely no interruption. Today not only is an intolerable cross axis introduced by the door to the Rotonda but five of the windows are blocked, greatly diminishing the original brightness of the room – a prime necessity of the whole composition. Finally the break in the desk arrangements disturbs the carefully thought-out ground-plan.

After 1880 Poccianti's old ideas for enlargement were taken up again. The new block was built not over the east walk of the cloister but on the extreme south, taking in the site once destined for Michelangelo's 'piccola libreria' and entered by the same door at the far end of the Library. These new rooms, whose junction with the Library ruthlessly cuts off its old southeast corner, fortunately have no effect on the interior, but they are a mediocre and inorganic conglomeration, and a rude shock for anyone whose expectations have been aroused by the Library. These modern rooms bear to Michelangelo's building a relation exactly the reverse of Poccianti's Rotonda; bad in themselves, they do not disturb the effect of the Library.

The Vestibule and the problem of Mannerism

At the beginning of this essay I showed how the change of plan involving the heightening of the Vestibule had apparently been accepted unwillingly by Michelangelo. Yet at a deeper level I believe that the pope's criticism only impelled him along a path that he had already begun to explore – an external pressure triggering off ideas already in his mind at the stage of the first plan.

The room is almost square in plan, and that square is almost completely filled with the staircase. Only narrow passages are left round it. At the level of the lowest storey the mass of the staircase dominates the room; the room is merely a shell enclosing the stair, whose sculptural form is like a precious object in a box or a relic in a shrine. Rooms are usually made for men. Here is a room made for a staircase.

This concept of a staircase in a box excludes the possibility of organic union between stair and walls. The stair is simply placed against the wall; all the mouldings at this level are carried on without interruption behind the staircase, and between the top newel posts and the frame of the door there is a gap wide enough to admit a man's hand. If man and room had been the protagonists of this drama, the staircase would have been organically connected with the wall.

If we look above the lowest storey to the two upper storeys we see no indication at all of the function of the room as a hall to contain a stair. A

60 West wall of the Vestibule, with the staircase in the left foreground

height of 11·50 m rises above us without any perceivable connection with its sculptural kernel, the stair. In other words, at the lower level the walls appear to fulfil a function – to enclose the stair; above, the room seems to exist for its own sake. Below, the shape of the stair determines the shape of the room; above, the room is there *per se*.[161] Here is a dichotomy, but the architecture does nothing to resolve it. The articulation of the Vestibule walls forms a unity, so that the two different characters of the room cannot be viewed separately. The spectator feels an incessant conflict between the two principles: the walls as shell for a sculptural kernel, and the walls as boundaries of a void. No solution is possible. Indeed, the significance of this architecture lies in the fact that no solution is possible. It is perpetually at variance with itself.

61 Plan of the Vestibule showing the relation of the staircase to the walls (after Geymüller)

11 In the first scheme, the horizontal system of wall articulation made it still possible to conceive of each level of the room as a separate entity. The two opposing conceptions of the room are already there, but the discrete arrangement of the storeys one above the other prevents them as yet from coming into open conflict.

Before the Vestibule staircase, all Italian Renaissance staircase halls form absolute spatial unities. Stairs are always against walls; the free-standing staircase is unknown. These stairs present no kind of problem. The Laurenziana Vestibule, faced with an entirely new situation, opens up a new world. It is the first true staircase hall in Western architecture and the ancestor of all Baroque staircase halls. To say this places it in a historical sequence, but says nothing about the meaning of the architecture itself. Michelangelo created, indeed, a type which was taken over by the Baroque and was in many ways decisive for its development – but is it therefore itself Baroque?

We have seen that an irreconcilable conflict, a restless fluctuation between opposite extremes, is the governing principle of the whole building. What is true of the whole is also true of the parts. It has, for instance, often been pointed out[162] that the projection of sections of the wall contradicts the proper function of columns and pilasters. The proper task of the orders is to bear loads and to articulate wall surfaces. The orders thus generally stand in front of the wall. But here the wall stands in front of the orders. This has led to the comment that the walls have expanded into the room, and those who see it in this way have been conscious of an overwhelming sense of mass.[163] In my own view, a truer interpretation of this architecture begins with the fact that the usual status of wall and orders is simply reversed. The observer is plunged, without being aware of it, into a situation of doubt and uncertainty. He perceives that walls and orders have exchanged functions, and his immediate instinctive reaction is to say that this is impossible. The whole wall articulation thus presents a conflict which the architecture does nothing to resolve. This is not the case with the 11 first scheme; there the conflict is still avoided. The tabernacle bays are framed by pilasters so that the recesses with their columns appear to break into a projecting wall plane.

An analysis of the stair leads to exactly the 35 same result. The side flights climb upwards, but in the central flight the whole sense of movement is reversed: the steps fall in a cascade from the Library door.[164] At the meeting-point of all three flights the two directions clash. Mounting one of the side flights and arriving at the landing where they join the centre, one has the sense of being pulled down again. Descending by the central flight one is fighting against the upward current of the side flights. There is no solution: one is forever torn between upward and downward movements. This motif of ambiguity is introduced only after the change of plan; though the way is prepared for it, Michelangelo avoids any suggestion of contradiction between the middle and side flights.

After this survey it is easy to trace the same theme of insoluble conflict in every detail.[165] The separation of inner and outer door frames 4 can be interpreted in no other way. We 4 eventually realize that each member has been given two different and irreconcilable meanings. In the articulation of the whole, the cumulative piling up of layers is replaced by a more intense, uniform, vertical arrangement; just the same sort of development leads from the early windows of the Library to the later doors.

A word remains to be said about the 6 tabernacles. Again, the function of each architectural member is reversed. Pilasters narrowing towards the base, with triangular or segmental pediments above, enclose the niches. The capitals of these pilasters seem to have nothing to do with the pilasters: they are much too small and lie on a plane recessed behind them. A capital normally stands at the point of stress between the upward thrust of the supporting member and the downward pressure of the weight above it: the burden, as it were, squeezes the top of the pier laterally. Here, however, instead of carrying the entablature of the pediment, the capitals hang from it. Since capitals are there, one inclines *a priori* to attribute to them their usual function. Then one realizes that one is looking merely at the form emptied of its content. And so on: triglyphs, components of the Doric entablature, hang like dewdrops below the pilasters. Part of the actual niche is encompassed by a narrow moulding. This moulding is taken across the back surface of the niche a little below the top. At the bottom

62 Tabernacle of the main storey of the Vestibule interior

63 Cappella Gondi, S. Maria, Novella, Florence, by
Giuliano da Sangallo

64 Sala Regia, Vatican, Rome

the niche continues below the moulding, so that
one has the impression of a smaller box placed
inside a larger. One feels that one could lift the
framed box out of the niche, leaving the plain
niche behind. But look more closely: the surface
of the niche right at the top lies in the same plane
as the surface surrounded by the moulding, i.e.
the impression of there being two boxes one
inside the other is wrong. Thus, repeatedly, one
element neutralizes another.[166]

If we wish to establish the place of the
Biblioteca Laurenziana more exactly in the
history of architecture we must go beyond
Michelangelo himself. Is the ambivalence that
we have noted as the decisive characteristic of
the Vestibule solely an expression of his own
individuality or can it be recognized elsewhere?
Can we distinguish such self-opposing, self-
contradicting architecture from architecture
that does not have this quality?[167]

Let us look at a few simple examples.[168] First,
the altar wall of Giuliano da Sangallo's Cappella
Gondi in S. Maria Novella, Florence, of 1506.
The design is based on a triumphal arch. Each
pilaster carries its own projecting entablature.
The inner pilasters are clearly linked with the
outer ones by continuous mouldings at the
levels of base, capitals and architrave. But just as
clearly they are linked with each other, forming
a frame for the central altar; crowned by a
triangular pediment they make a self-contained
aedicule, an intention made clearer still by the
ovolo moulding which runs along the projecting
central cornice. The inner pilasters thus acquire
an ambiguous role. The bay divisions are
obscured, and the observer remains undecided
to which of them the inner pilasters belong.
Every attempt to work out the architecture
according to one system immediately leads to
the other. So here we have an ambivalence that
is essentially the same as that of the Lauren-
ziana. The same tension is created, the observer
is left with the same doubts.

This kind of architecture gives the eye a
specific stimulus to movement. The eye wan-
ders ceaselessly here and there.[169] To express
this phenomenon in a word I have used the term
ambiguous. It is important to understand that
this impression of ambiguity evoked by the
Cappella Gondi and the dual role of its com-
ponent orders is distinct from both Renais-
sance and Baroque conceptions of architecture.

Let us look at a typical Renaissance design, the arrangement of the orders on the façade of the Palazzo Rucellai, begun 1446.[170] Here every bay of any storey is of equal value with any other, in terms of height, width and demarcation. The complete identity of all bays is a basic feature of the design. Apart from those at the corners, every pilaster relates equally and indifferently to the bay on either side of it. The repetition of such accents is essentially self-sufficient, stable. There is no ambiguity, no movement. The system is obvious at first glance; in the Cappella Gondi, on the other hand, it demands prolonged scrutiny.

As a typical Baroque scheme let us take the façade of S. Susanna in Rome, 1597–1603. It is perhaps the finest example of a façade composed of walls on different planes, with orders emphasizing the movement between them. Each bay equals one plane of the wall, and is given a clear and individual frame. At the point where one wall plane (i.e. one bay) comes into contact with the next, two articulating orders stand side by side. In place of the mechanical repetition of the Palazzo Rucellai, the façade of S. Susanna is based on a dynamic, vital movement towards the centre. The bays grow broader, step by step, towards the central bay; the transition from pilaster to column, the increasing amount of incident in the walls, all this signals a crescendo, an accumulation of energies at the central point. The unequivocal sense of movement is aided by the clarity of the bay divisions. The indifference about this point which had not mattered in the Palazzo Rucellai is unthinkable here. Each bay has to be exactly defined. In both cases – the Palazzo Rucellai and the façade of S. Susanna – bay and order are, however, clearly distinguished: in one case by the complete identity of endlessly repeated units, in the other by the absolute differentiation of enclosed, isolated units. The unmoving orders of the Palazzo Rucellai enjoy equal status; those of the dynamic S. Susanna stand in an unmistakeable hierarchy.

The special ambiguity of the Cappella Gondi with its *duality of function* is thus clearly distinguishable from both Renaissance self-sufficiency and Baroque movement. Duality of function, here illustrated in a quite simple example, is one of the fundamental laws of Mannerist architecture. On it depends, for the

65 Palazzo Rucellai, Florence, by Alberti

66 S. Susanna, Rome, by Maderno

67 Ceiling of the Loggia of the Casino of Pius IV, Vatican, Rome, by Pirro Ligorio

most part, the effects achieved by Michelangelo in the Laurenziana. It can be used in connection with the orders in all kinds of complicated ways, many of them much more complex than the 67 Cappella Gondi. The ceiling of the Loggia in Pius IV's Casino in the Vatican garden may be cited – executed in 1561 to the designs of Pirro Ligorio.[171] Or it can be used with other architectural members, apart from the orders. The frames of doors and niches in the Vestibule are prime examples. An extreme instance of the lengths to which this idea can be taken is the 64 wall articulation of the Sala Regia in the Vatican, the design of which goes back to Michelangelo's pupil Daniele da Volterra, after 1547.[172] In all these cases individual members seem to be fulfilling dual functions, breaking up apparently coherent units and puzzling the observer's mind and eyes with ambiguity and movement.

As the starting point for the elucidation of a further basic law of Mannerist architecture, let us take the façade of S. Giorgio de' Greci in Venice, built after 1536 according to a model by Sante Lombardi. The bottom storey follows the principle of a triumphal arch; that is to say, the outer pilasters have their own individual projections, while a continuous projecting cornice joins the two middle ones. In the next storey the two inner pilasters are joined to the outer ones to frame two aedicules, and the centre appears as an unframed, so to speak, open, part of the wall (with a round window in it). In the third storey, consisting only of the central bay, the pilasters are joined again across the top. Pilasters standing one above the other are thus united in conflicting directions, so that above closed bays (bays bounded by orders) are open ones (bays bounded only by the orders of adjacent bays), and vice versa. Equivalent bays

nowhere stand one above the other. Any attempt to find a vertical axis of equivalent bays is defeated by the fact that the pilasters alternate in meaning as they rise. This, I suggest, may be called the principle of *inversion*.

Inversion forbids an unequivocal vertical reading of the façade; the eye is led to wander from side to side, up and down, and the movement thus provoked can again be called ambiguous. Duality of function produces ambiguous movement in a single-storey building, and inversion in buildings of several storeys. Often both principles appear in the same building.

The two examples taken from Renaissance and Baroque architecture show quite clearly that the principle of inversion is foreign to both periods. In both the Palazzo Rucellai and the façade of S. Susanna orders standing one above the other are of equal value, so that the façades can be read vertically without any ambiguity.

In both of the Mannerist examples, the Cappella Gondi and S. Giorgio de'Greci, the ambiguous movement expressed in the orders is quite independent of the walls. Duality of function and inversion take place against an unbroken wall surface. Remove the orders and a complete, unarticulated wall remains. This is not to say that the wall cannot express ambiguous movement. As an example of this the façade of the Library can serve, a part of the building that we have not so far analyzed at all. The row of windows lies in a plane slightly deeper than that of the unbroken wall surface above. At the level of the windows one takes the plane of *their* wall to be the wall proper. The 'pilasters' between them seem to be simply articulating members which could be removed from the wall like a frame. But these same 'pilasters' actually form an unbroken surface with the wall above. This compels us to see the 'pilasters' as the remains of a forward wall plane, out of which rectangles have been cut for the windows, leaving only these narrow strips. Which interpretation is dominant depends upon whether the building is read from below upwards or from above downwards. One can thus say that the wall itself evokes the impression of ambiguous movement;[173] what appears to be wall has the effect of a recessed plane, what appears to be a pilaster strip has the effect of wall. Just as duality of function and

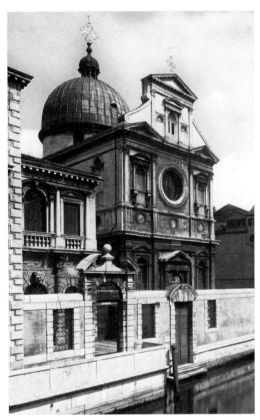

68 S. Georgio de' Greci, Venice, by Sante Lombardi

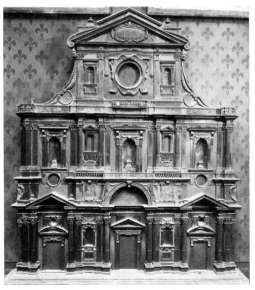

69 Buontalenti's model for the façade of Florence Cathedral (Museo di S. Maria del Fiore)

65

inversion made a clear conception of bays, whether related horizontally or vertically, impossible, so now one remains uncertain as to the real nature of the outside wall. The duality of function peculiar to the wall may be called *permutation*.[174]

Look once more at the Palazzo Rucellai and S. Susanna. The wall of the Palazzo Rucellai remains one undivided plane. The façade of S. Susanna consists of layered planes, but each plane is clearly defined, it runs unbroken up the whole height of the building.

When orders or walls contain such conflicts within themselves the impression is one of ambiguous movement. Duality of function, inversion and permutation lead the eye restlessly to and fro. The state of tension inherent in such architecture is irreducible: there is no possibility of an ultimate balance and repose. Italian architects of the 16th century found innumerable ways of elaborating, varying and combining these principles. A particularly subtle example of all three is Bernardo Buontalenti's model of 1587 for the façade of Florence Cathedral.

Nowhere, however, has the idea of conflict been carried through with such invention, individuality and relentless consistency as in the Vestibule of the Laurenziana. It pervades the whole building in its totality as well as in its details. Nevertheless, if the Vestibule is in a class of its own, it still falls into place as part of a movement; it is the supreme representation of a style appearing everywhere during these years, a style which is as distinct from Baroque as it is from Renaissance.

This movement is Mannerism, into whose origin, history and meaning it is not necessary to enter here.[175] As generally understood, the term is used to cover the style of the period between about 1520 and 1600. In the early literature on the subject it was applied exclusively to painting.[176] But in fact the same concepts are equally meaningful in both painting and architecture: the *figura serpentinata* and the fluctuation between surface and depth easily equate with ambiguity, inversion and permutation: the identity of idea is evident.

Having insisted upon the distinction between Renaissance, Mannerist and Baroque architecture, I must take care not to overstress it. In spite of their differences, this whole

period, from the early 15th century to the mid-19th, can logically be seen as a unity, separated as decisively from the Gothic that preceded it as from modern architecture. What distinguishes and unites these five hundred years is a specific attitude towards structure. Gothic structures depend on the skeleton of the piers; the walls merely fill the intervals between them. Remove the walls and the structure would stand on its own. In the second half of the 19th century, iron, steel and concrete began to change our conception of building. Once more, as in Gothic architecture, we have essentially a skeleton without walls. But during our period, between the Gothic and modern systems, walls were the chief feature. Take those away and the building collapses. The structural strength is in the walls. The walls are divided and articulated by orders (that is the system of columns, half-columns and pilasters taken over from Antiquity) but one could remove them and still leave the walls unimpaired in their structural function.

Both walls and orders can, of course, be treated in the most diverse ways, but essentially they fall into one of two categories – the first rigid, inflexible, self-contained and static, the second flexible, tense and dynamic. No one has yet written an exhaustive history of architecture in these terms, but we habitually think of the sequence as a chronological one – static Renaissance buildings leading to dynamic Baroque ones. True, static buildings do come at the beginning of the period, and dynamic ones not until the late 16th century, but the static continue to exist side by side with them, and at the end of the period even supplant them once again.

Static architecture (Palazzo Rucellai) knows no conflict whatsoever. Dynamic architecture (S. Susanna), with its interpenetrating masses, its ceaseless movement and its clashing of vital energies, has suspense and conflict, but carries the resolution of that conflict within itself. Yet both types of building can be endowed with ambiguity if walls and orders are made to contain two conflicting possibilities, so that the mind is faced with unanswerable questions.

The concept of Mannerist ambiguity can be applied to both static and dynamic buildings. It can be confined to the orders without affecting the wall, and vice versa (interior of the Library); it can appear in door or window frames

69

without reference to wall or orders, and in decorative details. Or, as in the case of the Vestibule, it can inform the whole structure. The result is that there are buildings bearing the stamp of Mannerism to a greater or lesser degree from the earliest, scarcely perceptible signs of functional duality in S. Maria di Loreto in Rome to Buontalenti's model for Florence Cathedral. Every Mannerist building poses the question: is it essentially static or dynamic? If we ask that question of the Laurenziana the answer is: fundamentally static. In the Vestibule we have a rigid system of four walls, each articulated strictly within itself.

Because of the very deep relief of its wall planes the Laurenziana has been claimed as a Baroque building. It is true that from the 15th century onwards there was a general tendency towards the emancipation of sculptural masses. This development reached its highest point in the Roman Baroque of around 1650; afterwards a reaction set in. Already by the 1520s there is an intense striving after free plastic massing (see Raphael's Palazzo Caffarelli of 1515). So the Vestibule is not an isolated phenomenon but forms a link in a chain. But no one had previously dared to cram so much movement into so confined a space.

The strong plastic element in the architecture of the 1520s and 1530s is in complete accord with what was happening in painting and sculpture, and to describe it the term proto-Baroque has sometimes been used. This has led to the mistake of seeing the early Baroque of around 1600 as a direct development from proto-Baroque. In fact there is a deep cleavage between them, though I cannot examine this in detail here. In architecture it is a question of distinguishing between the essentially static structure of proto-Baroque and the fundamentally dynamic structure of true Baroque.

We have now established the specific character, the stylistic position and the importance of the Laurenziana. To sum up: (1) the type of the Vestibule is a new creation; in it for the first time the idea of the Baroque staircase is worked out. (2) The unrelieved tension inherent in the building both as a whole and in detail compels us to separate it from both Renaissance architecture (tensionless, static) and Baroque (dynamic, but containing a release from tension within the building itself); the Laurenziana belongs to a large group of buildings embodying similar principles, common between 1520 and 1600, which may properly be called Mannerist. (3) Basically the element of conflict in the Laurenziana is developed out of a rigid, static system. There seem to be no buildings before 1550 that are dynamic in their structure, in which walls and orders embody laws of movement. Thus the ideas represented by the Laurenziana are applied to a fundamentally Renaissance framework, even though (4) the play of masses and the strong relief of all parts brings it close to the High Baroque.[177] But it would be wrong to conclude from this that the Laurenziana is Baroque in character; it is clearly in the line of High Renaissance buildings. (5) The particular character of the Vestibule arises from the fact that such strong relief and such differentiated walls are used in so small a room. It is this which produces the effect of overwhelming oppression and the dominating impression of ambiguous, conflicting energies.

The Laurenziana stands at the beginning of a completely new approach to architecture. The ideas conceived and carried out here went far beyond anything that other architects dared imagine. Here is the key to a wide area of unexplored or misinterpreted architectural history, and the explanation of much that was to happen in the next two centuries and beyond.

Appendix I: Problems of construction

The choice of site for the Library did not depend entirely on how much of the monks' dwellings were to be sacrificed (see Appendix III) but also on the cost of construction. On 13 April 1524 (Frey, *Briefe* . . ., p. 224) the pope declared himself to be satisfied only 'quando voi non abbiate arrifondare; perche non vole fare una libreria per avere arrifondare quasi tutto un convento'. On 29 April 1524 (*Ibid.*, p. 226) the pope refused to agree to Michelangelo's plan of strengthening the walls by more than one *braccio*, since they had only the roof to support. After this, discussion of the strengthening continues, and Baccio Bigio is called in for consultation.

On 13 May (*Ibid.*, p. 227) Michelangelo proposed to erect pilasters outside and inside to run the whole height of the building. Baccio Bigio, on the other hand, proposed to strengthen the walls of the new building by a quarter on the inside, without touching the old walls at all, making the extra quarter rest on the vaulting. Fattucci suggested that Michelangelo should consult specialists on the subject.

Eventually, Michelangelo evolved a not too costly way of giving in effect new foundations to the whole building at the back (west side, Pl. 9): against the whole wall he placed arcades supported on pillars which thus took the weight of the upper building. The 'disegno de'pilastri', acknowledged by Fattucci on 7 July 1524 (Frey, *Ibid.*, p. 232), doubtless refers to these pillars at the back of the building. The pope is content with this solution and Michelangelo is to begin on the foundations.

On 17 September we learn that the execution is in the hands of Baccio Bigio (*Ibid.*, p. 236), leaving Michelangelo free for the figures of the Medici Chapel. On 6 November (*Ibid.*, p. 240) a number of the pillars are already constructed.

Just as on the façade, the windows of the Library lie in a deeper plane – here apparently the plane of the old walls. On the subject of this scheme the malicious prior of S. Lorenzo, Figiovanni, angered by the dirt and discomfort caused by the work, expressed himself to the pope that Michelangelo was turning the library into a dovecote ('fate la libreria in colombaia', 1 October 1524: Frey, *Ibid.*, p. 237).

On the façade (east side) the cloisters acted as buttresses to old and new walls. In the west wall as in the east the relation of interior to exterior is clearly expressed. The skeleton of the new building consists of pillars bound together by thinner, that is to say lighter, walls. The pillars appear on the outside as piers, inside as pilasters. This solution of the problem of construction considerably diminishes the weight of the new walls.

Outside, as in, the windows lie in a recessed plane; the plain wall above the windows outside is built all of one piece with the piers which divide them, while on the inside the same piece of wall is recessed and therefore lightened by the almost square tabernacles.

Fattucci wrote to Michelangelo on 12 April 1525 (Frey, *Ibid.*, p. 250) that the pope was pleased with the windows inside and outside, and also with the tabernacles over them on the inside. Michelangelo had evidently sent to Rome a final report on the details of the Library articulation; the outside windows were at that time already in process of construction (*Ricordo* of April 3, 1525. See Milanesi, *Lettere* . . ., p. 597). One can also deduce from Fattucci's letter that the Library façade as we see it today was considered complete by Michelangelo, that the plain stretch of wall above the windows was not, in fact, to be enlivened in any way.

Special difficulties were presented from the beginning by the security of the Vestibule walls. Under the Vestibule is the chapel of the monastery. Since the Vestibule had to be wider than the chapel it was apparently necessary to erect a wall in the room next to the chapel, on which wall the south wall of the Vestibule now rests.

At the back of the Vestibule (west side) the strengthening of the wall projects 34 cm beyond the surface of the Library wall. This strengthening rests on the vaulting of a Quattrocento loggia above which there was at the time of Michelangelo's construction an open terrace, from which a spiral stair led to the roof of the Vestibule (visible on the drawing of Battista da Sangallo, Pl. 27 and in G. B. Nelli's measured drawings of the Vestibule: Uffizi no. 3712). The terrace has now been glazed and roofed in.

To the east wall also Michelangelo gave more strengthening than he gave to the neighbouring wall of the Library. This wall of the Vestibule projects, however, only 11 cm beyond the Library. As soon as Michelangelo reckoned with the strengthening of the Vestibule walls he was compelled to double the piers at the point where the Vestibule projects beyond the Library. The doubling of the piers was necessitated also (as can be seen from a glance at the ground-plan) by the interior design. Both these elements, the slightly projecting façade of the Vestibule and the juxtaposition of the two piers, interrupting the regular sequence of the windows of the façade, must have been welcomed by Michelangelo in the interests of the general effect of the façade in the first plan: this conception of Library and Vestibule left one just aware of two different buildings, but not so that the primary unity of the whole was disturbed. It eliminated the shock of discovering behind a single façade an interior divided into two quite different kinds of room.

The homogeneity of interior and exterior shown in the Library was from the beginning impossible in the Vestibule, as can be seen from the section in Pl. 8. The necessary discrepancy between inside and outside leads to a comparative thinness of the walls at certain places. It was apparently in consideration of this fact that Michelangelo avoided a massive superstructure. The broadening of the piers in the upper part of the building was to carry the heavy beams of the roof.

The small window in the middle of the façade before the renovation of the 19th century demands some explanation. It is a later opening apparently of a time when, for reasons as yet obscure, the windows of the north and west wall were partly bricked in. This window lies too high to be brought into connection with the intermediate plan, but on the other hand, it is too low for the final plan.

Of the second storey on the inside only the south wall was completed under Michelangelo's direction. The three other walls remained in the rough, and were finished only at the time of the renovation of 1904. Only thus is it understandable that the window should be opened without consideration of the articulation of the storey. It can thus in no way be connected with the original building.

Appendix II: Origin of Sheet Casa Buonarroti 48 (Pl. 11)

The stages by which this sheet was produced can be followed step by step. Michelangelo first marked off the sides and top of the wall. Then he began at the top putting in the lines of the vaulting, did not go on with the attic but established the base into which he immediately inserted the two doors, at equal distances from the boundary line of the wall. Simultaneously with the left-hand door the section of the staircase was added. Only then did he begin to fill the space between vault and base with the attic. The articulation of the attic he drew too broad from the beginning, so that the bay which should have lain axially below the small rectangular window in the wall of the vault fell a little too much to the right. The first tentative indication of the central bay of the attic is that vertical line which breaks into the left-hand circular panel. The following bay on the right with its circular panel is considerably broader, so that the last projecting rectangular bay had to be correspondingly smaller in order to be included within the original outline. Though he has succeeded in squeezing this bay into the original outline, half of a receding bay with which the attic on the left-hand side should correspondingly finish, is missing. This missing half attic bay was now added outside the original outline, and, to avoid difficulties in the bay of the main storey, he extended the new outline to the bottom. A similar extension must now be added at the left-hand side, but logically he did not draw the new boundary line here – as on the right – parallel to the old, but at an acute angle. Hence at the bottom there was an extension so that the door frames were again equidistant from the new outlines. In the main storey drawn last of all a change of scale in

relation to the attic still ensued. The axis of the central tabernacle division is thrown out to the right of the corresponding part of the attic, and the following pair of columns is even more markedly displaced in relation to the bay with the circular panel properly lying over it. Severe

narrowing down of the last tabernacle bay could at least restore to some degree axial connection with the corresponding attic bay, but a pilaster of the tabernacle bay, and the outermost column, had to be drawn outside the proper boundary line.

Appendix III: Discussion of the site and beginning of building

At the beginning of plans for the Library stands the discussion of site. Below is collected all that can be gleaned today from sources on the subject:

1. Before 30 December 1523, a design for the Library by Michelangelo's helper, the miniaturist Stefano di Tomaso, arrived in Rome (Frey, *Briefe . . .*, p. 201). On this scheme there is a division into two libraries: one for the Latin and one for the Greek books (Fattucci's letter of 2 January 1524. Frey, *Briefe . . .*, p. 204). The pope demands a design from Michelangelo's own hand. That this first design was not by Michelangelo and was sent without his knowledge is proved by a letter of his own hand to Fattucci of January 1524 (Milanesi, *Lettere . . .*, p. 431 – clearly, the answer to Fattucci's letter of 2 January); in this he protests that he knows nothing of the Library building, but will find out about it on the return of Stefano from Carrara. This justifies the conclusion that Stefano di Tomaso – who took further part in the affairs of the Library – was responsible for the first design.

2a. Michelangelo's first plan arrived in Rome on 21 January 1524 (Fattucci's letter to Michelangelo of 30 January; see Frey, *Briefe . . .*, p. 209). From Fattucci's letter it can be deduced that Michelangelo chose the present position for the Library. This is proved by the phrase '. . . volta a mezodi,' i.e. as today, facing north and south. The pope demands – against danger of fire – vaulting in both the lower storeys; this also can only be referred to the present site. In Fattucci's letter of 9 February (*Ibid.*, p. 211) it is explicitly stated that this scheme is planned over the monastery. At the pope's desire Michelangelo sends accurate plans of both

storeys of the monastery to Rome. It emerges that this scheme necessitates the destruction of seven rooms on the ground floor and seven on the first.

b. Clement VII, although pleased with the scheme itself, nevertheless according to Fattucci's letter of 9 February asks for plans for another site to be drawn up – since the use of this one involves the destruction of too many of the monastery rooms. We learn here of the new plan as follows: 'Let Stefano or any one else you think fit inform himself as to the placing of a library on the square and towards the Borgo San Lorenzo and see exactly how much of what would have to be taken for the library belongs to the priests and how much to shops and house owners.' It is further to be ascertained what the price of the purchase would be.

In order to preserve the monastery intact, the pope here contemplates taking the Library out of the precincts of the church to that street which runs from the cathedral to the Piazza San Lorenzo and is still today called Borgo San Lorenzo. The drawing Casa Buonarroti 81 (Frey 235; Thode, II, p. 120, III, no. 143) seems to have originated in connection with this scheme. It gives a plan of the site with the names of occupants. From top to bottom the list runs: 'losteria – di san Lorenzo – meser andrea martelli – una chapella in santo stefano – del bechuto – di san lorenzo – del bechuto – san Lorenzo.' Here, then, is noted, as the pope's letter demanded, what belongs to the clerics and what to private owners. Of a S. Stefano in that neighbourhood no trace is to be found. 'Del Bechuto' is the name of an old Florentine family (Orlandini del Beccuto), to whom before 1432 a palace in that quarter also belonged (today Palazzo Vai. See

Limburger, *Gebäude von Florenz*, 1910, no. 706. About Andrea Martelli see Frey, *loc. cit.*). The names on the sheet thus give no evidence for the identification of the site. Thode sees in this sheet the plan of the houses adjoining the Library on the west side; the list from top to bottom he takes from south to north. Both ideas are without foundation. Just as unlikely is Frey's attempt to connect the drawing with a passage in a letter of 10 March 1524: 'Circa le case che sono verso la via della Stufa dice [the pope] che le vole gittare in terra. . . .' The Via della Stufa runs north in the line of the façade of S. Lorenzo (Pl. 10). This must refer, therefore, to the houses which still today stand against the long north wall of the church, and has nothing whatever to do with the Library building. This clearance would scarcely be so important as to demand a plan of the site from Michelangelo's own hand. On 18 February Michelangelo's consignments had not yet reached Rome. In a letter of this day Fattucci asks Michelangelo to send the cost for 'bottege, case, camere che s'abino a guastare sotto et sopra' (Frey, *Briefe* . . ., p. 212). Should this be taken as a comparision between the cost of the respective plans?

c. End of February Fattucci acknowledges a letter of Michelangelo's (*Ibid.*, p. 213), but declares that he does not want to show it to the pope, as it does not show how many rooms must be destroyed. Michelangelo must write on this subject and perhaps send sketches. Since a few weeks previously the destruction of seven rooms above and seven below was spoken of, a new plan by Michelangelo must here be under consideration, a plan which involves fewer rooms being destroyed. Michelangelo thus attempts to meet the pope over the question of the destruction of part of the monastery, since he is reluctant to abandon the site which he regards as being the right one for the Library.

If the Library were placed on the Piazza and Borgo San Lorenzo Michelangelo considers that the façade of the church would be overwhelmed by the superior height which the Library must have. This idea of Michelangelo's is perhaps at the back of Fattucci's words: 'Piacegli [the pope] assai la vostra consideratione rispetto alla faccia di S. Lorenzo.' Before this he says Michelangelo is to build the Library where *he* wishes.

d. Michelangelo sends two designs to Rome which are acknowledged on 10 March 1524 (Gotti, *op. cit.*, I, p. 165; see also the beginning of the letter in Frey, *Briefe* . . ., p. 216). A scheme is accepted in which the Library is 96 *braccia* long (55·68 m; actual measurement: 58·40 m), in which a difference in level at the entrance of 6 *braccia* has to be contended with (3·48 m; actual measurement: 3·04 m), and in which, finally, dwelling rooms lie under the Library which the pope wished to have vaulted in order to make them fireproof. All this points to the conclusion that a scheme was chosen on the present site, a scheme which in its fundamental division into staircase hall and Library and approximately in its main measurements already agrees with the actual construction.

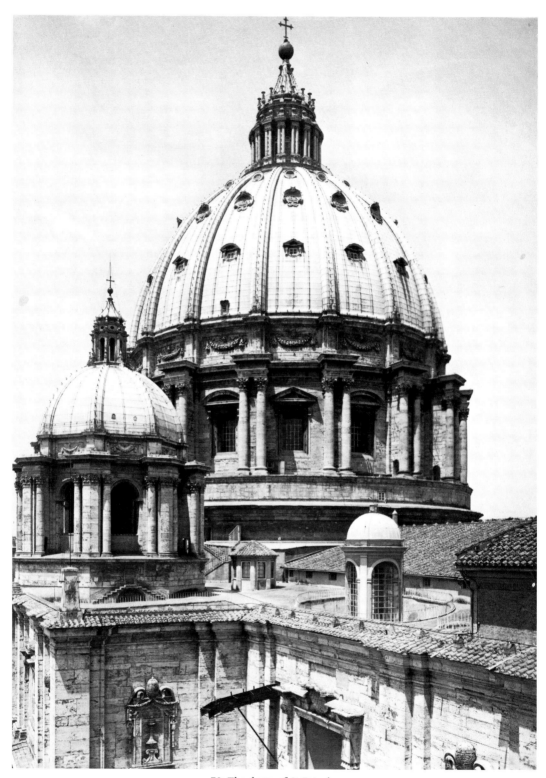

70 The dome of St Peter's

II
MICHELANGELO'S DOME OF
ST PETER'S

THE DOME of St Peter's has always been regarded as the most sublime symbol of Christian architecture. The magnificent silhouette of the elevated, soaring structure still dominates the city from many viewpoints. Sixteen strong ribs rise from the powerful buttresses of the drum and appear as conductors of an intense energy – energy that is released through the lofty lantern.

No antecedents prepared for this extraordinary design. But once the dome was standing, domical structures became dependent on it for three hundred years. None of the later imitations, variations and transformations – not even the domes designed by such great architects as Hardouin Mansart, Fischer von Erlach, Juvarra, Sir Christopher Wren and Soufflot – approached the grandeur, compactness and tension embodied in the prototype.

Surely, we owe the existence of the dome of St Peter's to one of the rare conjunctions in the history of art: a towering genius was available when the occasion arose and was given a free hand.

But is this universally admired dome entirely Michelangelo's work? Does the structure we see before us correspond to his ultimate design? During the 1920s and early 1930s, the question was intensely studied. I myself took part in the discussion: in 1934 I published a long paper in the *Zeitschrift für Kunstgeschichte*, translated thirty years later into Italian with the title *La cupola di San Pietro di Michelangelo*. Accepting to a large extent the conclusions of my original paper, James Ackerman, in his book on *The Architecture of Michelangelo* (first published in 1961) brilliantly summarized the position that seemed the only possible one, namely that the present dome does not correspond to Michelangelo's final design in some vital respects.

But historical truth is not easily come by. In recent years the dome of St Peter's has caused a small inflation of studies and once again the whole problem seems in a state of flux. I cannot review all these studies, but have to refer at least to two and in particular to one by Cesare Brandi, a scholar who wields great authority in Italy and abroad. In 1968 he read a paper before the Accademia dei Lincei in Rome entitled 'La curva della cupola di San Pietro' – a paper that was subsequently published. Brandi's interpretation of the written and visual documents leads him to believe that, by and large, the present dome corresponds to Michelangelo's ultimate intentions. Despite some critical refinements, we are back to the position of over a generation ago, before the meticulous modern sifting of the rich historical material began.

Thus we have to go over the ground once again, keeping Brandi's arguments in mind, and also those of the second author I have to refer to, namely Charles de Tolnay, who took up a position close to that of Brandi: as early as 1930–31 he maintained that Michelangelo's last project for the dome must have shown the elevated curve and Tolnay is probably the only scholar who never changed his view one iota; he returned to it with new arguments at the International Congress of Art History at Bonn in 1964, in a paper published in the Acts of the Congress in 1967.

Let me begin by reminding you of some of the basic chronological facts. Antonio da Sangallo the Younger, who for over twenty-five years had been in charge of the new church of St Peter's begun by Bramante, died on 29 September 1546. Michelangelo was appointed his successor probably on 1 November 1546; the appointment was ratified on 1 January 1547. For over seventeen years, until his death on 18

71 Anonymous drawing showing the crossing under construction in about 1553–54 (Uffizi 4345)

72 G. A. DOSIO. View of the crossing looking north, c. 1562 (Uffizi 91)

February 1564, the building of St Peter's remained Michelangelo's greatest, and often exasperating worry. After the master's death the office as architect to St Peter's fell first to Pirro Ligorio who was, however, hastily dismissed (on 31 October 1565) when it appeared that he had tried to alter Michelangelo's design. Ligorio was succeeded by Vignola who remained in charge until his death on 7 July 1573. Thereafter Giacomo della Porta took over. He vaulted the dome between 1586 and 1590 and finished the lantern in 1593.

We can learn a great deal about the problems prevailing during Michelangelo's term of office by asking how work at the dome proceeded and how much of the dome was standing when he died. The documents preserved in the Archive of St Peter's provide a full answer. They were published by Karl Frey over half a century ago. Frey's authority as an accomplished archivist was such that nobody dared to challenge the procedure of this highly esteemed German professor. What he did was to publish contracts and payments in the sequence in which they had been entered in the ledgers. I need hardly point out that there is neither rhyme nor reason in such a procedure. In fact, Frey's method led himself, as well as others, to serious misunderstandings, for the thousands of miscellaneous documentary minutiae offered by Frey made it absolutely impossible to follow the construction of the dome as a co-ordinated operation.

I had been struggling with these documents thirty-five years ago – just like others before and after me – and had tried in vain to elicit reliable answers from them. When I returned to them in 1963 it struck me that in order to make sense they had to be rearranged completely. I indexed all the payments to individual masons under their names together with the specific job for which the payments were made, and it turned out that the time invested in this not exactly thrilling job was highly rewarding. The following indisputable facts emerged:

1. On 24 February 1552 the great cornice over the arches of the crossing was finished, a fact that has always been known. A slightly later stage is shown in an anonymous drawing in the Uffizi.

2. Twelve and a half capitals of the internal order of the drum were finished at the begin-

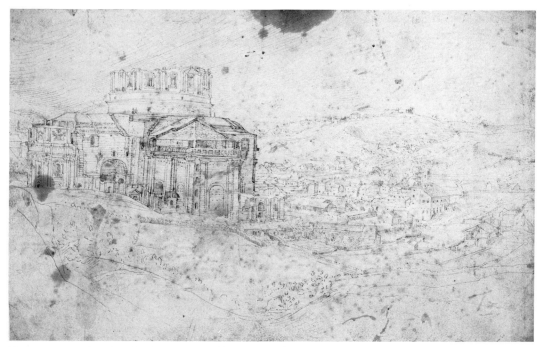

73 Anonymous drawing showing St Peter's from the north-west, *c.* 1566–67 (Stuttgart, Staatsgalerie, 5811)

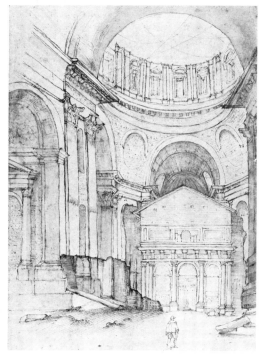

74 View, possibly by Ammanati, of the crossing looking west, *c.* 1562 (Hamburg, Kunsthalle 21311)

ning of 1556. Thereafter work came to a complete stop. It was resumed after a break of over five years, in September 1561, and by February 1564 the remaining nineteen and a half capitals were finished (there are sixteen paired pilasters, i.e. thirty-two capitals in all). In other words, in 1556 only six double pilasters with their capitals were in position, while at the time of Michelangelo's death in 1564 the entire order was standing *but without the entablature*.

The aspect of the drum in 1562 – i.e. after the resumption of work – is recorded in two drawings, one by the architect Dosio in the 72 Uffizi, the other (perhaps by Ammanati) in 74 Hamburg. The Uffizi drawing shows a view northward through the crossing. Of the five bays of the drum here represented, only that over the north-western pier is finished. The Hamburg drawing shows the crossing as one looks west (i.e. towards the choir). Five bays of the drum with their windows crowned by alternating segmental and triangular pediments (important!) are finished. The window of the last bay on the left is still without its architectural frame. The bay on the left in the Uffizi 72 drawing corresponds to that on the right in the

75

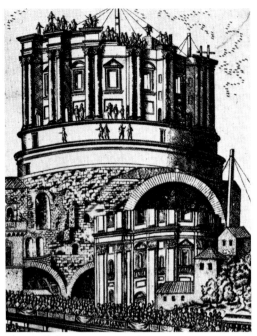

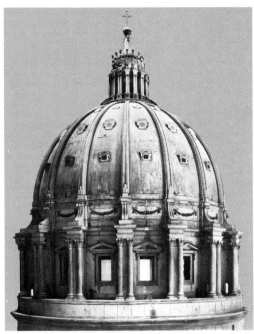

75 Detail from a woodcut of 1565 showing the part of entablature of the drum already complete

76 Wooden model of the dome (Rome, St Peter's)

74 Hamburg drawing. Thus, at this moment (probably fifteen months before Michelangelo's death) only five bays were certainly finished.

3. The columns of the exterior order were prepared between the beginning of 1554 and May 1556. But on the exterior, too, work ceased completely for five years. Between May 1561 and August 1564 the order with the capitals, once again without entablature, was in position. In October 1562 a strong rope for lifting the drums of the columns was paid for and we see

72 the contraption in operation in Dosio's drawing.

4. The entablature above the double columns was paid for between 4 January 1565 and 12 November 1568, i.e. it was begun under Ligorio and finished under Vignola. A number of

73 illustrations allow us to follow the progress of

75 this work. My example, an engraving of 1565, shows the entablature in *statu nascendi* in the east and north-east of the drum.

5. The attic over the entablature was paid for during Giacomo della Porta's tenure, 1588–89, and everything from the attic upwards belongs to the final stage. In the interior, at least part of the architrave and cornice were paid for in 1588 and specified payments for the interior architectural decoration of the dome date from 1589.

76

This analysis of the documents has revealed the extraordinary and indisputable fact that work on the dome stopped completely between the spring of 1556 and the spring of 1561. In the light of this discovery, information supplied by Vasari, Michelangelo's friend and biographer, takes on great significance. He tells his readers that, when the construction of St Peter's progressed *but slowly*, a number of close friends urged Michelangelo to have a large model of the dome made, which would serve to nip any later diversionary tendencies in the bud. The friends prevailed: in July 1557 Michelangelo made a small preliminary terracotta model, upon which the large wooden model was based. This large model fortunately survives, at least in parts. It measures almost ten feet to the apex of the interior vault, which belongs to the original model. According to the documents, the model was executed between November 1558 and November 1561 (in fact, excepting the lantern it was finished in 1560).

Obviously, the model was deemed necessary after work had ceased in the spring of 1556 and the hope of redressing the situation seemed slim. Michelangelo himself refused to admit defeat. On 13 February 1557 he wrote to his nephew:

'As regards the building of St Peter's being closed down, there is no truth in this', and three and a half years later he tried to combat what seems to have been the talk of the town, namely 'that the fabric of St Peter's could not be going worse than it is.' A reliable model was all the more necessary, because – as the documents have taught us – not even the construction of the drum was far advanced when building activity stopped.

Vasari, who was very close to Michelangelo and regarded himself as his hero's spiritual executor, wanted to make sure that Michelangelo's dome design would never be tampered with. He included therefore in the 1568 edition of his *Lives* – four years after Michelangelo's death – a most detailed description of the wooden model of the dome. He introduced his description with the remark that at the time of the preliminary terracotta model – i.e. in 1557 – a large part of the interior drum windows and of the exterior order was finished.

Art historians have never doubted this piece of information and were naturally unable to explain why in the wooden model all the interior windows have segmental pediments and all the exterior windows triangular pediments, when, following Vasari, they assumed that Michelangelo had already executed alternating pediments before he began the model. In actual fact, the documents show that Michelangelo began executing the windows only *after* the resumption of work in 1561 and it was then that he decided to change the pediments.

The recognition of the true facts opens an interesting perspective on Michelangelo's working procedure: at a time when the drum was going up, details of the design were still vague. No wonder that the project was wrapped in a shroud of mystery; the mystery was only lifted when the large model forced him to make a definite statement. Until then his friends must have been much worried about his unwillingness to commit himself. The last-minute changes of the window pediments of the drum teach us that also the dome and the lantern might have undergone some adjustments if Michelangelo had been granted time to execute them. In any case there are indications that he pondered long over the lantern in the model and it also seems that he incorporated in the model alternative suggestions for certain details of the lantern.

With these provisos the model preserves Michelangelo's final project for the interior dome. Michelangelo planned a dome with two vaults, following a long tradition climaxed in Brunelleschi's dome of the Florentine Cathedral to which – as we know for certain – he had turned for instruction and inspiration.

After extended discussion among scholars there seemed unanimity of opinion that Porta had removed the original outer shell of the model above the attic and replaced it by his own shell and lantern. But Decio Gioseffi (who published a book on the dome in 1960) believed that Porta had used Michelangelo's original external shell and had only raised it; this idea had some following in Italy: Di Stefano in his *Cupola di San Pietro* (published in Naples in 1963) more or less accepted it and now Brandi has taken it up again. I think these gentlemen are mistaken and my reasons for this belief are implicit in what follows.

For the reconstruction of the original outer shell of Michelangelo's model a wealth of material is extant. Apart from Vasari's detailed and reliable description, we know eight studies by Dosio after Michelangelo's model (now in the Uffizi), dating probably from about 1566. In addition, we have the well-known engravings of Michelangelo's St Peter's by the French 82, 83 architect Dupérac, datable to 1568–69. Michelangelo's own drawings of the dome, 77 however, are not related to the model version.

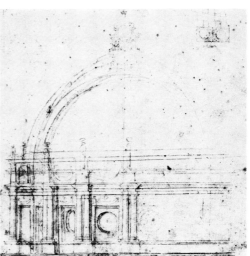

77 MICHELANGELO(?). Study for the drum and dome (Lille, Musée Wicar)

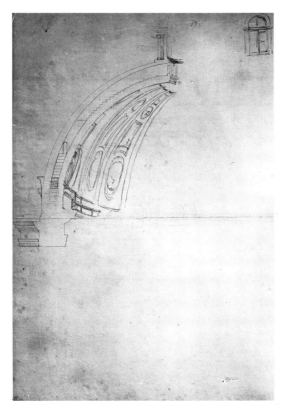

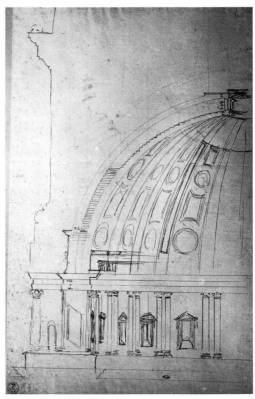

All this material, long known, and evaluated more than a generation ago, has fairly recently been increased by a remarkable discovery, made by Professor de Tolnay and briefly discussed by him at the Bonn International Congress of Art History. Some twenty years ago the New York collector Janos Scholz found in Paris a volume with miscellaneous 16th-century drawings and Tolnay recognized that twelve of them were related to Michelangelo's St Peter's. Owing to Mr Janos Scholz's generosity the entire volume is now in the Print Room of the Metropolitan Museum.

Of all this evidence I can only mention a few major points. According to Vasari's description, Michelangelo constructed his double-shell dome from three centres: *the centre C determines the hemispherical inner shell and the centres A and B the outer shell* (the thickness of which diminishes slightly towards the apex). As the diagram shows, the outside curvature would have been a trifle under the hemisphere. Vasari's description of the construction may be

correct, but he is silent regarding the location of the *centre C on the vertical axis* (although he supplies the location of A and B in relation to C).

Dosio, who worked experimentally before the model, was intensely interested in tracing the principle of construction of the double shells *including* the location of the centres in relation to the architecture of the drum. Dosio knew, of course, that the height of the dome and the rise of its curve depended on the heightening or lowering of the centres. My diagram which shows domes with *equal* radii but *different* location of the centres makes this abundantly clear.

In one of Dosio's drawings the shells are constructed from three centres corresponding to Vasari's description (the pricks of the dividers are visible in the original). I may also direct attention to the sketchy indication of the lantern.

In another drawing Dosio constructed the dome from four centres. The outside shell forms an exact hemicycle. Here he placed the centres

80

78 G. A. DOSIO. Drawing of the dome from the model (Uffizi 92a recto)

79 G. A. DOSIO. Drawing of the dome from the model (Uffizzi 94a recto)

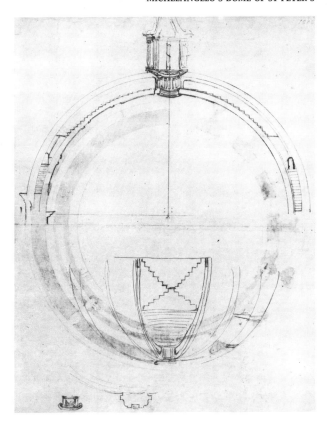

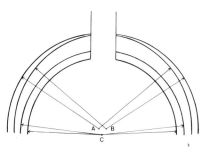

80 Diagram showing the construction of the dome from three centres

81 G. A. DOSIO. Section of the dome from the model, with a sketch of the stairway, upside down, below (Uffizi 2031a recto)

too low. Of the lantern only an inner structure is indicated together with a curious fan-like ceiling. Along the left margin of the sheet he drew the large-scale profile of the outside attic. The mouldings below correspond to the model *and* the execution; the cornice at the top corresponds to the model, but *not* to the execution.

Dosio's section of the dome is constructed from seven centres. But here they are placed too high. Once again we find here an inner lantern with the fan-like roof and also a sketchy indication of the outer lantern.

Below and upside down there is a sketch of the cruciform stairway in the lower part of the vault, as described by Vasari and still traceable in the model. Moreover, at the bottom of the sheet there is a profile of the ribs planned by Michelangelo and a small sketch of one of the dormer windows.

Dosio's various attempts at reconstruction show that Michelangelo's model had a hemispherical outer shell, and in this respect Vasari's

description and Dosio's drawings supplement each other.

While experimenting at the model a few years ago, I managed to determine with sufficient accuracy the position of the centre of the inner hemisphere. It lies $2\frac{1}{2}$ inches above the cornice of the drum, i.e. at approximately half the height of the attic. Now the only visual document which is correct in this respect is Dupérac's engraving of 1568/9. This section has an elevation as its counterpart. Both engravings show Michelangelo's project of the entire church and, though they contain some prob- 82 lematical features, they are exceptionally 83 thorough as far as the dome is concerned. The details reveal that Dupérac incorporated the alternating pediments of the drum windows in accordance with the execution and based the rest – dome and lantern – on a careful study of the model.

The purpose of Dupérac's engravings seems to me rather obvious. I doubt that they were freelance work for the print trade, although

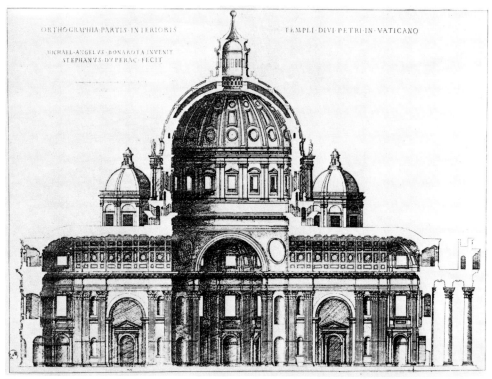

82 S. DUPÉRAC. Longitudinal section of St Peter's, based on Michelangelo's project. Engraving

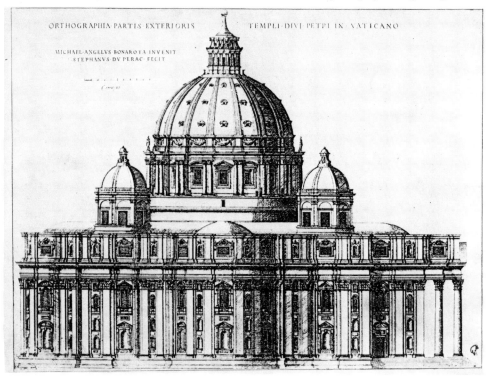

83 S. DUPÉRAC. Exterior elevation of St Peter's, based on Michelangelo's project. Engraving

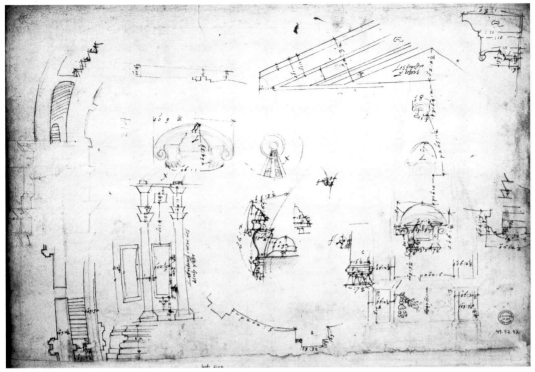

84 Sheet of sketches made from the model (New York, Metropolitan Museum of Art)

they were sold commercially. More likely, they were commissioned by an interested party who wanted to publicize widely an authoritative statement of Michelangelo's final conception of St Peter's. Later I shall try to substantiate this view.

Dupérac's section shows a low inner lantern corresponding to the indications found in some of the Dosio drawings. Ample material for Michelangelo's planning of this strange feature had first been assembled by the late Dr Koerte almost forty years ago. Nevertheless, not everyone has accepted Koerte's conclusions. But Dupérac is now entirely vindicated by the evidence of some sketches on a sheet in the Metropolitan Museum of Art, New York.

Here you have two pilasters and two windows of the inner lantern together with two beams of the roof, jotted down before the model for the sake of securing all the dimensions. The inscription in French: 'La tribune entre les deux volte' clinches the identification. In all essentials the sketch corresponds to Dupérac's

rendering of the inner lantern. Next to the sketch, in the centre of the sheet, there is a plan of the roof and the inscription 'X' ascertains this connection.

Most of the other sketches on the sheet relate to the exterior. There is a detail of the triangular pediment of the drum windows, inscribed 'Les fenestres par dehors'. Other details concern the dormers and the attic; finally, there is a plan of a rib with steps in the centre, precisely as described by Vasari and represented by Dupérac.

So far as a control is possible, the inscribed measurements were accurately taken from the model (segment of window and attic). But, as every architect knows, it is typical for this kind of free-hand sketch that the proportions do not tally with the inscribed measurements. Nonetheless, the sketches and measurements in conjunction make an exact reconstruction of many details of Michelangelo's model possible, for which we had only relatively scanty evidence.

81

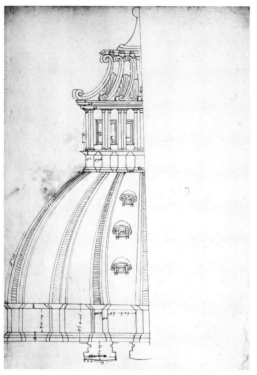

85 Exterior of dome, made from the model (New York, Metropolitan Museum of Art)

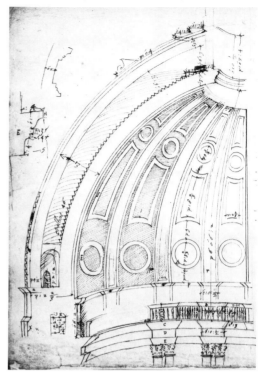

86 Section and interior of dome, made from the model (New York, Metropolitan Museum of Art)

Now it is remarkable that in Dupérac's engravings the rendering of the attic, of the ribs and dormers and, as we have seen, of the internal lantern correspond very closely to the sketches, and this is also true of the measurements, so far as the scale of the engravings allows us to check. In any case, in my view no doubt is possible that the engravings are indeed faithful reproductions of the model.

85 This is further confirmed by another drawing in the Metropolitan Museum. In spite of its amateurish quality, this drawing is most important, because it shows the shape and details of the outside lantern of the model.

There are strange inconsistencies in the drawing, and the whole lower part can only be regarded as a diagrammatic rendering, a kind of foil for the lantern. In the attic – and not only there – the inscribed measurements have gone haywire and so have the proportions: the lantern is much too high in relation to the dome. Proportional blunders are carried over into the lantern. According to the inscribed measure-

ments the twin columns are 19 *palmi* (i.e. 14 ft) high and the crowning scrolls are 12 *palmi* (i.e. c. 9 ft) high, but the draughtsman rendered the scrolls higher than the columns. In the Dupérac engraving, by contrast, the proportions are correct.

I mention immediately that Giacomo della Porta, in his executed lantern, followed these measurements fairly closely, although he altered some details of the design.

Tolnay regards this drawing and a second one among the same Scholz material (showing a section through the model) as proof for his conviction that (in his words) in the model the 'line of the outer calotte was elevated above the hemispherical inner calotte'. In actual fact, the draughtsman was puzzled, as the clusters of pinpricks in both drawings show. Like Dosio, he tried out methods of construction. I think Tolnay's approach to these drawings cannot be supported by evidence. In his opinion the outside view was done *from* the model and the section *for* the model. As author of these

drawings, he named a French carpenter, a Giovanni Francese (i.e., John from France) who, according to Vasari, had a hand in the execution of the model (there are French inscriptions on the drawings showing the section and on the other drawings of the series).

I very much doubt that the otherwise unknown Giovanni Francese was the draughtsman, nor can I accept Tolnay's characterization of these drawings. About 1960 I closely studied all the Met drawings because they puzzled me very much. As a result of long familiarity with them it became evident that of the twelve drawings related to the dome of St Peter's, four are by the hand of an assistant; and three of these four duplicate other drawings in the group. The original of the fourth, the drawing of the exterior, is, however, not extant. I suggest that here the assistant drew a readable copy from rough sketches, similar to those on the other sheet – sketches, one has to assume, that were made by the chief draughtsman before the model. Only in this way can one explain the strange vagaries and the amateurishness of the drawing. The section, however, is by the chief draughtsman; it was also executed in the studio and a number of details were subsequently checked before the model.

My division of hands among the Met drawings received an unexpected support from a series of drawings I found in the National Museum at Stockholm; they have so far been left out of the discussion and are still unpublished. These drawings are again by a French hand, but it seems by a hand different from the two hands I traced in the Met series of drawings and, surprisingly, some of the Stockholm drawings are very closely related to the drawings in the Met. The watermarks of the paper of some of the Stockholm drawings allow us to date them in the 1570s.

I can reproduce only a few interesting comparisons. First, a carefully rendered measured drawing of two and a half windows of the interior drum with inscribed measurements, not of the model, but of the executed structure; the drawing is unfinished; it does not show the entablature above the drum windows. Exactly the same view is presented in a Stockholm drawing. Here the capitals were not finished, but by contrast to the Met drawing entablature, attic, gallery and ribs are shown. This part does

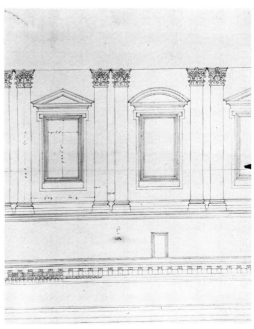

87 Windows in the interior of the drum (New York, Metropolitan Museum of Art)

88 Windows in the interior of the drum (Stockholm, National Museum)

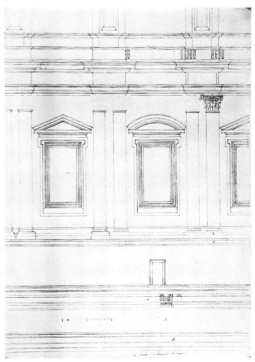

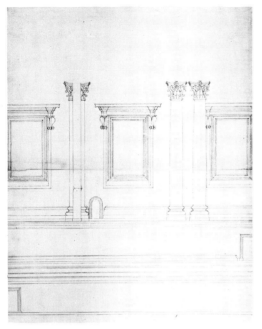

89 Windows on the exterior of the drum (New York, Metropolitan Museum of Art)

90 Windows on the exterior of the drum (Stockholm, National Museum)

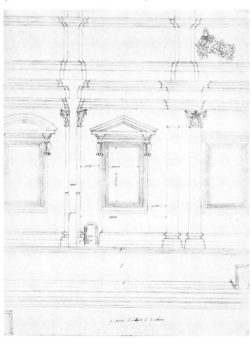

not conform to the execution, but to the model. Whatever the precise relation between the two drawings, they lead back to a draughtsman who worked on a scaffolding on the building site and supplemented his findings there with measurements taken on the model.

Two other drawings showing the outside drum are similarly related. The unfinished drawing is in the Met. The drawing with inscribed measurements of the actual drum, with entablature, and attic is in Stockholm (below the inscription 'S. Pietro le dehors de la tribune').

Supplementing these drawings are others showing the section through the drum in exactly the same scale. In this case, we have a drawing in the Met by the hand of the assistant, with inscribed measurements, again of the executed building. Large at the left is the entablature of the outside base (identifiable by letter F).

An unfinished drawing, also at the Met, is – in my view – by the main hand. A third drawing in Stockholm corresponds exactly to the annotated one in the Met, (but I have fairly conclusive reason to believe that it is not by the same hand).

I now want to juxtapose these sections for a moment with a similar section carefully drawn and inscribed by Dosio (Uffizi). Without carrying through a detailed comparison, a quick glance will convince you that the French draughtsman and Dosio worked independently: these sections differ in a great many details. Dosio's section can be seen as a kind of foil to the section in Dupérac's engraving. The resemblance between the Dupérac engraving and the Met drawing is so close that it cannot be accidental. In fact, in my view the chief draughtsman of the Met drawings was no other than Dupérac himself. The close affinity of drawing and engraving apart, the very procedure of the draughtsman (namely, to study the building *and* the model in order to achieve full documentation) corresponds to that followed for the engravings. Moreover, all the inscriptions are in French and, as the repetitions show, the drawings were known in their time and regarded as authoritative. Thus it seems an almost inevitable conclusion to regard some of the Met drawings as Dupérac's own preparatory studies for his engravings.

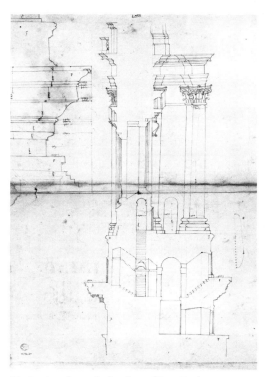

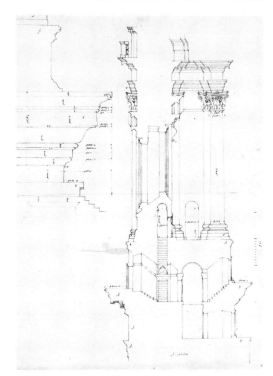

91 Section through the drum (New York, Metropolitan Museum of Art)

92 Section through the drum (Stockholm, National Museum)

93 G. A. DOSIO. Section through the drum (Florence, Uffizi, 2033A)

94 S. DUPÉRAC. Detail of Pl. 82 showing section through drum. Engraving

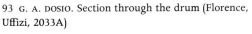

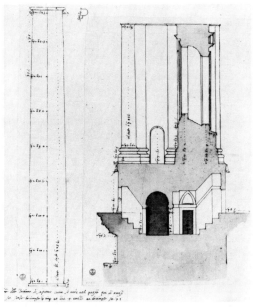

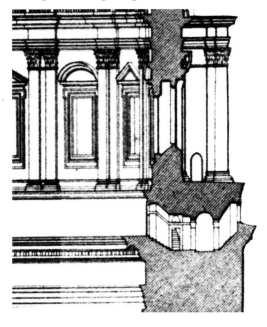

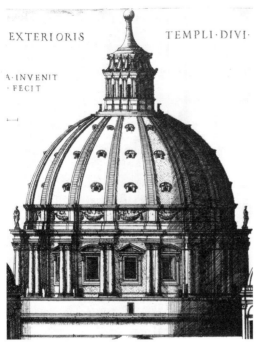

EXTERIORIS TEMPLI·DIVI·

A·INVENIT
·FECIT

95 S. DUPÉRAC. Exterior of the dome, based on
Michelangelo's project. Engraving

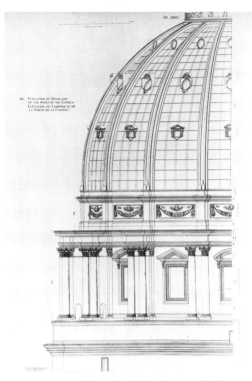

96 LETAROUILLY. Exterior of the dome, as built.
Engraving

If my conclusion is correct, as I believe it must be, the documentary value of the engravings as reliable testimonies for Michelangelo's ultimate dome conception is immensely enhanced (it also seems obvious that we have to regard them as more trustworthy documents than the two Met drawings with the elevated dome).

It would now appear that possibly the same friends, who had urged Michelangelo to have the large model made, commissioned Dupérac to execute the engravings soon after the master's death. This is, of course, a mere assumption, but it is a reasonable one considering the existence of a large and powerful anti-Michelangelo party. The choice of Ligorio after over five months of haggling was a compromise that yet revealed the strength of the anti-Michelangelo faction. For Ligorio too had long been critical of Michelangelo.

All the alterations of Michelangelo's design were executed by Giacomo della Porta. The documents taken in conjunction with the original parts of the model and the drawings by

Dosio and Dupérac allow us to establish exactly where Porta's changes begin. As I have mentioned before, the lower moulding of the outside attic still follows Michelangelo's design, but the width of the projecting posts was reduced and consequently the width of the panels with the garlands was increased. The actual height of the attic remained unchanged. But at its top a rich and complex cornice replaced Michelangelo's simple and forceful moulding. In addition, the attic looks higher, for Porta inserted at the base of the dome a spring-like, undulating moulding over three feet high. As a result, the ribs no longer meet the projecting posts of the attic directly. Porta further obscured the foot of the ribs by adding Sixtus V's coat of arms. He made the ribs narrower, gave them a softer profile and eliminated the central steps.

He also transformed the architectural frames of the dormers and treated each row of dormers individually. There is a crescendo from the first row, reminiscent of Michelangelo's design, to the luxuriant, typically late 16th-century forms of the second row, while the dry circular motif

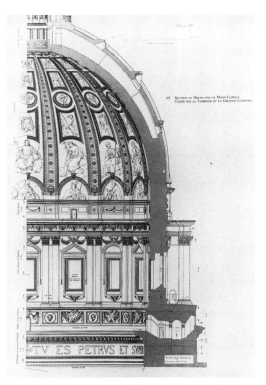

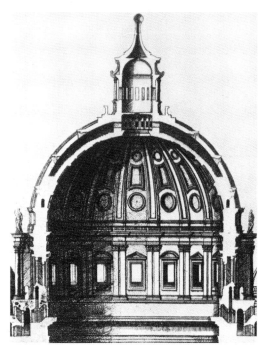

98 S. DUPÉRAC. Interior of the dome, based on
Michelangelo's project. Engraving

97 LETAROUILLY. Interior of the dome, as built.
Engraving

of the top row effects an anticlimax. Michelan-
gelo, by constant repetition of the same dormer
design, avoided focusing interest on the
neutral fields between the ribs; Porta's drama-
tization of subordinate motifs draws attention
precisely to these areas.

Further, Porta replaced Michelangelo's two,
stepped rings at the top of the dome by a single,
comparatively weak ring, the profile of which
joins that of the ribs. Thus rib and ring together
frame a field. By contrast, Michelangelo treated
neutral fields, dynamic ribs and horizontal
barriers as incompatible architectural elements.
His is a design of unrelieved severity. The ribs
run dead against the enclosing ring and there is
no attempt at a compromise. Moreover, the ribs
are sharply separated from the neutral fields and
the steps running up each rib would have
intensified the antithesis between these ruffled
vertical courses and the smooth spherical
panels, an antithesis that Porta eliminated by
giving both rib and panel the same texture.

The same kind of transformation takes place
in the lantern: scrolls in front of the base ease

the transition from the dome to the ring of the
twin columns. Porta's S-shaped scrolls, with the
small volute above and the large one below
rolled inward in the reverse direction, have by
their very nature a tame and almost sluggish
quality. Porta used a similar type of scroll in the
area of the attic where Michelangelo had
planned energetic concave scrolls with volutes
turning outward at both ends – a shape of scroll
which effects a decisive isolation of the attic,
and appears at the same time as a vigorous
response, as it were, to the thrust of the
crowning cone. Porta's vase-shaped ornaments
above the attic, the profiled base of the cone, its
S-shape and vertical ribbed articulation – all this
softens transitions, creates links and introduces
richness of motifs, where once again Michelan-
gelo had planned to treat each unit (base, order,
attic and cone) as strictly separate. Greatest
economy of the architectural means would have
excluded any softening of the contrasts between
these units.

Porta's reshaping of the interior was no less 97
drastic. It begins above the cornice of the drum. 98

87

He heightened the attic by more than three feet and also introduced high bases to the ribs. The point from which Porta's ribs spring lies about six feet above that chosen by Michelangelo. In addition, relieving arches rise from the base and effect a narrowing of the width of the rib. The outside mouldings of the ribs together with the mouldings of the arches seem to belong to the neutral fields whose directional pull therefore rivals that of the ribs. Finally, lion's heads, Pope Sixtus V's emblem, surmount the base of the ribs. It is obvious that Porta's procedure at the interior of the dome parallels exactly his procedure at the exterior.

According to Michelangelo's design the ribs were to rest firmly on the cornice of the attic and the neutral fields were to be strictly separate from the ribs. Michelangelo had planned purely geometrical panels for these fields and, characteristically, the oblong ones were to be checked by circular ones above and below in order to counteract directional movement. A final blow to the purely architectural forms Michelangelo had here envisaged came with the execution of the Christological programme in mosaic, surely devised at the time of Sixtus V, but begun at a slightly later date.

Even more important than all these changes was Porta's elimination of the inner lantern. This motif, which had a long pedigree and is not as rare and as strange as some critics believe, was needed by Michelangelo to prevent a freeing of dynamic tension – precisely what Porta sought to achieve, both outside and inside. Michelangelo conducted the structural energy along the ribs, along the order of the inner lantern and into the sixteen beams of the canopy; they converge in the centre. There is no hope of release. Outside he brought about a similar result by the smooth cone which presses on the lantern like a heavy weight.

Entirely in keeping with his problem-laden conception, Michelangelo planned a tight, compressed hemispherical dome, and entirely in keeping with *his* problem-resolving approach, Porta gave the dome a more elevated, soaring and elegant curve. In order to accomplish this change, he had to raise the centres of the interior and exterior shells, that of the interior shell by about $11\frac{1}{2}$ ft and that of the exterior by about 15 ft, and this gave him a dome with a steep rise in the lower part. Secondly he had to locate both centres over 13 ft beyond the vertical axis which gave him the elevated curve inside as well as outside.

We can now express Porta's heightening of Michelangelo's dome project in figures. According to my own calculations at the model, Michelangelo's dome from the cornice of the drum to the internal ring at the apex would have been $71\frac{1}{2}$ ft high. Porta added almost exactly one-third, and Porta's external shell rises to a point over $26\frac{1}{2}$ feet above Michelangelo's. Nobody can deny that this is a considerable difference.

Porta's elevated dome reflects a change in aesthetic values and this becomes even clearer when we consider the relation between the dome and lantern. Porta decreased the height of Michelangelo's projected lantern by 6 ft. Obviously, the actual reduction in height of the lantern and the increase in height of the dome are complementary features: the executed dome (above the cornice of the drum) is related to the lantern as 3:2. In Michelangelo's project the proportion is 5:4. The new relationship proclaims the essence of the change: oppressive weight has been turned into buoyant airiness.

It has been maintained that Porta only developed tendencies already inherent in Michelangelo's project. We have seen that such a conclusion is not supported by evidence. Yet we know that Michelangelo wavered long between a hemispherical and an elevated dome. In fact, under the influence of Brunelleschi's Florentine cupola, he first planned a high dome as shown in the famous Haarlem drawing, which can confidently be dated in 1547, at the beginning of his activity at St Peter's. Even over ten years later – probably shortly before he began the model – he still vacillated between both possibilities as this sketch in Oxford (which concerns mainly the lantern) demonstrates: a telling proof of his indecision to the very last moment.

But once he had made up his mind the result was irrevocable and irreversible. An iron necessity seems to inform the ultimate design: the dynamic force that rises from the paired giant pilasters of the body of the church through the double columns of the drum and up into the double columns of the lantern is contradicted by the dome itself, which rests like a heavy load on the substructure, and by the enormous, op-

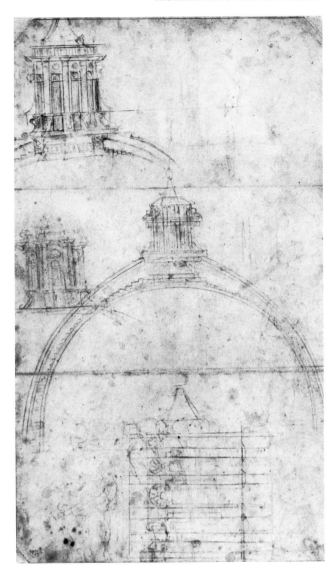

99 MICHELANGELO. Sketch for the
lantern (Oxford, Ashmolean
Museum)

100 MICHELANGELO. Designs for
dome and lantern (Haarlem, Teyler
Museum)

pressive lantern, which epitomizes the meaning
of the design.

Porta resolved such contradictions, from the
grand concept down to minute details, but were
these changes dictated by compelling reasons
other than aesthetic ones? Porta was responsible
to a committee of clerics, traditionally a con-
servative body. The question why they allowed
him to abandon Michelangelo's design can only
be answered when the minutes of the committee
meetings, in which Porta's proposed changes
were discussed, have been found. But there is no
doubt that the committee cast its vote for a

design that was infinitely more conciliatory
than Michelangelo's and to that extent the
committee was surely on the side of popular
opinion, through the ages.

But, when all is said and done, we still
experience the great force of Michelangelo's
conception. The drum with its majestic but-
tresses laid down the law for all time. Nor had
Porta a free hand in the area of the dome. His
changes, though substantial, modified rather
than obliterated Michelangelo's project and we
can still fathom the great master's mind though,
perhaps, only through a glass, darkly.

89

101 The Sketchbook f 67r: elevation of the Amphitheatrum Castrense

III
THE 'MENICANTONIO' SKETCHBOOK
IN THE PAUL MELLON COLLECTION

AMONG the post-war finds belonging to the Bramante orbit hardly anything can compare in importance with the so-called Menicantonio Sketchbook. Although the existence of this book is by now well known among scholars very few have actually seen it, and since I am one of the lucky few I shall begin with some general as well as personal remarks.

The sketchbook appeared in the early 1950s on the New York market. It was purchased by the great antiquarian book seller H. P. Kraus. He did not reveal from whom he had bought it, but I later saw another manuscript with 16th-century architectural drawings in Kraus's possession, a manuscript which, I was informed, came from the same source. With more than one book of the same provenance, there is hope that one day the veil of secrecy may be lifted.

Among Mr Kraus's research assistants was the late Hans Nachod, a fine scholar and one of the editors of Thieme-Becker during the 1920s. In June 1955 Nachod published the first account of the sketchbook in Mr Kraus's own periodical, *Rare Books*. This scholarly though brief essay contains an analysis of the content of the sketchbook page by page, ten illustrations of the more important drawings, and an attempt to reconstruct the original writing on the back of the top cover later defaced by the present inscription which reads: ANIBALE FONTANA BONIEN: Si/CIVIS. BON. FACIEBAT./MDXIII. The only thing we know about this Annibale Fontana from Bologna is this clumsy attempt at claiming for himself an authorship that was not his. With the help of an ultra-violet lamp Nachod believed that he could decipher some of the almost obliterated letters of the earlier writing. I had no means of checking Nachod's reading under ultra-violet light, but the inscription cannot have read exactly the way he

102 Inscription on the cover of the Sketchbook

assumed it did. Despite many shortcomings Nachod's paper is still the only general one to this day, and this for reasons which will become clear in a moment.

At the time the sketchbook was for sale, it came to the notice of a few scholars, in particular Otto Förster, who was then preparing his work on Bramante (published in 1956). Although Förster never saw the sketchbook it was he who believed the original signature to have read DOMENICUS ANTONIUS DE CLARELLIS and who identified him with Domenico Antonio de Chiarellis called Menicantonio, a *capomastro* of the fabric of St Peter's and one of Bramante's assistants. Förster himself published in an excursus to his book most, but not all, that is known about Menicantonio from documents and other literary sources. He also added four new illustrations to the ten published by Nachod. Later authors, Arnaldo Bruschi, Giuseppe Marchini, Peter Murray, Graf Wolff Metternich and Konrad Oberhuber owed their

103 Diagram of the binding signatures. Blank pages are indicated by a short line next to the main line. A short line to the left of it means a blank recto, a short line to the right of it a blank verso.

Broken lines indicate missing leaves. Figures in italics show the original number of leaves, other figures denote existing pages.

knowledge of the sketchbook to the information assembled by Nachod (who had seen it) and Förster (who had not).

When the sketchbook appeared in New York, Mr Placzek, the Avery Librarian at Columbia University, and I made desperate attempts to acquire it for Columbia, but we could not raise the purchase price. Then the book disappeared, but slightly later I learned that Mr Paul Mellon had bought it. He incorporated it into the large collections in his country house in Virginia, over a hundred kilometres south-west of Washington, in a location not easily accessible. Naturally, few scholars have had a chance of studying the book in its secluded habitat. On the other hand, Mr Mellon, with good reason, did not cherish the idea of sending it to more accessible places for inspection. Under these circumstances, work on the book was practically at a standstill after Nachod's pioneer essay. But in 1969–70 I was attached to the National Gallery in Washington, of which Mr Mellon is the President; so contact was easily established, and I was privileged to visit his house and collections several times.

The volume measures 209 by 144 mm. I believe that it is preserved in its original covers. It is certain, however, that the present binding cannot have been the work of a professional bookbinder; it was rather put together by an amateur. The covers are of cardboard and the front cover is strengthened with a parchment page from a manuscript. The book has no spine and, it seems, never had one. Where the spine would normally be the separate signatures (or quires) are visible, all looking uniform and all having the same kind of strong drawing paper. The front and back covers are held together by three double strings glued across the signatures at regular intervals. All this looks contemporary, but the possibility cannot be excluded that the volume has been tampered with in the past. In fact, I think it was.

Today the volume consists of 81 folios (not 77 as Nachod reported). There is a double pagination, not mentioned by Nachod and only briefly referred to by Förster. The later, rather small, ink (?) numbers – often, though not always, in the lower right-hand corner – run through to 81 without interruption. This is the reason why Nachod used these numbers for his catalogue. They were surely not written in by

104 The Sketchbook, f 5v/6r:
Mausoleum of the Plautii and part of
a door

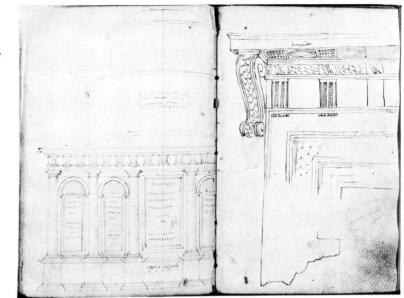

105 The Sketchbook, f 6v/7r: Details
of Bramante's *tiburio*

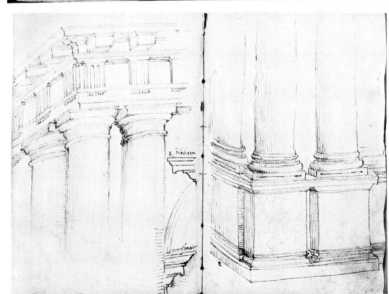

106 The Sketchbook f 21v/22r:
Temple of Fortuna Virilis, detail of
an entablature, and detail of the
Arch of Constantine

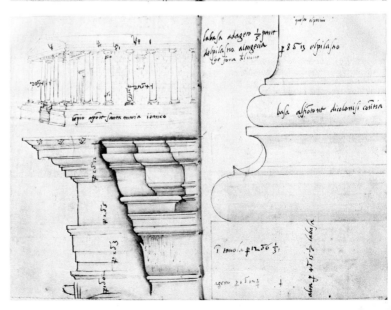

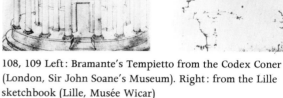

108, 109 Left: Bramante's Tempietto from the Codex Coner (London, Sir John Soane's Museum). Right: from the Lille sketchbook (Lille, Musée Wicar)

107 The Sketchbook, f 60v: Bramante's Tempietto

him as Förster seems to assume. The other set of figures is larger, in pencil, and usually at the top right-hand corner of the page. The pencil numbers run to 101 (instead of 81). They may still be of the 18th, and hardly later than the early 19th century. Thus one is tempted to conclude that many pages of the sketchbook are missing.

I cannot offer an entirely convincing suggestion of what happened to the sketchbook in the 19th century. However, a study of the present arrangement of the signatures may at least provide a workable hypothesis. The book now consists of six signatures and some single pages which may be all that remains of a seventh signature. A diagram of the proposed reconstruction may make this clear.

At last we can turn to the drawings of the sketchbook. I suggest dealing with the following questions: first, whether the drawings are by one or more hands; secondly, the approximate span of time during which they were created; thirdly, whether the book contains a casual collection of drawings or points to the realization of a recognizable programme; and fourthly, to what extent a hypothesis regarding the artist's dependence on Bramante can be formulated.

After a first inspection I went away with a strong doubt as to whether the book contained drawings by one hand only. Apart from the extremely weak pencil drawing of a rosette on folio 80 recto, some 17th-century notes together

with insignificant pencil and pen sketches on folio 80 verso, and on the last page some scribbled accounts and the name Domenico Poltrone (perhaps a nickname: *poltrone* meaning 'lazy bones') also by a later hand, there are some disparities even in the bulk of the drawing. Different kinds of ink were used, especially a dark brown ink and a much lighter greyish brown one. An example of the latter is a rather carefully drawn view of the Mausoleum of the Plautii near Ponte Lucano on the road to Tivoli (the inscription reads *a preso a tiguli*, f. 5v.). Next to it (f. 6r), in the same light ink is the fairly free sketch of part of a door inscribed *bramante*. On folio 6 verso and 7 recto we have, once again in this light ink, free-hand perspective sketches on details of Bramante's *tiburio*, that provisional structure built by Bramante to protect the papal altar during the renovation of Old St Peter's, a structure well known from Heemskerck's and other artists' *vedute*, but never shown in such splendid detail except perhaps in the less skilful sheet of the Codex Coner (f. 62 v.).

In the earlier part of the book hatching is common and there is comparatively little wash. Later, hatching virtually disappears and there is hardly a drawing without ample use of wash. At first I wondered whether the sketchy and the carefully executed drawings could be by the same hand; in addition, the writing seemed to present problems. But after prolonged studies I have buried all these doubts. I hope an example such as folios 21 verso and 22 recto will carry

103

94

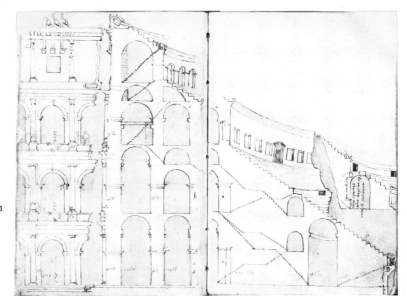

110 The Sketchbook, f 39v/40r: Elevation and sections of the Colosseum

111 GIULIANO DA SANGALLO. Plan and section of the Colosseum (Rome, Vatican)

112 ANTONIO DA SANGALLO. Section and view of the Colosseum

conviction. On 21 verso there is a fine free-hand sketch of the Temple of Fortuna Virilis; it appears together with meticulously executed details of Orders. (Folio 22 recto shows what seems to be a detail from the Arch of Constantine.) Also the inscriptions on the sketch and the measured drawings are evidently by the same early hand. This is confirmed by the correspondence in the direction of the letters, by their firm and still slightly pointed character as well as by the idiosyncratic 'p's' and 's's'.

You may, however, understand my original doubts by comparing the view of Bramante's Tempietto with the section through the Colosseum (f. 60v and 39v/40r). The page with the Tempietto is interesting enough. It combines an elevation of the exterior with a perspective view of the interior. What immediately strikes the eye are the utterly faulty proportions: the columns are much too high, the drum is too low and so are the doors, niches and windows. Even worse, the window of the drum shown in the section (on the right) does not tally with the windows of the elevation (on the left); in fact the window sill, nonsensically, appears to be level with the floor of the gallery above the colonnade. Despite all these and other shortcomings, the drawing confirms (in my view) that Bramante seriously considered a small, candelabra-shaped lantern, a form also recorded in a number of other drawings, for instance in the Codex Coner and the Kassel and Lille sketchbooks. But let me add in parenthesis that I

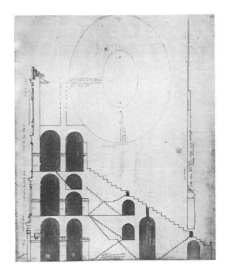

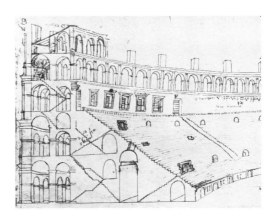

think it can be demonstrated that Bramante vacillated between this kind of decorative lantern and an architectural type in the tradition of the lanterns in S. Maria di San Satiro in Milan.

110 Let us now turn to the Colosseum. On folio 39 verso we have first the elevation and next to it the section through the vast structure. Folio 40 recto continues the section and combines it with a perspective view of the rows of seats and an upper wall. Of course, one wonders whether the artist of the Tempietto drawing, who seemed to be lacking the rudiments one expects of an architectural draughtsman, was capable of such a complex performance. The answer, I suggest, is that our artist had no prototype to follow for the Tempietto (his drawing may well be the earliest rendering we have of the Tempietto), while for the Colosseum he could fall back on a

111 convention established by Giuliano da Sangallo and followed throughout the 16th century in

112 drawings such as that by Antonio da Sangallo or those in the Codex Escurialensis and even that in the Aspertini sketchbook. It would be easy to point out many differences between these

drawings, and yet their basic interdependence cannot be denied. Thus, the answer to my first question is that, excepting the last few pages, the entire book – drawings and writing – must be the work of one man only.

Regarding my second question, the time span during which the sketches were drawn, I expect there will be general agreement to accept the date 1513 (inscribed on the front cover) as the year in which the sketchbook was begun. I cannot think of a valid reason for disputing this date. The author may have known and followed the more explicit inscription in Giuliano da Sangallo's Vatican codex (*Questo Libro e di Giuliano di Francesco Giamberti . . . chominciato A.D.N.S. 1465*). As we know, Giuliano added to his *Libro* for almost fifty years.

The sketchbook contains four palace designs, three of which have been published by Nachod and others. One design, closely fashioned after the Bramante palazzo type, goes under the name 11 of Casa di Raffaello. The second shows what seems to be a rejected project for the Palazzo 11 Branconio dell'Aquila, and the third represents

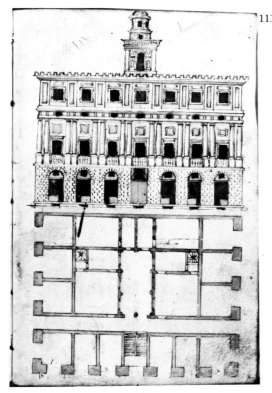

113

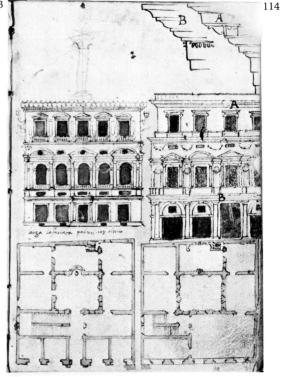

114

the palace as it was built together with plans of the ground floor and the *piano nobile* and, in addition, details of the entablature above the ground floor and the cornice. The fourth palace design is a fine partial elevation of the Palazzo Alberini, now Cicciaporci, in via del Banco di Santo Spirito as Count Wolff Metternich first recognized. This building, begun in 1512, was carried on by Raphael's studio from 1518 onward. If we assume that the author of the sketchbook got hold of a drawing of the palace while it was under construction, the terminal date for the entire book would be *c.* 1520, for the only drawing which is perhaps slightly later is that after the centralized plan of St Peter's attributed to Peruzzi and datable at about 1521.

It seems to me that one can get a little further. I have reasons to believe that the bulk of the drawings were created in fairly quick succession. Now, Marchini made a very astute observation. He noticed that the drawing of the Palazzo Branconio dell' Aquila was made before the execution of most of the decoration and perhaps even the main cornice was finished. We

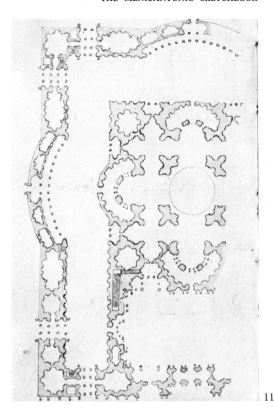

116

113 The Sketchbook, f 8r: Casa di Raffaello

114 The Sketchbook, f 39r: Palazzo Branconio, rejected project and palace as built

115 The Sketchbook, f 9r: Detail from Palazzo Cicciaporci

116 The Sketchbook, f 70v: Plan of St Peter's, after a drawing attributed to Peruzzi

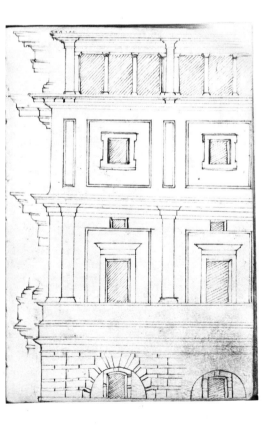

know that the palace was inhabited in 1520. One is therefore inclined to date the sketchbook drawing shortly before that year.

Other drawings point to the same years. Take the interior view of the Pantheon, one of the 117 most important and revealing sketches in the book. While our artist was in many ways indebted to Giuliano da Sangallo's Vatican Codex, which he must have studied carefully, his rendering of the Pantheon is independent of Giuliano's and is obviously derived from the well-known Raphael drawing in the Uffizi (164), 118 as Becatti has correctly seen. I am well aware

97

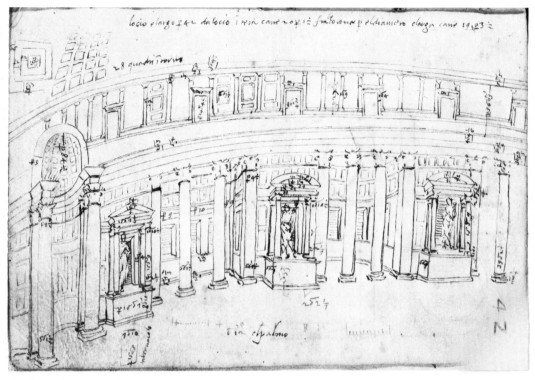

117 The Sketchbook, f 33r: Interior of the Pantheon

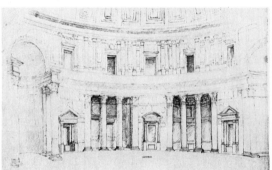

118 RAPHAEL. Interior of the Pantheon
(Uffizi)

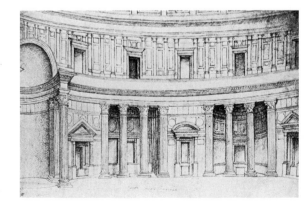

119 Codex Escurialensis. Interior of the
Pantheon (Escorial, Library)

that the authenticity of the Uffizi drawing is disputed: even the latest two authors who discussed it do not see eye to eye. Anna Maria Brizio talks of 'attribuzione incerta' while Becatti vigorously defends Raphael's authorship. All, however, will be in agreement as to the exceptional role which the Uffizi drawing played in the history of Renaissance representations of the Pantheon. It was frequently copied more or less faithfully and, as Wolfgang Lotz has demonstrated, even the Pantheon view in the Codex Escurialensis depends on it. I also agree with his dating of the drawing between 1514–18 but would propose to place the sketchbook drawing at the end of this period rather than at the beginning.

I should like to take the discussion of this drawing a little further because it gives us a good insight into the mentality of its creator. For representational reasons Raphael had distorted the view he wished to offer: he wanted to show an entire wall including the entrance and apse niches, and this forced him to reduce the wall articulation from three to two recesses screened by columns. The artist of the Escurialensis evaded this problem by limiting his view to the middle of the third aedicula. The sketchbook master, by contrast, included a column of the third recess – thus correcting and, in a sense, criticizing his prototype.

There is another point to which I should like to draw attention. Raphael's perspective approximately corresponds with the impression a visitor receives when entering the Pantheon. Any photograph of the interior of the Pantheon can be used to prove it. The circular lines in the sketchbook drawing – contrary to Raphael's – sink down from the centre towards the edges. This evidently derives from the bird's-eye view shown in the Codex Coner and proves that the artist of the sketchbook was influenced by two different conventions which he combined, though surely without being conscious of what he was doing.

To return to the dating of the sketchbook. Despite the '1513' of the inscription, I would prefer to assume that only a few of the assembled sketches were executed at that early date and that the bulk of the drawings are later and stem from the end of the second and the beginning of the third decade. I would like to assume this although (apart from the drawings I

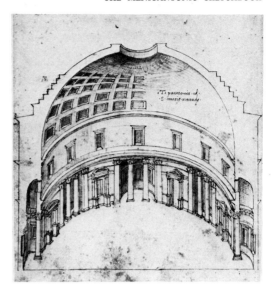

120 Interior of the Pantheon from the Codex Coner (London, Sir John Soane's Museum)

have discussed) few others can be definitely dated within the brief margin of these later years and although, on the face of it, there is no compelling evidence for either date. The reason why I think that the drawings were made within a relatively brief and later period takes me to my next point, namely to the question of whether the book reveals a recognizable concept.

I am convinced that, far from containing a random collection of material, the book was conceived as a programmatical statement, a kind of visual draft for a treatise. It is mainly for this reason that I cannot visualize a too extended period of time spent over its compilation. I would now tentatively say that the majority of the drawings date from the five-year period between about 1517 and 1522. But further study will probably yield greater precision.

Now for the programme expressed by the sequence of the drawings. The first 32 folios are concerned with the architectural orders. The series begins with the Tuscan and Doric orders and includes such Doric examples as Bramante's *tiburio* and the Bramantesque palace type with twin Doric columns in the *piano nobile*. As a kind of introduction to the Ionic part we find on folio 12 verso a large Ionic base and capital from the theatre of Marcellus, inscribed *a li Saveli* because the ancient theatre was owned and

121

99

inhabited by the Savelli family. The Ionic part
122 continues on folio 14 with representations of
Ionic entablatures: the central one had been
lying outside Bramante's office at St Peter's as
the inscription *cimase fora dell' opera* indicates,
while the top one, inscribed *cornice ali Saveli al
ionicho*, is again from the theatre of Marcellus.
Later, the Temple of Fortuna Virilis appears as
an example of Ionic architecture as the in-
scription *tempio a ponte santa maria ionico*
clearly shows. The Corinthian material begins
123 on folio 20 verso, but the drawings on the
previous and the following pages are not
arranged, as are those of later architectural
treatises, as a clean, tabulated, pedagogical
survey of the orders; in keeping with the late
Quattrocento and early Cinquecento fashion the
pages are filled with a medley of Classical
exemplars – a method still reminiscent of
medieval model books and also found in most of
the contemporary sketchbooks. Of particular
124 interest are the folios 25 verso to 32 which are
125 filled with a large number of copies after Roman
129– entablatures and bases of columns. I shall have
133 to say a word more about these pages.

121 The Sketchbook, f12v: Base and capital from
the Theatre of Marcellus

122 The Sketchbook, f14r: Ionic entablatures

123 The Sketchbook, f 21r: Corinthian base and
entablature

124 The Sketchbook, f 25v/26r: Roman entablatures and bases

125 The Sketchbook, f 31v/32r: Roman entablatures, including the Pantheon and S. Prassede

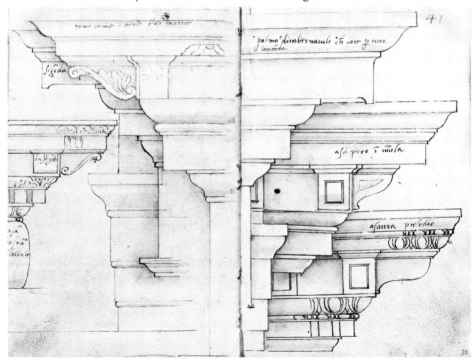

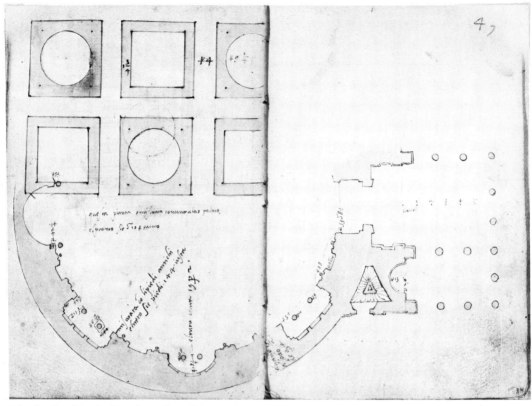

126 The Sketchbook, f 33v/34r: Plan of the Pantheon

117 A new part begins with the view and plan of
126 the Pantheon on folios 32 verso to 34 recto. The
exemplars of the orders are followed by exem-
plars of whole buildings and, as it should, the
most prestigious ancient building opens the
series. Although, once again, no stringent
system was followed, and although some more
details of orders appear here and there, fairly
clearly separable groups of buildings can be
127, distinguished. There is a large section on Roman
128 Baths and the Basilica of Constantine (folios 47
verso to 54). This is followed by an even larger
section concerned with centrally planned – i.e.
135 Greek Cross and circular structures (folios 55
verso to 66 recto). The section ends with two
ancient curved walls, a reconstruction of the
101 elevation of the Amphitheatrum Castrense (at
Porta Maggiore), and two views of the great
exedra of the Foro Traiano. Finally, there is the
section of New St Peter's and this is followed by
a few triumphal arches.

One may not regard this programme as

especially exciting or revolutionary, for the
orders, Roman Baths, the Colosseum and the
Roman theatres, as well as centrally built
structures such as the Temple of Vesta and S.
Costanza, belong to the conventional study
material to be found in other notebooks of the
period. It is true that in many respects the
Mellon Collection book ties in with a tradition
that in its day had already been well estab-
lished, above all by the towering figure of
Giuliano da Sangallo; its dependence on Giul-
iano is often striking and is even evident where
there is no direct connection. The recon-
struction of the Vesta Temple (f. 58v/59r), for
instance, is quite different from that of
Giuliano's, but it owes to Giuliano the method of
revealing a perspective view of the interior by
breaking open the exterior as if split by a natural
catastrophe. Even the anachronistic balustrade
is taken over from Giuliano who was obsessed
by the idea of adding this alien element to his
reconstructions of ancient buildings.

127 The Sketchbook,
f 51v/52r: Reconstructions
of the Baths of Diocletian

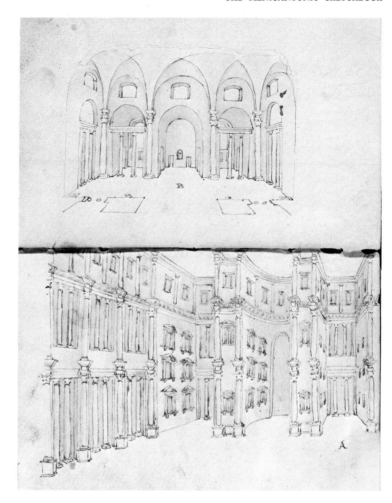

128 The Sketchbook, f 54r:
Reconstruction of the
Basilica of Constantine

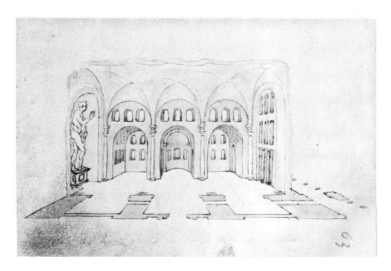

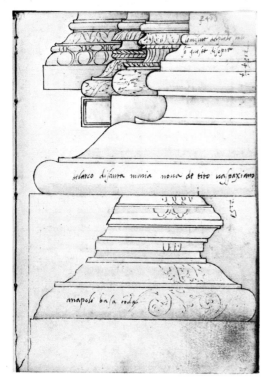

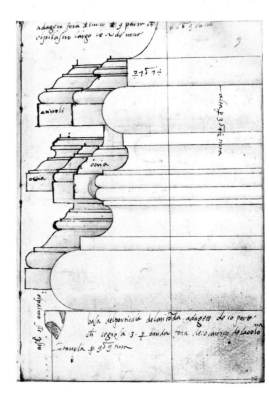

129 The Sketchbook, f 27r: Base from the Arch of Titus and a *basa tonda* from Naples

130 Top right: the Sketchbook, f 28r: Bases of columns from the Pantheon, Tivoli and Ostia

131 GIULIANO DA SANGALLO. Base of column from the Pantheon

Yet the originality and novelty of the book should not be underestimated. This takes me to the last point I want to mention. A word must be said about the many pages with densely arranged bases and entablatures. They are rather dramatically placed on the page: there is a large leading motif in the foreground and behind it, as it were in echelon, are similar motifs. Some of this material was carefully measured, much – particularly material from outside Rome – was probably copied from other drawings, but the organization on the page is always original. Some characteristic examples: folio 27 recto with the base from the Arch of Titus in the foreground and a *basa tonda* from Naples underneath; folio 28 recto showing the base of the portico columns of the Pantheon and in the background bases from Tivoli and Ostia. (For comparison see the base of the Pantheon column in Giuliano's codex.) Folios 29 verso/30 recto: entablatures from S. Maria sopra Minerva, the Arch of Constantine (here called l'arco di Trasi), S. Pietro in Vincoli, and S. Maria Nuova. My last example is folios 30v/31r with similar entablatures from the Capitol, S. Pietro in Vincoli, and the Arch of Constantine. Compare

132 The Sketchbook, f 29v/30r: Entablatures

133 The Sketchbook, f 30v/31r: Entablatures

134 FRA GIOCONDO. Roman entablatures and bases

this impressive series with the older simple distribution of Classical details as we know it from the Codex Escurialensis or the drawings of
134 Fra Giocondo and others. So far as I can see, the only one who had occasionally been tending towards the direction developed by the sketchbook master had been Giuliano da Sangallo. But these fascinating studies can hardly have been our artist's own inventions and I would tentatively suggest that he used Bramante's studies after the antique undertaken, as Vasari assures us, in Rome.

The reconstructions of Roman baths, es-
127 pecially the Baths of Diocletian, rely again on Giuliano and perhaps also on Antonio da Sangallo the Younger, but they are not exact copies as a comparison with Giuliano's (or is it Antonio's?) reconstruction of the east front demonstrates. The same is true for the drawings
128 after the Basilica of Constantine. The reconstruction of the façade of the Baths of Diocletian

is remarkable. It is logical, imposing, and impresses by a severe Classical dignity. Should 12
we assume the hand of Bramante or perhaps Raphael behind this? I doubt it, for the design shows few links with the Roman manner of either artist.

Some puzzling designs appear among the series of centrally planned structures. While there are few problems connected with these drawings and those by Bramante of S. Celso and S. Biagio, (which Förster and most recently Bruschi have discussed), we find in the same section a number of strange architectural designs, depicting both plans and elevations, which display Bramantesque features without Bramante's spirit. The most ambitious of these designs (f. 70r.) shows features of Bramante's 13
semicircular niche of the Belvedere combined with elements taken from the projects for St Peter's. The somewhat ridiculous triple repetition of tuba-blowing statues of Fame, perching on top of three lanterns, suggests a building dedicated to *Fama*. Who knows – was this perhaps to be a temple dedicated to Glory, that glory to which our artist aspired? Be that as it may, there is little doubt in my mind that in all these rather amateurish projects he wished to don the garb of the great Bramante.

The last large section may be regarded as the apogee of the whole book. It is concerned with St Peter's and contains the most notable and at 11
the same time most perplexing material. I refrain from analyzing these drawings because in the last few years they have been amply discussed by a number of specialists on Bramante, Raphael and Peruzzi. Rather than go over the same ground again I have tried to give a general idea of the entire sketchbook and, implicitly, of the personality of its author. The way I see him at present is as a minor figure, rather moderately endowed by nature, but a man close to the immediate circles of Raphael and Bramante. He must have been exceedingly ambitious and his dream of greatness made him embark on the enterprise we have before us. In planning some form of a coherent statement about the contemporary architectural panorama and its Classical sources he may have been guided and even encouraged by talks with Bramante, but for the actual working procedure he had to turn to the example set by an old practitioner in this field of study: Giuliano da Sangallo.

135 The Sketchbook, f 58v/59r: Temple of Vesta, ground-plan, section and elevation

136 The Sketchbook, f 69v/70r: Elevation and plan of temple with Bramantesque features

137 VILLARD DE HONNECOURT. Page from Notebook, *c.* 1235 (Paris, Bibliothèque Nationale)

IV
THE CHANGING CONCEPT
OF PROPORTION

NOBODY will deny that our psycho-physical make-up requires the concept of order and, in particular, of mathematical order. The human body itself is based on symmetry; its two halves are equal; the more perfectly it is proportioned, the more beautiful it appears to us. Our interpretation of nature is predominantly mathematical. We express the laws governing all phenomena, those which surround us as well as those of the universe, in mathematical terms. When Galileo studied the laws of motion, he measured the rate of increase of motion of a falling body and said: 'It is requisite to know according to what proportion such an acceleration is made.' If one comes to think of it, it appears most extraordinary that of all the phenomena connected with a falling body it should be the abstract, mathematical proportion of acceleration which is regarded as the common law for all falling bodies.

Such an approach is not, as is often believed, a distinctive characteristic of late European civilization. In fact, it would not be difficult to show that all higher civilizations believed in an order based on numbers and relations of numbers, and that they sought and established a harmony, often a fanciful and mystical one, between universal and cosmic concepts and the life of man. As long as monumental art and architecture were devoted to religious, ritual, cosmological and magical purposes – in a word, as long as their content was metaphysical – they had to be expressive of this order and harmony. If this is correct, the approach of 19th- and also 20th-century artists to proportion would seem to be almost without precedent. I think that hardly ever before in history did a constellation prevail in the arts when proportion (or the principle of order) was left exclusively to the discretion of the individual artist. Further on I

shall attempt to explain how and why it happened that the artist nowadays regards proportion as his personal province, and why he usually believes that acceptance of general standards would interfere with his intuition.

Modern psychology supports the contention that the quest for a basic order and harmony lies deep in human nature. Is it then an instinct like hunger and thirst, or is it due to an intellectual urge? To be sure, mathematics is the most abstract intellectual occupation: we cannot express the proportion of the acceleration of motion of a falling body, nor even conceive of the idea, without mastering the abstract language of number and mathematical logic. Similarly, order and proportion in the arts means giving a conscious and intellectual direction to a subconscious impulse. All systems of proportion were and are implicitly intellectual concepts, and even artists who, during the last hundred and fifty or two hundred years, believed that they were following their own intuition were more often than not dependent on the past, and used scraps from old systems of proportion, such as the 'Golden Section'.

If the abstract language of mathematics was always harnessed to express an inborn desire for order, the question arises, whether it has been one and the same basic order mankind has been seeking to represent; in other words, whether there is one and only one system of proportion that is true, right and satisfactory. The question is far from being purely academic. But if we agree that there are many true, right and satisfactory proportions, does this not prejudice the whole problem? A comparison with an instinct like hunger may help: people in different countries and at different periods produced and produce different food to satisfy

109

their hunger, i.e. they have different tastes, and this means neither that hunger does not exist nor that one people is right and all the others wrong. However, this is precisely the impasse into which proportion fell in the 19th century. The whole question was either brushed aside (mainly by artists), or treated by historians as if there was only one unassailable truth. Naturally, each historian pleaded for the universality of his particular truth: one saw the secret of all good proportion in the Golden Section, another in the hexagon, a third in the pentagon, a fourth in the circle, to mention only a few of those well-meaning efforts.

Turning to history, we find that there were, in fact, many different systems of proportion. The order in which the Egyptians believed was different from that of the Babylonians or Chinese or Greeks. It is in Egypt and Babylonia in the third millennium BC that we find for the first time a strict mathematical order in the arts. How can we explain that artists and architects created their rigidly geometrical pyramids, temples and tomb chambers? Surely they were tied to a prescribed order which had been carefully worked out, and which they were neither allowed nor willing to break. Such a situation could only arise in a highly developed and complex social structure, in town civilizations based on a strictly organized hierarchy. The intellectual leadership was in the hands of the priests. It was they who regulated rites, rituals and ceremonies, and sacred buildings had to conform to the rules laid down by them. Since all great art was sacred art, it reflected or echoed that cosmic order of which the priests were interpreters and custodians. But when we turn to Greece we are faced with a new situation. In the rising town civilization of the Greek city states, and particularly in Athens, we find a new class of free citizens who began a rational inquiry into the nature of the universe. Under their hands mathematics became a theoretical science, and it was they who first made a systematic attempt to interpret nature mathematically. This unique achievement was never forgotten and, indeed, made our Western civilization possible. It is to Greece too that we must turn for the ideas on proportion that remained current in the Western world. Leaving aside non-European systems of proportion, I shall discuss in the following pages some trends in Greek and post-Greek developments.

Pythagoras is usually named as the real founder of theoretical geometry. He applied his theoretical findings to natural phenomena; and the extraordinary numerical relationships which he discovered led him to believe that the ultimate truth about the structure of the universe lay in certain ratios and proportions. He found support for this belief in the observation that musical consonances depended on invariably fixed relations of the strings of the musical instrument. Since this discovery was of great importance for the further history of proportion in Europe, I must explain it more fully.

If you have two strings under identical conditions, one exactly half the length of the other, and strike them, the pitch of the shorter string is one octave above that of the longer one, i.e. the ratio 1:2 corresponds to the pitch of an octave. By halving the shorter string we get an octave above the first one, and the ratios of the two octaves can be expressed as 1:2:4. Take two strings in the ratio 3:4 and the difference in pitch is a fourth and by repeating the experiment with strings in the ratio 2:3 the difference in pitch will be a fifth. The Greek musical scale consisted of three simple consonances, namely octave, fifth and fourth, and two compound consonances, namely double octave and an octave plus a fifth. It appears then that the whole harmonic system known to the Greeks was contained in the ratios 1:2:3:4. The discovery that all the musical consonances are arithmetically expressible by the ratios of the first four integers, the discovery of the close interrelation of sound, space (length of the string), and numbers must have left Pythagoras and his associates bewildered and fascinated, for they seemed to hold the key which opened the door to unexplored regions of universal harmony.

So far our demonstration has been confined to geometry (division of the string). Arithmetic revealed more mysteries: by applying the Pythagorean theory of 'means' to the ratios of the intervals of the Greek musical scale, the latter received a mathematical logical *raison d'être*. To understand this, it is important to differentiate between ratio and proportion. Ratio is a relation between two quantities, while proportion is the equality of ratios between two

pairs of quantities. That is to say, in a true proportion there must be at least three magnitudes, two extremes and a middle term, usually called 'the mean'. It is significant that the three most important types of proportion, the properties of which were fully recognized by Pythagoras and his followers, determine the consonances of the musical scale. The first of these proportions is the so-called geometrical proportion in which the first term is to the second as the second to the third (1:2:4). Thus it is the geometrical proportion that determines the octave. The second type was given the name 'arithmetic proportion'. Here the second term exceeds the first by the same amount as the third exceeds the second, as for instance in the proportion 2:3:4. In other words, the arithmetic proportion determines the division of the octave into fifth and fourth. The third type was called 'harmonic proportion'. Three terms are in harmonic proportion when the distance of the two extremes from the mean is the same fraction of their own quantity. Take 6:8:12; the mean 8 exceeds 6 by $\frac{1}{3}$ of 6 and is exceeded by 12 by $\frac{1}{3}$ of 12. This is an inversion of the previous case, for 6:8:12 divides the octave into fourth and fifth. Thus these three types of proportion and the musical consonances are closely interlocked.

Plato in his *Timaeus* cast Pythagorean mathematics and mathematical mysticism into a majestic cosmological myth which gave mankind the most coherent and imaginative explanation of the world before the rise of modern science, and its influence continued to be vital for over 2000 years. The Pythagorean-Platonic tradition remained the backbone of all considerations about proportion, even during the Middle Ages, which were so much under the sway of Aristotelian logic. The theory of the means and the belief in the beauty of the 'musical' proportions had come to stay, and experienced a remarkable revitalization in the age of the Renaissance. A convincing visual demonstration of this is supplied in Raphael's 'School of Athens' (painted between 1509 and 1512), where Pythagoras is shown with a young man before him holding up to him a tablet on which the consonances of the Greek musical scale are represented in diagrammatical form, expressed by the ratios 6-8-9-12. In the encyclopaedic context of the *Stanza della Segnatura* this can only have one meaning. The

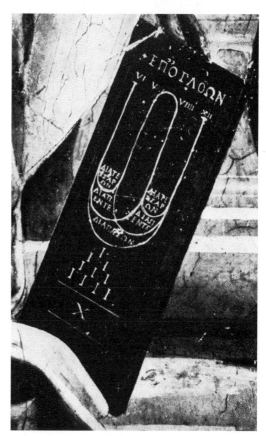

138 RAPHAEL. Detail from *The School of Athens*, showing a tablet with the numerical ratios of the Greek musical scale

philosophical work of the Renaissance was focused on the attempt to reconcile Plato and Christianity. One tried to interpret the great harmony created by God in terms of the Platonic numerical order, and artists were convinced that their work should echo this universal harmony. If it did not, the work was inharmonious and out of tune with universal principles.

We find all this clearly stated in the writings of Renaissance artists and critics. Alberti, in his *Ten Books on Architecture*, written about 1450, referred to Pythagoras and said that 'the numbers by means of which the agreement of sounds affects our ears with delight, are the very same which please our eyes and our mind.' And Alberti submits an arithmetical theory of proportion which is derived from the harmonic intervals of the Greek musical scale. Whenever

111

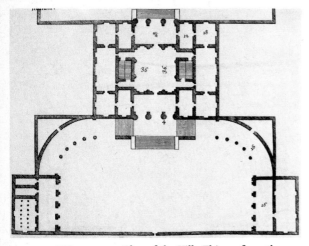

139 PALLADIO. Plan of the Villa Thiene, from the *Quattro Libri*

140 The five Platonic solids

141 The construction of the pentagon, Euclid Book IV

112

we are able to test procedure and practice, we find a strict application of musical ratios. The dimensions inscribed by Palladio in the plan of Villa Thiene, supply a characteristic example. All the rooms are based on the harmonic series 12-18-36, representing the ratios 1:2, 2:3 and 1:3. I do not suggest that Palladio or any other Renaissance artist translated musical into visual proportions; but they regarded the consonant intervals of the musical scale as the audible proofs for the beauty of the ratios of the small whole numbers. In addition, discussions of the geometric, arithmetic and harmonic proportions abound in architectural treatises between the 15th and 18th centuries. These proportions which, as we have seen, always adumbrate musical harmonies, were advocated for the relations between length, height and width of rooms (e.g. 6:8:12).

Plato in the *Timaeus* employed two different kinds of Pythagorean mathematics. His explanation and division of the world-soul is based on the *numerical* ratios derived from the harmonic intervals of the Greek musical scale with which we are now familiar. When dealing with what might be called his atom theory, the ordering of Chaos, Plato reverts to the most perfect *geometrical* configurations, namely tetrahedron, octahedron, cube, icosahedron and dodecahedron, the only five solids with equal sides, equal faces and equal angles. The faces of three of these regular solids consist of equilateral triangles, the elements in the construction of tetrahedron, octahedron and icosahedron. The square faces of the cubes can also be broken down into triangles by the diagonal which divides each face into two right-angled isosceles triangles. Finally, the dodecahedron consists of twelve pentagons, and the pentagon is built up of isosceles triangles in which each of the angles at the base is double the vertical angle (72° and 36°). All these basic figures of plane geometry were charged by Plato with a deep and, it is not too much to say, mystic significance; and, I think, it is due to the emotional importance attached to them that they had such an extraordinary influence on European ideas of proportion.

The equilateral triangle, the right-angled isosceles triangle, the square and pentagon and derivative figures like the octagon and decagon formed the basis of medieval aesthetics. Most

142–4 Projected methods of constructing Milan Cathedral – (a) *ad triangulum*, by Gabriele Stornaloco; (b) *ad quadratum*, for the sake of comparison the equilateral triangle has been added; (c) as executed, combination of equilateral and Pythagorean triangles

medieval churches were built *ad quadratum* or *ad triangulum*. The evidence for this is overwhelming, and in the case of Milan Cathedral we are in the fortunate position of having contemporary drawings as well as full reports of the deliberations of the council meetings. The Milanese, not having an able architect amongst themselves, called in a Frenchman and a German in succession. At the decisive meeting of 1392, the question was discussed whether 'this church ought to rise according to the square or the triangle. It was stated that it should rise up to the triangular figure and no farther.' The basis for the design was, in other words, the equilateral triangle. The mathematician Gabriele Stornaloco co-ordinated the triangular framework with a simple grid which formed a rational basis for the execution. Shortly afterwards, the original decision was reversed and the new plan was placed into a grid of squares.

Meanwhile building had been started according to triangulation and was continued up to the piers of the aisles. But since the elevation of the nave in the schemes *ad triangulum* and *ad quadratum* appeared too high, the council decided to switch over to yet another geometri- 144 cal pattern. The interesting thing is that nobody suggested lowering the nave arbitrarily, but that it was regarded as necessary for the new height to tally with an established geometrical concept. This was found in the celebrated Pythagorean triangle, which had always been given a place of honour by virtue of its mysterious qualities; for this is the only right-angled triangle in which the sides are in an arithmetical progression (3, 4, 5). Moreover, Vitruvius, whose work was (contrary to often expressed opinions) familiar to the Middle Ages, had in his ninth book given particular sanction 145 to this Pythagorean 'invention'.

145 The Pythagorean triangle, from Cesariano's edition of Vitruvius, 1521

Another well-documented case is the church of S. Petronio in Bologna. The building had been started on a vast scale in 1399, but progressed slowly and dragged on into the 16th century, when a considerable reduction not only of extension but also of height appeared necessary. In 1592 an architect who was still aware of medieval conceptions of proportion published an engraving in protest against the proposed reduction of height. He suggests that by abandoning the medieval triangulation the church would lose proportion and coherence. It appears that triangulation or the grid of squares formed the geometrical skeleton of cathedrals like Chartres, Reims, Amiens and Cologne. Medieval artists and builders used the square not only as a simple grid but also in a more complex configuration which assumed ever greater importance from the 12th century onwards. By good fortune, some late-medieval German masons make us familiar with traditional methods in works which were printed at the end of the 15th and the beginning of the 16th centuries. Roriczer, the author of one such

148

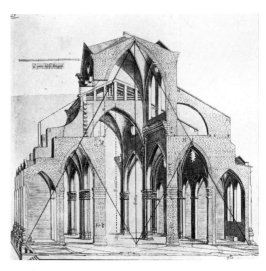

146 The construction of pinnacles, from M. Roriczer's *On Pinnacles*, 1486

147 Doubling and halving of the square, from Cesariano's edition of Vitruvius, 1521

148 S. Petronio, Bologna. Engraving of 1592, contrasting the suggested low nave, seen behind, with the original height determined by triangulation

ftangen werden fie auß vñ ein gebogē
damit fie kürtzer vñ lenger gemacht wer
den ſolche ding ſtrecken ſich gar weyt/
dañ ſieſind in trefflichen dingē fürbrau
chen ,im geben vnd nemen/vñ allerley
hand wercke/vñ wie diß inſtrument ge
macht ſoll werden / alſo hab ich nach
folget auf geryſſen/ Nun iſt die brauch
ung diß inſtruments mancherley/ſune
men / nach eins yetlichen wolgefallen/
vnd er ſein bedarf.

41

41

41

b

c

Die geraden linien / halten ſich in der leng/ gar mancherley fort in iren geſchlechten gegen einr
anderDer ſelben vnderſchid will ich eins teyls anweigen/darum das ſie zu vil dingen nütz ſind
dañ man kan mancherley werck darauß machen / dieweil es nit ſchlechdich bey den linien blei
ben wirdet/ ſonder die mügen vmbs ogenn werden vnnd ebne ſelbt oder gantze Corpora machen / wie
dann das die werck auß nottorfft erheiſchen / darauß vil breuchliche vnnd nütze ding zuerfinden ſind/
D iij

149, 150 Dürer's 'serpent compasses'

book, entitled *On Pinnacles* (1486), writes: 'If you want to make a plan of a pinnacle according to the masons' tradition, and geometrically correct, begin with the square.' Next he places a square from centre to centre of each side of the primary square which results in the surface of the inscribed square being half that of the larger one. By the same method he inscribes another square in the second square and so forth. Turning the second square by 45°, we have gained three squares with sides parallel to each other, and these squares give us the diminishing tiers of the pinnacle. This method had a very wide application, in particular for the construction of Gothic spires, and we can trace it back to the earliest surviving notebook of an architect, Villard de Honnecourt, dating from the mid-13th century. Again, when we open Vitruvius's ninth book we find this method explained, and Vitruvius, quite correctly,

claims Plato as its inventor. In his *Meno* Plato used the doubling or halving of the *area* of a square to exemplify the incommensurability of the sides of the two squares.

This method was not only employed in architecture, but also in painting and even in objects of use. Dürer's 'serpent compasses', with which, he maintained, serpent lines can be constructed, are a case in point. In this connection the strange instrument commands our interest not for its peculiar performance but for the geometrical proportions according to which Dürer designed it – proportions which are of no importance for the usefulness of the compasses. It will be seen that the diameters of the discs and of the arms and even their lengths are constructed according to the same method which Dürer, following the old masons' tradition, calls the 'just measure' (which implies the right relation of one part to the other).

149, 150

115

151 LEONARDO DA VINCI. Study in human proportions (Windsor, Royal Library, copyright reserved)

It has, I hope, become evident that two different classes of proportion, both derived from the Pythagorean-Platonic world of ideas, were used during the long history of European art, and that the Middle Ages favoured Pythagorean-Platonic geometry, while the Renaissance and Classical periods preferred the numerical, i.e. the arithmetical side of that tradition. The question arises why this happened. For an answer we must first enquire a little further into the properties of both kinds of proportion. The arithmetic proportions epitomized in the ratios of the Greek musical scale consist of integral numbers or simple fractions: they consist, in a word, of commensurable ratios. By contrast, many of the geometrical proportions cannot be expressed by integral numbers or simple fractions; i.e. they are incommensurable or irrational. In the equilateral triangle, for instance, the height (i.e. the perpendicular) is incommensurable to the length of the sides and can only be expressed by the square root of 3. The hypotenuse of the right-angled isosceles triangle, i.e. the diagonal of the

square, is related to the shorter sides as $1 : \sqrt{2}$, and the length of a side of the larger to the length of a side of the smaller square in the construction of the 'just measure' is related as $1 : \frac{\sqrt{2}}{2}$. The construction of the pentagon implies the cutting of a straight line into extreme and mean ratio. What Euclid (VI, 30) calls 'to cut a line in extreme and mean ratio' is nowadays called the Golden Section, in which the smaller part is related to the larger as the larger to the whole, and this proportion is, of course, incommensurable.

It seems almost self-evident that irrational proportions would have confronted Renaissance artists with a perplexing dilemma, for the Renaissance attitude to proportion was determined by a new organic approach to nature, which involved the empirical procedure of measuring, and was aimed at demonstrating that everything was related to everything by number. I think it is not going too far to regard commensurability of measure as the nodal point of Renaissance aesthetics. Measuring means for Alberti 'a reliable and commensurable annotation of dimensions, by which as much knowledge is gained about the relation of single parts of a body to each other as about their relation to the whole of a body.' This principle may be checked by going through Leonardo's comprehensive studies in proportion. In all his studies, he used exclusively numerical proportions. He measured and compared the proportions of one part of the body with another and established relationships of small integers, such as 1:2 and 1:3. By contrast, Villard de Honnecourt, in his above mentioned sketchbook, shows figures the proportions of which are determined by a framework of Pythagorean geometry, such as equilateral triangles and pentagrams.

While to the organic, metrical Renaissance view of the world rational measure was a *sine qua non*, for the logical, predominantly Aristotelian medieval approach to the world the problem of metrical measure hardly arose. And although the Pythagorean-Platonic concept of the numerical ratios of the musical scale never disappeared from medieval theological, philosophical and aesthetic thought, there was no overriding urge to apply them to art and architecture. On the contrary: the medieval quest for ultimate truth behind appearances was

perfectly answered by geometrical con-figurations of a decisively fundamental nature; that is, by geometrical forms which were irreconcilable with the organic structure of figure and building. The contrast between Villard de Honnecourt's and Leonardo's pro-portioning of figures is a typical one: the medieval artist tends to project a pre-established geometrical norm into his imagery, while the Renaissance artist tends to extract a metrical norm from the natural phenomena that surround him.

Of course, metrical proportions were also used during the Middle Ages – indeed, no building is possible without them – and geom-etry played an important part in Renaissance aesthetics. On the other hand, it must be asked whether the same numerical and geometrical proportions had also the same meaning in the Middle Ages and the Renaissance. The answer seems to me in the negative. For during the Middle Ages metrical proportions were used as a practical expedient and never, or hardly ever, as an integrated principle to which all the parts would conform. Thus the height of a pier may have a metrical relationship to its diameter, but its height and width are, metrically speaking, arbitrary in the overall geometrical pattern of the building. During the Renaissance, by contrast, metrical proportion was the guiding principle of order which would reveal the harmony between the parts and the whole. It is for this reason too that architects of the Renaissance, and not of the Middle Ages, fully embraced Vitruvius's well known module system which was the only way of guaranteeing a rational numerical relationship throughout a whole building. Turning to geometry, we may choose the square as an example, because the square was of exceptional importance during the Middle Ages and the Renaissance. The medieval 'just measure' with its setting of one square into another was discarded by Re-naissance artists, no doubt, because of the incommensurability of this configuration. But it was during the Renaissance that artists became aware of the simple numerical ratios of the sides of a square, and in the ratio 1:1 (unison in music) a Renaissance mind found beauty and perfect harmony. Thus it appears that such a simple geometrical figure as the square can be used in a metrical and rational as well as in a geometrical

but irrational context, and can elicit completely different reactions.

It is also true that Renaissance artists absorbed the geometry of the *Timaeus* – Leonardo himself designed the five regular Platonic bodies for Luca Pacioli's *De Divina Proportione* (1509) – but they studied these solids *qua* problems of space: a cube, for instance, allows a rational enquiry into the foreshortening of its sides. It is for this reason that treatises on perspective often begin with the regular bodies. Finally, it is true that Renaissance artists were well aware of the particular and exceptional properties of the Golden Section: Pacioli, in the treatise devoted to it, had called it 'divine'. But, as I shall show in a moment, while the Golden Section played an important part in medieval geometry, the old and continuously repeated myth of its pre-dominant role in the art of the Renaissance must be exploded.

It was only in the 18th century that this Pythagorean-Platonic tradition began to break down. Until then it was never doubted that objective standards of proportion are necessary in a work of art, even though nobody was so naive as to think that absolute measures can be perceived. In the new era which dawned, beauty and proportion were no longer regarded as being universal, but were turned into psychological phenomena originating and exist-ing in the mind of the artist. Thus beauty and proportion became dependent on what was believed to be an irrational creative urge. This was the answer of the artist to the new conception of the universe which emergerd from the 17th century onwards – a universe of mechanical laws, of iron necessity with no ulterior plan, a universe in which the artist had to find his bearings by substituting purely subjective standards for the old super-personal ones.

When we turn the pages of Burke's *Enquiry into the Origin of our Ideas of the Sublime and the Beautiful* (first published in 1757), we find ourselves face to face with an emotional and subjective aesthetic theory. Burke categorically refutes the Pythagorean-Platonic notion, which the Renaissance had fully embraced, that beauty resides in certain fundamental and universally valid proportions – in other words, that mathematical ratios as such can be beautiful. He

denies that beauty has 'anything to do with calculation and geometry.' Proportion, according to him, is only 'the measure of relative quantity' – a matter solely of mathematical inquiry and 'indifferent to the mind'. Moreover, at the same historic moment aesthetics emerged as a separate field of study concerned with the problem of the autonomy of artistic creation. The reciprocal notions 'proportion' and 'beauty' were stripped of their metaphysical and universal character. They now appeared the result of an irrational creative urge; that is to say, they were turned from absolute truths into phenomena of subjective sensibility.

To accomplish the break of the arts away from mathematics, however, was no easy task. In actual fact, the 'relapses' during the 19th century were countless. As a rule the artists, it is true, kept aloof. Romantic artists and their progeny clearly had no use for the shackles of intellectual number theories which would appear to endanger their hard-won freedom. And it may be said at once that we have not yet outlived the freedom for which the 18th century prepared the way. The new initiative came from scholars, historians, philosophers, and psychologists. These men approached the same problem from a great variety of angles. Yet within the confusing mass of contradictory systems, one can discover definite trends that prepared our present position.

To be sure, the most important single event was the sudden prominence acquired by the Golden Section. Of course the Golden Section had been known to the Greeks and to the Egyptians before them.[1] Euclid had discussed it authoritatively in Book VI of his *Elements* and elsewhere in the same work, and the wonderful properties of this proportion were never forgotten. It is well to remember that, unlike any other true proportion, the Golden Section contains only two magnitudes and that the two 152 smaller members always equal the whole, thus: $(a+b):a = a:b$ (i.e., $1·618:1 = 1:0·618$). Mathematically speaking, this is indeed a proportion of extraordinary beauty and perfection. Leonardo da Pisa, called Fibonacci (1175–1230), discovered that if a ladder of whole numbers is constructed as shown, so that each number on the right is the sum of the pair on the preceding rung, the arithmetical ratio between the two numbers on the same rung rapidly approaches

$$\frac{AC}{2} \qquad \frac{a+b}{a} = \frac{a}{b}$$

152 Construction of the Golden Section

the Golden Section. Thus for practical purposes the Golden Section, which can be constructed geometrically, may be approximated by such arithmetical ratios as 5:8 or 13:21, etc.

1	1
1	2
2	3
3	5
5	8
8	13
13	21

Together with the Golden Section, the Fibonacci series became a treasured heirloom of Western mathematical thought. Nevertheless, compared with the commensurable ratios of the small whole numbers, the incommensurable Golden Section played an insignificant part in Renaissance and post-Renaissance art, precisely because of its incommensurability.

It was Adolf Zeising who argued in a learned and persuasive treatise published in 1854[2] that the Golden Section was the central principle of proportion in macrocosm and microcosm. To him it was the perfect mean between absolute unity and absolute variety, between mere repetition and disorder. Zeising's fervent and mystic belief in the all-embracing property of the Golden Section was contagious, not only because of the learning and persuasiveness with which it was advocated, but also because the general trend was in the direction of an

appreciation of irrational rather than rational proportions. And so a bridge can be constructed, leading from Zeising and his disciples to Hambidge's 'dynamic symmetry' and on to Le Corbusier's 'modulor'.

Only recently M. Borissavliévitch[3] defined the beauty of the Golden Section:

It represents the balance between two unequal asymmetrical parts, which means that the dominant is neither too big nor too small, so that this ratio appears at once clear and of just measure. The perception of such a ratio is easy and rapid because of this clarity . . . and because it agrees with the hedonistic and aesthetic law, the law of least effort, hence the beauty of the Golden Section.

It will be noticed that the author bases his defence of the beauty of the Golden Section, not on grounds of mathematical perfection, but on those of a purported aesthetic law; as he further explains, it is our optico-physiological make-up that leads to the beatific sensory experience. Naturally, he gives high praise to Gustav Theodor Fechner's inductive aesthetic,[4] and he has full faith in the latter's experimental result, long since discredited, that 'normal' people find the highest sensation of aesthetic delight in Golden Section rectangles.

Hardly did Fechner's scientific method seem to have buttressed Zeising's findings than Theodor Lipps, the propagator of empathy, asserted that 'it may now be looked upon as generally conceded that the ratio of the Golden Section, generally and in the case of the Golden Rectangle, is entirely without aesthetic significance in itself, and that the presence of this numerical ratio is nowhere the basis of any pleasant sensation.'[5]

Yet before and after Lipps's assertion, the champions of the Golden Section encountered success after success. To name only a few, in Germany F. X. Pfeifer carried on Zeising's work (1885);[6] in France the Golden Section found advocates, from E. Henszlmann's *Théorie des proportions*[7] to Matila Ghyka's *Le Nombre d'or*;[8] while the pentagonal theory of F. M. Lund[9] no less than Ernst Moessel's 'geomtry of the circle'[10] are controlled by the Golden Section *Leitmotif*. The most enthusiastic partisan of the Golden Section, however, is Ch. Funck-Hellet, who since 1932 has published a steady stream of

works expounding the mysterious qualities of an order which he summarized in the monumental sentence, '*Tout étude sur la proportion tourne autour du nombre d'or.*'[11]

Funck-Hellet's investigations are too esoteric to be effective. It was Hambidge's suggestive 'dynamic symmetry' that scored the greatest and most lasting success. Hambidge (1867–1924) read his first paper, entitled 'Natural Basis of Form in Greek Art', in 1902, but his idea slowly developed in subsequent years. In 1916 he began to lecture on the subject, and from then on he had powerful patrons. In 1917 appeared his *Dynamic Symmetry*, which had the support of the influential Denman W. Ross at Harvard University. In 1919 he started the short-lived periodical *Diagonal*, financed by Yale University; 1920 saw the appearance of *Dynamic Symmetry: The Greek Vase*, again under the auspices of Yale University; in 1923 he published *Dynamic Symmetry as Used by Artists*; and in 1924, the year of his death, appeared his well-known work, *The Parthenon and Other Greek Temples*.

153 Greek bronze oinochoe, from Hambidge's *Dynamic Symmetry; the Greek Vase*, 1920

153

These titles reveal part of the secret of Hambidge's success: he bridged the gap between Greek art – still the ideal of the older generation of modern artists (Picasso, Le Corbusier) – and modern aspirations. Briefly, his theory was based on the following appealing assumption: what the logarithmic spiral means for the structural understanding of growth in botany, as in shell formations, etc., the incommensurable root rectangles (with their sides of $1:\sqrt{2}$, $1:\sqrt{3}$, $1:\sqrt{5}$) mean for the structural understanding of Greek art and architecture.[12]

Although the interest of mathematicians in the logarithmic spiral dates back to the 17th century, it was only with T. A. Cook's *The Curves of Life* (New York, 1914) and D'Arcy W. Thompson's classic *Growth and Form* (Cambridge, 1917) that the importance of the logarithmic spiral for the morphology of natural phenomena was fully explored. What could be more appealing than the discovery that the Greeks had worked according to the law of dynamic growth found in nature? Moreover, Hambidge has the simple and strong diction of a man with deep convictions: he disarms even before a potential opponent collects his wits. 'The Greek artist,' he tells us, 'was always virile in his creations, because he adopted nature's ideal' – namely, to base his work on root rectangles. And what modern artist, one is tempted to ask, can resist the challenge that the 'realization of nature's ideal and understanding of the significance of structural form should enable him to anticipate nature, to attain the ideal toward which she is tending, but which she can never reach'?[13]

Some archaeologists accepted Hambidge's theories with enthusiasm. L. D. Caskey of the Museum of Fine Arts in Boston followed him;[14] Gisela Richter, then the Curator of Greek and Roman Art at the Metropolitan Museum of Art, was in sympathy. Artists began to work in accordance with Hambidge's ideas. Architects like Walter Dorwin Teague[15] were fascinated. In fact, even *ante festum*, Samuel Colman's *Nature's Harmonic Unity: A Treatise on Its Relation to Proportional Form*[16] professedly made use of Hambidge's theories.

After 1945 the circle of followers expanded. George Jouven, Architect en Chef des Monuments Historiques, makes Hambidge's dynamic rectangles the core of his investigation of 17th-

and 18th-century French architecture.[17] One can confidently maintain, however, that at this period architects worked almost without exception with a commensurable module system derived via the Italian Renaissance from Vitruvius. Hambidge had proved (in any case to the satisfaction of many) that the use of commensurable proportions leads to 'static symmetry'; by contrast, the incommensurable ratios recommended by him lead to 'dynamic symmetry' with its infinitely superior vitality and flexibility. According to him, few periods in history were aware of the secret of dynamic symmetry. By demonstrating that French architects of the Baroque were so initiated, Jouven implicitly pleaded the superior quality of their work.[18] In a much more rational book than Jouven's, the Italian architect, Cesare Bairati[19], made an equally unfortunate attempt to trace the use of root rectangles in the Italian architecture of the 16th and 17th centuries. Dynamic symmetry inspired others to new ventures. Irma A. Richter[20] modified Hambidge by replacing his root rectangles with concentric circles which had a Golden Section relationship to one another. She claimed her method to have been the guiding principle in great works of art from Chartres to Piero della Francesca and from Raphael to Cézanne.

Hambidge seemed to carry everything before him. Had he really solved the problem of proportion for Greek art and shown the road to salvation for modern artists? He was biased – and in this lay his strength. Surely, by exalting dynamic symmetry at the expense of static symmetry, Hambidge was advocating his own creed and that of his time. While he developed his theory at Yale, we find some of the most advanced artists in Paris groping in the same direction. The year 1912 saw the first exhibition of the *Section d'Or* group, to which, among others, Léger, Gleizes, Delaunay, Metzinger, Marcel Duchamp, Duchamp-Villon, and Gris belonged. But in 1925 the activity of the group came to an end without a clear theoretical statement, apart from the suggestive name.

Not everything was sweet harmony, and not everyone was converted. Sober-minded archaeologists like W. B. Dinsmoor[21] had nothing but derision for Hambidge's ideas. Others prepared for a counter-attack. It came with a vengeance as early as 1922 from the pen of Theodore A. Cook,

whose work as a scientist paved the way for dynamic symmetry. In an article entitled 'A New Disease in Architecture,'[22] he ridicules interest in the Golden Section as a sudden and devastating malady that showed no sign of stopping. His attack was concentrated on the works by Lund and Colman and above all on Hambidge, who 'has an especially virulent form of the disease'. His main counter-argument was that 'the excessively delicate phenomena of beauty can never be either defined or reproduced by such ancient and childlike simplicities as the Golden Measure, the Root-five Rectangle, or the Square.' To him the beauty lay not in the 'unabashed and platitudinous rectangles' but in the delicate divergencies, the variations from dull exactitude. Cook must have written this under the influence of W. H. Goodyear's persuasive publications on 'optical refinements' in Classical and post-Classical architecture. The terms of reference Cook used for his condemnation of Hambidge were therefore hardly less doubtful than was Hambidge's own theory.

In his important work *Aesthetic Measure* the mathematician George D. Birkhoff[23] discusses Hambidge in two sentences: 'The theory of Hambidge concerns itself mainly with geometric ratios derived from irrational numbers... Such ratios cannot be appreciated by the eye.' Thus he dealt a blow at the very essence of dynamic symmetry. But can irrational ratios really not be appreciated? Fechner and Borissavliévitch gave positive answers from a psychological and physiological point of view. Or is the whole question of the visual appreciation of one type of proportion as against another basically wrong?

Hambidge's critics, of course, were also recruited from among freedom-loving artists and architects. For Percy E. Nobbs[24] Hambidge is simply one of the architectural astrologers 'who have achieved fame through exploiting that mystic faith in perfect numbers which has impelled them – all for the supposed benefit of future designers – to spin webs of circles, diagonals, triangles, squares, and parallelograms over the elevations of ancient buildings.' After the war Eliel Saarinen[25] asserted that dynamic symmetry was a diagrammatic method arbitrarily superimposed upon architecture.

It appears that in spite of the enthusiasm built up for the Golden Section and the allied root rectangles during the last hundred years, opinions regarding the use and usefulness, the efficacy, the perceptibility, and the beauty of these proportions differ widely, and more material to demonstrate this fact could easily be adduced.[26] Nor has dynamic symmetry helped to 'explain' the miracle of the Greek achievement. If one takes the trouble to delve into some of the proportional analysis of the 'poor old Parthenon' (to quote Theodore A. Cook) published from Penrose's days on (1851), it will be seen that almost anything under the sun can be proved: that the design was based on the Golden Section (Zeising, 1854), on commensurable ratios (Pennethorne, 1878), on triangulation (Dehio, 1895), on the ratios of small whole numbers (Raymond, 1899),[27] on root-five rectangles (Hambidge, 1924), on Greek modules (Moe, 1945),[28] and so forth.

Can one blame sceptics if they brush aside the whole quest for proportion as a silly pastime, unrecorded in J. Huizinga's *Homo Ludens*? On the other hand, the very fact that so many able and highly intelligent men of the past and present devoted and still devote years of their lives to the investigation of this problem should make us careful, and should lead us at least to concede that we are after all facing a serious concern of *Homo sapiens*.

Reflections of this kind led to the First International Congress on Proportion in the Arts, held in Milan on 27 to 29 September 1951.[29] The urge to discuss a problem keenly felt in the early post-war years brought together philosophers, painters, architects, musical historians, art historians, engineers, and critics from many countries. They had gathered because they agreed on the one point: that some kind of controlling or regulative system of proportion was desirable. But although the Milan Congress had repercussions down to Le Corbusier's *Modulor 2*, which appeared in English in 1958, it nevertheless fizzled out without making an appreciable impact on the younger generation.

The bankruptcy of the Milan meeting was publicly sealed at a historic meeting of the Royal Institute of British Architects in London on 18 June 1957, where a debate took place on the motion 'that systems of proportion make good design easier and bad design more difficult' – a motion that was defeated with forty-eight

voting for and sixty voting against.[30] One of the leading Italian architectural periodicals, *L'Architettura*, directed by the versatile Bruno Zevi, who had actively participated in the Milan Congress, acclaimed the wisdom and courage shown in refusing to support the motion and declared that 'no one really believes any longer in the proportional system'.[31]

This is very nearly a correct statement, for even many of the supporters of the motion had their reservations. Nor is it possible to prove that one system of proportion is better than another or that certain proportions are agreeable and others not. Such aspects appeared central when the problem lost its universality and shifted to the level of empiricism. In most periods of history artists were convinced that their specific system of proportion had universal validity. These systems derived their all-embracing character from thought processes rather than from sensations. It is now two hundred years since the belief in absolute values was shaken, perhaps for all time; it can surely not be won back by an act of majority decision. As long as a broad foundation for a resurrection of universal values is lacking, one cannot easily predict how the present dilemma can be resolved. The very formulation of the motion put before the RIBA meeting shows that we have left far behind the realm of the absolute, and are submitting to pragmatic and opportunistic motivations.

In attempting to pin-point the position of today, one has to admit that the majority decision at the RIBA reflects the current reaction of artists, architects and critics, and that a definite shift of response to the problem of proportion had taken place between the Milan and London meetings. The reason seems obvious. We have all witnessed the quick rise and the easy victory of Abstract Expressionism, the almost general acceptance of an art based on the hardly controlled incident.[32] As far as painting is concerned, one may talk of the 'splash-and-dribble style'. No wonder that the *objet trouvé* is adulated as a work of art, and the piece of driftwood is often preferred to man-made sculpture. At such a moment of absolute subjectivism any interest in systems of proportion would be out of order. And clearly, to a large sector of the most serious young artists, the word 'proportion' is anathema.

Is this, then, the end of a process that began in the Romantic era? Will future generations of artists also regard systems of proportion as incompatible with creative processes? In a fascinating paper Sir John Summerson seems to argue[33] that, as far as architecture is concerned, the old systems of proportion that belonged to a formal order are indeed dead and buried at a time when 'the source of unity in modern architecture is in the social sphere, in other words in the architect's programme'. But is it not a fact that the architects of the past were faced with similar problems on a different level? The formal order was not a superimposed discipline, but an integral part of their planning. It seems to me that Summerson's *quid pro quo* implicitly affirms the subjective standpoint of architects and artists, which may be summarized in Eliel Saarinen's words, 'To lean upon theoretical formulas ... is a sign of weakness that produces weak art.'[34]

It is well known that Le Corbusier's answer is quite different. He distinctly believes in the older systems of proportion, newly dressed by him and his team. The elements of his Modulor are traditional and extremely simple: square, double square, and divisions into extreme and mean ratios. These elements are blended into a system of geometrical and numerical ratios: the principle of symmetry is combined with two divergent series of irrational numbers derived from the Golden Section. In contrast to the older 'one-track' systems of proportion, Le Corbusier's is a composite system, and – in spite of its ultimate derivation from Pythagorean-Platonic thought – its vacillating quality seems to reflect the spirit of our non-Euclidian age. What is even more important, by taking man in his environment, instead of universals, as his starting point, Le Corbusier has accepted the shift from absolute to relative standards. His Modulor lacks the metaphysical connotations of the old systems. Today an attempt at reviving them would only smack of quackery.

The next step on the way adumbrated by Le Corbusier is to regard the whole question as one concerning technology. Modulor societies advocate issuing building components of a fixed size, and at this level the quest for proportion is sufficiently characterized by the phrase, 'Standardization takes command.' One of the best studies of this kind is by Ezra D. Ehrenkrantz,[35]

154 Le Corbusier's *Modulor*

whose ideas partly reflect the work on modular co-ordination undertaken by the Building Research Station at Watford, near London. The author also surveys the many similar attempts launched on a national and international level during recent years.[36] So it would seem that practitioners are all agreed in giving systems of proportion a new lease of life, if such systems can increase the industrial potential, allow quicker and more economic construction, and thus help to raise the living standard of the masses. We may say, therefore – too pointedly perhaps – that the belief in systems of proportion in modern society is proportionate to the amount of industrial energy they generate.

I considered ending my paper at this point, but too many aspects of the problem of proportion would have remained unmentioned. The few scattered remarks that follow may perhaps help to show the question in broader perspective.

It is a fact of considerable interest that outside the realm of art scientists and philosophers keep alive the quest for the great order in macrocosm and microcosm. Whitehead's well-known Platonism may be recalled: 'The Platonic doctrine of the interweaving of Harmony with mathematical relations has been

triumphantly vindicated.' Einstein's prophetic words that 'human nature always has tried to form for itself a simple and synoptic image of the surrounding world' are fully supported by the whole history of human thought and endeavour. Such behaviour may be biologically conditioned. As Lancelot Law Whyte has expressed it: 'If biology comes to recognize that all organic processes are ordering processes, then thought itself may be understood as a special kind of ordering process.'[37] Gestalt psychology bears out such hypotheses. It has been found that in animal as well as human behaviour symmetrical and regular forms – forms, in other words, which can be expressed in terms of simple mathematical relations – are seized upon. The human brain is capable of ordering the most complex sensory stimuli and shows a clear preference for the perception of simple mathematical patterns.

In his Princeton lectures Hermann Weyl[38] discussed the many types of symmetry that prevail in crystals and in plant and animal life, and for which man has shown an unflagging enthusiasm in his artistic productions over thousands of years. Symmetry, as the balance of parts between themselves and the whole, is a primary aspect of proportion. Bilateral symmetry is only one of seventeen species of symmetry. It is the symmetry of the human body, and for that reason of towering importance to mankind. Again the concordance of the two halves of the body can be expressed in terms of ratios and proportions, and it is these in fact which we perceive without fail. Every disturbance of the balance of parts (e.g., a short leg, a crippled hand) evokes reactions such as pity, irritation, or repulsion.

When all is said and done, it must be agreed that the quest for symmetry, balance, and proportional relationships lies deep in human nature. It can confidently be predicted that today's 'organic chaos' is a passing phase, and that the search for systems of proportion in the arts will continue as long as art remains an endeavour of man.

155 Interior of Santo Spirito, Florence, by Brunelleschi

V

BRUNELLESCHI AND 'PROPORTION IN PERSPECTIVE'

IN AN article published in 1946 Giulio Carlo Argan explained that it was impossible 'to distinguish Brunelleschi's researches on perspective from his artistic activity, that is to say, from his architecture.'[1] To substantiate his thesis, Argan threw his net very wide, helping us to understand why 'the origin of the fundamental ideas of Renaissance art – perspective and design – must be sought in the work of an artist-hero'. Thus he reversed the appraisal of a position which until not so long ago appeared trivial or even embarrassing, namely that it was the architect Brunelleschi who invented painter's perspective. During the 19th and early 20th centuries his invention was simply registered as a fact or pragmatically explained by referring in general terms to the importance that perspective has for architecture.[2] Since then it has been recognized and emphasized more than once that the invention of linear perspective was a vital and necessary step in the rationalization of space, a conception on which the whole edifice of Renaissance art rests.[3] But nobody before Argan made a serious attempt at co-ordinating Brunelleschi's interest in perspective and his work as an architect. The present paper is much more limited in scope than Argan's. It aims at clarifying one particular problem: briefly, my question might be styled 'proportion in perspective'. When we talk of Renaissance rationalization of space we mean an optical space of measurable quantities; we mean, moreover, that distances of objects seen by an observer can be rendered mathematically correctly in the two dimensions of a picture. Renaissance artists found that the same law relates every point in space to any observer's eye, and in consequence the problem of the rationalization of space was from the very beginning also the problem of the harmoni-

zation of space. Panofsky was, I think, the first to formulate that 'from the point of view of the Renaissance, mathematical perspective was not only a guarantee of correctness but also, and perhaps even more so, a guarantee of aesthetic perfection.'[4] Argan has tried to align this truth with Brunelleschi's practice. In contrast to Argan's paper the following notes will be of a technical rather than a philosophical nature.

Fifteenth-century definitions of perspective show that correctness was seen in terms of proportion. We may let Manetti speak; he said in the Life of Brunelleschi that the latter invented perspective 'which succeeds in expressing well and proportionately[5] the diminutions and enlargements of far and near objects as they appear to the eyes of men [showing] the size that corresponds to the distance of these objects: buildings, plains, mountains, landscapes of all kinds and everywhere, figures and other things.' In his *De prospectiva pingendi* Piero della Francesca was even more explicit. He identified perspective with 'commensuratio',[6] by which he meant that there is a definite ratio between the distance of objects in space and their size on the cross-section of the pyramid of vision. This he expressed more clearly further on by saying that perspective shows things seen from afar 'in proportion, according to their respective distance'.[7]

If Renaissance perspective guarantees proportionality between objects in space and their rendering on the picture plane, the question of ratios between equal objects at various distances from the eye is naturally raised. This is the principal point under review. Its discussion may put some strain on the reader's powers of endurance. But the result may perhaps justify the procedure; once we are aware that Re-

naissance perspective was not only the science of proportionality between object and image, but also the science of proportion between different images, Brunelleschi's fascination by it will be seen in a new light. Indeed, it would almost appear a historical necessity that he, the genius who brought about single-handed the new metrical architecture of the Renaissance, should have regarded harmony and proportion in the elevations of his buildings and their changing perspective views as a single problem; evidently, subjective viewpoints would invalidate or even annul the awareness of absolute measures if it was not possible to prove that binding laws of proportion also reign in 'perspective space'.

The charge against Renaissance and Classical architecture from the Romantic era onwards was directed precisely at this problem: it was held that the aspects of buildings change as the spectator moves about and that therefore absolute proportions cannot be perceived. Renaissance architects, on the other hand, saw no contradiction between objective proportions and subjective impressions of a building. Their approach to perspective testifies to this as much as the formal principles applied to their buildings. About the architecture itself no more than a few passing remarks can be made at the end of this essay, since my question is primarily a theoretical one. A discussion of proportion in perspective is handicapped by the lack of information regarding Brunelleschi's ideas. It is therefore necessary to draw conclusions from what Alberti, Piero della Francesca and Leonardo have said.

After his celebrated and often quoted definition of 'painting as the intersection[8] of the visual pyramid', Alberti leads the reader of the first book of *Della Pittura* to mathematics, and this important passage has not been given the attention it deserves. We may let Alberti speak:

... we must add the theorem of the mathematicians which demonstrates that if a straight line cuts two sides of a triangle and if this line forming a new triangle be parallel to a side of the first and bigger triangle; then the smaller triangle will be proportional to the bigger one. Thus we are taught by the mathematicians.

It hardly needs explaining that Alberti relied

here directly on Euclid. The most relevant theorem among those on proportionals in Book VI of *The Elements* runs: 'If a straight line be drawn parallel to one of the sides of a triangle, it shall cut the other sides, or those produced, proportionately, etc.' Alberti deemed it necessary to be more explicit. He carries on:

But we, in order to make our discourse clearer, shall explain this matter more fully. To begin with it is necessary to know what we mean by proportional. We say that those triangles are proportional whose sides and angles bear the same relation to each other ('abbiano fra se una ragione'): so that if one side of the triangle be twice as long as the base and the other side be three times as long,[9] each similar triangle, whether bigger or smaller, provided its sides have the same relation to its base, is proportional to the former. For

156

the same ratio that one part bears to the other in the smaller triangle, one part will also bear to the other in the bigger. All triangles therefore of this nature will be proportional.[10]

After these remarks about the proportionality of similar triangles one would expect Alberti to return to perspective. But this is not what he does. In order to explain proportionality further he resorts to the example of a tall and a little figure which are proportional when the parts of their bodies bear the same relations to each other. Alberti demonstrates here, to put it differently, that equality of ratios between part and part and the parts with the whole in two different figures, which the Renaissance usually expressed by numerical equations (e.g. $1:2=2:4$), can also be represented by the geometry of similar triangles. Thus the similarity of triangles has taken us into the field of human proportion.[11]

After this Alberti summarizes the position in the following words:

If this be sufficiently explained, we may lay down for granted the doctrine of the mathematicians, as far as may serve for our purpose, that every intersection of

any triangle parallel to the base must form a new triangle proportional to the bigger one. So that objects which are proportional to each other, correspond to each other in all their parts.

It is at this stage that Alberti reminds us that visual pyramids are formed of triangles. 'Let us then,' he exclaims, 'transfer our argument to the pyramid of vision.' And he logically concludes this part of his investigation with the remark that it is 'manifest that every intersection of the visual pyramid parallel to the surface seen, must be proportional to the latter.'[12] The proof of representational correctness, in other words, has been given in terms of the proportionality of similar triangles.

157

It is worth remembering that this is the mathematical concept on which Renaissance theory of perspective rests. A brief synopsis of the first book of *Della Pittura* may show that Alberti's whole argument is clearly built up towards this climax. He begins with the explanation of simple geometrical terms such as point, line and angle; he then summarizes the principles of Classical and medieval optics, familiarizing the reader with the character and function of visual rays and the pyramid of sight which they form. Since pyramids of sight define surfaces in space and since painting consists of a combination of surfaces in two dimensions, Alberti concludes that one can regard the painter's panel as a cross-section through the visual pyramid; if this is correct, as it evidently is, the theorems of similar triangles can be applied to perspective. It is only after this mathematical demonstration that he was ready to advise practitioners on methods of constructing perspective. It is this part on actual procedure that has attracted most interpreters of Renaissance perspective. For Alberti the recom-

mended procedure was simply a way of applying the theorems of similar triangles.

We may now return to the example of the tall and little figure and state what Alberti only implied. We can imagine the triangles formed by the figures as visual pyramids with the apex as vanishing point. Then, instead of seeing two figures objectively differing in size, we seem to look at figures of equal size placed at different distances in space from the eye of the observer. If, on the other hand, we imagine the eye at the apex of the triangle, the smaller figure will be the projection of the larger on the intersection of the pyramid of sight. As long as the two figures can be defined by similar triangles, they will be proportional to each other. It appears then that the same theorems of plane geometry unite proportion and perspective.

Now the term *proporzionale* used by Alberti in connection with similar triangles is the adjective of *proporzionalità* ('proportionality') which, in Renaissance usage, is the most comprehensive notion expressing relations. Ratio involves the comparison of one magnitude with another, proportion that of one ratio with another and *proporzionalità* that of one proportion with another. Similar triangles produce, in fact, *proporzionalità*.

When Ghiberti said that 'only proportionality makes beauty' and Daniele Barbaro, in his commentary to Vitruvius, that 'the whole secret of art consists in proportionality,'[13] they were thinking of a uniform system of proportion obtaining throughout a work of art or a building. We now know that such a uniform system may not only be expressed arithmetically, by way of 'quantitatum certa et constans adnotatio,' to quote Alberti's *De statua*,[14] but also demonstrated geometrically, by way of the similarity of triangles. Alberti's famous remark in the sixth book of *De re aedificatoria*, 'omnia ad certos angulos paribus lineis adaequanda,' by which he means that everything must be arranged with definite (or identical) angles and equal lines, reiterates in terms of similar triangles the Vitruvian axiom, emphasized again and again by Alberti himself, that the same system of proportion must relate part to part and the parts to the whole. As far back as 1883 A. Thiersch[15] demonstrated proportionality in 158 Renaissance buildings by laying similar triangles through their various parts.[16]

127

158 S. Maria del Popolo, Rome (after Thiersch)

The theorems of similar triangles bridged for the Renaissance what appeared from the mid-18th century onwards a gulf between absolute proportions and the changing appearance of a building. But an important point remains to be clarified: what are the ratios according to which a number of objects in space diminish for the eye of an observer? There is no discussion of this problem in Alberti's *Della Pittura*, where one would expect it. His only reference to it is a negative statement. In a well-known passage he refutes the rule according to which intervals between equidistant horizontals in space diminish on the intersection in the ratio 3:2, i.e. he rightly denies that the second unit appears as one-third less than the first, the third as one-third less than the second and so forth. This rule can be expressed by the suggestive continued proportion $\frac{a}{b}=\frac{b}{c}=\frac{c}{d}$, etc., but in spite of the fundamental error, Alberti gladly acknowledged that the lines 'follow in proportion.'[17]

In his *De re aedificatoria* Alberti never discussed at any length the optical appearance of architecture, although more than once he seems to have written with the observer in mind.[18] When talking about the preparation of buildings in models and drawings, however (Book II, ch. 1), he states explicitly that architects should not draw perspective views, but absolute measurements.[19] And yet he insists that an architect ought to know not only mathematics, but also painting. He does not expect him to be an accomplished painter; it suffices if he is conversant with fundamental principles,[20] and this means that he requires him to know the rules of perspective.

Piero seems to have been the first thoroughly to investigate the ratios of diminution in perspective. Characteristically, after an introduction on visual angles he turns in his *De prospectiva pingendi* to a restatement and elaboration of the Euclidian theorems of similar triangles. In the present context his fifth example is particularly relevant; for he demonstrates proportionality of similar triangles and drives his points home by using numbers. It is worthwhile following him in some detail. A large triangle ABC with sides AB = 18, AC = 21 and BC = 6 is divided by FD parallel to BC. ED = 4 divides AB into 12 and 6 and AC into 14 and 7 units.[21] The resulting ratios are: EC (7): AE (14) = FE (2): ED (4) = DB (6): AD (12); and FE (2): CB (6) = DB (6): AB (18) = CE (7): AC (21); and De : BC = AD : AB = AE : AC. Hence AE × FE = ED × EC and FE × AD = ED × DB and also DB × AE = EC × AD, etc.[22]

159

After his eleventh proposition Piero applies the findings of plane geometry to perspective, and his first concern is with the ratio of dimunition of objects in space.[23] This alone shows how much artists of the period must have had this problem on their minds. Their deliberations on this point, though never explicitly stated, may perhaps be expressed by the following question: the diminution of objects in space changes in accordance with, or relative to, the change of position of the percipient; is there one single law by which the changing ratios of diminution can be defined? Only a generally valid law would guarantee harmonic mathematical order in optical space. This law had to be established by projecting the objects in space on to a real or ideal intersection. Renaissance theorists were well aware that Classical and medieval optics, based on measuring the visual angle between eye and object,[24] would not allow a mathematically correct determination of ratios between distance and diminution. In fact, a

large object and a smaller and nearer one may be viewed under the same visual angle.[25] Possibly with a critical eye on Euclid's *Optics*, Piero himself expressed the Renaissance point of view more clearly than anyone else when he mentioned as the fifth and perhaps most important point in his definition of perspective 'the intersection [of the pyramid of sight] on which one projects objects in proportion and which allows to judge their dimensions; without intersection the diminution of objects cannot be defined, since [without intersection] diminution cannot be demonstrated.'[26]

Piero's emphatic statement that without intersection it is impossible to determine the mathematical relationship between distance and diminution, epitomizes the whole question. The columns of a portico receding towards the vanishing point form similar triangles, i.e. they are proportionate to each other, but the ratio between their diminution and distance from the eye can only be found by projecting them on to the intersection. If we regard, in Piero's fifth proposition, FD as the intersection of the visual pyramid ACB, with the eye at A and the base CB as the object in space, the size of the latter on the intersection FD will be DE. Conversely, if we know the distance AB, the size of the object BC and its projection ED we can compute the distance DB. A new situation arises when we have to deal with more than one object in space. For each of these objects placed at different distances from the eye forms the base of a new visual pyramid. Our original question must therefore be further specified; and we must ask if there is a law of proportion between the projections on the intersection of the bases of different visual triangles or, to put it more concretely, between the projections on the intersection of a number of objects in space.

To answer this question satisfactorily an important premise was necessary, namely that the objects should be of equal size, parallel to each other and placed at equal distances from each other. Only when a progression or series of equal ratios exists in the elevation, can we expect to find a law of ratios when these objects appear foreshortened on the intersection.

Nowadays this problem presents no difficulty whatsoever, nor can it have been beyond the reach of the average Renaissance artists.[27] What complicated the issue was their lack of modern symbols. It was also for this reason that, instead of formulating general laws, they had to adumbrate them by way of concrete examples. Piero's procedure may therefore appear rather cumbersome. He begins his investigation with the negative statement that ratios in perspective follow none of the well-known progressions, neither the geometrical (2, 4, 8, etc.) nor a progression in which the previous term is always two-thirds or three-quarters of the next as in the series 4, 6, 9 and 9, 12, 16, nor any other similar progression. But a particular 'diminishing proportion' arises which depends on the distance of the eye from the intersection and the distance from the latter to the object seen. To clarify the diminishing proportion created by perspective Piero gives an example[28] in which he gives four parallel 160 lines, each 1 *braccio* long and at equal distance of 1 *braccio* from one another. Let the first line be the intersection, and the distance from the intersection to the eye be 4 *braccia*. The ratio of diminution can then be expressed by the progression 105, 84, 70, 60. That is to say, the ratio of the intersection (which equals the height of the object) to the first object appearing on it is 105:84, i.e. 5:4, or, to put it differently, the objective height of the first object to its

apparent height is 5:4. The next ratio 84:70 or 6:5 does not express the objective height of the second object to its apparent height, but the diminution on the intersection of the first to the second object; equally 70:60 or 7:6 is the ratio of the second to the third object on the intersection. Piero goes on to explain how this series changes with the changing distance of the eye from the intersection: if the eye is 6 instead of 4 *braccia* from the intersection, the diminishing progression apparent on the intersection can be expressed by the numbers 84, 72, 63, 56, i.e. by the ratios 7:6, 8:7, 9:8.[29]

It is at once obvious that Piero's diminishing progression is not limited to the two examples given by him. Extending his description, it follows that, if the eye is one unit from the intersection, the progression begins with two over one; and the whole series expressed in ratios of small numbers runs: $\frac{2}{1}\frac{3}{2}\frac{4}{3}\frac{5}{4}\frac{6}{5}\frac{7}{6}\cdots\frac{n+1}{n}$. By choosing a different first object, or by taking the eye at a different number of units from the intersection, the series may start at any point.

How did Piero find this progression? He does not tell us in so many words. But the way his mind worked is already apparent in his fifth demonstration; if, to return once again to it, AD (distance of eye to intersection), AB (eye to object) and BC (height of object) are known quantities, then, according to the proportionality of similar triangles, also DE (projection of CB) is a known quantity. Moreover, in the present context Piero explains that 'the second to the first line is always related as the distance from the eye to the first line (which is the intersection) is to that of the second line to the eye.'[30] If we translate this rather complicated statement into the terms of his example, it can be easily followed, for 84:105 (image of the second line to the first) =4 (distance of the first line from the eye) :5 (distance of the second line from the eye). In other words, Piero is aware of the proposition, adumbrated in his fifth demonstration, that the ratio of diminution of equal magnitudes on the intersection is inversely proportional to their distance from the

eye.[31] Since this is true for all the projections of objects on to the intersection, it is evident that Piero had found, based on the proportionality of similar triangles, a diminishing progression of universal validity.

But, strangely enough, Piero did not pursue this problem any further. He declared that one cannot easily express the changing ratios numerically and that he was therefore satisfied with demonstrating them geometrically. We may nowadays wonder about his hesitation, since his progression is anything but complicated. One of the reasons for his silence on this point in the later parts of his work may have been the difficulty the 15th century still had in formulating simple fractions.[32] On the other hand, he may have thought that the problem was essentially solved.

Leonardo is usually credited with a fresh approach to the problem of 'proportion in perspective'. In fact, most recent authors wrongly believed that he was the first to tackle it at all. His notes of the early 1490s, which are mainly relevant in this context, lack the coherence and consistency of Piero's Treatise and are probably less original than is generally assumed. But he made an important contribution by formulating the connection between 'proportion in perspective' and musical consonances. His method of computing a law of ratios in perspective differs from that of Piero. While each fraction of Piero's series $\frac{2}{1}\frac{3}{2}\frac{4}{3}\frac{5}{4}$ expresses the ratio of diminution of two consecutive projections on the intersection, Leonardo determined the ratio of each projection to the objective height of each object, which would appear an obvious procedure. The comparison of the two diagrams 163 and 164 shows that his result does not, and cannot, differ from that of Piero;[33] but the arithmetical progression at which Leonardo arrived had the advantage of unsurpassed simplicity; it runs $\frac{1}{2}\frac{1}{3}\frac{1}{4}$ $\frac{1}{5}\frac{1}{6}\ldots$. It must however be said that Leonardo never mentioned this series explicitly. He only implied it in more than one of his notes. The following seems to be his most important direct statement:

If you place the intersection at one braccio from the eye, the first object, being at a distance of 4 braccia from your eye, will diminish $\frac{3}{4}$ of its height on that intersection (i.e. it will appear as $\frac{1}{4}$ of its height); and if

A B E G

162

163

164

it is 8 braccia from the eye, $\frac{7}{8}$; and if it is 16 braccia off, it will diminish $\frac{15}{16}$ of its height, and so on by degrees, as the space doubles the diminution will double.[34]

Leonardo's conclusion 'as the space doubles the diminution will double'[35] is easily understood if we express the sizes of the projections on the intersection as $\frac{1}{4}\frac{1}{8}\frac{1}{16}$. The other terms of the progression follow as a matter of course. When Leonardo emphasized in his notes that the same harmonies reign in music and in perspective space,[36] he must have had a figure like our Pl. 164 before his mind's eye. One may regard the intersection in this diagram as a monochord;[37] equal and equidistant objects in space determine points on this line which divide it in the ratios $1:\frac{1}{2}$ or 2:1, $1:\frac{2}{3}$ or 3:2, $1:\frac{3}{4}$ or 4:3 which are the ratios of octave, fifth and fourth. These ratios, which may be noted as the progression of the first four integers (1:2:3:4), form the hard core of Renaissance proportion.[38] Piero had found the same relationships, as Pl. 163 shows. One can only speculate why in his text he did not draw Leonardo's weighty conclusions.[39]

Finally, the question arises why Piero did not state in so many words Leonardo's simple progression. That he, as well as others, had been aware of it, cannot be doubted, for experimenting with similar triangles would inevitably reveal it.[40] The following explanation might probably be near the truth. The progression $\frac{1}{2}\frac{1}{3}\frac{1}{4}$ $\frac{1}{2}$. . . only applies when the distances between the eye, the intersection and the objects in space

are equal. If the distance between eye and intersection is, for instance, four units and that from the intersection to the first object and from object to object one unit, as in Piero's example Pl. 160, the projections on the intersection relate to the whole height of the objects as $\frac{4}{5}\frac{4}{6}\frac{4}{7}\frac{4}{8}$. . . . In other words, by using Leonardo's procedure the character of the progression changes with a change of the conditions pertaining to produce the series $\frac{1}{2}\frac{1}{3}\frac{1}{4}\frac{1}{5}$. . . .[41] Only by establishing ratios between two consecutive projections, as Piero did, will the same progression be applicable to all cases of equal objects equidistant in space, regardless of the distances of eye and intersection. Moreover, Piero's progression renders the ratios of diminution of vertical objects in space as well as of horizontal dimensions, whereas Leonardo's progression does not.[42]

It appears then that at this particular moment Leonardo's interest was focused on demonstrating the potency of Pythagorean-Platonic harmonies in optical space, while Piero seems to have wished to establish a general and infallible law of perspective ratios.

How much of all these considerations about continued diminishing progressions in space was known to Brunelleschi, and how far were his experiments supported by theory? We have no reason to doubt Manetti's statement, previously quoted, that Brunelleschi rendered the size of objects corresponding to the distance of these objects. Whatever his method when painting his famous panels, theoretical clarifi-

cation must have preceded these experiments. It must have been he who found that the projections of objects on to the intersection of the pyramid of sight are proportionate to these objects because objects and projections form similar triangles. This conclusion finds support in P. Sanpaolesi's carefully argued paper about Brunelleschi's mathematical equipment[43] and John White's systematic analysis and reconstruction of the painted *vedute*.[44] We may confidently state that Brunelleschi had discovered that two-dimensional projection was the only method of proceeding to laws of ratios between the observing eye and the diminution of objects in space. Whether he ever tried to express this numerically, that is, how far he anticipated Piero's and Leonardo's explorations, must remain an open question. But it would be wrong to conclude from Alberti's silence in *Della Pittura* that the matter was not clearly formulated in Brunelleschi's circle. A glance at Alberti's *Ludi matematici*[45] shows that he knew very well how to use the theorems of similar triangles to compute the unknown height of a tower or the width of a river. One must take it for granted that artists had known about the simple proportion

165

$$DE\ (=x) : AD = BC : AB$$
$$x : 1 = 1 : 2$$
$$x = \tfrac{1}{2}$$

ever since similar triangles had been used in the context of perspective, and from this one is bound to infer that Leonardo's progression can never have been a secret.

Whatever the precise position, if Brunelleschi wanted to prove that objects in space diminish in accordance with a law of continued ratios, so that a building seen from any point or angle does not lose its metrical coherence, he had to 'invent' painters' perspective since the two-dimensional projection was the only mathematical way of determining the relation between distance and diminution. And just as a continued diminishing progression in perspective is tied to the postulate of parallel and equidistant objects of equal size, so proportion

in perspective views of architecture requires a coherent metrical organization in the elevation.

The principal formal characteristics of Brunelleschi's new Renaissance architecture may be summarized under the terms of homogeneity of wall, space, light and articulation. These 'homogeneities' are the necessary conditions not only to guarantee coherent metrical development in plan and elevation, but also to ascertain continued ratios in perspective view.

The visitor who enters the church of S. Lorenzo has hardly a chance of seeing a wall of the nave or even a part of it fully extended. He moves along the nave between two arcades which diminish towards the distance in a definite progression. At whatever point he may choose to stop, the law of proportion in perspective is equally valid, if he regards the column nearest to him as standing in the ideal plane of the intersection.[46] Continued progressions in perspective are, of course, the by-product of every style with sequences of identical motifs, but it was only during the Renaissance that 'perspective ratios' became an essential element of stylistic consideration – differing from the so-called 'optical refinements' of ancient and medieval architecture – and that everything was done to make the perception of a harmonic diminishing series in space a vividly felt experience. In S. Lorenzo the floor of the nave is laid out in squares corresponding to the size of the bays, and the dark line of the central axis invites the visitor to move along it so that both walls of the nave seem to diminish equally towards the vanishing point.[47] The squares of the floor together with the coffers of the ceiling supply spatial co-ordinates, and their function as metrical guides is comparable to the function given in Renaissance pictures to the foreshortened marble floor. The coffers are integrated with the module system of the whole building. The diameter of each coffer from centre to centre of the frame is $4\tfrac{1}{2}$ modules (if we regard, with Geymüller, half the diameter of the column as the module[48]) and this measure exactly corresponds to the width of the windows in the clerestory. Moreover the diameter of the filling of each coffer equals two modules, i.e. the diameter of the column.[49]

The corroborating evidence of the formal principles of Brunelleschi's metrical architecture, of his investigation of linear perspective,

166 Interior of S. Lorenzo, Florence, by Brunelleschi

Manetti's report about it and the line of research followed up by Alberti and Piero della Francesca, allows the following inference: Brunelleschi recognized that the mathematically incontestable theorems of similar triangles guarantee proportionality in a metrically coherent building both in its objective elevations and subjective views; and, as a corollary, that the awareness of 'proportion in perspective' depends on the postulate of an imaginary intersection of the pyramid of sight. This appears to be the upshot of the whole problem and the internal data strongly support it as true. To unmask as chimerical this abstract mathematical conception of seeing hardly requires an appeal to the physiology of vision; we do not see a building as if it were projected on to an intersection of the visual pyramid, nor do we see it as a consecutive series of stills, and so forth.[50]

And yet, if Brunelleschi was prepared to apply the laws of perspective to all nature – 'plains, mountains, landscapes of all kinds and everywhere,' to quote Manetti again – and project it on to the cross-section of the visual pyramid, we cannot stop short of his own architecture. We all know that the way we see visual images depends on the notions in which we believe. Brunelleschi's invention of linear perspective set the seal to the Renaissance conviction that the observing eye perceives metrical order and harmony throughout space. If one is keyed up to the metrical discipline of buildings like S. Lorenzo or S. Spirito and tries 155 to see as if through a screen the lines retreating 166 towards the vanishing point and the quickening rhythm of the transversals, it is possible to evoke visual reactions similar to those which Renaissance people must have experienced.

133

167 Trompe l'oeil choir of S. Maria presso S. Satiro, Milan, by Bramante

Granting that Brunelleschi wanted his buildings to be looked at as if they were projected on to an intersection, the difference between architecture and painting becomes one of artistic medium rather than of kind. Once stated, one only wonders that such little attention has been paid to this rather manifest observation. Nor can it here be discussed in all its ramifications. Not only does it throw light on the deep gulf separating ancient and Renaissance architecture, but also on the rev-olutionary development of the Renaissance stage, on the sudden flowering of the art of the *intarsiatori* and the meaning of painted illusionism. The architectural setting of Masaccio's 'Trinity', the first great work of Renaissance illusionism made under the impact of Brunelleschi's ideas, obliterated in its original place (to which it has recently been transferred) the borderline between real and painted architecture: the beholder looks, as it were, into a real chapel.[51]

Renaissance illusionist painting is a reversal of the case I have tried to make out for architecture. The acceptance of painted reality as if it were real is no less unreal or 'unrealistic' than that of building in three dimensions and looking upon the result as if it were painted. That 15th-century painters thought it necessary to make plans of their architectural settings as if they were to be built, would seem paradoxical if they had regarded space constructed and space painted as different in essence. The phenomenon of Bramante's feigned choir of S. Maria presso S. Satiro, which has always puzzled critics[52] and which even such a thoughtful judge as Jakob Burckhardt called a freak, is indeed inexplicable without the criteria here introduced. Whether real or feigned, the choir should be seen by the beholder, approaching it on the central axis of the nave, like a projection on to the intersection of the visual pyramid: only thus can he fully experience the diminishing ratios of the architecture, and only then do real and imaginary space become one.[53]

After the foregoing, one is justified in believing that painted architecture provides a clue as to how real architecture was looked at. In Renaissance pictures architectural interiors are as a rule shown as perfectly symmetrical, as if one moved along the central axis of the nave of S. Lorenzo. Such perspectives are often juxta-

posed to a frontal deployment of the same architectural arrangement. Raphael in the 'School of Athens' did what Bramante had done in S. Satiro: the perspective view continues an articulation which appears fully extended in the adjoining bays of the transept. A similar device was often used for exteriors of which one front 168 extends parallel to the picture plane and the other at right angles to it. One has, therefore, an elevation as a foil against which to judge the foreshortened part of the building. In actual fact both fronts, whether seen in the picture or in reality, look different; and yet we are vividly aware of coherence and continuity. We see, in fact, the objective measures of the frontal projection also in the foreshortened part. This awareness depends on the observance of the formal princples of homogeneity which I have mentioned. Thus the architecture of the period, if viewed like buildings in Renaissance pictures, produces a psychological situation in which proportion and perspective are felt as compatible, or even identical realizations of a metrical and harmonic concept of space.

When architects began to abandon Brunelleschi's formal principles of homogeneous wall, space and articulation, it was a signal for the break-up of the Renaissance unity between objective proportions and the subjective optical appearance of buildings.

168 Detail of an architectural view, *c.* 1460–70, panel painting (Urbino, Palazzo Ducale)

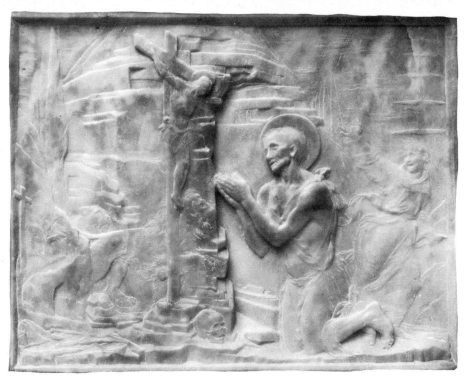

169 DESIDERIO DA SETTIGNANO. *St Jerome in the Desert* (Washington, National Gallery of Art)

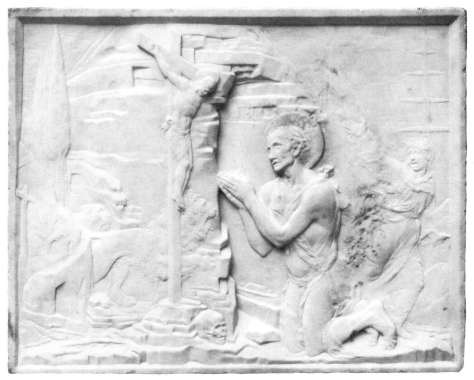

170 DESIDERIO DA SETTIGNANO. *St Jerome in the Desert* (New York, Collection of Michael Hall)

VI

DESIDERIO DA SETTIGNANO'S 'ST JEROME IN THE DESERT'

IN THE spring of 1970, during my tenure as Kress Professor in Residence at the National Gallery, Washington, I had the good fortune of being able to arrange for the confrontation, twice repeated, of Desiderio's relief of *St Jerome in the Desert* with an identical marble relief in the private collection of Mr Michael Hall, New York. Stucco as well as marble repetitions of important pieces abound in Florentine Quattrocento sculpture and are common in Desiderio's work.[1] As a rule we have little difficulty in recognizing the key piece on which the contemporary copies and versions depend. No one in his senses would suggest 'demoting' Desiderio's *Turin Madonna* in favour of any of the half dozen repetitions known to us.[2] But a decision is not always that easy, as the case of the *Dreyfus Madonna* shows, which has often been discussed in the course of the last eighty years. There was not only the problem of attribution, but also that of determining the key piece. Before the Dudley version in the Victoria and Albert Museum was known, many regarded the Dreyfus version (now in a private collection in New York) as the original; it is only recently that, owing above all to Sir John Pope-Hennessy, the superior quality of the Victoria and Albert Museum piece has been established beyond reasonable doubt.[3]

At the start I wish to dispel any fears: the case I am going to submit does not parallel the one I have just mentioned. I am not going to dethrone a work of art that to many is the favourite piece in the sculpture collection of the National Gallery. Nor am I going to suggest that Mr Hall's *St Jerome* was copied after the National Gallery one. But before unfolding this story, I wish to make a number of points. The appearance of the second version has given occasion to study Desiderio's relief and attempt to throw light on some features which first seemed extremely puzzling. Excepting questions of attribution and dating, much of the literature on this important work is less than adequate.[4] It therefore seems appropriate to start at the very beginning.

Provenance, history, and condition of the Washington relief

Contrary to what is often maintained, the relief has no old and revealing provenance.[5] It was found in the late 1880s in Florence by the Baltic Baron Karl Eduard von Liphardt (1808–91), an aesthete of the Victorian era, who in his day enjoyed a reputation as a connoisseur. He was highly esteemed by such men as Wilhelm von Bode whom we have to regard as the founding father of modern studies in Florentine 15th-century sculpture. So far as I can see, the Baron never disclosed the relief's original habitat nor is there a word about it in some much later correspondence on file in the National Gallery. The Baron died in Florence in 1891 and it seems that thereafter the relief was taken to the baronial family seat at Rathshof near Dorpat in Estonia. There the relief remained until after the Russian Revolution when the first owner's grandson, Baron Renaud de Liphardt, managed to take it with him to Copenhagen.[6] Through the good offices of Dr Valentiner it passed in 1921 to the Widener Collection in Philadelphia and from there to the National Gallery.

This story shows that during the long period of thirty years – between 1891 and 1921 – the relief was practically inaccessible and no more than a handful of art historians could have seen it in its far-away Baltic domicile. We do not know how the relief was treated during its northern exile, but Baron Renaud's cor-

171 Photograph of a cast of about 1890, then in St Petersburg (Brogi)

respondence with Dr Valentiner allows us to assume that it was always regarded as one of the most exquisite treasures the family possessed and accordingly given a place of honour in the house. Nevertheless, there are undeniable indications that something had happened to the surface of the relief between the 1890s and its permanent exhibition in the National Gallery. The evidence is as follows: there is a Brogi photograph in existence with the caption 'Pietroburgo . . . Donatello (da un calco del Lelli),' i.e., the photograph was not taken of the original which at that time was in Russia,[7] but of a cast by a certain Lelli. In 1899 his firm published a catalogue of casts sold at their establishment and among the casts after Donatello there appears our relief as No. 205.[8] The cast must have been made before 1891 (the year the original was probably transferred to Estonia), while the photograph dates from a period when the original was no longer available in Florence. If anything, casts lose some sharpness of definition and some subtle detail, but in this case the cast shows more detail throughout than the original does in its present state, and this is only to a minor extent due to the strong light from the right to which it was exposed by the photographer. Thus we have to presume that before 1891 the surface of the National Gallery relief looked different. The only alternative would be that the cast was not made after the Liphardt-National Gallery relief, but after another version available in Florence with more sharply defined detail. It can, therefore, safely be said that both the brown discolouration of

large areas of the marble that had originally been white, and the present appealing alabaster-like softness and *sfumato* of the surface have to be regarded as relatively recent 'acquisitions'. Presumably the relief in its pristine condition, before having been rubbed down by repeated cleaning and washing, would have presented a much crisper, more clearly defined and less pictorial aspect. In sum, we cannot get away from the fact that the cast represents a truer image of the Quattrocento surface – an image that is more in keeping with 15th-century possibilities – than is today's much cherished surface of the relief.

Attributions, dating, and illustrations

As early as 1899 Bode published the relief as a work by Desiderio da Settignano in the great standard publication *Denkmäler der Renaissance-Skulptur Toscanas*.[9] Knowing the history of the relief, one is not astonished to find that his large reproduction was made of a cast.[10] Bode had a special photograph taken, this time sharply lit from the left, and this made the cypresses in the left and right background as well as some other details stand out very clearly, even clearer than they appear in the Brogi photograph. Unpardonably, the Munich firm of F. Bruckmann who were responsible for the illustrations used a cast with a diagonal break in the upper left part and with other belmishes. Since to this day no one suspected that a cast rather than the original had served the photographer, some observant people wondered how and why the break in the marble had disappeared!

Bode's attribution was not immediately or wholeheartedly accepted. Adolfo Venturi mentioned the relief in 1908 in his *Storia dell'arte italiana*[11] as a likely work by Desiderio and only in his iconographic study of St Jerome, published in 1924, did he unhesitatingly subscribe to the attribution.[12] In 1907 and 1909 Paul Schubring[13] in the *Klassiker der Kunst* volume on Donatello showed the work with others as a Donatello school piece. Both he and Venturi used the Brogi photograph of the cast without any comment. Even worse, Planiscig, in his Desiderio monograph of 1942, returned to the illustration Bode had used forty-three years before![14] I am spelling all this out at some length

171

because it appears that no early photograph of the original existed, or, in any case, was published, so that a check on the condition of the piece at the time it left Florence will never be possible. It was only over sixty years after its discovery that Charles Seymour, Jr abandoned the earlier obnoxious procedure by publishing some plates made from highly satisfactory photographs taken of the original by Henry Beville, the National Gallery's skilful photographer.[15]

The rest can be communicated more summarily. Even without aiming at completeness, there is no doubt that as time went on the vast majority of scholars, and among them the best connoisseurs, past and present, of Florentine Quattrocento sculpture, accepted Bode's Desiderio attribution.[16] The piece is now sometimes treated with such assurance as Desiderio's that the uninitiated might be misled into believing that it is a documented work. But there have been a few dissenting voices: in 1928 Valentiner suggested Francesco di Giorgio as a more likely author;[17] in 1943 Georg Swarzenski argued that the piece was probably unfinished at Desiderio's premature death and that the landscape background in particular might have been executed by Benedetto da Maiano;[18] finally, a year later L. Goldscheider put forward a claim for Gregorio di Allegretto, the master of the tomb of S. Giustina, now in the Victoria and Albert Museum.[19] These divergent opinions have either been regarded as unworthy of consideration or have been indignantly refuted. But while the names suggested by those critics may indeed be unacceptable, their initial reaction was a sound one: they voiced their feeling of uneasiness regarding the Desiderio attribution. It is an undeniable fact that in some respects the St Jerome relief has no parallel in Desiderio's *oeuvre*. The *sfumato* apart, it would be the only known pictorial low relief (*rilievo stiacciato*) that he attempted. Moreover, it contains strange iconographic extravagances (which will be discussed at length), but it is a fact that in his accepted work Desiderio never revealed a taste for the anecdotal and the dramatic. On the other hand, try as one may, no other name will announce its claim as strongly as Desiderio's before the gentle devotional figure of the saint to whose prayer the figure on the Cross seems to respond by curving toward

him equally gently. The critical method that reconstructs an artist's personality by way of tracing similar stylistic phenomena in various works of art has been exceedingly successful in Desiderio's case. As we see him now, it is only with him that one can associate the saint's naively sincere, wholly dedicated mood, the expression of which is inseparable from an extraordinary refinement of sculptural values. A delicate, almost dainty quality characterizes all the works we now recognize as his and separates them from the more robust works of his contemporaries. No other Florentine sculptor would or could have rendered at this moment such aristocratically elongated, sensitively modulated hands as those of the saint.

As to the problematical features just mentioned, one feels moved to assume that the artist had to incorporate in his work explicit demands of a patron – a situation with which we are familiar and which in the present case will become more likely as we proceed.

Desiderio died at the age of thirty-five or thirty-six, in January 1464. His entire career as an independent artist covered probably less than fifteen years. For this period only two dates are available: the death of Carlo Marsuppini in 1453 indicating that this year would, therefore, be the date *post quem* for Desiderio's tomb of the Chancellor in S. Croce; and 1461 as the documented date for the placement of the finished Tabernacle in S. Lorenzo.[20] Thus Desiderio's two major works belonged to his middle years and their execution may even have overlapped to a certain extent. With these meagre facts it would seem difficult to arrive at a generally acceptable chronology during the brief span of his career. Nevertheless, some criteria, historically logical though naturally hypothetical, have been worked out and a fairly general consensus has been achieved. In 1942 Planiscig[21] still dated the Washington relief early. Probably owing to the war, Middeldorf's stylistic arguments in favour of a late date, published two years before,[22] had escaped him. With the exception of Seymour (who dates the relief between 1450 and 1455), recent critics such as Pope-Hennessy and Cardellini followed Middeldorf. I also believe that the late date, i.e., the beginning of the 1460s, is the correct one and I shall have occasion to advance new arguments in favour of that date.

Iconographic problems

It would be incorrect to say that the iconography of the Washington *St Jerome* has attracted no attention,[23] but as far as I can see there is little about it in the Desiderio literature.

The works of art in which St Jerome appears from the 15th century onward are legion. The present essay is, therefore, not the place for a general discussion of the saint's iconography,[24] but I cannot refrain from voicing some sweeping remarks that will help to make the special character of our relief intelligible. By the mid-15th century 'St Jerome Praying in the Desert' was a well established iconographic type. The saint is usually shown in a landscape, often hardly reminiscent of a desert, kneeling before the Cross and beating, or preparing to beat, his breast with a large stone and meditating over a skull, while his free arm and hand are often extended in a gesture of submission; next to him are his traditional symbols, the cardinal's hat and the lion. In Italy the saint is usually represented aged and bald, with a long white beard.

172 St Jerome, detail of the National Gallery relief

This description immediately reveals to what extent Desiderio deviated from tradition. In the relief the saint is kneeling on both knees,[25] his hands joined in prayer; he is extremely thinly clad, his garment or rather rags leaving most of his body nude, and he is clean-shaven. On the ground under his elbows lies the cardinal's hat. Before him, approaching him from the left in a gap between the Cross and the rock, stands the lion with his right paw raised and his mouth open (so that the canines and the rolled-up tongue are visible) as if he were addressing the saint who is absorbed in prayer, and asking him to extract the thorn. The lion is accompanied by an anguished-looking lioness. At the far right an acolyte takes flight gazing open-mouthed and with terror in the direction of the lions. There is a cross at the left edge somewhat back in the landscape. We have to presume that the acolyte had been praying there when he saw the lions approaching. Thus we encounter features here which I have called anecdotal and dramatic; though most of them may not be unique,[26] some are rare or even very rare and require comment.

The beardless St Jerome has a northern pedigree. Surviving examples, particularly in Netherlandish painting, are numerous and it may well be true that the highly individual characterization occasionally given to the saint was intended as a recognizable portrait. Thus F. Oswald[27] has rather convincingly demonstrated that the representations of a beardless St Jerome in paintings by the Master of the Altar of St Bartholomew show the features of Archbishop Antonino of Florence (1389–1459). But it is unlikely that the Italian depiction of St Jerome as a clean-shaven hermit, which had some currency though mostly limited to Florence, was intended as an allegorical portrait. The first clean-shaven St Jerome in Italian art occurs among the rare 14th-century sculptures representing him on Giovanni di Balduccio's *Arca di San Pietro* in S. Eustorgio in Milan (1339).[28] This figure showing the saint standing in cardinal's garb is as isolated as Jacopo della Quercia's beardless St Jerome on the marble altarpiece in S. Frediano at Lucca (finished 1422) or even as the beardless saint in his study in Antonello da Messina's well-known painting in the National Gallery, London. In this case it seems likely that Antonello followed a now lost Van Eyck model.[29]

173 Acolyte, detail of the National Gallery relief

174 Acolyte, detail of the Hall relief

175 Lion, detail of the National Gallery relief

176 Lion, detail of the Hall relief

A coherent and interconnected series of clean-shaven St Jerome images begins with Andrea del Castagno's fresco of the Trinity with St Jerome standing as a penitent hermit between the Virgin and St Anne in the Chapel of Girolamo Corboli in SS. Annunziata, Florence. The near-toothless mouth and the bags under the eyes may, perhaps, indicate that Castagno selected some features characteristic of the saint's namesake to whom the chapel belonged. But the upturned, foreshortened head shows that the artist did not intend to create a portrait. Castagno's fresco is not securely dated. There is, however, some evidence that it was painted

141

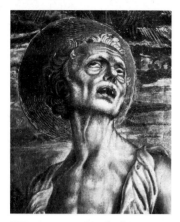

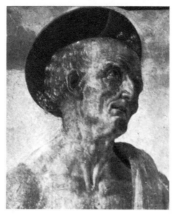

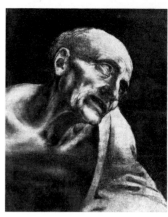

177 CASTAGNO. Head of St Jerome, from SS. Annunziata, Florence

178 VERROCCHIO. Head of St Jerome, from S. Maria e Angiolo, Argiano

179 LEONARDO DA VINCI. Head of St Jerome, detail (Rome, Vatican Gallery)

between 1451 and 1455,[30] and good reasons can be adduced for the assumption that Desiderio was attracted by Castagno's work. Indeed, there cannot be much doubt that Desiderio transformed this head, so full of drama and passion, into one expressing self-examination and humility.

 For the next important stages in the development of this type we have to refer to
178 Verrocchio's altarpiece of Christ with St Jerome and St Antony in the sacristy of S. Maria e
179 Angiolo at Argiano and Leonardo's unfinished St Jerome in the Vatican Pinacoteca. The former, dating from before 1473,[31] has a standing St Jerome with a head which parallels Desiderio's emaciated beardless head of St Jerome created about ten years earlier; the latter,[32] dating from about 1480, shows Leonardo drawing inspiration both from his teacher Verrocchio and from Desiderio,[33] but at the same time giving this kind of head a new dimension of contrition and psychological depth. Leonardo's rendering of the beardless St Jerome constitutes a climax. This form was used occasionally;[34] but perhaps the only significant work of art in this vein is the St Jerome in Piero Pollaiuolo's altarpiece of the
180 *Coronation of the Virgin* in the Collegiata at S. Gimignano, painted in 1483 shortly after Leonardo's *St Jerome*. Here, among the attending saints, appears the kneeling St Jerome, open-mouthed, emaciated, desolate with remorse, a figure unthinkable without Leonardo's model.[35]

 It would appear to be in keeping with the gentleness of Desiderio's approach to devotional

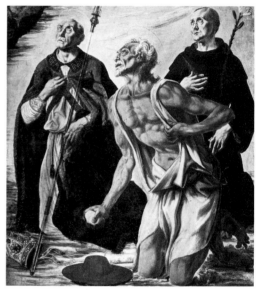

180 PIERO POLLAIUOLO. Detail from the *Coronation of the Virgin*, Collegiata, S. Gimignano

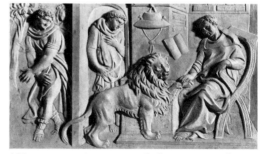

181 JACOPO DELLA QUERCIA. St Jerome extracting the thorn from the lion's paw, in S. Frediano, Lucca

142

imagery that he excluded the rock in St Jerome's hand[36] which conjures up brutal chastisement, and replaced it with the reverent gesture of the hands joined in prayer. These hands assume particular significance; they provide the focus of attention for they are judiciously placed in the exact centre of the composition, within the spatial caesura provided by the meeting of the movement from left and right.

There is nothing in the legend of St Jerome that would not allow the showing of his hands folded in prayer and yet the established pictorial convention had such force that this motif was hardly ever chosen. Among Florentine Quattrocento artists it seems only to appear in some works of the Botticelli follower Jacopo del Sellaio (1442–93). He was fond of the St Jerome theme and a whole group of his paintings survive slightly varying a composition that shows St Jerome praying in the desert.[37] There is a puzzling relationship between Desiderio and Sellaio[38] to which I shall have to return in due course. But at this stage it may be said that it was Sellaio who followed Desiderio, for he was fourteen years younger than the sculptor and all his documented works date from after Desiderio's death.

We next turn to the acolyte whose wild emotive reaction is so unexpected in the peaceful atmosphere of the praying recluse that he has always attracted special attention. The inclusion of such a figure was warranted by the legend which contrasted Jerome's calmness with the panic of other hermits who were with him at the time of the appearance of the lion. For reasons not easily explained, the representation

of this motif is extremely rare, although artists did take it up now and again. Three examples may here be given. The first time an Italian sculptor attempted to be true to this tradition was probably when Quercia did his rendering of the scene in the predella of the S. Frediano altarpiece at Lucca (1422). Here the beardless St Jerome clad in a monk's habit is seated in his 181 study carrying out the operation on the lion, while an attending monk who blocks the doorway seems entranced by the event, and a second one outside the portals runs away overcome by fear, the emotion clearly shown in his facial expression as his head turns back to the extraordinary incident. Vittore Carpaccio, in his famous cycle in S. Giorgio degli Schiavoni 182 in Venice (1502–07), represented the scene within the confines of an ample monastery, where, at the appearance of the lion, only the saint remains unmoved despite the debility of extreme old age, while the young monks take flight in all directions. My third example, Benozzo Gozzoli's fresco in S. Francesco at 183 Montefalco, a little Umbrian town south-east of Perugia, may have been known to Desiderio. As we shall see he was attracted by this rather old-fashioned pupil of Fra Angelico. The fresco dates from November 1462. Not unlike the much earlier version by Quercia it shows the saint attending to the lion, a blessing acolyte behind him, while two monks, one gazing in awe under the gate, the other in flight, approximately parallel those in Quercia's relief. The stance of the legs and the thrown back head of his counterpart in Desiderio's relief are very similar, but one tends to overlook this because

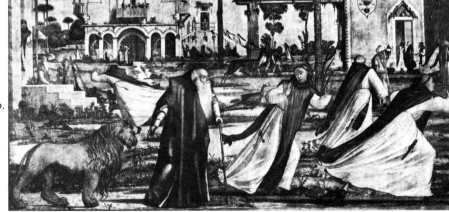

182 CARPACCIO. Detail from *St Jerome and the Lion* in the Scuola di S. Giorgio degli Schiavoni, Venice

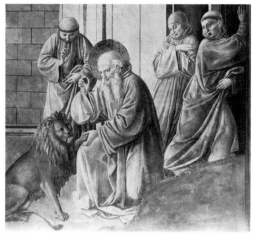

183 GOZZOLI. Detail from *St Jerome extracting the thorn from the lion's paw*, in S. Francesco, Montefalco

184 CASTAGNO. *David* (Washington, National Gallery of Art)

185 The Pedagogue, from the group of the Niobids (Florence, Uffizi)

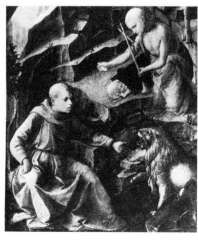

186 FILIPPO LIPPI. Detail from *St Jerome in the Desert* (Altenburg, Lindenau Museum)

of the outstretched arms, the wind-blown classical-looking garment and the splendid head with the crying mouth and the mass of hair in wild disarray. To make this figure historically intelligible, we have to postulate not only the impact of the post-Paduan Donatello (i.e., post 1453), but also, as Seymour has pointed out, a knowledge of Castagno's shield with the figure of David, now also in the National Gallery. Few will doubt that this work, usually dated about 1450, was known to Desiderio. Moreover, without the experience of Classical figures neither Castagno's nor Desiderio's invention would have been possible.[39] It would thus seem that the ancestry of Desiderio's remarkable figure includes a knowledge of Gozzoli, of the late Donatello, of Castagno and, directly or indirectly, of Roman art. The result is a convincing climactic contrast between the saint who is living in the Faith calmly immersed in spiritual communion with Christ, and his attendant who is thrown off balance by the base instinct of physical fear. This contrast has never been more movingly rendered in representations of the Jerome legend.

Let us now turn to the lion, the cause of all the consternation. First it must be realized that Desiderio blended two scenes which usually appear separate: the extraction of the thorn and the penitent St Jerome in the desert. The removal of the thorn is here, but it is only indicated rather than shown explicitly. The lion is waiting and begging, but the saint is not yet prepared to aid him. The normal iconographic pattern consists of the physical excision of the thorn such as that represented by Quercia and Gozzoli and the position assumed by St Jerome after the thorn's removal when he has returned to prayer and the lion has joined him as his faithful companion.

For reasons to be substantiated later, I would claim that Desiderio's fusion of scenes was stimulated by a small picture by Fra Filippo Lippi, now in the Museum at Altenburg, which is usually dated in 1455/6.[40] The main area of the picture is taken up by the young, beardless St Jerome kneeling, cross in hand, and praying in a rocky landscape. In the left foreground St Jerome appears a second time extracting the thorn from the lion's paw. Thus we have here united on one small panel two different moments of the legend: the saint praying before the

appearance of the lion and the removal of the
thorn. If one wanted to combine these two
scenes in one image, the only way of doing it
would seem that chosen by Desiderio. More-
over, there seems to be a distinct connection
between Filippo Lippi's and Desiderio's lion.
Both show the open mouth and curled tongue.
The junior partner was, no doubt, Desiderio.

Desiderio's lion is a wonderful creature: he is
done with an astonishing understanding of
anatomy, movement and expression. By com-
parison, even Gozzoli's lion looks wooden and
stylized and displays an old man's rather than
leonine features. Desiderio's lion stems from the
Ghiberti-Donatello tradition. Its nearest parallel
seems to be in the Ark panel of Ghiberti's *Porta
del Paradiso*, a work that must have enormously
impressed the young sculptor when it was
unveiled in 1451.

Another point requires comment: the lion is
accompanied by a lioness whose head appears at
a safe distance from the centre of action. The
lioness is a kind of counterpart to the acolyte,
and one might even argue that she is perhaps
meant to illustrate the curbing of fear in the
beast by the magic attraction of the God-
inspired man. It must, however, remain open
how far one is permitted to take the in-
terpretation without the support of documents.

187 GHIBERTI. Detail from the Ark panel, Baptistery
door, Florence

188 SELLAIO. *St Jerome in the Desert* (whereabouts
unknown)

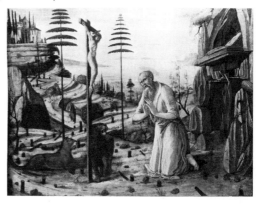

189 ROSSELLINO (?). *St Jerome in the Desert*
(whereabouts unknown)

190 DELLA ROBBIA workshop. *St Jerome in the Desert*
(Florence, Casa Buonarroti)

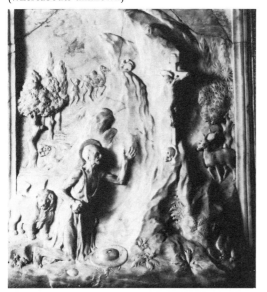

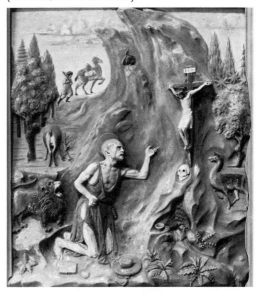

Nevertheless, it can be confidently stated that in a work in which everything has been so carefully considered the lioness would not be a thoughtless addition, as at least one author seems to have assumed.[41] Practically no attention has been paid to this motif, and yet it is not entirely isolated; it makes an occasional appearance in a limited Florentine circle and, so far as can presently be determined, all these works are interrelated. The first time a lioness graces the scene is, to my knowledge, in the Altenburg Filippo Lippi. Strangely enough, such a careful observer as R. Oertel[42] explained away the lioness by maintaining that she is the head of St Jerome's lion that is mirrored in a pool of water. In reality St Jerome's lion is open-mouthed, while the so-called mirror image keeps its mouth firmly shut and, in addition, does not show any indication of a mane: in other words, the second lion's head is that of a female lion looking out from the lion's lair under the big stone plateau that separates the two scenes. Desiderio showed about as much of the lioness as he knew from Lippi's painting, but she has now become a sensible and concerned companion to her mate.

Close in spirit to Desiderio's relief is the painting by Sellaio to which we have referred before. Here the lion, standing under the Cross, is facing the beholder, while the lioness resting full length on her haunches to the left of the lion looks like a permanent addition to St Jerome's desert establishment. One can have little doubt that this expansion was derived from Desiderio's relief. A similar expansion is to be found in a marble relief attributed to Antonio Rossellino[43] and apparently well known in its time. This is attested by the fact that it served as a model for a glazed relief of the Robbia workshop but, interestingly enough, the lioness, who in the marble advisedly appeared in the middle ground, was omitted.[44] Finally, there is in the Uffizi a drawing attributed to Antonio Pollaiuolo, of which a rather rare engraving exists,[45] showing a Leonardesque, beardless St Jerome kneeling before the Cross in a wide landscape, and in the foreground next to him there is another strange expansion of the lion theme: a lion is shown attacking a lioness, and further in front there is a second lioness resting.[46] This accretion to the lion theme had, of course, no future and, as far as I can see, remained entirely isolated.

Scholars have often remarked on the landscape background in Desiderio's relief, usually, however, without differentiating clearly between the relief method as such and the individual motifs used in the landscape. The method of the *rilievo stiacciato*, the low relief that yet takes the eye back into perspective-pictorial space, layer after layer, clearly derives from Donatello's work of the 1420s and 1430s. No one will want to object to Seymour's recurrent insistence on this fact.[47] But it does not seem permissible to proceed, as Seymour attempts to do, from there to an early dating of the relief, for whether one dates it in the early 1450s or the early 1460s, this type of the pictorial low relief was then, in any case, rather antiquated and must be regarded as a revival, possibly requested by the patron. By contrast to the relief method scarcely any of the details used in the landscape are reminiscent of Donatello.[48] These details take us close to Desiderio's own time.

First one must mention the trees: there are two perspectively receding lines of cypresses in the relief, one on the left and the other much farther back on the right, and, in addition, there is above or rather behind the acolyte a high, strangely clipped tree. Very similar rows of cypresses are common in Gozzoli's frescoes in the Chapel of the Palazzo Medici-Riccardi and there, too, are trees with branches and leaves transformed by the art of topiary into a succession of circular discs diminishing toward the top. The frescoes were commissioned in mid-1459 and finished in 1461. Despite their conservatism, many artists were fascinated by them and I have no doubt that it was in this chapel that Desiderio learned his lesson. It would also seem that the recurrence of the clipped trees in the works of Sellaio, Perugino and other late 15th-century artists goes back to Gozzoli. But it is worth mentioning that such clipped trees – often probably representing the holm oak (*quercus ilex*)[49] – may have been fashionable at that time. The fashion persisted and even nowadays one encounters in Italy holm oaks clipped precisely as we see them in Quattrocento pictures.

A consideration of the rock formation leads to similar results. The high rock, suggesting stony desert, towering behind St Jerome almost in the shape of a pyramid is reminiscent of

191 Clipped trees, from Gozzoli's fresco in the Palazzo Medici-Riccardi, Florence

192 Clipped holm oaks in Tuscany today

Ghiberti's pyramidal Ark in the *Porta del Paradiso* relief. This similarity strengthens our impression that Desiderio had been deeply moved in his youth by Ghiberti's work. But the studied rendering of the rock had another source. Once again we have to turn to Gozzoli. Similar chiseled rock formations are to be found in the Medici Palace frescoes. Normally, the cave in St Jerome in the desert paintings is built up of roughly vertically placed rocks. Desiderio's piece has no cave and the rock behind St Jerome is structured horizontally. There is no need to make a detailed description, but I think a passing reference should be made to the placing of large slabs of stone, one above the other, particularly above the saint's head. Now, the rock formations in Filippo Lippi's Altenburg *St Jerome* are extraordinarily close to Desiderio's: here, too, is to be found a piling up of horizontal slabs. The inspiration that Desiderio drew from Gozzoli and Filippo Lippi and, specifically, from the Altenburg painting cannot be in doubt.[50]

On the basis of all the considerations here submitted we have to conclude that Desiderio cannot have done his relief before the mid-1450s and not before 1461 if the impact of the Gozzoli frescoes in the Palazzo Medici-Riccardi be admitted as I think it must. Moreover, the iconographic oddities of the relief, though not isolated within the contemporary Florentine ambience, suggest that Desiderio may have responded to advice given by his patron.

The Hall version

In the course of the foregoing long exposition the reader has had ample opportunity to study the illustrations of the Hall version of the relief. The similarities between the two pieces go far beyond those often encountered between original and copy. If the two photographs shown (Pl. 169 and 170) are placed one over the other, they match entirely, but when seen together, the reliefs seem to show slight differences. The Hall relief is actually a trifle larger than the National Gallery piece: the length of the latter, omitting the carved 'frame,' is 51·20 cm as against 51·30 cm of the Hall version.[51] Some internal measurements taken at random with large calipers on the originals also reveal tiny differences; e.g., the diagonal from the top of the tallest cypress on the left to the acolyte's big toe on the right below measures 56·80 cm in the National Gallery relief and 57·00 cm in the Hall version. Despite the care that was taken over controlling such measurements I would not like to draw any conclusions from them either one way or another at this time, for the differences are so small (one is concerned with millimetres rather than centimetres) that a margin of error cannot be excluded. If it be then agreed that to all intents and purposes the two reliefs correspond, and correspond not only in size, but also in technical handling as well as the design down to the minutest details – what is the explanation? Before attempting an answer to this important question, a few words about the condition of the Hall version are in order.

The whitish or rather light grey surface of the Hall version reveals very little discolouration, as opposed to the brownish patina of the Gallery piece that adds to its seductive surface quality (see above, p. 138).

A study of the backs of both reliefs clearly shows that they are both of white marble of the same colour, and according to a cursory investigation by a marble specialist they might well come from the same Carrara quarry.[52]

The surface of the Hall version has also suffered. An overall polish on the high points may be noted, but much worse, in the right lower half of the relief, especially between the saint and the acolyte and extending to the hair, ear and halo of St Jerome, there have been rust stains; they have been treated (probably not too long ago) with some acid with a disastrous effect, for in some areas, easily visible in the illustrations, the surface has been badly pitted through erosion. In spite of this regrettable attempt at cleaning, in most parts the Hall relief has more detail than the National Gallery piece. 193, A comparison, especially of the head and body 194 of Christ and the mane of the lion, makes this immediately clear.

The question, therefore, arises whether the 171 plaster cast known to us through the Brogi photograph was made after the Hall version rather than after the one at the Gallery or, conversely, whether the Hall version is a fairly modern marble reproduction after the plaster cast. The answer to both alternatives has to be negative. Even though one may not want to put too much reliance on the caption of the Brogi photograph, the location 'Pietroburgo' carries some weight; but I think one has to regard the connection between the Gallery version and the cast as inescapable, because Bode obviously took it for granted that the cast had been made after the Liphardt relief. On the other hand, there are no indications whatsoever that the Hall version is a mechanical marble reproduction based on the cast. On the contrary, a careful study of it confirms one's conviction that it is a second contemporary version coming from the same workshop as the relief in the National Gallery.

Even if we grant the Quattrocento sculptor a degree of skill and precision superior to what is thought possible today, two such absolutely identical pieces cannot have been executed without some mechanical aid. Reliable terracotta reproductions of a key marble could always be made from moulds. But in order to copy a marble sculpture in marble we would imagine that modern pointing machines were

necessary. If I am correct in postulating that both pieces were contemporaneous and were executed in the same workshop, the question of procedure has to be answered. The answer lies, I believe, with the recommendations made by Leon Battista Alberti.

In his brief treatise De statua, written, as we now know, in the early 1430s rather than in the 1460s as previously assumed, Alberti was largely concerned with the problem of mechanical methods of reproduction.[53] This is not the place to follow Alberti in detail. Briefly, he discussed on the one hand most detailed measurements of average bodies and on the other explained the construction and use of the simple tools of his invention which would ensure absolute precision in copying. While art historians have lavished their attention on Alberti's De pittura and its effect on Quattrocento practice in painting, they have not, to my knowledge, investigated the impact Alberti's De statua had on sculptors. It seems likely that some advanced sculptors, who accepted Alberti's deep-rooted belief in the scientific foundation of art, would have experimented with his recommendations and possibly have used them as starting points for further explorations. Unfortunately, the next treatise on scupture, that by Pomponio Gaurico, published in 1504, is silent on this point. But Gaurico, a distinguished humanist, was not interested in deliberations of this kind.[54]

One has to consider the problem opened up by Alberti as one of the greatest importance. When we know more about mechanical processes used in the Quattrocento, we will also understand how a duplication such as that of the St Jerome relief and of other similar instances was accomplished. At this time I can only submit the problem without being able to pursue it. In our special case I believe that Desiderio made a terracotta or wax model that served him and his assistants, perhaps his sculptor brothers, working side by side. It would be difficult to decide at this point in time which of the two versions was di sua mano. It is the burden of my argument that when the two reliefs left the workshop, both showing the precision now only available in the old photograph of the cast, two patrons were convinced of having been equally well served by the sculptor.

193 Crucifix and lion, detail from the National
Gallery relief

194 Crucifix and lion, detail from the Hall relief

195 RAPHAEL. *Crucified Christ and Saints* (London, National Gallery)

VII
THE YOUNG RAPHAEL

LIKE MOZART, Raphael was taken from this world in the prime of his youth. He was born at Urbino 6 April 1483 and died exactly 37 years later, on 6 April 1520. Thus he lived two years longer than Mozart. Both masters compressed into their brief lives the herculean work of several long life spans; both produced with incredible ease; both delighted succeeding generations by the grace and harmony of their creations; and both had an immeasurable influence upon their art. But while at eighteen Mozart was hailed as 'the greatest composer that ever lived,' no such assertion could have been made about Raphael as painter at the same age. It is the mystery of the earliest Raphael that I would like to fathom now.

When the boy was eight, his mother died, on 7 October 1491.[1] His father, the painter Giovanni Santi, married again a few months after his wife's death. But his new happiness was of short duration: he died on 1 August 1494. Raphael's uncle, the priest Bartolomeo Santi, was appointed his guardian. He withheld the step-mother's inheritance; the matter was taken to court and on 17 June 1495 sentence was pronounced against the guardian. Nonetheless, litigation dragged on for almost five years. By that time the young Raphael was in his seventeenth year. We may never find out how much he suffered from the unsavoury conditions at home nor whether he stayed all these years in Urbino. It seems likely that he was in his native town in June 1499. The next surviving court document of 13 May 1500 talks of 'pro dicto Raphaele absente' – which may mean either that he did not appear in court or that he had left Urbino.[2]

In the 15th century and even much later children were apprenticed at a very early age. When his father died, Raphael was eleven-and-not-quite-four-months. In spite of his youth he would have been in his father's workshop for some time, learning, as was the custom, technical processes such as preparing and mixing the colours and priming the panels, as well as picking up the rudiments of his art.

Vasari mentions in the first edition of his work, published in 1550, that Raphael as a child helped his father to the best of his ability.[3] In the revised second edition of 1568 he is more assertive: Raphael as a boy assisted his father greatly with many of his works.[4] This change was, of course, dictated by the familiar image of the child prodigy whose genius becomes evident when other children are mere toddlers. Moreover, Vasari continues, the loving father soon discovered that the boy could no longer profit in the paternal workshop. So he decided to apprentice his son to Perugino, travelled over to Perugia and made the necessary arrangements; and when the child left Urbino for Perugia, his affectionate mother shed many tears. If Vasari was correct, this event took place before the boy was eight, and at that age the child would not only have had a number of works to his credit as his father's assistant, but would also have outgrown the father's art! Under Perugino's guidance – Vasari assures us – the young Raphael soon acquired such skill that it was impossible to discern between the master's and the pupil's works.

Although this account of Raphael's beginnings is notoriously legendary, we should not forget that Vasari was excellently informed about the great master by assistants and pupils of his Roman years, and even for the pre-Roman Florentine period Vasari had two reliable witnesses in his friends Aristotele da Sangallo and Ridolfo Ghirlandaio, who were associated with Raphael in those early days after 1504. It may be unjust to attribute the typical traits of

196 RAPHAEL. *The Crowning of St Nicholas of Tolentino* (Naples, Museo di Capodimonte), fragment

1500, the first of his work contracts of which we have knowledge. It is the contract for the *Crowning of St Nicholas of Tolentino* in S. Agostino at Città di Castello.[7]

Unfortunately, only a few fragments of this key work survive, namely God the Father and part of the Virgin, now in the Museum at Naples, and the bust of an angel in the Museum at Brescia.[8] But a partial copy at Città di Castello and a few original drawings – one for the whole composition in the Musée Wicar at Lille – allow us to reconstruct the original appearance of the work. Broadly speaking, the style of these fragments is Peruginesque, and it is characteristic, that, until the connection with the Città di Castello altarpiece was discovered, the Angel at Brescia was always attributed to Timoteo Viti, a minor Umbrian artist under Perugino's strong influence. Although the fragments of this picture together with the preparatory drawings are of inestimable value for our knowledge of the young artist, at a first glance the mystery of his earliest years seems to become even greater. How was it possible that a seventeen-year-old artist without a now clearly recognizable past was commissioned to paint an important altarpiece over ten feet high?

Before I attempt to answer this question, I have to mention that the contract names, next to Raphael, a second artist, Evangelista di Pian di Meleto. Meticulous research has brought to light some facts about him.[9] At the time of Giovanni Santi's death, he had been an assistant in the workshop for over ten years. Around 1500 he was quite well off and owned, among other things, some real estate. Later, certainly from 1515 on, and possibly since 1502, he had a common workshop with Timoteo Viti, who died in 1523. Evangelista died in 1549 as an old man. Although we have no certain idea of him as an artist,[10] his satisfactory economic position as well as his association with Timoteo Viti indicate that he must have enjoyed a considerable reputation in his time.

More than sixty years ago, a distinguished scholar, Georg Gronau, suggested that Evangelista set up workshop with Viti immediately after Giovanni Santi's death and that the young Raphael joined this workshop as apprentice.[11] Some critics accepted this unproved hypothesis.[12] Others, and among them such a great Raphael scholar as Oskar Fischel, brushed the

hero-worship to Vasari's inventiveness, for the tale of Raphael's prodigious feats as a child was probably circulated in Roman studios. In any case, a story essentially corresponding to Vasari's was printed as early as 1549 (i.e., twenty-nine years after Raphael's death) in Simone Fornari's Commentary on Ariosto's *Orlando Furioso*.[5]

Where the legend originated, we shall never discover. One is reminded that sometimes precocious artists helped to create the aura surrounding their childhood. Bernini for instance maintained that he had made a relief portrait of his father at the age of six and that a year later he had astonished Pope Paul V by his accomplished draughtsmanship.[6]

What do we know *for certain* about Raphael's activity between his early childhood and his seventeenth year, that is, before 1500? The answer is: nothing, absolutely nothing. The veil is lifted for us by a document of 10 December

Evangelista-Viti hypothesis aside. Fischel, in fact, strangely vacillated in his views. He maintained, almost in the same sentence, that 'Raphael came to maturity, as an artist, under the influence of his father' (i.e., you recall, before the age of eleven), that the father committed the son to the charge of Perugino, and that it is almost a matter of indifference whether this happened or not.[13] Some older scholars, among them Passavant (author of the first fundamental Raphael monograph) and the great Cavalcaselle, compromised by letting Raphael go to Perugia after his father's death, in 1495. This view was backed by Roberto Longhi's authority in a paper in *Paragone* in 1955,[14] while, like others before him, Sidney Freedberg in his detailed study of the High Renaissance,[15] published in 1961, dates Raphael's apprenticeship in Perugino's studio between 1500 and 1504.

The reason for such contrasting views, I submit, must be sought in Raphael himself rather than in the faulty research of scholars (indeed, the scholars left no stone unturned in their attempt to throw light on Raphael's earliest period). In the face of so much uncertainty the monumental Città di Castello commission would seem to offer a real puzzle. Strangely enough, however, nobody has expressed any astonishment about it, because projecting back from our knowledge of the later Raphael we tend to assume that the young one was given unlimited opportunities.

For an explanation of the commission let me suggest the following hypothesis. The fact that Raphael and Evangelista appear as collaborators in the contract indicates that they were regarded as a team. One is led to believe that even after Giovanni Santi's death Evangelista remained in his former employer's workshop, which was well established and worth maintaining for the sake of the son. This conclusion is corroborated by a telling piece of evidence: in the contract Raphael's name appears first and, in spite of his youth, it is he and not the much older Evangelista who is called 'magister.' *Magister*, or master, was the designation for the head of a workshop. Now Raphael was the legal heir to his father's business, and it must be for this reason that he rather than Evangelista is called 'master'.

If this simple logic would seem acceptable to you, we may be a step nearer the truth: the

commission was given to an old and reputable firm in the neighbouring Urbino rather than to an unknown lad of seventeen. But was the lad really so unknown? We can perhaps shed light on this question after having scrutinized events following the St Nicholas commission.

The *Crowning of St Nicholas of Tolentino* was finished before 13 September 1501, the date of the final payment.[16] The next certain date refers to the *Crucified Christ and Saints*, now in the National Gallery, London, painted for the Gavari altar in S. Domenico at Città di Castello. Raphael placed his signature at the bottom of the Cross, and the inscription still existing above the Gavari altar mentions the year 1503 for the completion of the work.[17] Once again, this is a large altarpiece, almost ten feet high, and Raphael alone, without a collaborator, was responsible for it. Surely, the *St Nicholas* altarpiece had established his reputation at Città di Castello. It may be that the proud signature, his first so far as we know, points to the discontinuance of the paternal workshop with its tradition of anonymity.[18] A year later he finished the famous *Sposalizio* for S. Francesco at Città di Castello, now in the Brera in Milan, a painting almost six feet high, with many figures. He signed and dated it: 'Raphael Urbinas 1504.'

A pattern seems to be visible. Raphael's first three documented paintings were executed for churches in Città di Castello: the first one, in collaboration with an older colleague, made him known so that other patrons in the same town sought his services. Considering the size of these three panels, one tends to conclude that Raphael did not handle other large commissions during these years; that, in other words, he must have spent much of his time between 1500 and 1504 in Città di Castello, for when the *St Nicholas* was finished in September 1501, he soon began the *Crucified Christ and Saints* for S. Domenico, and when this was finished in 1503, he began the *Sposalizio* for S. Francesco.

Now I think it is not fortuitous that Vasari enumerates these three works in their correct chronological sequence;[19] furthermore he appropriately remarks that both the *St Nicholas* and the Crucifixion are painted in the manner of Perugino, and he adds that everyone would attribute the Crucifixion to Perugino if it had not Raphael's signature. Finally, he declares that in the *Sposalizio* Raphael transcended the

196

195

197

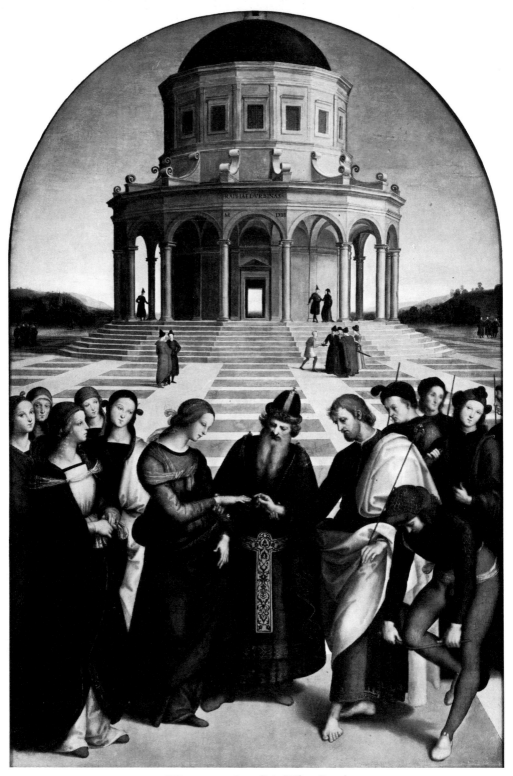

197 RAPHAEL. *Sposalizio* (Milan, Brera)

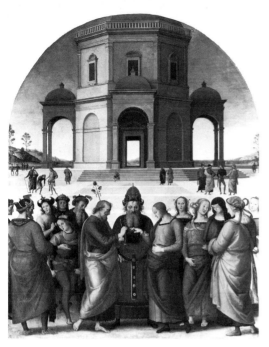

198 PERUGINO. *Sposalizio* (Caen, Musée des Beaux-Arts)

199 RAPHAEL. *Coronation of the Virgin* (Rome, Vatican Gallery)

200 PERUGINO. *Ascension of Christ* (Lyons, Musée des Beaux-Arts)

manner of Perugino. A comparison with Perugino's *Sposalizio* painted for the Cathedral at Perugia almost exactly at the same time as Raphael's, proves that Vasari knew what he was talking about for, despite the closeness of the two pictures, Raphael's is distinguished by psychological and compositional differentiation and by a new sense for the organic and rhythmic quality of the bodies. All this shows what a well-informed and shrewd observer Vasari was.

May we then also accept Vasari's guidance[20] in dating the *Coronation of the Virgin*, now in the Vatican Pinacoteca, *before* the *St Nicholas*? This large painting (it is nine feet high) with many figures was commissioned by Alessandra di Simone degli Oddi for S. Francesco at Perugia. Once again, Vasari tells us that, while the picture is undoubtedly by Raphael's hand, those without training in connoisseurship would firmly believe it to be by Perugino.

It is usually argued that since the Oddi, Perugia's leading family, were exiled after the fall of Cesare Borgia in August 1503, the painting must be dated in that year.[21] The logic is not entirely convincing. If Vasari is right, this

155

picture would have been painted before 10 December 1500, the date of contract for the *St Nicholas*. At the risk of being slaughtered by my colleagues, I want to proclaim that Vasari's chronology is correct. The *Coronation* is firmly linked by a thousand ties to Perugino's work of the late 1490s and so are the panels of the predella, which are always regarded as particularly progressive.[22]

All the works by Raphael you have seen so far bear the stamp of the same style. They were created within a clearly circumscribed tradition of the Umbrian landscape, and, more than that, they are so close to Perugino, they show such a familiarity with Perugino's stylistic idiosyncrasies, that Raphael must have had a period of training in Perugino's immediate orbit. To this extent Vasari was surely correct. In view of Perugino's own itinerary – he was at Perugia only part of the years 1495 and 1496 and absent almost throughout 1497 and 1498 – one cannot see how Raphael could have joined him before 1499.[23] Once Raphael had appeared at Città di Castello at the end of the 1500 as *magister*, one wonders whether he had time and inclination to return to Perugino intermittently as a studio hand during the next few years. This also appears unlikely in view of the fact that by 1503 Raphael had a reputation as a master in his own right not only in Città di Castello but also in Perugia. When in that year the abbess of the Monteluce convent outside Perugia looked for the best artist to paint a *Coronation of the Virgin* for her church, a number of citizens as well as the reverend fathers, who had seen Raphael's work, nominated him for the job.[24] Two years later, on 12 December 1505, a contract was drawn up, but Raphael had no time then to execute the work.

Such considerations lead me to assume that Raphael joined Perugino some time in 1499. Having been reared in a Peruginesque tradition, the leading Umbrian style, he rapidly assimilated the master's manner. Early in 1500, when Raphael was just seventeen, Perugino would have recommended him for the *Coronation of the Virgin* for S. Francesco, painted under the master's eyes. This large commission seems to have had repercussions and contributed to the first Città di Castello commission.

However you may date the *Coronation*, it remains certain that in the brief span between

1500 and 1504 Raphael painted four large altarpieces, three of which are documented and the fourth attributed to him by a never-challenged tradition. An artist who was capable of such a performance between his seventeenth and his twenty-first year must have painted more and possibly much more during the same years – this is everybody's silent argument – and he must also have painted before 1500, for he cannot have risen like a phoenix from the ashes. So art historians have enriched his early years by attributions sometimes of doubtful validity. We have seen that they believed that Raphael worked in Perugino's studio either between 1495 and 1500 or between 1500 and 1504. Although the first assumption is unlikely and the second impossible, they have examined carefully and with the methods of modern criticism Perugino's work of the decade 1495 to 1504 for traces of the young genius.

Towards the middle of the 1490s Perugino's style broadened, became more Classical and, at the same time, more sensitive; for less than ten years he remained at the height of his power. Thereafter a rapid decline and petrification set in. No wonder that some art historians regarded Raphael as the moving spirit behind Perugino's best period. Others discovered Raphael's hand in a number of his master's works. Nobody went further than Adolfo Venturi, who, in his book on Raphael and subsequently in his *Storia dell'arte italiana* states with assurance that the entire wall with the Prophets and Sibyls in the Cambio – the old stock-exchange at Perugia with Perugino's most ambitious fresco cycle – was painted by Raphael at the end of 1504.[25]

Although Raphael must have assisted Perugino (if I am right, mainly in 1499), the truth of the matter seems to be that it is difficult if not impossible to come to an agreement regarding the extent of his collaboration in Perugino's pictures.[26] And this for the simple reason that the style of the early Raphael before and after his entry into Perugino's studio conformed to a remarkable extent to that of the ambience in which he worked. Raphael grew up in a provincial atmosphere where, true to medieval workshop practices, little room was left for the assertion of individuality.[27]

In support of this view I may also quote Raphael's early drawings. Preliminary drawings survive for the three documented altarpieces

painted at Città di Castello as well as for the *Coronation of the Virgin*.[28] But there are neither drawings by Raphael connected with any of Perugino's works, nor drawings for any picture before 1500.[29] This may be purely accidental; on the other hand, it may reflect the fact that Raphael's art did not emerge from anonymity until the turn of the century. Even the portrait drawing at Oxford, which was usually regarded as a self-portrait of the boy at the age of fourteen or fifteen, has more recently been dated around 1504.[30] A claim is now made for a drawing in the British Museum[31] as being a self-portrait of *c.* 1500.

Before stating my conclusions, let me rapidly fill in Raphael's activity between 1504 and 1507: i.e., between his twenty-first and twenty-fourth year. According to Vasari, Raphael, after having finished the *Sposalizio*, joined his friend Pinturicchio at Siena, in order to help him with the great cycle of frescoes in the newly erected library of the Cathedral.[32] I cannot go into this episode and would only mention that most modern critics reject Vasari's story – unjustly, in my view.

Vasari informs us that after the Sienese intermezzo Raphael went to Florence. We have questionable evidence (in a letter of dubious authenticity)[33] that he arrived there late in 1504. In the following four years, before his permanent transfer to Rome, he paid extended visits mainly to Perugia, and he also returned to Urbino, but much of his time, though probably less than is generally assumed, he must have spent in Florence. In any case, his large works of these years were almost without exception created outside Florence: in 1505 he began the fresco of the *Trinity* in S. Severo at Perugia, but probably finished it a couple of years later. In the same year, 1505 rather than 1506, he painted an altarpiece with the Virgin and Saints for the Ansidei chapel in S. Fiorenza at Perugia, now in the National Gallery, London. The work is signed and dated, but the reading of the date is not unequivocal. Shortly afterwards he was engaged on the large altarpiece for S. Antonio at Perugia, now in the Metropolitan Museum. Finally, in 1507 he finished the signed and dated *Entombment* for S. Francesco at Perugia, now in the Borghese Gallery.

These works provide increasing evidence of a change of style, a change best studied in the long series of Virgins and Holy Families which are the greatest glory of the so-called Florentine years. Since the demonstration of this change is deservedly a cherished classroom exercise, I need not repeat it here. Suffice it to say that Raphael (twenty-one at his arrival in Florence) saw a new world opening before him.

He came at the most stirring moment of Florentine artistic history: when Leonardo and Michelangelo competed with their battle cartoons in the Palazzo Vecchio, when Leonardo's *St Anne* cartoon and the *Mona Lisa*, Michelangelo's *David* and *Doni* tondo, and Fra Bartolomeo's *Last Judgment* in S. Marco, established the canons of the great Classical style which we call the High Renaissance. Raphael capitulated before the irresistible fascination of this experience. He scrapped what he had learned and accepted wholeheartedly the new mode of expression.

If, of Raphael's *oeuvre*, only the *Madonna Solly* in Berlin (traditionally ascribed to Raphael and never doubted) and the *Virgin with the Goldfinch* in the Uffizi had survived, and there were no literary tradition or name, no art historian would dare to ascribe these two works to the same master, and a student bold enough to maintain that they were painted by the same hand less than four years apart (as they probably were), would never pass his examination. At the time of the *Virgin with the Goldfinch*[34] Raphael was twenty-three. Two years later, after his settling in Rome, his style went through another profound metamorphosis: it now acquired dramatic density and monumentality. The artist of the *Madonna della Tenda*, now in Munich, seems to have little in common with the artist of the *Virgin with the Goldfinch*; and if you look at the *Madonna Solly* and the *Madonna della Tenda* side by side, the twelve or thirteen years separating them seem to be eons.

These observations have led us to one of the most interesting phenomena of the entire history of art: the wish and capacity of an artist to change his style radically. To us this phenomenon does not appear strange. We are used to granting artists the freedom of stylistic choice and we find nothing remarkable in the fact that pictures by Picasso of 1904 and 1908 are so far apart that only fore- or hind-knowledge of the facts can see them as emanat-

201

202

157

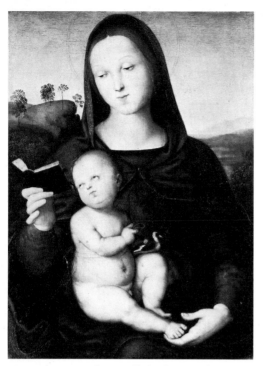

201 RAPHAEL. *Madonna Solly* (Berlin, Staatliche Museen)

ing from the same hand. Nor are we astonished about the breathtaking rapidity of stylistic changes. But we must not forget that the will to choose freely among stylistic possibilities and the capacity of rapid change did not always exist.[35] In fact, I believe that Raphael is the first illustrious case.

For medieval artists the road to eminence lay in the closest possible imitation of one master. This was part and parcel of the medieval workshop practice and was also propagated as the only correct course of study. Cennini,[36] in his late medieval manual written in Florence after 1400, warns apprentices against imitating many masters, and advises them to follow one master only in order to acquire a good style. At the end of the century Leonardo reversed this position. A painter, in his view, should not attempt to imitate another painter's manner. This, surely, is a telling pointer to a fundamental re-orientation of the artist's profession. We are right in talking of the emancipation of the Renaissance artist: he exchanged the comparative restriction of a guild-controlled manual

occupation for the freedom of a self-controlled intellectual profession. When Raphael breathed the air of Florence, he abandoned what were essentially late medieval provincial conventions and responded wholeheartedly to the new metropolitan standards.

This miracle of transformation happened when he was twenty-one. A man emerged who discovered within himself infinite possibilities which he pursued with unbounded self-confidence. Few art historians were and are prepared to acknowledge the depth of this transformation. So far as I can see, only Heinrich Woelfflin saw it without any blinkers. 'It is likely', he wrote in his *Classical Art*,[7] 'that never again a talented pupil absorbed the manner of his teacher to the extent Raphael did Perugino's. ... In his beginnings he cannot be separated from Perugino. ... He comes to Florence ... he discards the Umbrian tradition and surrenders entirely to the Florentine situation.'

In approaching the work and development of an artist (and I do not mean Raphael only) we usually operate with terms of reference which have their own life and history. Such 16th-century writers as Fornari, Vasari and Borghini[38] found it praiseworthy and a sign of particular talent that the young Raphael was capable, within a very short time, of imitating Perugino's manner to perfection. It is clear now that this assessment had its roots in medieval workshop traditions. Modern art historians, by contrast, obsessed by the concept of originality, search Raphael's *juvenilia* tenaciously for traits of his genius; imitation, and perfect imitation at that, can, in their view, be a sign only of mediocrity, never of strength. Such ideas begin to be discernible in the 18th century, when the modern conception of genius arose, and are first vigorously expressed in the critical writings of the Romantic era.

Vasari, of course, had to account for Raphael's change of style, ensuing greatness and universality. He reasoned that Raphael studied the works of the ancient and modern masters and that he took the best from them. In this way he superseded them all.[39] The concept of selection from many masters in order to achieve perfection was ultimately derived from the often repeated legend, known through Pliny, of the Greek painter Zeuxis, who picked out the most beautiful parts from five Croton virgins

and combined them into the ideal beauty of Helen. By selecting the best from other artists rather than from nature, the element of style was introduced into the discussion, for the issue now centred in the union of the different manners of a number of artists. This theory, first applied by Vasari to Raphael, was current through the late 16th and the 17th centuries;[40] it was not until about 1800 that it was fastened upon the Carracci with the derogatory label 'eclecticism'.[41] The very method which Vasari regarded as style-forming and quality-enhancing appeared now to lead to the precisely opposite result.

The stigma of eclecticism that had perverted Vasari's concept of selection prevented modern art historians from taking Vasari seriously. True to their own terms of reference they approached Raphael with the premise that it must be possible to trace a structural unity through a great artist's work, from the very beginning to the end. It is silently taken for granted that this *Gestalt* unfolds as the artist matures and that it yields its secrets if only we try hard enough.[42]

Such metaphysical assumption was foreign to the older critics. And yet they laid the foundation for it. It was during the Renaissance that the notion of individual style was first grasped and savoured (Aretino speaks of the quietude which we experience when confronted with the qualities of the divine Raphael), that artistic talent was first regarded as a gift of God granted to the elect as a birthright, and that in this new context the mythic concept of 'the great artist in the child' became a biographic requisite.

Vasari was neither logical nor tainted by modern psychology; he was also too much down to earth to let the mythic framework overcloud the testable facts. Thus he sees the young Raphael's road to greatness in three stages: first, the supercession of the father by the child as a kind of mythical prelude to this extraordinary career; secondly, the stage of faithful imitation of Perugino; and thirdly, the stage of critical selection of style elements from the art of Raphael's great contemporaries.

Vasari's stages two and three spell out the visible facts. So far as we can check, Raphael's prodigious talent served him merely to conform until the age of twenty. If he had died in 1503, his name would not have survived. When fate

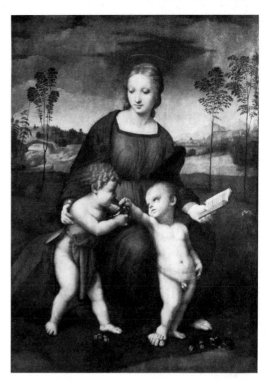

202 RAPHAEL. *Virgin with the Goldfinch* (Florence, Uffizi)

brought him into contact with the giants Leonardo and Michelangelo, he showed an uncommon ability to assimilate their manner within the shortest possible time. One who had a real insight – Michelangelo – wrote in 1542: 'All that Raphael knew in his art, he had from me,'[43] and according to Condivi Michelangelo repeated more than once that Raphael had his art not as a natural gift, but as the result of persistent study.[44] The implications of this comment seem to me obvious: Michelangelo thought that, when the provincial Peruginesque Raphael first arrived in Florence, he lacked what we would now call a personal style. Only then did studious application make of him what he became.

Surely, despite the tremendous ease of production which Raphael must have shown from earliest childhood, he was not a child prodigy like Mozart. It was only the last crowded twelve years of Raphael's brief life that brought unexpected fulfillment, to an extent never again experienced by an artist.

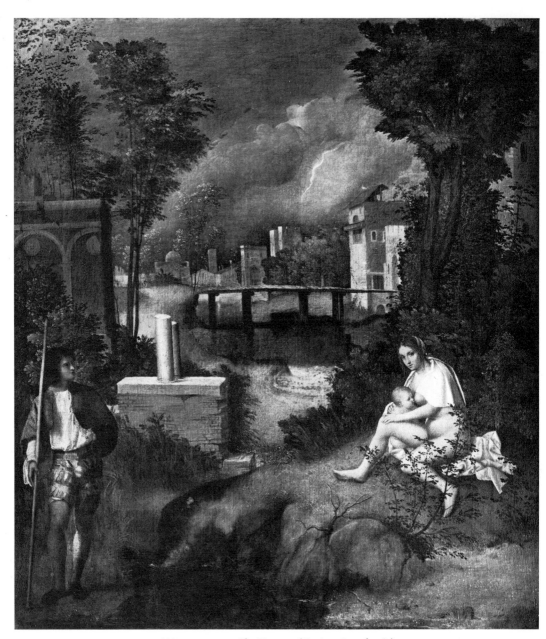

203 GIORGIONE. *The Tempest* (Venice, Accademia)

VIII
GIORGIONE AND ARCADY

WHEN ONE turns to the literature on Giorgione, one encounters the word 'mystery' with almost boring monotony. I do not want to be an exception to the rule and would like to begin with a mystery of the mysterious Giorgione, a mystery that is, however, so obvious that it has hardly ever been discussed.

I think it can generally be stated that the main body of the work of great masters is well defined, because their mode of perception is entirely unique. Doubts as to authorship arise only about their marginal, never about their focal creations. This is a fact silently and generally accepted as symptomatic of true greatness. Raphael, Michelangelo, Titian, Poussin, Rembrandt, Watteau and many others prove the point. Problems of authenticity grow in proportion to the limitation of talent. So far as I can see, Giorgione is the only exception.

Giorgione specialists belong to two hostile camps: those whom I want to call the 'pan-Giorgionists' attribute a large number of paintings to the master, while their opponents, the 'contractionists', limit his oeuvre to a very small number of pictures. However, with the exception of two works – the *Virgin with Saints*, which is still in the cathedral of Giorgione's native-town Castelfranco, and the *Tempest*, in the Accademia in Venice – there is no unanimity even among the contractionists. Doubts have been voiced about the *Three Philosophers* in Vienna, and the authorship of such exceptionally fine paintings as the Allendale *Adoration* (now in the National Gallery in Washington), the *Judith* in Leningrad, the *Self-portrait* in Brunswick, the Dresden *Venus* and the Louvre *Concert champêtre* has been shifted from artist to artist according to the predilection of the critic.

Normally, so much discord among experts would indicate that we are dealing with a weak artistic personality. However (and this is the mystery I have alluded to) the contrary is the case. Despite the problems offered by the majority of these works, Giorgione has always been unanimously acclaimed as one of the greatest Italian masters of all time and, paradoxically, *all* critics have always agreed to link a certain distinct and unmistakeable quality to his name.

It was precisely the originality of Giorgione's art that captivated the imagination of the many artists who worked in his orbit – so much so that their paintings often appear to be mere extensions of his. They sacrificed their individuality to the magic spell of his brush. It is for this reason that Giorgione's authentic works will forever remain problematical, and I need not take up a critical position here. If I see the problem correctly, all Giorgionesque paintings – originals, attributions, copies after lost works, imitations as well as pictures by followers and pupils – are of almost equal value for my particular enquiry.

My first point must obviously be to try and define the specific character of Giorgione's art. The technical side of this question offers no difficulties. In this respect agreement is complete, in spite of the different terminology used by the older and the more recent critics. If Vasari, the 16th-century biographer, talks of Giorgione's *morbidezza*, his 'softness', caused by his 'working directly with brush and paints without preliminary drawings' and of the *sfumato* in his shadows; if Ridolfi, the 17th-century biographer of Venetian artists, praises the *grazia* and *tenerezza* (the 'charm' and 'tenderness') of his colours, and Boschini, a 17th-century Venetian critic, 'the impasto of his soft brush' and the 'shading of outlines – so gradual that natural objects become dazzlingly

161

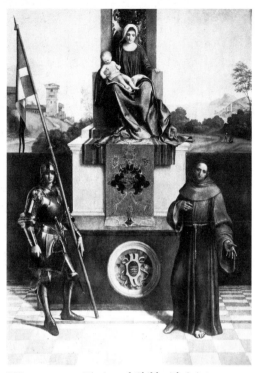

204 GIORGIONE. *Virgin and Child with Saints*
(Castelfranco, Cathedral)

colour.' Since Vasari made the ancient notion that art is concerned with the imitation of nature the focal point of his own theory of art, he regarded Giorgione's work as a brilliant moment on the road to the realization of this concept.

Following Vasari, 17th-century critics declared *mimesis*, the faithful imitation of nature, to be the purpose of art and consequently they too approached Giorgione's art from this point of view. Thus Ridolfi wrote in 1648: 'Surely Giorgione was, beyond any doubt, the first who showed the right path in painting, because his palette came closest to representing natural objects with ease.' Boschini expressed the same idea twice, even more forcefully, the first time in his famous *Carta del navigar pittoresco* of 1660, where he said that when Giorgione began to work:

> He filled with admiration every heart
> So much alive seemed Nature in his art.

Four years later he elaborated the same idea in the *Ricche minere della pittura veneziana* by declaring that Giorgione's mellow (*pastoso*) and easy manner 'must be regarded as true nature rather than pictorial fiction'. He ends with a typically 17th-century play upon words: Giorgione, he says, 'created such a congenial and lifelike harmony that one no longer knows whether Nature is Painting or Painting is Nature'. The concept of Giorgione's mastery over nature by means of his chromatic triumphs persisted far into the 18th century. All these writers regarded Giorgione's colourism as an expedient by which to achieve verisimilitude in painting.

Nowadays, the concept of *mimesis* as the true goal of art finds champions only among the lowest of the lowbrows. No modern art critic would want or dare to rise in the defence of *mimesis* and consequently Giorgione's art has never, in our time, been considered in this light. Once again, however, modern critics and historians seem to be in full agreement. The vocabulary used by them to characterize Giorgione's art is replete with analogous words such as 'lyrical', 'idyllic', 'union between nature and man', 'music', 'Virgil', 'Arcady', and so forth. None of these epithets appears in the writings of authors closer to Giorgione's own lifetime. Evidently, the older writers did not

true', they describe a phenomenon which a modern art historian, Giuseppe Fiocco, has expressed thus: 'Giorgione's name means the unreserved mastery of colour as an autonomous instrument of expression, it means pure painting.'

In other words, everyone agrees that Giorgione opened up a new dimension through his use of colour (and, implicitly, of light) and that he was, in a way, the first modern artist. Over sixty years ago Lionello Venturi aptly remarked that after Giorgione 'the submission of colour to tone values became part of the patrimony of European painting.'

Less unanimous are the opinions about the effect, the artistic result produced, or – if you like – the spirit revealed by Giorgione's new handling of paint. It is worthwhile to consider for a moment how the 16th and the 17th centuries interpreted his revolution. According to Vasari, the aim of Giorgione's innovation was 'to advance the rendering of living and natural objects and to portray them as best he could in

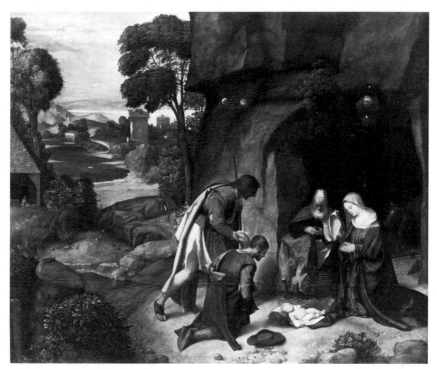

205 GIORGIONE. *Adoration of the Shepherds* (Washington, National Gallery of Art)

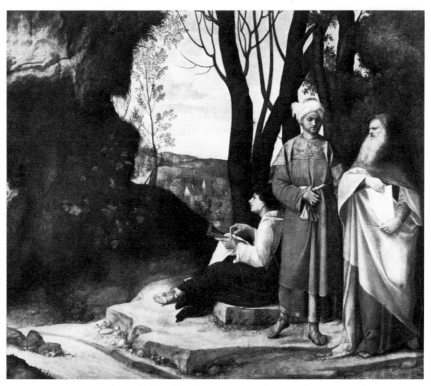

206 GIORGIONE. *The Three Philosophers* (Vienna, Kunsthistorisches Museum)

perceive the idyllic, poetic, Arcadian quality –
precisely that quality which we now regard as
the very essence of Giorgione's art. Both views
cannot be equally true. Either the concept of
mimesis of the older critics or the concept of
pastoral poetry of modern writers misses the
master's intentions.

Unfortunately, not a single direct statement
either by Giorgione himself or by any of his
contemporaries has come down to us which
would offer a definite clue. All the same, an
attempt can be made to reconstruct his ultimate
aims as well as the expectations of his patrons.

To this end we may first take a closer look at
the pedigree of the modern interpretation of
Giorgione. I think it was the Venetian Antonio
Maria Zanetti who in his fine work on Venetian
painting (*Della pittura veneziana*) of 1771 first
said that one of Giorgione's characteristics was
to have 'added to solid cognition the free play of
fantasy and imagination'. Autonomy of the
imagination is a typical concept of the second
half of the 18th century. Later it became part
and parcel of the Romantic vocabulary and from
there was taken over into modern art criticism.
Thus Lionello Venturi, in his basic book on
Giorgione published in 1913, and others talk of
the free rein the artist gave to his imagination.

The *l'art pour l'art* movement of the 19th
century characteristically modified the Roman-
tic image of Giorgione. One of the chief
leaders of that movement, Walter Pater, in
his famous paper on Giorgione published in
1873, formulated the principle: 'All art con-
stantly aspires towards the condition of music'
and explained that Giorgione 'is typical of that
aspiration of all the arts towards music –
towards the perfect identification of matter and
form.' Pater thus brought about the alliance
between Giorgione and music, and this alliance
has remained an inviolable axiom of writers on
Giorgione ever since. Moreover, the metaphori-
cal music in Giorgione's pictures was illogically
linked with Vasari's remark that the painter was
exceedingly fond of music.

Pater regarded art as pure form without
ulterior purpose and Giorgione's paintings
appeared to him 'morsels of actual life, con-
versation or music or play, but refined upon or
idealized, till they come to seem like glimpses of
life from afar'. With such sentences Pater
conjured up the Romantic idea of a purposeless,

arcadian and paradisiac art. In those same years
Crowe and Cavalcaselle talked of the soothing
character of Giorgione's landscapes and
Lermolieff remarked that 'his original and
immensely poetical genius radiates a light so
pure and . . . speaks to us with such force and
conviction that no one who has grasped it once
can ever forget it again'.

At this point we have to ask ourselves
whether the modern way of looking at
Giorgione's paintings and our own spontaneous
reaction to them (which is not so spontaneous
because it is derived, as we have seen, from
Romantic and late 19th-century ideas) reaches
out towards the essence of the master's art. To
answer this question I want first to call upon an
indirect witness, the Venetian nobleman and
humanist Marcantonio Michiel, who, shortly
after Giorgione's death, commented upon art
collections in Venice and on the *terra ferma*.
These well-known annotations are highly in-
teresting and fundamental for our knowledge of
Giorgione. Michiel's descriptions, though brief,
indicate sufficiently what it was that appeared
new and attractive at the time in the master's
paintings. He describes the *Three Philosophers*
as: 'The canvas in oil, representing three
Philosophers in a landscape, two of them
standing up and the other one seated, and
looking up at the light, with the rock so
wonderfully imitated.' The Dresden *Venus*, then
in the house of Messer Jeronimo Marcello, is
described as 'The canvas, representing Venus,
nude, sleeping in a landscape,' and the *Tempest*
as 'The little landscape on canvas, representing
stormy weather and a gipsy woman with a
soldier'. Despite their brevity these notes
indicate that Giorgione's skill of representing
nature and figures merging into it held the
attention of his contemporaries. This is also
supported by the fact that many major and
minor painters soon adopted – as I have
mentioned – not only Giorgione's colouristic
technique but also his way of saturating
landscape and figures with an all-pervading
spirit of tranquillity.

This last remark moves me to a general
observation. All modern beholders have reg-
istered similar reactions to Giorgione's imagery
(and we can now say that this must also have
been true to a certain extent of the con-
temporaries) because they are faced with a

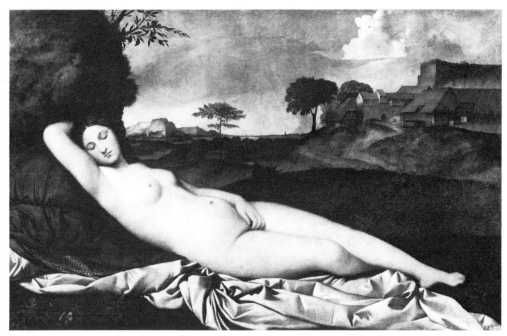

207 GIORGIONE. *Venus* (Dresden, Staatliche Kunstsammlungen, Gemäldegalerie Alte Meister)

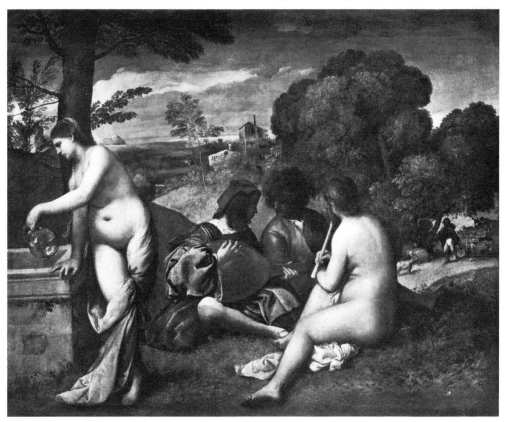

208 GIORGIONE. *Le Concert Champêtre* (Paris, Louvre)

phenomenon that has, I believe, a psychological basis of universal validity. The undulating forms in Giorgione's works, the warm and soft tone values, the sweet and gently swinging rhythms, the somewhat melancholic mood that pervades figures as well as landscape, combine to produce the impression of an ideal world – poetic, serene, and utterly peaceful.

In my view there is little doubt that writers of the 16th and 17th centuries were incapable of expressing this new phenomenon within the traditional categories of art theory. Only after the breakdown of these time-honoured concepts in the late 18th century could the Giorgione phenomenon be approached with a fresh and open mind. On the other hand, there is good reason to believe that the Venetian public was more enlightened and understanding than the critics who were fenced in by a theory.

We may now conclude that it was the writers of the Romantic period and of the 19th century who opened the way to an interpretation of Giorgione's art compatible with the visual evidence. Yet at the same time they introduced the problematic concept of the freedom of the artistic imagination, or rather of the imagination liberating itself from the fetters of tradition and the bondage of a narrative and allegorical art form. It seemed to them paradoxical that dreams, fantasies and painted music could be tied to traditional themes, to an intellectual discipline or to a prescribed programme. Thus the 19th century created its own image of a Giorgione reflecting the ideal of *l'art pour l'art*.

It was this position from which modern art historians set out, and from here they developed three different critical attitudes. Some accepted the 19th-century image of Giorgione without reservation. To prove the point, I shall quote a passage from a recent essay on Giorgione, published by Piero Fossi in 1957. 'Giorgione', the author says, 'breaks away from history and society – his poetic art stems from contemplation . . . from the harmony of the universe where the world of man is removed and freed from the bondage of social intercourse, the vicissitudes of passion and interests . . . in order to retire into a peaceful solitude and to live in harmony with the harmony of the universe. It is like a new Eden . . . where all breathes love and love is free of sin.'

Another group of Giorgione scholars rebelled against such a non-historical approach and went to the opposite extreme. They regarded Giorgione as an intellectual artist, guided by complicated thoughts. The name of the German Gustav Hartlaub deserves particular mention in this context. He suggested that Giorgione belonged to an humanist confraternity (an unproven hypothesis) and was mainly interested in representing esoteric subjects of an hermetic-alchemical nature. Rejecting Hartlaub's theory, the Italian historian Ferriguto tried to prove that Giorgione, a typical representative of the literary and philosophical trends of his time, set out to illustrate current intellectual concepts. But, adds another Italian, Stefanoni, who largely agrees with Ferriguto, Giorgione 'neither took over nor explored these concepts in their abstract, scientific-doctrinaire sense – he rather invested them with an illustrative-didactic character'.

These scholars saw the essence of Giorgione in the secret intellectual message which, in their opinion, he tried to convey. We are at the farthest remove from the *l'art pour l'art* interpretation. Whatever the merits of these studies, Ferriguto in particular reconstructed with great skill the circle of Giorgione's patrons among whom were such humanists, philosophers, writers and noblemen as Domenico Grimani, Geronimo Marcello, Gabriele Vendramin, and probably also Marcantonio Michiel, Aldus Manutius and, above all, the poetic Pietro Bembo.

A third group of art historians, greatly indebted to these studies, take up a position, as it were, half-way between the two other critical attitudes. They stress the autonomy of Giorgione's art without dissociating it from the intellectual ambience of Venice. Morassi, for example, after discussing the development of the new melodic music in Venice synthesized astutely that 'the entirety of those Venetian impressions, visual as well as musical, were the delicate threads which formed the weft of the cultural background against which the artist could develop the magic of his colour'. And later: 'The company of such men as Almoro Barbaro, Gerolamo Donato, and Giovanni Badoer, all steeped in philosophy and Classical studies, would also kindle the imagination of an artist like Giorgione.'

It is more than a hypothesis that Giorgione's patrons, accomplished humanists that they were, expected pictures from him which they would understand and which were in keeping with their own interests. It is also more than a hypothesis that Giorgione frequented the court of that fascinating lady, Caterina Cornaro, Queen of Cyprus, who resided at Asolo near Venice. Here, at this centre of modern literary movements, Pietro Bembo composed *Gli Asolani*, a book on the power of love, through which

> . . . with primeval beauty be renewed
> The Golden Age, the old beatitude.

This is a sentiment expressive of the new pastoral poetry. And so arises the view put forward by the modern scholars whom I am discussing that Giorgione's arcadian pictures are not – as the 19th-century writers wanted – vehicles of vague, indistinct and general notions about the harmony of the universe, but concrete expressions of the pastoral movement in Italian literature.

Thus, more than four hundred years after the artist's death, the way has been cleared, by trial and error, for an understanding of the true Giorgione. While this is, I believe, undeniable, Giorgione's specific position in relation to the arcadian movement has yet to be defined. This is what I now want to attempt to do.

The Middle Ages was heir to an old theory of history which was reconciled with the Biblical stories of the Paradise and the Fall of Man. This concept of history, first conceived by the Babylonians and masterfully formulated in early Greece by Hesiod in his *Works and Days*, saw the development of mankind as a progressively degenerating succession through Four Ages. It was, however, Ovid's Classical exposition of this theme that the Middle Ages and even the Renaissance accepted as Gospel truth. Thus one reads in the commentary to the *Metamorphoses* of the Venetian edition of 1552 that the Golden Age lasted from Adam to Noah, the Silver Age from Noah to Abraham, the Bronze Age from Abraham to the Birth of Christ, and the last one, the Iron Age, from the Birth of Christ to the present day.

This Ovidian theme pervaded the entire pictorial iconography of the Renaissance and even of later times. Though essentially pessimistic, the historical concept of the Four Ages contained the messianic promise of a new state of innocence, of universal felicity and rectitude, for the new millennium was prophesied in the *Book of Daniel*, in the fourth apocryphal *Book of Esdra* and elsewhere in the Bible as well as in Virgil's *Fourth Eclogue*, which exerted such immeasurable influence during the Middle Ages and the Renaissance.

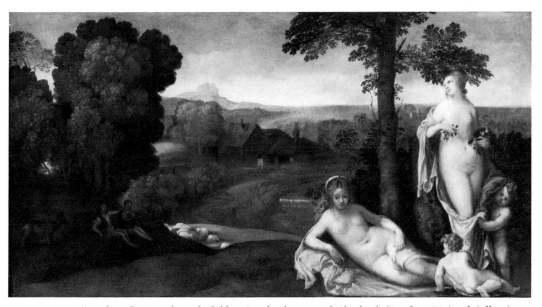

209 GIORGIONE (attributed). *Nymphs and Children in a landscape with Shepherds* (London, National Gallery)

Most surviving paintings of the *Four Ages* must be regarded as illustrations of Ovid's text, even if of the entire series of four only the Golden Age has been chosen for representation. This is not unusual, because the Golden Age denotes at once the glorious dawn of mankind and the expectation of bliss in the future.

In contrast to this trend, which always contains a didactic element, there exists another one leading to Giorgione. The Renaissance concept of a new Golden Age could be severed from its religious and messianic foundation and linked to the pastoral utopia of antiquity. We should not forget that the bucolic genre flourished in the 3rd century BC in the poetry of Theocritus, that Theocritus was much admired in the Renaissance and that one of the first editions of his works was published in Venice in 1495 by Aldus Manutius, who (as I have mentioned) was probably one of Giorgione's patrons. In addition, Virgil's *Eclogues*, based on Theocritus, were always known and venerated, even during the Middle Ages when they exercised a strong influence on allegorical pastoral poetry. Virgil was the first to place the realm of pastoral felicity in Arcady, a harsh mountainous province of Greece, while Ovid, in his *Fasti*, identified life in Arcady with the Golden Age.

This compound of poetic ideas fascinated scholars and writers of the Renaissance and paved the way for the rebirth of bucolic literature. Sannazzaro's *Arcadia*, written around 1480 but not published until the early years of the 16th century, inaugurated a veritable flood of bucolic poetry, and famous poets from Boiardo and Tasso to Molza contributed to the new genre. The fashion spread from Italy to other European countries where it was accepted with great enthusiasm.

Sannazzaro already made use of all the characteristic motifs of bucolic poetry: sincere love for simplicity and a guileless rural life; withdrawal from the superficial intellectualism of the cities; in addition, a vague nostalgia, an all-pervading, inexplicable yearning, an atmosphere of melancholy – pangs of love and death present even in Arcady.

The first one to translate bucolic dreams into reality was Lorenzo the Magnificent in his villa at Careggi near Florence. Politian, in his songs, likened the villa to Arcady and the group of friends who gathered there to arcadian shepherds. This was the ambience for which Signorelli painted his famous picture (destroyed during the last war) with Pan enthroned as ruler over Arcady and god of the herds, the nymphs, fauns, satyrs and shepherds. I do not intend to add to the numerous attempts at interpreting this emblematic masterpiece; I merely wish to draw attention to the peaceful atmosphere of melancholic dreams – befitting the arcadian state of mind – which pervades this work. One almost seems to hear the muffled sound of flutes filling the air with elegiac music.

It is important to realize that the arcadian spirit is here exclusively communicated by means of human figures. The arcadian landscape, described in bucolic poetry, is lacking. To provide it was the great contribution of

210 SIGNORELLI. *Pan* (formerly in the Kaiser-Friedrich-Museum, Berlin)

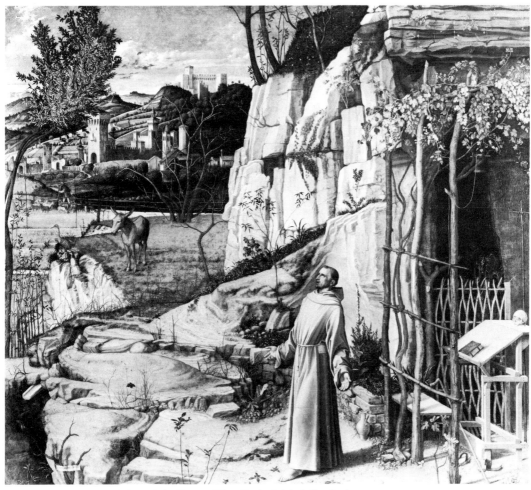

211 GIOVANNI BELLINI. *St Francis in Ecstasy* (New York, Frick Collection)

Giorgione. This was no easy task. Renaissance literature could draw on models from Classical poetry, but there were no pictorial representations extant which would have shown how the Ancients envisaged the realm of Pan.

In historical perspective it seems inevitable that the extraordinary step of translating the rural atmosphere of bucolic poetry into visual form was taken in Venice. Venice – home of strange visions such as the *Dream of Polifilo* and of exquisitely sensitive landscape painting in the circle of Giovanni Bellini, birthplace of an artistic spirit that was freer, more spontaneous and less intellectual than that of Florence (and which about the middle of the 16th century produced the sensuous and intuitive art criticism of such an individualist as Aretino) – was

the only place where Giorgione's arcadian art could have originated.

The arcadian atmosphere suggested by universally comprehensible stylistic elements had to be expressed by way of arcadian themes which should, moreover, please clients and patrons. Now it should be noticed that the majority of Giorgionesque paintings present little or no difficulty of interpretation. Giorgione and his followers chose easily understandable subjects, a fact which one tends to overlook on account of some few emblematic works. It so happens that three or four of his most important paintings (the *Tempest*, the *Three Philosophers*, the Louvre *Concert champêtre* and also the Dresden *Venus*) still present us with innumerable problems of interpretation.

169

212 GIORGIONE. *The Infant Moses* (Florence, Uffizi)

A word or two on Giorgione's handling of religious imagery may help to illuminate his approach to pagan themes. Paintings like the *Virgin* of Castelfranco, the *Judith* in Leningrad and the Washington *Adoration of the Shepherds* are perfectly simple from an iconographical point of view, even though they are painted in a new and personal style and although they display the new type of idyllic landscape. Only one among his religious pictures has puzzled beholders, namely the Uffizi painting with the infant Moses who is offered a pan with jewels and a fire-pan and chooses the latter. This strange subject illustrates a passage in the *Talmud*, but it appears also in Pietro Comestor's *Historia scholastica*, the most popular ecclesiastical history of the period with an enormous circulation and almost annual new editions between 1473 and 1526. Thus what strikes us as strange now was perfectly familiar to an educated Renaissance society.

Similarly, Giorgione's bucolic pictures illustrate subjects chosen from Ovid, Virgil, Plutarch and other Classical writers who were all well known to a wide public and who inspired artists throughout the Renaissance. We find such familiar subjects as *Leda and the Swan* (Padua), *Venus and Cupid* (Washington), *Apollo and Daphne* (certainly a school piece, Venice, Seminario Arcivescovile), the *Finding of Romulus and Remus* (Frankfurt), the *Rape of Europa* (lost, but known from an engraving by Teniers), and the *Judgment of Paris* (only known through later copies). In addition, I would like to mention the small canvas at Princeton of *Paris Abandoned on Mount Ida* (now generally regarded as an original) and the *Finding of Paris* (which is known only through copies). These two are less common themes, but their source is Hyginus's *Fables*, which were widely read during the Middle Ages and the Renaissance.

In all these cases the mythological theme lures us back into an enchanted world, when the gods and heroes of a remote past were dwellers on this earth, and we have reason to believe that the Venetian *cognoscenti* did not seek any hidden meaning in such pictures but enjoyed them for their direct and obvious message. We are far removed (as Giuseppe Fiocco once said) from the sphere of the traditional Renaissance allegory.

In support of my interpretation I would like to direct attention to the fact that contemporary

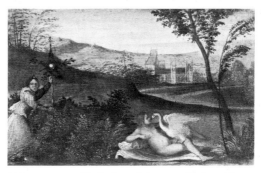

213 GIORGIONE (?). *Leda and the swan* (Padua, Museo Civico)

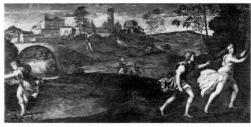

214 SCHOOL OF GIORGIONE. *Apollo and Daphne* (Venice, Seminario Arcivescovile)

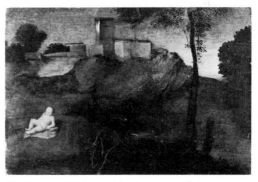

215 GIORGIONE. *Paris Abandoned on Mount Ida* (Princeton University, Art Museum)

pastoral poetry was illustrated in Giorgione's circle, and this probably happened much more often than we are aware of at present. As an example I mention the four small panels in the 216 London National Gallery, which were first published as by Giorgione, but are now more convincingly attributed to Previtale. The subject matter of these paintings seemed strangely insoluble until Professor Gombrich discovered that they are straightforward illustrations of the second *Eclogue* of the Ferrarese poet Tebaldeo, published in Venice in 1502 (as part of his *Poemi*

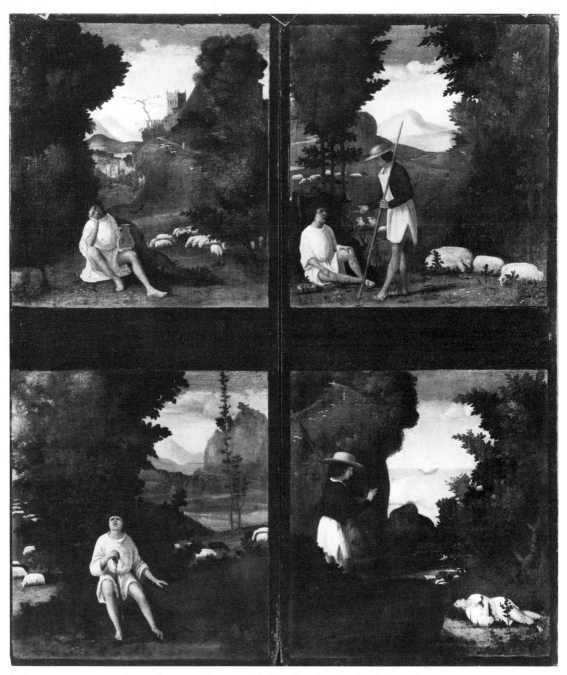

216 ANDREA PREVITALE. Scenes from an *Eclogue* of Tebaldeo (London, National Gallery)

volgari). Tebaldeo's bucolic poems were immensely popular and were sung everywhere and by everyone, so that such pictures, far from presenting any riddles, were understood and savoured by many people at a first glance.

There also exist a number of half-figures, painted by Giorgione and his followers which, so to speak, represent inhabitants of the arcadian world, such as the *Shepherd with Flute* at Hampton Court and Naples and the *Singer and Musician* in the Villa Borghese.

On the strength of all this material we may conclude that Giorgione, true artist that he was, endeavoured to resuscitate by purely visual means the various aspects of the arcadian world, that world of bliss tinged with sadness, dreamed about by the poets and the philosophers, the noblemen and the commoners of the Renaissance. It was the melancholic dream of a mundane Utopia, which has always haunted men crowded in large cities: a melancholic dream because it is spun around the unobtainable ideal of primeval happiness; a mundane Utopia because it holds out the promise of peace of mind in this world rather than in the hereafter.

Herein lies Giorgione's instantaneous triumph: the New Eden which he painted with his enticing brush was in complete accord with the spirit of his time, for he was able to give visual expression to the vague longings of his fellow-citizens. And it was precisely the mundane character of his paintings which secured him lasting success. Giorgione's true successor was Claude Lorraine who, with his bucolic landscapes peopled with the gods and heroes of antiquity, soothes the beholder into the peacefulness of Virgil's Golden Age. It is the spirit of Claude and, through him, of Giorgione, that found an unexpected realization in the English landscape garden of the 18th century.

In 1712, at the beginning of the movement, Addison wrote: 'You must know that I look upon the pleasure which we take in a garden as one of the most innocent delights in human life. ... It is naturally apt to fill the mind with calmness and tranquillity ... and suggests innumerable subjects for meditation'. It is this state of mind, I believe, that Giorgione and his followers tried to express in their paintings, and it was this state of mind that Giorgione's humanist patrons wanted to see made tangible.

217 GIORGIONE. *Shepherd with Flute* (Royal Collection, Hampton Court)

218 CLAUDE LORRAINE. *Juno confiding Io to the care of Argus* (Dublin, National Gallery of Ireland)

219 The garden of Stourhead, Wiltshire

IX
'SACRI MONTI'
IN THE ITALIAN ALPS

IN THE second half of the 15th century two young Milanese of noble family entered the Franciscan Order of Friars Minor: Bartolomeo Caimi, author of a number of learned theological books, an erudite man who never left his native land, and his kinsman or perhaps brother Bernardino, a great traveller, a man of action and the spoken word. The older encyclopedias usually devoted more space to Bartolomeo's achievements than to those of his relative. Yet Bernardino's life was infinitely more colourful; and while Bartolomeo's books moulder unread on the shelves of ancient libraries, the tangible result of Bernardino's energy, enthusiasm and persuasive sermons still casts a spell over vast numbers of the faithful. It was he who inaugurated one of the most extraordinary enterprises in the history of Catholic devotion and religious art, an enterprise rarely matched in its successful appeal to popular imagination and, at least until recently, its failure to attract the sophisticated or erudite traveller.

Fra Bernardino was born about the middle of the 15th century and died in 1509, according to the inscription on his tomb. In 1477 he was appointed one of the guardians of the Holy Sepulchre in Jerusalem, an office traditionally held by the Franciscans. On his return to Italy in 1478 he began to elaborate a great plan. During his stay in Palestine he had witnessed the results of the growing power of the Turks. Western trade in the East was rapidly crumbling and pilgrimages to the Holy Land had become more and more hazardous. In Europe popular religious fervour was increasing, encouraged by the Franciscans no less than by such newer foundations as the Windesheim Brothers of the Common Life. At the same time, the growing unrest caused by various heretic reformatory movements evoked forebodings of greater troubles to come. It was at this moment of heightened ardour and increasing danger that Bernardino's idea found immediate response: he suggested no more and no less than to bring Mount Zion right to the people in Europe and the Holy Places within reach of all the faithful, there to worship in peace and safety.

Within little more than two years Bernardino's plans began to take shape. He found the right spot, obtained the necessary financial help, and finally, in 1481, was granted the Pope's permission to carry out his great enterprise. His 'New Jerusalem' was to be near Varallo in Lombardy, at the foot of the Alps, not far from his native Milan, a country which he very likely knew well from his youth; a country, moreover, which seemed exposed to reformatory threats from the north as well as from neighbouring Piedmont, the only part of Italy where heretic sects had gained a firm foothold. His choice of the particular spot was determined by certain geographical features, namely a similarity, however tenuous, between the promontory over Varallo and the hill of the Holy City. At any rate, it was felt at once that this landscape setting had the quality of a powerful symbol, a quality which never lost its hold. Two hundred years later Canon Torrotti wrote: 'The neighbourhood of this our own Jerusalem is the exact counterpart to that which is in the Holy Land, having the Mastallone on the one side for the brook Kedron, and the Sesia for the Jordan, and the lake of Orta for that of Caesarea.'

Fra Bernardino's foundation ties up with less ambitious medieval attempts to acquaint the West with the Holy sites at Jerusalem, particularly with the Holy Sepulchre, 'copies' of which were erected all over Europe from the 5th century onwards; the group of buildings

220 Varese, Chapel x, the Crucifixion by Dionigi Bussola

221 Varallo, Chapel XXXIV, seen through the peephole in the screen

222 Varallo, Chapel XXXVI, the Via Dolorosa, by Tabacchetti and Il Morazzone

connected with S. Stefano at Bologna, for instance, was called Jerusalem at a very early date. Fra Bernardino's concept stems from this tradition, but is also related to contemporary enterprises: it was at this period that, for the benefit of the pilgrims, the Franciscan monks in Palestine began to organize stopping places, later called 'Stations', along the *via sacra*, marking the dramatic episodes during Christ's walk to Calvary. From the early 15th century onwards copies of these 'Stations of the Cross' sprang up in many parts of the Western world, at Cordoba, Messina, Goerlitz, Nuremberg, Louvain, and other places. The chapels there erected varied in numbers. As a rule there were twelve, occasionally even less, and only later was their number fixed at fourteen. Fra Bernardino immensely extended the scope of such earlier schemes by treating the whole mountain as if, in the words of Samuel Butler, 'it had been a book or wall' covered with illustrations.

Forty-three chapels, each depicting a multifigured scene from the life of Christ's ancestors or His earthly existence, were to be strung out among the chestnut trees, inviting the pilgrim to follow the paths winding from the church of the Madonna delle Grazie, through the entrance gate to the grounds and on to the chapels dedicated to *Adam and Eve*, the *Annunciation*,

223 Varallo, Chapel XXXIII, Ecce Homo, by
Tanzio and Il Morazzone

224 Varallo, Chapel XXXV, Christ condemned to
death, by Tanzio and Il Morazzone

the *Visitation* and *Joseph's Dream*; the *Nativity*,
the *Adoration of the Magi* and that of the
Shepherds; on to the *Presentation in the Temple*
and the *Flight into Egypt*; to the *Massacre of the
Innocents* and the *Baptism*; on and on, to and
fro, until the pilgrim reached the last chapel
which purports to be a true replica of Christ's
Sepulchre, just as another chapel is, according
to tradition, a faithful copy of the Virgin's tomb.

Nowadays few, if any, of the earliest scenes
are preserved in their original state or setting.
But from the first chapels erected under Fra
Bernardino's supervision to the last ones exec-
uted in the 18th century the pattern remained
the same: the scenes are enacted, as it were, by
lifesize and lifelike figures, first made of wood
and later of terracotta or plaster. By every
conceivable device the painted backgrounds
and multi-coloured figures are made as realistic
as possible in order to evoke in the beholder the
sensation of participating in the actual event:
hair and beards are often made of horsehair;

draperies are sometimes real fabric; the porcupine in the *Temptation of Christ* has real quills; the ropes dangling from the roof under which Christ heals the paralytic are real ropes; sand and soil, often brickwork and shrubs, are real. The earliest chapels were simple, rectangular rooms, now with a glass partition between the spectator and the stagelike setting of the spectacle. Later, the entire building was given to the scene enacted, which the visitor, protected by a porch, can only view through a peephole in an ornamental iron screen, thus assuring the correct standpoint for the full impact of the illusion.

It is evident that a deep gulf separates Fra Bernardino's 'copies' of the Holy Places from earlier ones. To aim at a copy in realistic terms was alien to the primarily symbolic medieval attitude. By contrast, those who erected the Stations of the Cross in the 15th century wanted to reproduce visually and exactly the events believed to have taken place along the *via dolorosa*, and their analytical enquiry went so far as to measure the precise intervals between the hallowed spots in order to be true to facts. All this is characteristic of the vivid realism of the new age, but Fra Bernardino went a step

further than anyone else. He wanted to be 'correct' from the broadest landscape setting to the minutest detail. For us the promontory at the foothills of the Alps with the Monte Rosa in the background may remain patently unreal and imaginary. For Fra Bernardino and the pilgrims visiting their own Mount Zion it was the evocation of reality, not the literal likeness, that counted.

Despite the difference between the medieval and Fra Bernardino's approach to religious imagery it is at once obvious that the realistic scenes have deep roots in the miracle plays of the late Gothic era. Each chapel may be likened to a scene from the *sacre rappresentazioni* frozen into permanence, and this was surely a strong lever to stimulate popular imagination, but the carefully arranged illusionism in each scene greatly transcends the links with the past. The conquests of the Italian Renaissance have been incorporated; they give this popular art a rather sophisticated quality. A glance at the names of the painters, sculptors, and architects employed tells us why.

Fra Bernardino was clever in his choice and fortunate in the availability of his artists. The Alpine valleys were renowned for good crafts-

225 Varallo, Chapel XXXVI, detail of the Virgin

men; for centuries most skilled carvers and sculptors in Italy had come from the Valsesia and neighbouring regions. Now they found a wide field of activity in this and later sanctuaries. Better still, Fra Bernardino was able to win the services of Gaudenzio Ferrari, an outstandingly gifted painter, capable of carrying out the Frate's ideas. Ferrari, 'not only a very witty painter ... but also a most profound philosopher and mathematician', according to the writer Lomazzo, was a native of the Valsesia. Born about 1475, he must have entered the scene of the *sacro monte* as a young man, full of enterprise and daring, both certainly needed for the novel task of forging nature and religious tradition, architecture, painting and sculpture into a homogeneous whole. It was probably he who first suggested the sytematization of the earlier, somewhat haphazard arrangement of the chapels. Whoever wants to study Gaudenzio from his Quattrocento Milanese beginnings to his most accomplished Mannerist work must make the pilgrimage to Varallo.

Gaudenzio lived at Varallo until 1526 and after that worked there intermittently until 1539. With his death in 1546 the first generation of artists who had still known the founder of the Sanctuary came to an end. But even in succeeding generations Varallo remained attractive to artists of eminence. Distinguished names like those of the architects Galeazzo Alessi (1512–72) and Pellegrini Tibaldi (1527?–96) are connected with the *sacro monte*. During the late 16th and the early 17th centuries the work was continued with renewed intensity. It was the time when Lombardy, deeply stirred by the Counter-Reformation, saw a period of unparalleled artistic activity under her great archbishops St Charles Borromeo (d. 1584) and his nephew Federigo (d. 1631). The foremost painters then working in the chapels at Varallo were Il Morazzone (1571–1626) and Antonio d'Enrico, called Tanzio da Varallo (1575–1635), who are now once again beginning to receive the attention which is their due. They were great masters of fresco painting in the Gaudenzio Ferrari tradition which they developed in the direction of a typically counter-reformatory, poignant, and highly-strung style. During the same period a whole army of sculptors executed the great majority of figures. Their names, such as that of Tanzio's brother Giovanni d'Enrico,

226 Varallo, Chapel XXXVI, detail of the goitered Jew behind St Veronica

Giacomo Bargnola, Bartolomeo Ravelli, Giacomo Parracca, Michele Rossetto or Michele Prestinari, still mean little except to specialists. Only the Fleming Jean Wespin, called in Italy Giovanni Tabachetti, was once singled out and whimsically praised by Samuel Butler as 'a better man, take him all round, than Michael Angelo'. Tabachetti's robust northern realism, best studied in his masterpiece the *Calvary* with forty figures and nine horses (1599–1602), compares favourably, in fact, with the more formalized manner of his Italian contemporaries.

Fra Bernardino had died in 1509, but the work on the *sacro monte* went on for centuries broadly in conformity with his ideas. New buildings were still planned in the 18th century, and the last chapel was not finished until 1818. The folk character of this art produced a considerable levelling out of stylistic differences with the result that the entire mountain with its scores of buildings, its thousands of square feet of frescoes and many hundreds of figures presents a near uniform character. For three centuries the Sacro Monte at Varallo was the wonder and delight of pilgrims. St Charles Borromeo stayed there in 1578 and again in 1584, a few days before his death. In the 17th century Varallo had become so popular that, again according to Canon Torrotti, 'torrents of men and women of every nation under heaven' came to pray and contemplate or just to enjoy those 'assiduous Zephyrs', the mild winters or pleasant summers, or even only to observe the 'pilgrims and persons in religion of every

179

227 Orta, Chapels IV and V

228 Orta, St Francis before the Sultan

180

description; processions, prelates, and often princes and princesses, carriages, litters, caleches, equipages, cavalcades . . . by which I am reminded of nothing so strongly as of the words of the Psalmist: 'Come and see the works of the Lord, for He hath done wonders upon earth''.'

The fame of Fra Bernardino's *sacro monte* stimulated imitation and about a hundred years after the foundation of Varallo similar sanctuaries began to rise in the vicinity. The first was Orta, at the small lake of that name, in the old time about half a day's journey from the Valsesia. Then followed Varese and, finally, Oropa. Like Varallo, these three sanctuaries enjoy the most beautiful setting: Orta on a slim peninsula, jutting into the lake, in a soothing atmosphere of gentleness and peace; Varese, near Como, high up on a hill with magnificent views over the nearby lakes; and Oropa, the highest of all, surrounded by snow-capped peaks on three sides and looking far over the plain on the fourth.

Orta, an old Franciscan foundation, is the smallest and most homogeneously arranged of the four sanctuaries. As at Varallo, the original layout was probably not designed by an architect but by a member of the Order. Whoever was responsible for it had a loving eye for the particular charm of the landscape and great skill in using it for his purpose. Softly winding paths criss-cross the hillside, gently dipping and rising, thus making the area appear much larger than it actually is. The twenty chapels, built between 1591 and 1770, are completely integrated into the atmosphere of rural peace. They contain sculpted groups as realistic as those at Varallo, but here they illustrate scenes from the life of St Francis, while the frescoes depict types and anti-types from the Old Testament and the life of Christ.

Most of the artists employed came from the immediate neighbourhood, but although some of them were first-rate masters – such as the painters Procaccini and Nuvolone or the sculptor Rusnati – and although others like Bussola, Prestinari and the brothers Grandi had gained experience at Varallo, the sculpted and painted stories at Orta seem to lack freshness and naivety. Above all, the contextual relationship between sculpted groups and painted walls is not easily understood, in contrast to the simple and unified programme in the chapels at

229 Orta, the canonization of St Francis

Varallo. Apart from the overall planning, the main glory of Orta lies in the design of the stately chapels. At least fourteen of them were erected in the last decade of the 16th and the first quarter of the 17th century in a refined and most attractive manner. Here was an imaginative architect at work who knew how to give centralized schemes the greatest possible variety. His identity remains one of the many tantalizing questions which the insufficient research into the history of Orta leaves unsolved.

The theme of the chapels at Varese depended on an ancient cult of the Virgin. The present basilica, S. Maria del Monte, rises on the spot where St Ambrose dedicated to the Virgin a small chapel in the second half of the 4th century. It is for this reason that the chapels leading up to the sanctuary were conceived as symbolic representations of the rosary: three arches divide the fifteen chapels into three groups signifying the mysteries of joy, grief and glory. The idea was again that of an inspired cleric, but in this case the planning was

230 Varese, Chapel XIII, by Giuseppe Bernasconi

the figures for some ten of the fifteen chapels. Silva spent his whole life on this enormous task, and his work probably represents the most consistent effort ever made at creating this type of popular, realistic terracotta figure. The conventions established by him were broken by Dionigi Bussola (1612–87), a Milanese who had 22 studied in Rome and therefore knew how to imbue his figures in the Chapel of the Cross with a true sense of Baroque drama.

An entirely different world opens at Oropa. Here nothing will be felt of the primitive appeal of Varallo, the dreamy charm of Orta or the quiet dignity of Varese. The fame of Oropa's ancient and most venerable effigy of the Virgin, first housed in a small, reputedly 4th-century chapel which was eventually replaced in the 17th century by the present church, had always attracted large flocks of pilgrims and visitors. It does so even more today. With its wild and grandiose Alpine setting, its three vast terraced courtyards flanked by galleries and rows of shops, restaurants, dormitories and administrative buildings, all kept in excellent repair, Oropa offers something that no other sanctuary does. It caters for both spiritual needs and material wants. An efficient management provides free meals and beds for the poor, well-appointed and expensive accommodation for the wealthy, huge car parks and an endless array of souvenirs to suit all purses.

While on the other holy mountains the chief attraction for the faithful is the pilgrimage from chapel to chapel, in Oropa it is the church which is the focal point of worship. The twelve whitewashed, simple chapels, erected during 2 the late 17th and early 18th century, look as if they were added as an afterthought. They are grouped together on a pleasant but inconspicuous slope and again display their lifelike scenes by means of sculpted figures and painted backgrounds, most of the latter the work of Giovanni Galliari.

Strangely enough the precise history of Oropa has not been written, and the influence of the plans and sketches submitted by such internationally renowned architects as Guarino Guarini and Filippo Juvarra upon the formation of the whole or some of the buildings has yet to be clarified.

I have omitted from this brief review of the *sacri monti* two less important ones, those at

entrusted from the beginning to a known professional architect: Giuseppe Bernasconi from Varese. He designed the whole group and supervised most of the work himself. What remained to be done after his death was faithfully executed according to his plans. Stylistically, Bernasconi depended on the severe Classicism that was practised in Milan at the beginning of the 17th century. Most of the fifteen chapels erected between 1604 and 1680 230 are variations on the one theme of the porticoed temple, and this alone makes for a homogeneous appearance of the entire scheme. It is to the great credit of this provincial architect that he was capable not only of great diversity within such narrow limits but also of truly monumental effects despite the small size of the buildings.

In comparison with Varallo the number of artists engaged on the pictorial and plastic work is small, but the names of more than a dozen painters are known, among them once again the indefatigable Morazzone. Of the five or so sculptors the most important one is Francesco Silva (1580–1641) whose workshop provided

Crea, north of Asti, and at Graglia, in the vicinity of Biella not far from Oropa. The former, with twenty-three chapels, was begun in 1590; the latter was planned with about a hundred chapels at the beginning of the 17th century, but little of it was executed.

All these sanctuaries were meant to be focusing points for popular devotion, but there is an important difference between Varallo and the rest. While the foundation of Varallo was due, as we have seen, to the typically late medieval or early Renaissance craze for possessing in the Italian Alps an accurate replica of Jerusalem, no such idea inspired the others. They are foundations of the Counter-Reformation; they do not imply the concept of being accurate reproductions of the Holy Places, but must be regarded as variations on an established pattern and as a means of channelling the renewed religious fervour: they are beacons of faith lit along the Alps, tokens of defence against threats from the north.

It is not surprising that these places were destined to keep alive an artistic tradition which had its roots in the Middle Ages. It was only in the course of the 15th century that, with the emancipation of the artist, backed by an idealistic Classical art theory, 'high art' and 'popular art' became divorced. In practice, the breach took some time to become fully effective as the realistic polychrome *tableaux vivants* in terracotta by Niccolo dell'Arca and Guido Mazzoni, among others, go to show. Moreover, it remained customary for artists, mainly in the provinces, to work on both levels. Thus, 'high art' Neapolitan sculptors like Celebrano, Vaccaro, Sammartino and Matteo Bottiglieri did not hesitate to produce the painstakingly realistic, colourful Christmas cribs with which everyone is familiar.

The progressive hardening of the theoretical position may be followed from Leon Battista Alberti in the 15th, to Bellori in the 17th, and Winckelmann in the 18th century when 'high art' and 'low art' had finally parted company. And as Canova would have felt nothing but contempt for the 'naive' realism which was at home in the *sacri monti*, so art historians of the 19th century, concerned only with the history of high art, excluded any reference to them. Even at the beginning of the 20th-century guide-books, though alloting an occasional star to their positions, spared few lines to the charms of these repositories of truly popular art. Only the irascible Samuel Butler took up his pen in praise of his beloved Varallo, grudgingly admitting that the other places too were not entirely devoid of merit.

231 Oropa, sequence of chapels

232 DOMENICO MORONE. *Tournament scene*, Cat. Wks, No. 6 (London, National Gallery)

X

THE PAINTERS OF VERONA:
1480–1530

OUR basic source for the Veronese Renaissance, in spite of his many errors and shortcomings, is still Vasari. Hardly any of his information is first-hand. He visited Verona only twice, and then fleetingly. The first time was in the autumn of 1541.[1] Although, as Kallab has shown, he was engaged in research for the first edition of the *Vite* (1550) during this journey, his interest in local Veronese painting was evidently slight. From his autobiography we gather that it was the Roman antiquities which claimed most of his attention: 'in pochi giorni vidi in Modena ed in Parma l'opere del Correggio, quelle di Giulio Romano in Mantova, e l'antichità di Verona'.[2] There is consequently no description at all of any Veronese artist in the first edition. On his second visit (May 1566) he again had little more than a day at his disposal, for he made the journey from Mantua via Verona, Padua, Venice to Ferrara in twelve days.[3] But the second edition of 1568 has a much broader scope, and the Veronese school receives a long chapter under the title 'Fra Giocondo e Liberale ed altri Veronese.' For this he relied upon two informants, Fra Marco de' Medici from Verona and the sculptor Danese Cataneo, whom Vasari mentions particularly at the end of this section (V, 334). His accounts of the painters of our period draw heavily on the learned Fra Marco, who was well known among the artists.

Dal Pozzo, whose *Vite de' pittori, degli scultori, et architetti veronesi* appeared in 1718,[4] is the first local historian to deal with Veronese artists. He continued Vasari's work into his own period and is strictly speaking an original source only for this later generation. Otherwise his work is little more than a compilation of Vasari and Ridolfi.[5] On the painters with whom we shall be concerned, he has nothing to add to Vasari.[6] The value of his *Vite* resides solely in the notes, from which we learn what had been

destroyed in the 150 years since Vasari's second edition.

The next chronicler of Verona, Zannandreis, is something quite unique in Italian biographical literature.[7] To all appearances he was an ordinary merchant, for whom earning a living was a constant struggle. But underneath he was an ardent admirer of local art, to the study of which he gave up his few leisure hours. His manuscript, his life's work, was completed between 1831 and 1834, when he was sixty-six years old; it then lay dormant in the Biblioteca Communale of Verona till 1887, when Biadego published part of it on the occasion of a wedding.[8] Four years later he published the whole manuscript. Although Zannandreis' work suffers from a certain lack of critical insight into both sources and works, and from a dry, pedestrian style, he nonetheless provides an important compilation of what had been said about the Veronese artists from Vasari to his own period. He even examines unpublished archive material. In the parts concerning Domenico and Francesco Morone, Girolamo dai Libri and Cavazzola, he quotes copiously from Vasari, Lanzi, Dal Pozzo,[9] and other authors and chroniclers.

The Veronese tradition of local patriotic biographies comes to an end with Bernasconi in 1865.[10] The attempts of these writers to promote minor Veronese artists as unrecognized geniuses are of little interest to us today, but Aleardi's faithful reprint of the very rare Cavazzola monograph is still important.[11] Simeoni's publication of 1909,[12] which contains material on both the civic and literary history of Verona, is critical in method though not without its faults.

Dal Pozzo, in the last fifty pages or so of his guide-book, gives a very imperfect survey of Verona's notable works of art,[13] senselessly abandoning Vasari, whom he had followed in

the earlier part. Thus, Cavazzola's *Madonna on Clouds with Saints* (Cat. Works, No. 20); the three lower panels of Cavazzola's great altar of 1517 (Cat. Wks, No. 7) to Giolfino; the three upper to Francesco Morone. More useful and more thorough are the references to painting in Biancolini's historical work, *Notizie storiche delle chiese di Verona*, 1749–56, but even here, the harvest for the art-historian is fairly meagre.

Dal Pozzo and Biancolini arrange their material in such a way that their books cannot be regarded as guide-books. Maffei[14] leads us through the city in a more stimulating fashion, but neither they nor any other writers are much more than compilers. The situation changed only with the appearance of Dal Persico's excellent and exhaustive *Descrizione di Verona e della sua provincia* (2 parts, 1820). Benassuti's handy guide offers a general summary of Dal Persico.[15]

In recent years, art criticism has barely touched Veronese painting, and no coherent, scholarly account has existed until now. The section in Crowe and Cavalcaselle's *History of Italian Painting* gives the basic facts, although many details needed correcting and it is now outdated. Berenson's *North Italian Painters* provides a useful synopsis. Venturi's contribution (*Storia dell'arte italiana* VII, 3 and VII, 4) is thin by comparison and poorly illustrated. Local Veronese historians, utilizing the archives, have produced excellent work in relation to specific questions. The results, available in the journal *Madonna Verona*, published from 1907 onward, offer abundant and not yet fully explored sources of material.

If there is no good general history of Veronese painting, the situation with regard to monographs on individual artists is not much better. The little that has appeared about the masters dealt with here will be mentioned in the biographical sections devoted to them.

What was the character of Veronese painting between 1450 and 1530? In the hundred years that separate Pisanello and Paolo Veronese the art in Verona developed in a peculiar yet characteristic direction. The first generation (1450–1480) after Pisanello presents an impression of utter enfeeblement. The second (1480–1510) saw the beginning of a new period of creativity. Two disparate trends arise at this

time, running alongside each other until about 1530, occasionally converging. Then one of them withers away and from the other springs a new line which leads to Paolo Veronese.

A small picture of the *Madonna* by Francesco Benaglio in the Verona Museum (No. 350, Ill. Venturi VII, 3, p. 445) tells us something about the position of Veronese painting in the middle of the 15th century. It turns out to be totally dependent on Padua. Here, the impact of Donatello had come just at the right moment, in 1443, and it is easy to see signs of it in Benaglio's painting: the firm framing of the picture and the way in which the parapet cuts abruptly through the body of the standing Madonna.

The so-called Squarcione school of Padua, very much influenced (via Andrea Mantegna) by Donatello, led in turn to the even more sterile and provincial art of mid-15th-century Verona. Benaglio is perhaps most closely related to Gregorio Schiavone. His Veronese and Schiavone's Berlin *Madonna* both belong to the same type of genre-like scenes enlivened by putti. Compared to the Paduan, the Veronese picture seems to be primitive and superficial. In the type of Madonna and putti heads, in the severe outline and modelling of the bodies, in the parallel, tubular, pleated style of the Madonna's drapery, in the Mantegnesque fashion in which the folds of the children's clothes cling to their bodies and the treatment of the landscape, Benaglio is following the Paduan artist. All these motifs, however, became more superficial and insipid on their journey to the provinces.

For a generation following Pisanello's death Veronese painting remained in this artistic trough. There seemed to be a lack of spirit, for even the most stimulating influences were not taken up and interpreted individually. Jacopo Bellini's *Crucifixion* fresco of 1436, in Verona Cathedral (unfortunately destroyed in 1759) or Mantegna's S. Zeno Altarpiece of 1459, appear to have had almost no effect.[16]

Two new and virile movements arose around 1480. Liberale da Verona became the founding father of a school that culminated in Giolfino and the Caroti and tended to depend artistically on non-Veronese painters. Domenico Morone and his followers Francesco Morone, Girolamo dai Libri and Cavazzola, on the other hand, retain a specifically local character and form a

very clearly defined group within Veronese painting. During the next generation, however, the sharp distinctions in style between the schools of Liberale and Domenico became much less acute.

Liberale and Domenico represent opposite extremes. Liberale, a little younger than Domenico, went as a twenty-year-old to Monte Oliveto, near Siena, staying in Tuscany for almost ten years (1466–1476), and seems to have travelled again between 1482 and 1492. Domenico, however, hardly left his native town and apparently never went further than Mantua, not staying long even there. All this tells us something about the contrasting influences to which the two men were subjected. They were very different too in their approach to the central concepts of art. Liberale is concerned most with line, hardly at all with plasticity and colour. His rendering of people and objects is decorative, and he is close to his greater predecessor, Pisanello, in his feeling for linear concentration. Domenico, by contrast, is a sculptor at heart. The outline of a body, for Liberale mainly a decorative potential, interests Domenico as the spatial boundary of a cubic mass. Liberale shows great gifts as a miniaturist, the genre in which he began, producing excellent small-scale panels, but loses conviction with larger pictures. Domenico found his greatest fulfilment in fresco painting.

The sources of Domenico Morone's style can be understood as: firstly, a local tradition, dependent on the Squarcione school; secondly, Jacopo Bellini's *Crucifixion* fresco of 1436; thirdly, Mantegna (the S. Zeno Altarpiece); and, finally, Liberale. It will be shown how Domenico employed these elements.

Domenico's followers developed his style in the direction of the Cinquecento but without achieving his clarity of purpose or all-round ability. Basically, however, they retained the traditions of the late Quattrocento right up to the 1530s, and the whole movement breaks off abruptly before reaching its natural consummation.

These artists, so out of step with general developments, can have had very little effect, and no lasting or significant influence appears in any of their Veronese contemporaries.[17] One artist from outside the province, Girolamo Mocetto,[18] approaches them. His altarpiece in the sacristy of Santa Maria in Organo belongs in every respect to the circle of Girolamo dai Libri.

It was Liberale's circle which was able to advance. Caroto became a Mannerist; Torbido followed the lead given by the young Giorgione and Titian. The future of Veronese art, as with its politics, lay in dependence upon Venice – as exemplified by the greatest painter that Verona produced, Paolo Veronese.

Domenico Morone

The archive material on Domenico Morone has been collected by Gerola.[19] Domenico is mentioned in the land-tax register for the first time in 1482: 'Dominicus Augustini pictor', then again in 1492, 1502, 1515 and 1518.

A 'Magister Augustinus pelacanus', with a wife and three children, is listed by the registration office for 1455–56; 'Dominicus', his son, is thirteen years old. In 1465 it says: 'Dominicus eius filius (anni) 25' and in 1472: 'Dominicus pictor eius filius' is thirty years old. The young artist is married and has two small daughters. The records of 1481 mention: 'Domenego de Augustin depentor anni 39.' The father, who is mentioned as blind in 1472, has died. The number of children has increased by three. If we work back from these records we arrive at a birth date for Domenico that varies between 1440 and 1443, and there are further contradictions in the entries for 1501, 1514 and 1517; but the consensus of the early documents points to 1442 with reasonable certainty. He is last mentioned in 1518, so he lived to be at least seventy-five.

Documents shed little light on the painter's life. We know that he came from a family of tanners, indicated by the surname 'pelacanus'; that he was called 'depentor di Moroni' for the first time in 1501; and that he married twice. In 1492 and 1493, Domenico with Liberale and Antonio Giolfino, the three most outstanding artists in Verona, were made responsible for the placing of statues in the piazza of the Palazzo del Consiglio.[20]

When or how often Domenico left Verona neither the documents nor Vasari tell us; the natural inference is that, apart from a stay in Mantua in 1493–4, he hardly ever left his home. With the exception of the years 1481 and 1482, when Domenico lived near St Quirico, he seems

233 DOMENICO MORONE. *Madonna and Child*, Cat. Wks, No. 3 (Berlin, Staatliche Museen, formerly in the Kaiser-Friedrich-Museum)

to have occupied a house in the St Vitale district. Documented payments for works will be mentioned below.

Few of Domenico's presumably numerous works have come down to us. A characteristic 233 *Madonna and Child* is in the Kaiser-Friedrich-Museum in Berlin (Cat. Wks, No. 3). The picture was painted in 1484, when Morone was forty-two, and we may assume that there were paintings preceding this work. Morone's picture belongs to a type characteristic of Giovanni Bellini in the 1480s: the Madonna looks down in contemplation, with the Christ Child on her right arm giving the blessing. The semicircular top of the picture, no longer fashionable at this period, is normal with Jacopo Bellini's Madonnas and also appears in early paintings by Giovanni. The severe oval shape of the Madonna's face with her long fine nose and hard mouth also relates to Giovanni Bellini's early pictures. The treatment of the mantle, which fastens in front of the breast and billows out round each arm, is a sign of Liberale's influence.

It is easy to trace the Christ Child back to Francesco Benaglio. The benediction does not look convincing; the child's head covering is conventional. It comes from the Schiavone type and keeps close to Benaglio's figures of children. Light plays an essential part. The effect of solidity in the body and in the folds of the drapery is achieved through modelling with light and shade rather in the style of Cossa. The shadow of the arm on the Child contributes to the plasticity of the body, creating a feeling of space between arm and breast. Reflections, such as on the outline of the Child, on the shadowed cheek of the Madonna, and in the folds of the dress, indicate an understanding of the same problems of light that concerned Piero della Francesca.

The landscape provides the means by which Domenico resolves the stiffness of his predecessors and instils new life. He sees nature through open eyes: this countryside in the background is probably a view of Lake Garda, and is painted in a way that owes little to the Paduan school.

The brownish colour of the skin follows the style of Jacopo Bellini, but there are also nuances of Veronese colouring, notably in the brilliant red of the mantle.

This picture, the earliest that can be definitely attributed to Domenico, represents a stage when he was hesitating between old and new, looking to Jacopo and Giovanni Bellini, to the ebbing, old, local tradition and to the new linear style of Liberale. Domenico Morone's talent, however, cannot be explained simply by enumerating various influences. We must identify the paintings that most excited the young Morone in order to reconstruct the development of his style and personality. The local influence is the least significant. Young Domenico retained some elements that reflect Benaglio, but one senses that these are essentially limitations to be overcome in the future. Liberale's use of outline also cannot be reconciled for long with a style that is fundamentally three-dimensional and naturalistic. The influence of the Bellinis predominates: Jacopo and the austere, young Giovanni are kindred spirits to Domenico, though he has nothing in common with the softness of Giovanni's later work, but the adoption of overall brownish colouring shows how well Morone understood the aged

Jacopo Bellini. Domenico's conception of landscape made him the founder of the specifically Veronese type of Renaissance landscape.

There is as yet little sign of Mantegna's influence. It is wrong to see Domenico at this period as someone who is perfecting Benaglio's ideas; indeed he is busy throwing off the outdated forms of the Paduan school and the theories that went with them.[21]

The next signed picture dates from 1494, when Domenico was commissioned by the Marchese Francesco Gonzaga to paint the *Victory of the Gonzaga over the Bonacolsi* in 1328 (Cat. Wks, No. 5). A number of different historical events had to be combined in the picture, which is based on the account of the battle given in *Fioretto delle Croniche di Mantova* (reprinted in Venturi, *La Galleria Crespi in Milan*, 1900, p. 61–72). Three separate actions had to be combined: 1. In the background on the left, Guido, the eldest son of Luigi Gonzaga, with the soldiers of his ally, Cane della Scala, passes through the Porta de'Mulini and turns into the Piazza of Mantua; 2. In the foreground Luigi Gonzaga with two of his sons fights the Bonacolsi, while his people force their way into the Palazzo del Capitano in the centre right; 3. In the middle distance we see the ceremonial investiture of Luigi as Capitano of the city, historically quite a separate event.

In order to unify all these disparate parts, the artist chooses one of them as the main theme: the battle, which stretches from the left to the right edge of the foreground. All the events taking place in the middle ground lead up to and are dominated by the battle scene. Morone obviously enjoys the unbridled action and seems to like showing off his skill. If, however, the picture is examined group by group the movement of individuals is noticeably stiff and has only been achieved by rather consciously calculated devices. For example, the motif of fallen and falling men is found almost solely in the very front of the foreground. On the extreme left is a dead man, whose body lies feet first foreshortened towards the centre of the picture; on the extreme right lies another, the opposite way round. On the left is a fallen horse in profile parallel with the bottom line of the picture; on the right-hand edge a fallen horse points into the picture; exactly in the centre a stumbling steed is seen from behind, while over it another horse is rearing, ready to charge out of the picture. To the left and right knights are charging in diagonal directions. Every conceivable pose and action connected with battles has been brought together here. In the centre foreground, symmetrical combatants with lances are seen from front or back. The circle of warriors in the middleground shows young

234 DOMENICO MORONE. *Victory of the Gonzaga over the Bonacolsi*, Cat. Wks, No. 5 (Milan, Galleria Crespi)

soldiers in every possible variation of standing or striding movement.

The composition is balanced down to the smallest details. Foreground, middleground and background are clearly differentiated. The battle rages in the foreground, the other two scenes fill the middleground, and the landscape forms the background. The exact centre of the picture is occupied by the Romanesque tower of Mantua Cathedral (still standing today) and this vertical line, if extended downwards, would run between the rearing and the stumbling horse. The central rider and the two white horses that come at him from right and left form the organic nucleus of the battle group. The scene is contained on the right by the sharp edge of the Palazzo del Consiglio, and on the left by the so-called Torre della Gabbia, the stronghold of the Bonacolsi. The clearly constructed, peaceful, ceremonial scene takes place in a wide square formed by the Palazzo del Consiglio leading into the background and joining on to the house of Guido Bonacolsi on the right; by the parallel rows of houses on the left; and, in the background, by the wide façade of the Cathedral. The energy generated in the centre of the picture is channelled into the two subsidiary scenes on the left and right. On the left it flows through the linking figure of the mule-driver to the crowd of warriors and so into the background; on the right the battling throng that edges towards the Palazzo del Consiglio deflects it beyond the arcade towards the street on the right of the Cathedral and the city walls.

The great strength of the piece lies in the excellent modelling of the figures. All the forms are fully realized as physical entities, people and animals being modelled rather than drawn. The statuesque impression is enhanced by Morone's inhibition against representing spontaneous movements. Foreshortening and overlapping of the most daring kind increase the feeling of three dimensionality. The drawing is firm and clear down to the finest details. Light serves to accentuate the colour; the work is filled with light and air, unifying it with a sunny and luminous character. The play of light and shade is of particular significance. The flecks of light in the battle scene, the shining armour, the contrast with the deeply shaded parts, the chaos of shadows on the ground – all this furthers the illusion of space.

Domenico was fifty-two years old and at the height of his powers when he produced this battle scene, his most mature creation. The Veronese documents of 1492 and 1493 show that, along with Liberale, he is considered the most important painter in the city. This reputation probably secured him Francesco Gonzaga's commission. According to the dates quoted above Morone was still in Verona in 1493, though he must have moved to Mantua later that year because he would have needed time to complete the work by 1494. The picture must have been painted in Mantua for Morone shows an extraordinary familiarity with the locality. The architecture is faithfully observed, to the smallest detail. The landscape, however, is not in reality visible from the Piazza di San Pietro, and must have been added for compositional and spatial reasons. Its character is unmistakeably Veronese.

We do not know why this particular historical commission was given to Domenico; perhaps it was intended to hang in the Palazzo di San Sebastiano, which was built by Francesco Gonzaga but no longer exists. As we know from an inventory of about 1550, the other pictures and decorations in the castle are symbolic in character, and refer to Francesco Gonzaga or Isabella d'Este. Thematically the battle scene could belong to this group if it is interpreted as a symbol of the victory of the Gonzaga over their enemies.

Mantegna's *Triumph of Caesar*, begun in 1482 and completed in 1494, was hung in the new palace in 1506, and Costa's earliest work, *The Coronation of Isabella*, was hung there in 1505.[22] It must have been about this time that the palace was completed, and it is questionable therefore whether Morone would have been commissioned to paint a picture eleven years before it was to be hung. Mantegna's *Triumph*, also begun so long before, was probably not originally intended as decoration of the castle.

A stylistic comparison of Morone's 1484 Madonna and the 1494 battle picture shows the relationship between the two paintings. The main factor that both works have in common is a mental attitude; a certain rigidity that is noticeable alike in the Virgin's glance and in the stylized movements of the battle scene. In each case Domenico has thought the composition through very clearly, keeping the line firm,

even angular. Compare, for instance, the cocked thumb and little finger of the Virgin in the Berlin picture with the sharp knees and elbows of the Mantua painting.

What was begun in 1484, comes to fruition in 1494 with the plastic conception of body forms and the modelling through light and shade. The space around the battle scene is airier and deeper; the landscape, seen as a series of isolated patches in 1484, has become a more integral part of the painting by 1494. All signs of local tradition have disappeared. There is no trace now of either Benaglio or Liberale.

In the Mantua picture every detail has been deliberated. We feel that we are in the presence of a man who is extremely concerned with perfecting his technique, but who is not particularly interested in problems of any other kind. The sentimental quality that appears in the late Giovanni Bellini would have seemed to him weak and insipid.

Domenico instead leant on the later Jacopo. As we have seen, he found Jacopo's art attractive, and may best be understood as a man in a similar position to Gentile Bellini. Both were rooted deeply in the art of Jacopo Bellini. The energetic temperament that Jacopo directed towards ever new observations of nature is checked in Gentile and compressed into tight forms. The impression of space in Gentile's history paintings is typically achieved through architectural structures that lead from the edges of the picture into the background, and a monumental building, parallel to the picture plane, which ties the two sides together. The action takes place in the foreground: a chain of people filling the whole width of the picture. Behind this row, figures are scattered about as if by chance. The much more lively Carpaccio retains Gentile's composition in essence but his feeling for drama transcends Gentile's dry objectivity.

Domenico adopts this composition of history painting, but he is more akin in spirit to Carpaccio than to Gentile: he avoids the overly severe symmetry, allows nuances free rein, and seeks movement. He follows Gentile only in the general tradition of this type of painting. Jacopo's influence can be recognized, as in the Madonna picture, by the reddish brown colouring. There are also a great number of analogies to be found in the types of figures, their move-

ments, proportions and characterizations, as a study of Jacopo's sketch books shows.

Some slight influence from Mantegna can also be detected here. I like to think that motifs such as the foreshortening of the fallen soldiers come directly from Mantegna. One of the disciples from the *Agony in the Garden* might have inspired such boldness.[23] It is clearer from his later development that Domenico 'discovered' Mantegna at about this time.

The frescoes in the library of S. Bernardino in 235 Verona bear the date 1503. Tradition attributes 236 them to Domenico Morone although, curiously, they have been widely misjudged by later critics. Researchers often either gave them entirely to followers of Domenico or made him responsible merely for the conception. Certainly traces of a pupil's hand can be found but it should be remembered that the master was finishing this huge work at the age of sixty-one. The crucial point is that conception, design and execution all breathe Domenico Morone's spirit. The total conception is homogeneous in every respect (Cat. Wks, No. 8).

It is first of all important to understand the nature of the commission. Count Lionello Sagramoso's will of 1493 directed that the proceeds from the sale of certain estates in Malcesine (Lake Garda) should be used to build and furnish a library in the Franciscan Monastery of S. Bernardino. Work probably began in 1497, after his widow's death.

The subjects of the paintings were to be famous Franciscans, but the actual execution was made difficult by five windows which split up the two long sides of the room. To unify the whole, the artist sytematically divided all four walls horizontally. A frieze of lifesize figures is placed over a decorative dado; above the frieze is a continuous, ornamented band. This band is interrupted, at equal intervals on the front and rear walls by three, and on both side walls by six, circular medallions, all with painted busts at equal intervals. The organization is thus essentially bipartite, but on the end wall the eye perceives a tripartite division, since it is divided into three parts by painted columns. The centre, emphasized also on the dado and frieze, is occupied by the Virgin and Child surrounded 235 by angels; thirteen other figures, divided into pairs, move towards her: to the right, the wife of the donor commended by St Clare; St Anthony 236

235 DOMENICO MORONE. *Virgin and Child*, in the Library of S. Bernardino, Verona, Cat. Wks, No. 8

236 DOMENICO MORONE. *Donor and St Clare*, in the Library of S. Bernardino, Verona, Cat. Wks, No. 8

of Padua and S. Bonaventura; S. Bernardino of Siena and St Louis of Toulouse. To the left, the kneeling donor with St Francis of Assisi. Together behind the columns are the five martyrs of the Franciscan order. Here Domenico's policy of dividing his figures into pairs runs into a snag, since the space available for the three saints is no larger than that for the two. He compromises by grouping the three saints closer together, by uniting the outlines of the two on the farthest left, and by making the three figures smaller than the others. Pairs of saints or Franciscans noted for their sanctity occupy the six panels of the long walls.

Two side doors which once existed in the narrow entrance wall have been bricked up, but the walls to the left and right of the present entrance door have no paintings; we can assume, therefore, that the two doors on either side were still there at the time. The lower part of the surrounds of the medallions on both sides of the door follow the arch of the now blocked entrances. These three entrances echoed the three parts of the wall at the other end.

Dado, frieze and ornamental band are all used to emphasize the important parts. The Madonna gains in impact by being placed on the central

axis. The painted columns of this wall, which reflect the division of the dado, are topped by putti in the ornamental band. A symmetrical ornamentation develops, with little variation, from these putti, who also emphasize the window axes on the long walls. The medallions are placed precisely over the centre of the figure scenes, and the same parts are marked on the dado by coloured circles. All the figure scenes between the windows are framed by decorated pilasters.

The entire composition is therefore fully thought out and logically structured. The spirit of Domenico Morone can be detected in this procedure. No other Veronese artist would have been capable of such a design. Let me draw attention particularly to two things: one is the artist's delight in strong and intense movement, shown, for instance, in the lively step of the five martyrs, and the excited discussion of the Franciscans; the other is the rich variation of poses and drapery. On the main wall, where the figures would normally be shown in profile, Domenico uses a frontal view as well, and adds a whole series of intermediate positions. In spite of the general movement towards the centre, the treatment does not appear systematized, but

vivid and lively. Domenico handles the same theme fourteen times on the side walls without repeating himself. The same is true of the drapery, including the rather dull monk's cowl, which he has managed to make interesting. And on the main wall particularly Morone displays a fertility of imagination that produces constantly fresh ideas.

The same kind of expression comes through in all of Morone's works, and can be seen in the fresco even more clearly than in the battle scene or the Madonna painting. There is a certain rigidity and coldness: the same glassy stare in the Child, the Virgin, the angels and saints. The people stand as if they were made of metal. The precise, clearly defined treatment of the folds reveals a highly developed sense of plastic values which dominates the whole conception. Even colour is sacrificed to it. The attire is always distinct and immediately identifiable, the lines hard and angular.

All this is consistent with the tendencies shown in Domenico's earlier works; his compositions are invariably constructed according to clear principles. Movement and abundance of motifs are important to him; so are questions of light and plasticity. A fixed expression in the eyes and suppression of movement indicate a quality of timelessness.

Within the limitations that Morone set for himself a definite development took place, which can be seen by examining the two Madonnas. The Madonna and Child of the fresco are less animated in expression and form. Domenico has moved in the direction of the Renaissance. The later representation is heavier and more tangible, the bodies broader, the long oval faces full and round, the thin hands with long fingers shorter and more fleshy. The outline is firmer and surer, gaining in strength and clarity. As Domenico's style developed several aspects became increasingly significant: plasticity, and the rendering of light, which grows more complex with reflections and contrasts. As Domenico extends his media ever further, a slow stiffening of expression becomes apparent; this eventually affects the forms too.

Mantegna's influence on Morone shows up here and there after 1490.[24] Domenico's stay in Mantua may well have brought the two painters together. Mantegna's *Madonna with Four Saints*,[25] painted in 1496 for S. Maria in Organo, made the greatest impression on Domenico, although by that time he was really too set in his ways to be much affected. The hardness of the design, the plasticity of the bodies and the ornate treatment of the folds are similar, but the real connection lies in an intellectual relationship. Domenico must have felt drawn to the greater artist, the master of every technique, who could so precisely calculate every effect. The same coolness chills the observer in the later works of both Mantegna and Domenico.

The attribution of the cycle of frescoes to Domenico is confirmed by a comparison with a signed work of 1502: the frescoes in the small church of S. Nicola da Tolentino al Paladon, which have been transferred to the Verona Museum (Cat. Wks, No. 10). Both frescoes, each with four saints, were painted on the side walls near the altar, and were later discovered under whitewash and exposed by Simeoni. These poorly preserved paintings with their exact inscriptions were a hastily executed work for a rural community: they do, however, bear the characteristic elements of Morone's style. The eight individual saints, almost all full face, stand in a perspective setting and are separated from each other by painted pilasters. The notion of setting the figures on a stage behind a mock architectural structure is repeated from the main wall of the San Bernardino library. The parapet motif, which cuts through the middle of both pictures horizontally, also recalls the window sides of the library. Without going into too much detail, one notices some very striking parallels between the two works: the strongly modelled heads, the solidity of the folds, handled already in an almost Mannerist style, and the reddish brown skin colouring. Even the ornamentation is made up of the same elements, although the execution of the 1502 fresco is less accomplished. One of the weakest figures is St Catherine, in which Francesco's collaboration can be clearly seen.

The three works we have been considering are definitely by Domenico Morone and span his career between the ages of forty and sixty. Those that follow now have been attributed to him with various degrees of certainty.

The first is a small Madonna in the Musée Jacquemart-André in Paris. The half-figure *Madonna and Child* would be the earliest surviving evidence of Morone's art (Cat. Wks,

No. 1). Compared with the Berlin picture, it is much more in the Paduan tradition. Nonetheless, all Domenico's hallmarks are here: the Madonna's long head with her narrow nose, raised slightly at the tip; the Child's head with extremely rounded cheeks and the same short neck that one sees in the S. Bernardino fresco; an uncertainty in the drawing of the hands, which is also characteristic of his later works; the line of Mary's mantle, which we already know from the Berlin picture; the town in the background resembling the battle picture and finally the lowered eyes of the Madonna, which recur in all the Madonna and Child pictures. Of the colour and modelling the museum catalogue says: 'Tous deux (Madonna and Child) sont baigné d'une lumière fraîche et crue qui caresse et modèle les blancheurs de leur chairs comme chez Cossa.' The strong lights on the eyelids and upper lip, the reflections on the outlines – all match Morone's style. The forms, however, correspond most closely to the period when he was under the influence of Benaglio.

Two panels that are part of the organ in S. Bernadino in Verona are traditionally, and surely correctly, attributed to Domenico. The organ is dated 1481, and the panels, with over lifesize figures of St Francis and St Bernard (Cat. Wks, No. 2), were probably executed at about that time. Stylistically they must be dated after the Paris and before the Berlin Madonna. The feeling for contour and animated line is strong; the plasticity of the bodies slight. The composition suggests the Paduan school. The saints under a mock architecture leading into the background, garlands of fruit, and putti with musical instruments are reflections of Benaglio.

232 Two small tournament scenes in the National Gallery, London (Cat. Wks, No. 6), can be linked to the 1454 battle picture, which they resemble in several particulars: the rather academic juxtaposition of poses (horses from the front, back and side); the wealth of motifs (the young man on a ladder, etc.); the modelling and the use of light. Indeed, certain of the faulty renderings of some of the bodies, hands, and horses with the peculiarly shaped tails are the same. The leaping horse and rider, in profile, and the one in front that is cut by the edge of the picture, are almost exactly like those in the middleground of the battle picture. It is possible that this fine little work may depict the tournaments at the

wedding of Gonzaga to Isabella d'Este in 1490.

Three small panel pictures that have hitherto been attributed to other artists may be grouped together as Domenico's. The first, a small picture of the *Virgin and Child* in the Verona Museum (Cat. Wks, No. 7) has passed for a Girolamo dai Libri, but undoubtedly belongs to Domenico's oeuvre, and to the period around 1490. The little Madonna forms a link between his early and late works. Both the Child, gazing out of the picture with large eyes, and the Madonna, her eyes fixedly lowered, are characteristic of Domenico. The faces are neither as long as the type of 1484 nor as round as that of 1503, but the elements are the same. Especially remarkable are the Madonna's high, arched forehead with its clearly defined hairline; the nose tipped slightly upwards; the great distance between the raised eyebrows and the rim of the eyelid; and the lips pressed rather tightly together at the corners. The distinctive features of the Child are the large head, the non-existent neck, the round fleshy cheeks, and the pointed chin. The treatment of light shows this picture to be Domenico's without doubt. The rich and animated modelling, the use of light on the nose, lids, upper lip and chin, and the reflections on the contours concur totally with Morone's style. The hands are especially worth noticing, for over the years Domenico's modelling of hands became more refined. Other factors that place this picture between the other two are the somewhat uncertain outline and the not yet very strong plasticity of the drapery folds. The characteristic brown skin colours occurs in all Domenico's works. Even in small details the similarity with signed works is convincing. The earlier Madonna has an identical hood over the crown of the head and the same anatomically inaccurate hands, a problem that Domenico never really solves. The Madonna's characteristic right hand is repeated in the 1503 frescoes, as is the child's arm, placed rather unclearly round the mother's neck (compare the hand holding a pear twig in the 1484 Berlin picture).

This small but pleasant picture is of particular significance because it shows us afresh how stimulated Domenico had been by Mantegna at the beginning of the 1490s. The half-figure of Mary, closely united with the Child against a monochrome background, without any architectural or other additions, refers back

237 DOMENICO MORONE. *Virgin and Child*, Cat. Wks, No. 7 (Verona, Museum)

238 DOMENICO MORONE. *Betrothal of St Catherine*, Cat. Wks, No. 9 (Stuttgart, Staatsgalerie)

9 DOMENICO
ORONE.
*John the
angelist*, Cat.
ks, No. 11
ergamo,
cademia
rrara)

to Mantegna's small picture of the Virgin. One may compare the pictures in Berlin (Simon Collection, Kaiser-Friedrich-Museum), Milan (Poldi-Pezzolo), Bergamo and above all the print of the sitting *Madonna and Child* in the British Museum, which Kristeller dates between 1480 and 1490.[26] Our dating of the small Madonna picture would fit in with this. The swaddling clothes wound around the Child's body also come from Mantegna. The quality of the work confirms the view that Domenico Morone reached the height of his artistic powers at the beginning of the last decade of the Quattrocento.

The second picture, a Betrothel of St Catherine, is labelled 'Veronese school' in the Stuttgart Gallery (Cat. Wks, No. 9). Its artistic traits certainly indicate Domenico's hand: Berenson recognized the connection with the S. Bernardino refectory frescoes and attributed these as well as this picture to Michele da Verona. It should actually be dated at around the turn of the century. This type of Madonna with the round hood fitting closely over the head, and the Child with large head and the extremely fleshy cheeks are both found in the fresco Madonna. The modelling of the drapery is no longer based on fresh observation of nature, as in the figure of the donor in the 1497 painting, but is closer to the more calculated technique used for the Franciscans themselves. The familiar brownish skin colouring is evident, particularly on the Madonna. The broad treatment of the landscape, which ranges from deep brown through green to light blue, closely matches the fresco. Modelling and treatment of light are more meaningful than with any other Veronese artist around 1500. The nun on the left can be compared in conception and treatment to the wife of the donor in the Franciscan fresco and the head of St Catherine to the Madonna's head of the middle period. Finally if one looks at the left hand of St Catherine and the right hand of the Madonna holding the wreath, one can recognize Domenico's peculiar limitation when it comes to anatomy.

The third work to be considered in this group is the three-quarter length of St John the Evangelist in Bergamo (Cat. Wks, No. 11). A general comparison to other works shows resemblances: the fixed glance of the eyes (reminiscent of Christ in the fresco); the type of

238

239

head (similar to St Catherine); the modelling of the golden hair (again like St Catherine); the sharp facial outline; the extraordinary use of light; the brown skin colour; the wisps of cloud (as in the fresco); the ill-drawn right hand – all are hallmarks of the Moronesque style. The picture belongs to Domenico's latest period, for rigidity of thought and form run parallel. The lifeless outline of the right-hand side and the treatment of the folds are worth pointing out. The way the drapery is handled corresponds to that in St Clare: there as here the broad oval curves of the folds run from the right shoulder to the left hand. However, what was still lively and based on observation of nature in the St Clare, has become mannered in the St John.

As we have seen, Domenico left few works: a total of eleven pictures, of which only three are signed. It is proof of the painter's stature that a clear artistic development can be traced even within such a small oeuvre. So far we have no pictorial evidence of the beginning or end of his career, but we can trace his progress logically step by step. As a pupil of Francesco Benaglio he probably began in the local tradition by following Paduan models; over the years he freed himself from that tradition and won himself a special position in his native town by his monumental art, his modelled bodies and pictorial ideas worked out with absolute consistency. This very consistency was a necessity for him – who had in the beginning been happy to follow living nature – but in the end it destroyed his artistic creativity. Whatever Morone painted after the St John can only have been more mannered and less sensitive.

There are sufficient clues to suggest that he was very active in several other fields. A poorly preserved cycle of frescoes in another part of the monastery of S. Bernardino, Verona, (Cat. Wks, No. 12) is probably Domenico's; several doubtful pictures (Cat. Wks, Nos. 13–15) could well be his; and there are payments which show that he must have played a part in some very large-scale artistic undertakings, although his precise contribution is now difficult to establish (Cat. Wks, Nos 16–17). From records we know that he mastered the technique of the façade fresco (Cat. Wks, No. 19), while a couple of *cassoni* that survive (Cat. Wks, Nos 6 and 19) show that he was no stranger to the world of delicate craftsmanship.

196

Domenico Morone: Catalogue of works

a *Dated and datable paintings*

1 *Madonna and Child* (half-length). Paris, Musée Jacquemart-André. *Musée Jacquemart-André*, 1914, p. 15. Hancke in *Kunst and Künstler* XII (1914), p. 627 (Ill. p. 631). Venturi, in *Storia dell'Arte* VII, 3, p. 502/3 (fig. 392), attributes it to Cristoforo da Lendinara.

2 *Organ wings with St Francis and St Bernard.* After 1481. Verona, S. Bernardino. Two over lifesize panels in tempera. Frequently ascribed to Francesco Morone, e.g. by Biermann, *Verona*, p. 119.

3 *Madonna and Child* (half-length), 1484. Berlin, Kaiser-Friedrich-Museum. Magazin No. 1456. Wood 0·55 × 0·36. Signed: 'Yhs. Dominicus Moronus pixit die XXVIIII aprillis MCCCC(L)XXXIIII.' Bode in *Jahrbuch der preussischen Kunstsammlungen* 1887, p. 120/22 with ill. Further illustration in Venturi VII, 3, p. 465 and Venturi, *La Galleria Crespi*, 1900, p. 63. Photo Hanfstängl 554.
There is no reason to believe that the inscription is a forgery because the number L, in its present condition, is incomplete.

4 *Madonna and Child* (half-length). Lovere, Galleria Tadini No. 28. Berenson, *North Italian Painters*, 1907, p. 266. Frizzoni in *Emporium* XVII (1903), p. 351.

5 *Victory of the Gonzaga over the Bonacolsi*, 1494. Mantua, Corte Reale. In 1713 still in the hands of the Gonzaga as 'opera del Mantegna'; later owned by the Andreazzi, Bevilacqua, Bonazzi, Gobio, Fochessati, and Crespi families. Canvas 1·65 × 3·16. Signed: 'Dominicus Moronus Veronensis pinxit MCCCCLXXXXIIII'. On a stone to the left are the words: 'Passarino Bonacursio victo tiramnorumque omnium perfidia superata Loisius Gonziacus toto eius populo aclamante annuenteque ante suos omnes primus Mantua num imperium adipiscitur.' Venturi, *La Galleria Crespi*, p. 61–72 with illustrations. Molmenti in *Bollettino d'Arte* 1913, p. 464 with ill. Photo Anderson 3463.
By the time it arrived in the Crespi Gallery the picture had been entirely overpainted.

2 6 *Tournament scenes* (Cassone paintings). London, National Gallery No. 1211 and 1212. Wood 0·44 × 0·47. Acquired and attributed by J. P. Richter in 1886. *Catalogue of the pictures in the National Gallery* 1921, p. 204. Schubring, *Cassoni*, p. 371–72 (Plate 144). Venturi, *La Galleria Crespi*, p. 64–65 with ill. Photo Hanfstangl 465, 466. Anderson 18165, 18162.

7 7 *Virgin and Child* (half-length). Verona, Museum No. 143. Panel 0·32 × 0·35. Trecca, *Catalogo*, 1912, p. 29. Ill. Venturi VII, 4, p. 792 as a Girolamo dai Libri.

5 8 *Frescoes in the library of S. Bernardino, Verona,*
6 1497–1503. Inscribed: '1503'. Documents in Simeoni, 'Il fondatore della Biblioteca di S. Bernardino di Verona', in *Atti e Memorie dell'Accademia di Agricultura*. Ser. IV, vol. VII (Verona 1907), p. 301. Insufficient text with ills.: N. Dal-Gal, *Un pittore Veronese del quattrocento. Domenico Morone e i suoi affreschi nel chiostro di S. Bernardino*, Roma 1909. Cf. Zannandreis, *Vite*, p. 84, who already excludes Cavazzola as a collaborator but names Francesco Morone as the painter. Compare also: Frizzoni, *Arte italiana del rinascimento*, 1891, p. 304; Crowe-Borenius, *A History of Painting in Northern Italy* II, 194ff. and Berenson, p. 259 (Michele da Verona). Partial illustration in Venturi VII, 3, p. 467. Photo Lotze 19084, 19086, 19997.

8 9 *Betrothal of St Catherine*, c. 1500. Stuttgart, Gemäldesammlung No. 509. Tempera on canvas (restored) 0·98 × 0·92. *Verzeichnis der Gemäldesammlung*, 1907, p. 185, includes a list of names with which the work has been linked. In addition: Fabriczy in *Madonna Verona* I (1907), p. 10. Borenius, *The Painters of Vicenza*, p. 100, points out its relationship to the frescoes. Similarly, Berenson. Ill.: Fabriczy. Photo Höfle No. 131 library.

10 *Frescoes from the church of S. Nicola da Tolentino al Paladon*, Verona province, 1502. In the Verona Museum since 1909, No. 2070, 2071, two pieces each 1·60 × 2·80. Inscriptions: (1) '1502 S. Rochus die S. Antonius de Padova 17 S. Ononfrius Octubris S. Lucia Dominicus Moronus P.' (2) 'Dominicus P. S. Caterina 1502 S. Leonardus die S. Gotardus 12 S. Dominicus

mense setembris.' Trecca, p. 186. Simeoni, *Gli affreschi di Domenico Morone nella chiesetta del Paladon*. In *Madonna Verona* III (1909) p. 67–71 (2 plates).

11 *St John the Evangelist* (three-quarter length), 239 after 1503. Bergamo, Accademia No. 552 (Morelli Collection). Canvas 0·39 × 0·45. *Catalogo* 1892, p. 17: Girolamo dai Libri. Likewise Berenson p. 240. Photo Arte grafiche No. 180.

b *Badly preserved works*
12 *Frescoes in the Cappella S. Antonio in S. Bernardino, Verona.* Descriptions in Vasari (ed. Milanesi), V, 308/9 and Crowe-Borenius II, p. 194. Simeoni, *Verona*, p. 158: a collaboration by Domenico and Francesco Morone. If one accepts the theory of a collaboration between father and son, then the paintings could not have been done before the mid-1490s. This is contradicted, however, by a single well-preserved section in the upper right of the chapel. It shows a skilfully worked piece of a woman's cloak, which has to be a product of the decade between 1480/90. One could obtain more accurate clues about the style of these works if it were possible to photograph the upper part of these frescoes – especially a half-figure of a Madonna with Child, and also those covering part of the upper wall in the nave.

c *Doubtful works*
13 *Trinity, with John the Baptist and St Albert.* Verona, Museum No. 864. Façade fresco, formerly on the Casa Sparavieri at the Ponte Acqua Morta. 2·07 × 1·73. Trecca, p. 185. According to Zannandreis, p. 87, by Francesco Morone. Likewise Biadego, 'La Cappella di S. Biagio di Verona,' in *Nuovo Architettura*, Veneto XI, part II (1906), p. 114. Ill. Biadego. A proper critique is impossible because of severe damage.

14 *Fresco of the Madonna and Child between St Christopher and the Magdelen.* On the façade of No. 17 Via Nicolo Mazza, Verona (formerly 51, not far from S. Paolo). It is signed: 'Opus Dominici De Morocini 1471.' Zannandreis, p. 59, concurs with the authority della Rosa, who identifies this with Domenico's name. Likewise more recent authors (cf. Simeoni,

Verona p. 333; Gerola, *Madona Verona* III p. 107/8 and Crowe-Borenius). Berenson does not mention the work. The fresco is now barely distinguishable, but going by an engraving in Nanin, *Disegni di varie dipinture a fresco che sono in Verona*, Verona 1864, plate 43, it might indeed be regarded as a very early example of Domenico's art. (Nanin, plate 44, ascribes another fresco to Domenico, *Paul and a donor*, but this can no longer be verified.)

15 *Justice of Trajan*. Cassone. Tondo. Florence, Berenson Collection. Published by Schubring, *Cassoni* (supplement) 1923, No. 955, plate XXII. This picture, known to me only through Schubring's reproduction, seems to be an original Morone.

d *Payments for works* in which Morone's share cannot be established

16 Payments for paintings in S. Maria in Organo, Verona, 1496, 1498–99, 1507, refer to frescoes in the vestry. Documented in Gerola, 'Questioni storiche d'arte veronese,' in *Madonna Verona* III (1909) p. 106.
Domenico was certainly the inspiration for the fine, animated organization of the whole room. As the celebrated head of a school of painters it was he who would have been given the commission and who entrusted its execution to his son. Cf. Part III.

17 Payment for works in the Capella di S. Biagio in S. Nazaro e Celso, Verona, 1498. Documented in Gerola, *loc. cit.*, and Biadego, *La Cappella di S. Biagio di Verona*, p. 110.
In the early 20th century there was a restoration of Falconetto's dome frescoes, named as a collaborator of Domenico. The latter's connection with this work can no longer be determined.

e *Lost paintings*

18 *Madonna with Saints*, 1496, in the Franciscan Convent of S. Maria delle Grazie near Arco (Trentinum). Signed: 'Domenicus Moronus de Verona et Franciscus filius pinxerunt AD 1496 die 16 Aprilis.' Gerola, *loc. cit.* p. 106 contains further literature. The picture disappeared at the beginning of the last century.
Of special importance here is the evidence of

collaboration between father and son. The Paladon frescoes demonstrated the character of such works done for the province.

19 *Façade painting in Piazza de'Signori*, Verona. Vasari (ed. Milanesi) V, p. 308. Zannandreis, p. 59, could still make out a small part of it: 'quasi più vestigio alcuno si vede delle altre pitture a chiaro scuro sulla facciata di una casa . . .'.

20 *Christ led to the Cross* 'con moltitudine di gente e di cavalli'. Verona, S. Bernardino. Vasari (ed. Milanesi) V, p. 309. Not mentioned elsewhere (only recorded as 'Vasari reports' in Pozzo, Bernasconi and others).

21 In Dal Pozzo, p. 30, we read 'Fù anco opera di Dominico la Miracolosa Imagine della Madonna di Lonigo Terra del Vicentino'. Zannandreis, p. 59, makes a similar remark, no doubt following Pozzo. Vasari in his Life of Francesco Morone, p. 310, states: 'Lavoro' il medesimo molte cose a Lonico, in una badia de' Monaci di Monte Oliveto dove concorrono molti popoli a una figure della Madonna, che in quel luogo fa miracoli assai.' There is probably no connection between the Morone and the Madonna. Nothing is known of works by Morone in Lonico.

f *Works erroneously ascribed to Domenico*

22 *Adoration of the Magi*. London, National Gallery No. 3098. Venice, Layard Gallery. Generally credited to Gentile Bellini. Cf. *Catalogue* 1920, p. 13. Likewise Venturi, *Le origini della pittura Veneziana . . .*, p. 34. On the other hand, Gronau, *Die Künstlerfamilie der Bellini*, p. 50, expresses doubts. Fiocco, 'Appunti d'arte Veronese', *Madonna Verona* VII (1913), p. 126/7, attributes the painting to Domenico. (Ill. p. 128). Ill.: Gronau, p. 48. Photo Alinari.

23 *Holy Family*. Altenburg, Lindenau Museum. No. 156. According to Berenson an early work by Domenico, but Schmarsow, 'Maîtres Italiens à la Galerie d'Altenburg' in *Gazette des Beaux-Arts* XVIII, (1897), p. 178, with ill., prefers to attribute it to Asuino da Forlì.

24 *St Bernard of Siena*. Milan, Brera No. 163. Borenius attributes this to Domenico. Cf.

Malaguzzi-Valeri, *Catalogo della Real Pinacoteca di Brera*, 1908, p. 82–83: Maniera del Mantegna. Ill.: Venturi VII, 3, 464. Ricci, *La Pinacoteca di Brera* 1907, p. 91. Photo Anderson 11067.

25 *The Atalanta legend*. Prague, Rudolfinum. Two pieces. Cassoni. Ascribed to Domenico by Schubring (*Cassoni*, p. 371 and plate 143). These are probably the same paintings which once hung in the Museo Moscardo in Verona and which have been credited to Girolamo dai Libri. Cf. Canossa, *La famiglia dai Libri*, p. 106.

26 *A Dominican preaching*. Oxford University Museum No. 24. At the exhibition of Venetian art in London (New Gallery) in 1895 the picture was given to Jacopo Bellini. According to Berenson, school of Domenico. (*Venetian Painting, chiefly before Titian, at the Exhibition of Venetian Art*, 1895. p. 23). Detailed analysis and complete list of the literature in Testi, *La storia della Pittura Veneziana*, 1915, II, p. 272/4: according to Testi, from the Veronese school around 1470. Cf. also *Cavazzola*, Cat. Wks, No. 24, 25.

27 *Madonna worshipping the Child*. Venice, Museo Correr, Room XV, No. 36. *Elenco degli oggetti esposti*, 1899, p. 242: 'Domenico Morone di Verona(?) – La siglia di Albrecht Dürer falsamente aggiunta.' Also marked '?' in Berenson. Since the reorganization of the collection in the Palazzo Ducale, I cannot trace the painting's location.

In various places in the older literature one finds erroneous attributions, which have now mostly been corrected. (In the *Elenco dei pezzi di pittura e stampe ...* of 26 Oct. 1812, reprinted in *Madonna Verona* I (1907) p. 204 (No. 57) it states: 'Morone il vecchio – La Beata Vergine ed altri santi.') This is probably an altarpiece now in the Museo Civico, attributed to the 'Pittore da cespo di garofano' and dated 1487. Cf. Trecca, p. 18 (No. 360).

Berenson, p. 266/7, mentions three pictures in private collections, about which I could learn nothing. (In the possession of J. E. Taylor in London – this collection was auctioned in 1912 – of Georg Chalandon in Paris, and in the former Layard Collection).

Robinson (*Descriptive Catalogue of Drawings by the Old Masters, forming the Collection of John Malcolm* 1876, p. 121, No. 337) describes as a work by Domenico a drawing of a saint, standing with a book, in the Malcolm Collection (now in the Victoria and Albert Museum.)

The followers of Domenico Morone

The three leading painters who followed Domenico Morone were his son Francesco, Girolamo dai Libri and Paolo Morando, known as Cavazzola. Before looking at their works individually I propose to discuss briefly the features that they have in common and their relation to the Veronese artistic tradition.

The scope of Veronese painting shows the limitations of a provincial school. The main emphasis was on devotional pictures of the Virgin, in two alternative formats: either small, for domestic use – a half-figure with the Christ Child; or lifesize Madonnas with saints, intended for churches. Yet the subject produced artistic achievements, and resulted in a particularly tight-knit pattern of development.

The religious theme was so narrowly defined that even the Old Testament was totally ignored. Secular subjects were hardly treated at all. Only Cavazzola concerned himself with portraits, a number of which can certainly be attributed to him. As a group, these painters went on producing the kind of pictures that had been standard in Tuscany for a hundred years.

To begin with composition. Here one has to go primarily by the large format Madonnas, since this was the biggest challenge that this group of painters was ever called upon to meet. The Gothic triptych lived on in Verona – as in Venice – until the late Quattrocento, longer than in Florence where painters, even by the beginning of the 15th century, had gone over to the unified type of picture, to the simple panel or canvas of the Renaissance. We know of a whole series of Veronese altarpieces from the middle of the 15th century, in which individual figures are isolated by means of ornamental pilasters. This type of composition went out of fashion immediately after Mantegna's S. Zeno Altarpiece (1456–1459). Francesco Benaglio's triptych in S. Bernardino in Verona[27] already shows Mantegna's influence. The Virgin, Child

240 FRANCESCO MORONE. *Madonna and Child with St Nicholas and S. Zeno*, Cat. Wks, No. 5 (Milan, Brera)

241 FRANCESCO MORONE. *Madonna and Child with St Joseph, St Jerome, St Anthony and St Roch*, Cat. Wks, No. 8 (Verona, Museum)

and Angels occupy the centre; the saints are grouped on the outside panels of the altar, three on each wing. And in his altarpiece in the Accademia in Venice[28] the pilasters separating the groups have disappeared. The Renaissance has prevailed.

The path from here to Francesco Morone's picture in the Brera (Cat. Wks, No. 5) is short. Foreground and background are clearly differentiated. The socle and throne on which the Madonna sits occupy the centre of the stage. The two saints stand in the left- and right-hand corners of the foreground. Symmetrical festoons meet directly above the Madonna's head at the upper edge of the painting. A rather bare landscape appears in the background. Horizontally, the work can be divided into two almost equal sections. The focal point lies along this line, roughly in the centre of the triple throne socle, and therefore the Madonna is seen from below. She and the Child in her arms appear full face, while the saints are shown in three-quarter profile. Essentially the picture is close to Francesco Benaglio, but Morone has simplified the composition wherever possible: the playing putti are omitted, and nothing remains of the rich architecture but the marble floor tiles. The saints have been moved nearer to the throne, to achieve a tighter composition.

With slight variations, the whole series of large Madonnas follows the same basic pattern. The *Madonna with St Martin and St Augustine* in Santa Maria in Organo (Cat. Wks, No. 6), for example, has additional angel musicians at the side of the painting, near the heads of each of the saints. The clothes are more splendid and carefully painted, the decoration on the throne is richer, the landscape more developed. The Berlin picture (Cat. Wks, No. 24) adds a new compositional element: the foreground is separated from the background by a parapet.

Two frescoes may be mentioned in the context of these devotional pictures. That of 1515 (Cat. Wks, No. 8) retains the old composition, and it is only with difficulty that Morone was able to add the bearded heads of St Jerome and St Anthony, in the spaces left and right of the Madonna, between her and St Joseph and St Roch. The fact that it was painted high up on the wall of a house meant that the artist had to adopt a *sotto-in-sù* perspective. The other fresco is over the side entrance of S. Fermo

(Cat. Wks, No. 28); here the saints have lost much of their symmetrical stiffness and begin to move freely. And instead of the invariable three-quarters view the artist shows St James on the left in profile and St Roch on the other side full face. As in the Berlin picture, the stagelike foreground is closed off by a curtain. Morone readily used the same construction for other compositions: as in the *Christ on clouds between the Virgin and St John* (Cat. Wks, No. 12), and the half-figure picture in Bergamo (Cat. Wks, No. 25). Here a representation of the Madonna with four saints was required. One cannot escape the feeling that Morone has merely compressed the composition of the 1515 picture a little and cut down the format at the upper and lower edges to fit the requirements of the half-length figures.

The simplest form of Girolamo dai Libri's type of devotional picture is the *Maffei Madonna* (Cat. Wks, No. 12). The overall construction is like Morone's but there are significant differences. The symmetrical arrangement is less rigid, the figures are more lively, the space is deeper and freer, and the landscape is brought determinedly into the composition. Girolamo had the ability to create many variations on the same basic theme. His altarpiece of 1526 (Cat. Wks, No. 13) shows a severe, symmetrical construction, individualized by the three half-figures of angels playing music and sitting in an awkward way in front of the stage. This not very happy idea seems to have preoccupied Girolamo.[29] It is Venetian in origin, taken either directly from Giovanni Bellini or indirectly through Bartolomeo Montagna, who lived for some time in Verona. It is unlikely that the angel heads on Mantegna's S. Maria in Organo Altarpiece were a decisive influence, but the extreme *sotto-in-sù* of that picture, which results in their bodies being cut off half way up, may have caused some misunderstanding of the motif. These angels are recognizable already in Giovanni Bellini in the 1470s (lost work from S. Giovanni e Paolo in Venice), in the 1480s (S. Giobbe Altarpiece, now in the Accademia), in the 1490s in the Frari, and after the turn of the century in S. Zaccaria. Putti musicians are used everywhere to fill the space around the throne.

The same composition is no more successful in dealing with donor portraits. In Girolamo's

242 GIROLAMO DAI LIBRI. *Madonna and Child with St Sebastian and St Roch*, the *Maffei Madonna*, Cat. Wks, No. 12 (Verona, Museum)

243 GIROLAMO DAI LIBRI. *Madonna and Child with Lorenzo Giustiniani and S. Zeno*, Cat. Wks, No. 13 (Verona, S. Giorgio in Braida)

244 GIROLAMO DAI LIBRI. *Virgin and Child with St Anne, Joachim and St Joseph*, Cat. Wks, No. 10 (Verona, S. Paolo)

245 GIROLAMO DAI LIBRI. *Madonna and Child with St Joseph, the Archangel Raphael and Tobias*, the *Madonna dell' Ombrello*, Cat. Wks, No. 16 (Verona, Museum)

244 *Virgin and Child with St Anne* in Verona (Cat. Wks, No. 10), the half-length figures of the donors are cut off rather unpleasantly by the lower edge of the picture, making them appear to gaze up at the saint from a hole in the ground. Girolamo also cuts off the bodies of the donors in the altarpiece in S. Anastasia (Cat. Wks, No. 4), although here the heads are held more naturally. Morone and Cavazzola each repeated this design twice,[30] possibly following the example of Mantegna. A similar approach is used in his early *St Sebastian* of 1455 and in the predella pictures for the Crucifixion on the S. Zeno Altarpiece. The motif was most often used by second-rank artists of the Giovanni Bellini school such as Basaiti, Previtale, Bissolo and Catena.

Another familiar aspect of Girolamo's composition is found on the altarpiece of 1526: a marble parapet that divides the landscape from the platform of marble tiles on which the saints stand. Morone had already used the device, but in Girolamo's compositions it assumes a much

greater importance.[31] The so-called *Madonna dell'Ombrello* (Cat. Wks, No. 16) shows an abrupt and confused transition from the marble floor of the foreground to the landscape behind. The *Madonna della Quercia* (Cat. Wks, No. 17) achieves a successful transition from foreground to background by placing the group of figures in an infinitely deep and rich landscape, eliminating the need for any further device. The fact that it was Girolamo and not Morone who found this solution is due to the two painters' different emphases on landscape.

The Berlin *Madonna* (Cat. Wks, No. 11) is related in style to the picture from San Giorgio (Cat. Wks, No. 13). The *Madonna dell'Ombrello* (Cat. Wks, No. 16) is more animated, with stronger movement and a greater emphasis on the landscape. With the *Madonna della Quercia* (Cat. Wks, No. 17) a new spirit breaks through and the old system is abandoned. The Madonna is enthroned on the clouds, from which she looks down. Where a throne would have been in the older convention there is now an empty

246 GIROLAMO DAI LIBRI. *Madonna and Child with St Peter and St Paul*, the *Madonna della Quercia*, Cat. Wks, No. 17 (Verona, Museum)

247 CAVAZZOLA. *Madonna on Clouds with Six Saints*, Cat. Wks, No. 20 (Verona, Museum)

space, through which the eye is led into a distant landscape. This meant that instead of the traditional symmetrical arrangement of three-quarter-length figures of saints, a new way had to be found to link the two sides together. The inner unity of the lower group is achieved through the rotational movement of the two saints.

Girolamo's fresco of the *Madonna with Saints* in the Piazza d'Erbe in Verona (Cat. Wks, No. 20), adapts Morone's type of devotional picture to a façade. Two examples of the Veronese landscape school should be mentioned in this connection (Morone, Cat. Wks, No. 36 and Girolamo No. 32).

Girolamo's *Virgin and Child with St Anne* in Verona (Cat. Wks, No. 10) remains closer to the old conventions than any other, but at the same time brings the figures of Mary and the Child wholly within the contours of St Anne. His *St Roch with St Sebastian and Job* in S. Tomaso (Cat. Wks, No. 5) also relates to devotional paintings in structure.

Cavazzola's *Madonna with Saints* in Calavena 265 (Cat. Wks, No. 6) follows the usual conventions in their simplest forms. In his late work, *The Madonna on Clouds with Six Saints* (Cat. Wks, 247 No. 20), the old and the new are in conflict, and the problems of construction are unresolved. Mary is raised on the cloud throne, surrounded by angels, but the saints below are symmetrically lined up three by three, on each side, without any apparent relation to the upper part of the picture. To harmonize the composition and clarify the connection of the foreground to the background, either the isolation of the lower group ought to be resolved or the Madonna ought to be returned to her normal place on the ground. Unlike Girolamo, who from the very beginning prefers a clear, unified viewpoint to create a relationship between people and landscape, Morando (Cavazzola) chooses a low viewpoint for his saints and a high one for his landscape. This produces a second flaw in his composition; however, this is a transitional work.

203

248 CAVAZZOLA. *Madonna and Child*, Cat. Wks, No. 1 (Verona, Museum)

249 CAVAZZOLA. *Madonna and Child with St John*, Cat. Wks, No. 5 (Berlin, Staatliche Museen)

For his small, half-figure Madonnas, Francesco Morone uses variations of all the basic elements that he had learned from Domenico: the old conventions of design, the full-face Madonna with the Child in her arms; the rear parapet (Francesco usually avoids the front one) or the curtain; the landscape quite unrelated to the foreground. How hard he strove for new effects can be seen from the way in which strikingly similar motifs recur again and again. The half-figure in Berlin (Cat. Wks, No. 9) is a parallel to the *Virgin and Child* in the Brera (Cat. Wks, No. 5). A comparison between the two reveals the means he uses to achieve variety of composition, but the differences only become apparent upon careful examination. In the Brera picture the Child looks passively at S. Zeno; in the Berlin picture of the blessing Christ Child, variety is achieved through a very slight shift of the pupils and a gentle raising of the right arm in the gesture of blessing. A bird appears in both pictures, but looks in opposite directions; in one it sits on the hand, in the other on the index finger.[32]

Other comparisons would illustrate the same point. Cavazzola's early *Madonna and Child* in the Verona Museum (Cat. Wks, No. 1) relies on a taut composition strongly stressing horizontals

and verticals. The late *Madonna and Child with St John* (Cat. Wks, No. 19) reaches the Cinquecento. The symmetry and isolation of the figures have disappeared and the horizontals and verticals no longer dominate the construction; instead, the emphasis has shifted to the right-hand side of the picture and the figures are brought together as a unity. The diagonal from bottom right to top left on the body of Mary, and the counter movement over the Christ Child's naked leg, through the knee and arm of Mary, are crucial for the composition. The stages in the development of this composition can be seen in the Madonnas in London (Cat. Wks, No. 11) and Frankfurt (Cat. Wks, No. 17) in both of which the figures begin to blend together and the horizontals and verticals have disappeared.

In the Verona circle, the devotional picture generally retains its early Renaissance technique of composition, which is characterized (let me say it again) by an inorganic disjunction of foreground and background, by severe symmetry, by the isolation of individual figures and by a love of decoration. Morone's compositions hardly deviate at all from these principles, whether he is painting for domestic or ecclesiastical settings. But Girolamo, in his

248

250 CAVAZZOLA. *Madonna and Child with John the Baptist and an Angel*, Cat. Wks, No. 11 (London, National Gallery)

251 CAVAZZOLA. *Madonna and Child with an Angel*, Cat. Wks, No. 17 (Frankfurt, Städelsches Institut)

pictures for churches, does develop clearly and quickly towards the Cinquecento, and so does Cavazzola in his half-figure Madonnas.

Liberale da Verona, always a follower of schools outside Verona, left not a single devotional picture that could compare in unity (not quality) with those from the school of Domenico Morone. Outside influences precluded uniformity of production. Painters belonging to his school also chose from a much wider range of subject matter. In his devotional pictures, however, Liberale generally retained the old symmetrical construction, while Giolfino and Caroto tried new approaches. They were producing pure Cinquecento works at a time when Morone and Girolamo were still painting their strictly constructed large-scale enthroned Madonnas.[33]

The conclusions to be drawn from devotional pictures can be applied to all other subjects, so we may confine our attention to a few typical features. Baptismal scenes are very similar in composition all over Italy in the Trecento and Quattrocento, and Perugia and Verona are especially akin, as regards both content and level of accomplishment. Anyone who compares Perugino's *Baptism* at Vienna with Girolamo dai Libri's in the Verona Museum (Cat. Wks,

252 CAVAZZOLA. *Madonna and Child with St John*, Cat. Wks, No. 19 (Verona, Museum)

253 GIROLAMO DAI LIBRI. *Baptism of Christ*, Cat. Wks, No. 18 (Verona, Museum)

254 FRANCESCO MORONE. *The Washing of the Feet*, Cat. Wks, No. 13 (Verona, Museum)

No. 18) might be forgiven for mistaking the latter for a copy after the former, though it was in fact done thirty years later. Yet if one looks at the details it becomes clear that they share nothing except a feeling for calm unified grouping and undramatic arrangement of figures with no attempt at variation of movement or directional contrasts.[34]

The theme of the Washing of the Feet was seldom treated in Italy, and so there was no traditional type of composition for the painters to follow. The three examples that I know from Northern Italy from about 1500 are: the painting by Agostino da Lodi (Pseudo-Boccaccino) in the Accademia in Venice, which follows the composition of the Descent of the Holy Spirit; Caroto's in the Verona Museum, which is based on the Last Supper; and Morone's (Cat. Wks, No. 13), which betrays a very obvious uncertainty in its composition: it succeeds neither in ordering the figures in space nor in unifying the groups placed near each other; moreover, about half way up it tends to divide into two parts – a dilemma typical of the lack of intellectual control.

Cavazzola was the only one of our group to paint portraits, nearly all of them of the same format with the entire width always filled by a roughly lifesized half-length figure (including arms and hands) against a neutral background. They all show strong Venetian influence: his *Gattamelata* that of Giorgione's *Concert* or the *Bravo* often attributed to him. Other compositions recall works by Bordone, Licinio, or Dosso Dossi's *David* (Borghese Gallery) and his *Satyr and Nymph* (Pitti Palace).

Milanese portraits of the period are smaller than lifesize and retain the landscape as background, whereas in Venice Giorgione, Palma, and Titian developed those features which are characteristic also for Cavazzola.

A few façade frescoes by this group of painters may be mentioned with the devotional pictures. Girolamo appears to have hardly bothered with frescoes; Francesco Morone's frescoes are mainly of a quality that does not stand comparison with his finely worked small Madonna pictures; most of Cavazzola's frescoes are lost and we have therefore no means of judging his ability in this field. Two examples only are worthy of discussion: the ceiling painting of the Cappella Pompei (Morone, Cat.

Wks, No. 23) and the fresco decorations in the sacristy of S. Maria in Organo (Morone, Cat. Wks, No. 11). Each provides a standard of comparison for judging the other. In the apse of the little, vaulted chapel there is a representation of God the Father, holding an open book in His left hand, blessing with His right, while trumpeting angels swirl about in the glory that surrounds Him. The four evangelists are distributed in round medallions at the apex of the vaults in the square main space. Each, holding an open book like God the Father, looks out from a simple framework. In the sacristy of S. Maria in Organo the system of ceiling and wall decoration is far superior. While the conceptually related parts have no formal unity, the wall and ceiling arrangement has been intricately thought out and richly decorated. Payments to Domenico Morone suggest that the conception of the design should be attributed to him, and a comparison with Francesco's monotonous frescoes in the Cappella Pompei support this thesis. The figure paintings are almost entirely restricted to the walls; here, separated by decorative pilasters, stand groups of famous Benedictines, painted in half-length and arranged in threes and fours. Below this frieze are ornamental frames with explanatory texts related to the monks above. The connection is skilfully achieved by placing the medallions with inscriptions on painted hooks, born by the architectural structure that serves as a balustrade to the monks.

This system fits the architecture of the room. Lunettes cut into the domed ceiling, and on these are painted half-figures of popes conversing in pairs. The figures thus build up from the groups of three in the frieze to two in the lunettes, and form an easy transition to the receding semicircles of the ceiling. At the very top, where the axes intersect, is a painted opening through which angels look down over a balustrade while the blessing Christ descends from Heaven. All this bears witness to the potent effect that the Camera degli Sposi must have had on Domenico when he stayed in Mantua. That he, not Francesco, was the real originator of this scheme is proved by the figures of men in conversation, an obvious reminiscence of the S. Bernardino Library.

Thus the only really important fresco of this group cannot entirely be attributed to Francesco

Morone, which means that none of these Veronese frescoes can in any way compare with the works of Domenico in S. Bernardino.

From composition, let us now turn to a consideration of form and colour.

The nude was not at all a favourite subject, and when painted is often angular and awkward with stiff joints and peculiarly positioned feet, especially when the figure is represented as moving. Although anatomy was never totally neglected, it was not a crucial factor in artistic study for this group of painters, and mistakes are not uncommon. Important joints, such as ankles and wrists, are clumsy; heads do not sit easily on necks; often the trunk, neck and head lack organic unity. Stiffness and angularity are also characteristic of the treatment of drapery. Folds are either long, parallel and tubular or broken and jaggedly pointed. They end in a straight line just above the feet.

Landscape backgrounds, painted with a mixture of naivety and naturalism that looks straight back to the early Renaissance, very often feature the countryside round Verona, with Verona[35] itself or maybe Lake Garda[36] in the distance. These painters liked showing hills at the foot of high mountain ranges, but realism is limited to details like the local flora[37] – it does not lead to the coherent representation of an entire landscape. The sky is alive with clouds, though earlier there is a preference for long, horizontal strips of clouds spanning the landscape and creating the same impression of parallelism as the trees in the landscape, the folds in the drapery, and the figures themselves.

Veronese painting, in particular that of the circle of artists under discussion, is easily recognized by the use of bright colour, which is common to all of them, although there are pronounced differences between individual masters. The impression created by these pictures is one of extreme light and clarity. Their basic tonality is a bright yellow, which rises from the horizon, saturates the landscape and is picked up in the lights of the skin, the hair and the drapery. Bright red is used frequently, producing a characteristic, peculiarly Veronese colour at the points of transition into yellow. A transparent pink is used for the skin, which in shaded areas becomes greenish or brownish or a kind of dirty umber.[38] A cool, bright violet – sometimes mixed more with blue, sometimes

207

Virgin and Child, especially, go back to Domenico's library fresco. Girolamo's Madonnas have a more oval head, and Cavazzola's in his best period have pointed chins. In Cavazzola's early works, however, e.g. the *Madonna and Child* in Verona (Cat. Wks, No. 1), the rounded Moronesque forms are still obvious, and the stiff, tubular, parallel folds of the drapery point in the same direction. Girolamo dai Libri used highly creased, flat folds from the very beginning, but even in his 1526 altarpiece, the straight contours, the drapery ending with a horizontal edge and the long, though much less sculptural, folds all show that he has not wholly emancipated himself from Domenico's influence.[39]

255, 256 FRANCESCO MORONE. Left-hand organ panel from Marcellise, inside (above) and outside (right), Cat. Wks, No. 7 (Verona, Museum)

more with red – is often used for garments, in the landscape and even for shadows on parts of the flesh.

Domenico Morone is the focal point from which specific influences radiate. It is not always easy to spot the small signs that indicate the transmission of ideas of form and colour from master to followers; the links that join them together are too close. But one can venture a few observations. Domenico Morone's influence is strongest on the development of his son, weakest on that of Cavazzola. Francesco takes over those rounded heads that are the hallmark of the later Domenico. Heads of the

There were, of course, other important sources for the art of Verona at this period, of which Mantegna is by far the most crucial.

To understand the dominant position that Mantegna occupied in this group, it might be best to concentrate on two works which were in Verona and which they could see day after day – the S. Zeno Altarpiece and the painting in S. Maria in Organo. Certain essential features – facial types, poses, drapery – were taken over wholesale, though it must be stressed that they were invariably given a specifically Veronese character: Mantegna's austere gravity became looser and all too often cruder; his powerful outlines relaxed; his strength of drawing was replaced by a softer, more picturesque manner.

257, 258 GIROLAMO DAI LIBRI. Right-hand organ panel from Marcellise, inside (above) and outside (left), Cat. Wks, No. 8 (Verona, Museum)

For example: the very similar heads of St Peter and St Benedict turn up again and again in the Veronese circle.[40] The type of the St John the Evangelist can be recognized in Girolamo's painting in the Mond Collection and (with head raised) 262 in Morone's *Crucifixion* of 1498. Cavazzola's Christ resembles the John the Baptist of Mantegna's S. Maria in Organo painting.[41] Girolamo was almost the only one to be strongly influenced by the Madonna in this late picture. The oval shape of the head and the way the hair is parted are endlessly repeated in his work. In general, the earlier S. Zeno Altarpiece, with its sculptural treatment of drapery and its bold,

angular broken folds was a much more powerful influence than Mantegna's later style, where the materials cling to the body as if damp and spin a web of thin, finely articulated folds over the forms beneath. Here and there both styles can be found together, as in Girolamo's *Pietà* at Malcesine, where Mantegna's early manner appears in the St John and the later one in the Magdelen. Girolamo generally prefers the early style, while Morone and Cavazzola depend less on Mantegna.

Particular features of the S. Zeno Altarpiece keep on recurring in Veronese art – for instance the magnificent cloak of St Peter,[42] the inlaid marble floor on which the action of many Veronese paintings takes place, and the garlands of fruit in the foreground. Girolamo's garland in his altarpiece for S. Anastasia comes closest to the original in its freshness of perception. It appears again in Morone's 1515 fresco and in the Madonna in the Brera, but in a more dessicated style. Finally, the pose of the Madonna herself, with one hand slipped under the Child's foot while the other embraces the tiny Child who puts His arm round His mother's neck – all these features are found often enough in the Veronese masters.[43] In the structure of the landscape and in colour, Mantegna's influence is less conspicuous. Only the yellow from St Peter's cloak in the S. Zeno Altarpiece appears from time to time, for instance in the St Joseph of Girolamo's *Adoration*.

241
240

If Mantegna is the dominant influence on Girolamo dai Libri, Francesco Morone succumbs to Giovanni Bellini. He follows Bellini in facial types[44] and in the attitudes of single figures.[45] It is not a question of direct copying, but of close association of style. Indeed, Bellini's influence was more than merely formal. There must have been regular contact between Verona and Venice. The use of canvas was first introduced into Verona by Jacopo Bellini, and from him Domenico Morone took his prevailing dark-brown skin colouring. This persists in the early pictures of Francesco Morone and Girolamo dai Libri, until under the guidance of Giovanni Bellini they begin to use brighter and clearer colours. Knowledge of oil painting reached Verona only through Giovanni Bellini's late works. It was Girolamo who went one step further than Bellini: by using a coarse grained canvas with thinly applied paint, he makes the

texture of the ground part of the effectiveness of the picture. Here we are already close to Titian and Giorgione's methods, though in other respects their influence is hardly perceptible. Only the composition of Cavazzola's portraits is in a general way Venetian, and there may be Venetian influences at work in certain details of his drawing, e.g. of hands.

The geographical position of Verona encouraged its artists to borrow whatever was worthwhile from wherever they found it. But in contrast to the Liberale-Caroto circle, our group (Francesco Morone, Girolamo dai Libri, Cavazzola) skilfully assimilated what they took from others and always kept their own artistic individuality. Connections can be followed even as far as the Milanese and Correggio. The idea of making the Christ Child and St John play children's games had been most beautifully realized by Correggio. The theme of the motherly Madonna with the two playing children was little known in Venice. Leonardo used it and from him it spread through the widening circle of his followers; Raphael used it in Florence and Rome; Correggio in the north. Cavazzola's Madonnas, particularly the last one in Verona (Cat. Wks, No. 19), derived basically from Correggio, but owe something, e.g. the Child's completely bald head in the Frankfurt picture, to Leonardo. This feature is so unusual that one cannot imagine it otherwise. There is also a colour element; the deep-set, shaded eyes with the emphasis on the lids come from Leonardo and are especially common in Cavazzola's later pictures. Moreover, especially in his 1517 altarpiece, he uses a very smooth primer in order to achieve the sort of surface favoured in Milan.

It is very probable that engravings by Marcantonio Raimondi after Raphael were studied. The increasing use of *contrapposto*, particularly by Cavazzola, serves to strengthen this view.[46] In fact one should probably see the strange circle of symbolic figures that appears in Cavazzola's picture of 1522 and that is peculiar to Northern Italy and especially Verona as the result of influences from Roman and Florentine art that are no longer completely traceable.[47]

Finally, a word about expression. While the Florentines tended to rely heavily on contrast, both between the main groups and movements of a composition and between individual

features and gestures within groups, North Italian practice was quite different. Nature was not idealized in order to make striking effects, but reproduced as it was seen. In expression and gesture, the North Italian painters could achieve excellence in details and on a small scale – the rendering of texture or the accidental qualities of the skin in portraits, for example – but were less successful in large-scale compositions. Indeed the truth is that their range of facial expressions and gestures is not wide enough to convey a great variety of movement and psychological contrast in a large painting with many figures. Only when, for instance, one of the figures collapses and his neighbour reaches up in despair does the action become really effective; however, this sort of effect is not naturalistic but dramatic, not North Italian but Florentine.

What is true of North Italian painting in general is true particularly of the Veronese. In a work like Morone's *Madonna with Saints* in S. Maria in Organo, neither the facial expression nor the gestures are in the least riveting. No parts of the picture make a less lively effect than the saints' heads and the monotonous symmetry of their arms. How limited the Veronese artists were can only be understood by going through a whole series of their paintings. If one systematically examines all of Francesco Morone's Madonnas, one is astonished to see how little they change over a period of thirty years. The gestures too are reduced to a set of naturalistic formulae. If one looks at the way the Virgin carries her Child, one finds very few differences between one picture and another. The same is true of the saints' poses, their arm movements, and so on.

Nevertheless, the development of expression and gesture which is observable in Venice in the years between Jacopo and Giovanni Bellini is to some extent reflected in the Veronese painters – least in Domenico Morone, rather more in his followers. Domenico's severity gives way to smoothness, almost sentimentality. The austerity of outline and the sculptural quality of the forms are softened; facial expressions are freed from rigid obedience to convention.

Still, our group of artists can hardly be said to enter the world of the Cinquecento. Faces and gestures reflect that late Quattrocento spirit that keeps a certain constraint in their tenderness

and their exuberance. Between Venice and Verona there is a time lag of more than a generation. The Venetian Quattrocento (Jacopo Bellini) is followed by the Early Renaissance (Giovanni Bellini) and then by the High Renaissance (Giorgione and Titian). In Verona Cavazzola's portraits represent the first creative stirrings of the Cinquecento only a few years before Titian painted his splendid *Assumption of the Virgin* in Verona Cathedral.

It is certainly no mere coincidence that Cavazzola is the only one of these artists from whose hand portraits have come down to us. He was the one with the widest artistic horizons. We have seen what an exceptional position he had reached. He certainly outstripped the others in his subject matter. Morone's compositions are rigid and almost unvaried; Girolamo treats the same themes with greater originality and imagination; but Cavazzola exhibits a really remarkable versatility and multiplicity of ideas. If Girolamo looks primarily to Mantegna and Francesco Morone to Giovanni Bellini, Cavazzola goes farther afield than either by assimilating influences not only from Venice but from Lombardy, Florence and Rome. While Morone and Girolamo base their colour on what Domenico in his maturity had been able to learn from the Venetians, Cavazzola in this respect too goes his own way in his masterly use of an almost magical blue and his acceptance of the influence of Milan. The situation is the same if we look at expression and gesture – Cavazzola is the most lively and versatile, Morone the most monotonous and unvaried. Indeed, it is not difficult to grade these painters by the quality of life they are able to confer on their creations: Morone's people, without character or psychological stature, display a certain sentimentality in his better pieces, but in his weaker ones do not rise above a fixed stare and a bored expression. By comparison, Girolamo's figures seem to have an inner strength and warmth. Cavazzola possesses the emotion that they both lack. Together with a sort of dreamy sentimental charm, it allows him to achieve such a remarkable work as the Frankfurt Madonna, who, though almost in a 251 dream herself, carries in her arms a singularly cheerful and lively Child. As his portraits prove, Cavazzola alone has the ability to grasp and convey personality.

If we look at the way each of these masters developed, the results are very much what we should expect. Morone, resistant to change of any sort, shows no real progress, so that it is very difficult to establish any chronology for his works. Girolamo dai Libri, though not exactly a man to sweep all before him, does allow himself to be slowly carried along by the times, and not only shows a clear development towards freer forms and increasingly painterly technique but

246 in his *Madonna della Quercia* produces what is compositionally the most advanced piece in the whole series. For the Veronese, this meant nothing less than a step towards the High Renaissance. Finally, Cavazzola displays a rapid and accelerating progress which breaks off all too soon with his early death.

Francesco Morone

Little is known of Francesco Morone's life. Vasari gives the date of his death as 16 May 1529 and his age then as fifty-five years. That would make his birth-date 1474. On the other hand the registers[48] of 1472 record him as being then one year old, and those of 1481 as ten years old. He is entered as having died in 1529 at the age of fifty-nine. So in all probability he was actually born in 1471. He left two daughters and a son. His wife Lucia seems to have died before him. We hear further from Vasari that Francesco studied under his father but soon surpassed the latter in artistic skill, a judgment that still enjoys almost total acceptance today, although the superiority of the father is beyond question. Personal ties linked Francesco to Girolamo dai Libri.[49] The two artists were the same age and not only had had a similar education but also shared very similar artistic views. Girolamo was the stronger character and many traces of his influence on his friend can be found, particularly during the time of their collaboration in 1515 and 1516. Although Vasari grants Francesco little more than the customary formal tribute, one would like to take the essence of his words at their face value: 'fù persona tanto da bene e così religiosa e costumata, che mai s'udì uscire di sua bocca parola che meno fosse che onesta'.

254 Francesco's traditional self-portrait, the water bearer in his large *Washing of the Feet*,[50]

illustrates Vasari's words and renders them perfectly credible.

While both Girolamo and Cavazzola have been the subject of research by art historians, Francesco has up till now been neglected. The reason obviously is the static nature of Morone's work and the absence of any clear and attractive pattern of development. He freed himself only slowly and painfully from his father's influence, but eventually moved towards greater depth, increased roundness of form and freedom of movement, contrasts of expression and overall brightening of colour. The influence of Domenico's studio is evident until about 1505; after that Venetian models are dominant. The time of his greatest activity and most attractive works comes to an end around 1515. Later the initial honesty changes to weakness.

Morone is at his best in his small Madonna pictures. In these, he usually succeeds in endowing the figures with a mood of pleasant lyricism.

A particular nuance of colour makes Francesco's pictures easily recognizable. No other painter uses such a bright pink for the skin. This he uses more and more, as he frees himself from Domenico. It is a peculiarity of his that, instead of applying the skin shading in dark colours directly on to the ground, he paints it over the pink tint of the skin, which continues to shine through.

The following attempts to arrange groups of paintings in chronological order and from the complete works to trace more clearly the master's development.

Francesco Morone: Catalogue of works

1 *Crucifixion with the Virgin and St John*, 1498. Verona, S. Bernardino, Capella S. Croce. Canvas 3·49 × 1·76. Originally the centre part of the larger altarpiece by Cavazzola (cf. Cavazzola, Cat. Wks, No. 7) Signed: 'Fraciscus Moron. P. 1498.' Cf. A. Avena, *Catalogo della esposizione d'arte antica*, Verona 1919, p. 26. Ill. Venturi, VII, 4, p. 498 – Richter, *Mond Collection* p. 274. Photo Alinari 3534.
The skilful modelling in the style of Domenico Morone, the severity and strength of the expressions, which surpass all his subsequent works in intensity, and the rich movement,

unusual for Francesco, show how much he had gained by working in the studio of his far more gifted father. He probably continued in this position until the beginning of the new century. For his collaboration with Domenico, see Domenico Morone, Cat. Wks, 8, 10, 12, 18.

2 *Two predella paintings, with St Francis and St Bartholomew.* Half-lengths. Verona, Museum No. 285 and 291. Wood, each 0·60 × 0·40. Transferred to the Museum from S. Bernardino. These belong to the painting described above; they were placed under Cavazzola's *Pietà*, and between the saints' heads by Cavazzola. See Cavazzola, Cat. Wks, No. 7. Trecca, *Catalogo* p. 44.

Badly overpainted and covered with heavy shiny varnish, the pieces are of almost no value to the critic and indeed can give very little pleasure to anybody. But the well modelled forms, the deep shadows on the skin and the harsh transitions into the illuminated parts – all probably similar to the work's original character – again show connections with his father's style.

3 *Baptism.* Fresco. Verona, Museum No. 464. 4·28 × 3·78. From the Capella della Dottrina in S. Nazaro e Celso, transferred in 1881 to the museum. Cf. Trecca, p. 114. Ascribed to Cavazzola by a number of older writers. Thus, Bernardini ('La collezione dei quadri nel Museo Civico di Verona', in *Bolletino ufficiale del ministero dell'istruzione pubblica* XXIX, 1902) and Biermann, p. 139 (Ill. here). See also Von der Bercken, *Malerei der Renaissance in Oberitalien* p. 229. Ill. in Biadego, *La Cappella di S. Biagio*, p. 112. Photo Anderson 12419.

Biadego, p. 111, tries to prove that two payments to Francesco Morone are related to this fresco. The first one, made in January 1498, does not explain what it was for. The second, on 13 August 1499 is recorded in Francesco's own hand: 'Io Francesco di Moroni filiolo do Mo. Domenego depentor de Santo Vidale ò recevude per compi pagamento de la cappella de San Biasio coè de la parte mia ...'. According to this, therefore, Francesco must have assisted his father in the S. Biagio chapel, an acceptable assumption, even if Francesco's part can no longer be determined. Biadego's opinion is contradicted first of all by the words 'de la

Cappella de San Biagio' but even more by the style of the work, which to me indicates a date closer to 1520. The fresco must have been finished by 1499, however. If, therefore, we do grant this and the following work a place here, it is done in order not to dismiss Biadego's thesis before definite proof be found for the dating of the *Baptism*.

4 *The Evangelists.* (Half-lengths.) Fresco. Verona, Museum No. 462, 463, 465, 466. Two pieces each, 1·60 × 1·45 and 1·58 × 1·45. Formerly on the ceiling of the Cappella della Dottrina in S. Nazaro e Celso, the same room as the *Baptism*. Moved with the latter to the museum in 1881, and like that formerly attributed to Cavazzola. Cf. Trecca p. 113–114.

5 *Madonna and Child with St Nicholas and S. Zeno*, 1502. Milan, Brera No. 225. Canvas 1·70 × 1·25. Signed: 'Franciscus filius d. dominici de Morone pixit. Anno doi MCCC ... 11 (1502) kl ..., oct. ... 1811.' Transferred from S. Giacomo della Pigna in Verona to the Brera. Cf. Malaguzzi-Valeri, *Catalogo della Reale Pinacoteca di Brera*, 1908, p. 130/31. In Crowe-Jordan an incorrect reading 1504. Ill. Venturi, p. 786. Ricci, *La Pinacoteca della Brera*, p. 84. Photo Anderson 11072.

This painting, now pale and dull from harsh cleaning, is a stylistic counterpart of the next far more significant one. I refer, therefore, to the analysis which follows.

6 *Madonna and Child with St Martin and St Augustine*, 1503. Verona, S. Maria in Organo. Canvas 2·00 × 1·36. Signed: 'Fraciscus filius Dominici de Moronis pinxit. 1503.' Cf. Avena, *Catalogo ... p. 28/9*. Engraving by Zancon, *Raccolta di N. 60 Stampe delle più celebre Pitture di Verona*, No. 36 Ill. in Biermann, p. 116 and Biadego p. 113. Photo Anderson 12387, Alinari 13539.

This painting is a key in the difficult task of dating Francesco's works. It sums up the principal elements of his early style. The first is a striving for symmetry in the overall composition, well thought out down to the smallest details. (The *Crucifixion*, painted under the aegis of his father, is an isolated case.) Note too such minor features as the arrangement of the branches silhouetted against the sky, growing

240

from the trunks which form the arbour, and the crown on the Child's head. The horizontal and vertical axes control everything. A threefold, strictly divided gradation in depth, without connections or transitions. Massive volume of the figures, placed block-like in space. Straight, uninterrupted outlines. Deep, three-dimensional, cylindrical folds next to smaller, carefully drawn, creased folds, most of which break at an angle close to 90°. Deep brownish shadows recall the late works by Domenico. The colours are exceedingly vivid, the expressions solemn but unaffected and natural.

255, 256 *7 Organ panels*, 1515. On the outside: *St Benedict and John the Baptist* by Francesco Morone, *Magdalen and St Catherine* by Girolamo dai Libri. On the inside: the prophets *Daniel and Isaiah* by Morone and the *Adoration* by Girolamo dai Libri. Marcellise near Verona, now in the museum. Canvas, four pieces – the outside ones $3·30 \times 1·55$, the inside ones $3·30 \times 1·75$. Painted for S. Maria in Organo. Cf. Crowe-Jordan V, p. 522 and Note 12, with documents: contract dated 12 Nov. 1515. For information on the varied history of the painting, cf. Canossa, 'Sulle antiche portelle di S. Maria in Organo', in *Madonna Verona* VII (1913), p. 183–185. Avena, *Catalogo*, p. 27/28. Ill. Gerola, *Le antiche pale di S. Maria in Organo*, p. 23/24. A sketch for the canvas with St John and St Benedict is in the Albertina (Inv. 17619. Drawing in red chalk $28·8 \times 19·3$ cm.) Ill. in Vol. II of the Albertina publication, sheet no. 181.

We shall confine ourselves to Morone's male saints and examine how the style relates to the preceding painting. The strict ruling principle of symmetry has been loosened. Note in particular the asymmetrical arrangement of the two angels on the picture of the prophets, and compare them to the angels in No. 6; also the animated landscape, in which, incidentally, Girolamo's hand can easily be recognized. Rigid lines have been dissolved: for instance, draw a horizontal line through the hands in No. 6, hands which always lie in the same plane, then try the same thing here. At the same time the less restricted forms have undergone a shift into both the background and foreground. The hands reach forward, the feet are set back. Some of the contours are broken, others rounded. Compare especially the left outline of Isaiah

with the outline of the saints' backs in No. 6. The three-dimensional quality of the folds has largely disappeared. Metallic qualities are diminished while textured ones are enhanced. The sharp creases in the folds become softer and there is a general tendency toward curving lines. Minimal shadows in greenish tones, an overall brightness with more harmonious colours. The convincing facial expressions become weaker (Isaiah's face could almost be called morose). It must be emphasized at this point that this stylistic change hardly amounts to greater intensity. What is still important ultimately is the constant uniformity. (Cf. points made above in various places.)

8 Fresco of the Madonna and Child with St Joseph, St Jerome, St Antony and St Roch, 1515. Verona, Museum No. 560. $2·55 \times 2·25$. Taken from a house near Ponte Navi to the Museum in 1874. Signed: 'Miseratrix virginum regina nostri miserere MDXV'. (Cf. Trecca, p. 184.) Sketch (study in red crayon) $18·9 \times 14·6$ cm in the Uffizi No. 596, Categ. I. Discussed and illustrated in Frizzoni, 'Alcuni appunti critici . . .' in *Rassegna d'Arte* IV (1904), p. 33. Here also a sketch, attributed to Morone, which I have not been able to see: a half-length of David playing the lyre. No. 1765, Categ. II. (The first sketch is given to Giovanni Bellini, the second to Giorgione.) The study for the fresco was first published under its proper designation in Vol. III of the Albertina drawings, sheet no. 273. The fresco is illustrated in Biermann, p. 118, Biadego p. 114, Trecca, Plate XIV. Photo Anderson 12460.

The fresco seems more old fashioned than the works just discussed. There is certainly a strong commitment to tradition here, and it is also possible to put the date of the preliminary studies back to 1514 and thereby separate them a little from the organ panels. These were not finished until 1516 and in them we have the added inspiration of collaboration with Girolamo. But all the evidence (see above, No. 7) points to the fresco being close in date to the organ panels.

9 Madonna and Child. (Half-length.) Berlin, Kaiser-Friedrich-Museum No. 46. Canvas $0·48 \times 0·40$. Signed: 'Franciscus Moronus. P.' In the halo of the Child: 'Unus Veronen. F. T.

Veronae.' Cf. descriptive catalogue of the paintings, 1921, p. 305 – Photo Stödtner, Hanfstängl 555.

Attention has already been drawn to the extraordinary similarity to the *Madonna* in the Brera (p. 204). Curiously enough, whenever anyone so far has tried to date these works, they have reversed the chronology. They place the Berlin work in the late period (thus v.d. Bercken, *Malerei der Renaissance in Oberitalien*, p. 141) and claim that the latest works had originated at the beginning of the century. Mary and the Child are still fixed in two clearly defined planes. (Compare on the other hand the suppleness of the Child's body, the slightly oblique position of Mary's body in relation to the Child who embraces her.) The dark shadows, the brownish skin tones, are in accord with a work of 1503 and agree convincingly with Domenico's choice of colours. In the magnificent left-hand side of the landscape one can recognize progress in the rendering of depth. The work belongs without doubt to the period after 1503.

10 *Madonna and Child*. (Half-length.) Venice, Palazzo Giovanelli. Signed: 'Francisc. Moronus F.' The painting was moved from Verona to Venice at the beginning of the last century. This small painting, of conventional format, could not have been done much later than No. 9, especially if one considers the brownish tone of the skin and the type of Madonna and Child.

11 *Frescoes from the vestry of S. Maria in Organo in Verona*. There is a more detailed analysis of the structure and style of the works on page 206 (cf. the description of the frescoes in Crowe-Jordan V, 521–22). Biermann, p. 116, wrongly attributes the frescoes in the nave also to Morone. Although Domenico Morone was actually given the commission, it is hard to see his hand in the execution. We may conclude that work did not begin in earnest until the beginning of the 16th century, at a time when Domenico was painting in the refectory and Francesco had reached the fullness of his youthful powers. Vasari V, p. 311 mentions collaboration with Domenico. Photo Anderson.

12 *Christ on clouds between the Virgin and St John*. Above, God the Father in a host of angels.

Verona, Museum No. 330. Canvas 2·90 × 1·50. From S. Maria della Vittoria. Cf. Trecca, p. 45. Crowe: Cavazzola. According to Biermann God the Father is a later addition, but there is nothing to justify this theory. Ill.: Biadego. p. 112. Photo Anderson 12466.

The painting belongs to the artist's early period with its strictly symmetrical structure, reliance upon cubical shapes, and rigid and straight contours. The treatment of the drapery shows progress in the development referred to. Red is the dominant colour here (Christ's robe is bright red, the Madonna's dress deep red, John's cloak is purple). This range of colours is particularly characteristic of Francesco Morone. In the shadows on the skin an opaque, almost dirty green predominates, while the flesh tones change from reddish to yellow. We are reaching the years after 1503.

13 *The Washing of the Feet*. Verona, Museum No. 305. Canvas 2·50 × 2·20. Moved from S. Bernardino to the Museum in 1858 (cf. Trecca, p. 45). According to Vasari (V, 310) Francesco's likeness can be seen in the water carrier. According to Bernasconi and Crowe, by Cavazzola. Ill.: Biermann, p. 117. Biadego p. 112. Photo Anderson 12462.

It is particularly difficult to pinpoint the date of this work. The year 1503, which Zannandreis and Bernardini give (p. 1379), is not convincing, but neither can I agree with Gamba who suggests a later date. To be sure, many of the details of shape and composition lend credence to its being a late work. However, the nature of the colours – grainy application, dirty opaque skin shading, brownish flesh tones, the use of a great deal of red – make it similar to No. 12, perhaps a decisive factor. I am unable to give solid clues.

14 *St Catherine and Donor*. Verona, Museum No. 259. Canvas 1·65 × 1·00. From the S. Gregorio Oratory (cf. Trecca p. 35). Photo Anderson 12465.

The painting shows Morone at his best but is unfortunately badly rubbed.

Francesco was at his most active between the years 1503 and 1515. Although the exact chronology of works within this period is hard to establish I shall try as far as possible, in listing them, to keep within this time frame, using the

254

259

259 FRANCESCO MORONE. *St Catherine and Donor,*
Cat. Wks, No. 14 (Verona, Museum)

criteria of stylistic development mentioned in
Nos 4 and 5 as a basis.

15 *Madonna and Child.* (Half-length.) Verona,
Cathedral, Sala capitolare. Signed. Cf: Tua in
Madonna Verona VI (1912), p. 164 and Simeoni,
Verona, p. 97.

16 *Madonna and Child.* (Half-length.) Padua,
Pinacoteca No. 35. Canvas 0·46 × 0·42. Signed:
'Fraciscus Moronus Ve. F.' Photo Anderson
10356.

17 Three panels: 1 *St Sebastian, St Paul, St
Antony and St Roch.* 2 *S. Bernardino of Siena and
a praying figure.* 3 *St Clare and two praying
figures.*

216

Verona, Museum No. 315. These panels belong
together. (1) 0·85 × 1·58; (2) and (3) 0·85 × 0·74.
From S. Chiara. According to Crowe, p. 524,
Morone's studio. Cf. Trecca p. 41, 45.

18 *The Apostles James and John.* Verona,
Cathedral, third altar on the right. Canvas.
Almost life-size. Wings of an altarpiece, the
centre of which (*Christ carrying the Cross*) was
replaced by a *Transfiguration* by Cignaroli. The
donor of the altarpiece, the Canon Filippino
Emili, is depicted in half-length on the panel
with St James. Milanesi's comment (Vasari V,
p. 310, note 3), that the centre-piece by Morone
is today in S. Zeno, is incorrect.

19 *St Francis receiving the stigmata.* Verona,
Museum No. 348. Panel 0·84 × 0·55. Cf. Trecca,
p. 43. Ill.: Venturi p. 781.

20 *Madonna and Child.* (Half-length.) Bergamo,
Accademia Carrara, Galleria Morelli No. 52.
Canvas 0·56 × 0·45.

21 *Polyptych in six panels.* Verona, Museum (no
number). Panel 2·67 × 1·90. From Tregnano
near Verona. Top centre: *Ecce homo;* left and
right, *Angel and Mary* from the Annunciation.
Lower row centre: *Nativity;* right: *St Martin;*
left: *John the Baptist.* Cf. Trecca, p. 54.

22 *Madonna and St Roch,* 1517. Venice, Acca-
demia. Fresco (fragment) Signed: '1517.' With
this work and those which follow we now go
beyond the achievements up to 1515. Nos 22–24
are moving in the direction of the 1520 piece
analyzed in No. 25.

23 *Frescoes in S. Maria della Vittoria* in Verona.
Dal Persico II, p. 19 and older authorities follow
the correct tradition based on Vasari. Later came
misguided attempts to attribute these works to
Cavazzola. Cf. Biermann, p. 139. Illustration of
God the Father in Biadego, *La cappella di S.
Biagio,* p. 116.

24 *Madonna and Child with St Antony and St
Paul.* Berlin, Schlossmuseum. Canvas
1·56 × 1·37. Signed: 'Franciscus Moronus. P.'
From the Solly Collection. Cf. Catalogue of 1912,
p. 292, No. 46 B. Ill. in Gerola: *Le antiche pale di
S. Maria in Organo,* Plate XV. Photo Hanfstängl

186 and Stödtner 24603. The coat of arms on the base of the throne belongs to the Rolandi family. One of their members was Abbot of S. Maria in Organo in the years 1502/04 and 1507/08. The style of the painting, however, seems to me to indicate a time after 1515.

25 *Sacra conversazione*, 1520. (Half-length.) Bergamo, Accademia Carrara No. 201. Canvas 0·80 × 0·67. Signed: 'Franciscus Moronus Veron. 1520 pinxit.' Photo Arti Grafiche, Bergamo 229.

All the stylistic elements that I have defined in the analysis of the paintings from 1503–1515 are present here in more developed forms. Symmetry is now avoided. (Compare such contrasting elements as St Anne glancing downwards and St Bernard upwards, with the corresponding figures in the 1515 fresco; also the rich interplay of the hands.) Spatial transitions are intended to eliminate strict divisions (St Anne's left hand, for instance, touches the Child) and the landscape supports the composition: the large bush in the centre, seen at first as a background for the main figure, forms a link with the landscape behind. This produces a unity between the various parts and a striving for movement. The attempt at a variety of emotional attitudes in the figures (adoration in St Joseph, surprise in St Francis, tenderness in St Anne, etc.) is essentially new. This entails, however, some loss of inner strength and composure (notice especially the sour-faced Child). An adaptation to Venetian models is

evident not only in the choice of figure types but also in the colouring. The flesh tones are lightly permeated with a reddish colour, which even shines through the grey-green shadows. Mary's blue mantle stands out against a deep green.

26 *Madonna and Child*. (Half-length.) Verona, Museum No. 182. Panel 0·65 × 0·44. Lower portion painted over; the frame ends in a semicircle. Cf. Trecca p. 44. Ill.: same. Plate V, Biermann, p. 115, Venturi, p. 784. Photo Anderson 12464.

With Nos 26 and 27 we proceed beyond the development of 1520.

27 *Madonna and Child*. (Half-length.) London, National Gallery No. 285. Wood 0·61 × 0·43. Cf. *Catalogue of the pictures . . . 1920*, p. 197. Ill.: Venturi, p. 787. Photo Anderson 18160.

Badly preserved works:
28 *Madonna with St James and St Roch*. Verona, S. Fermo. Fresco. Side portal, left. Signed: '1523 Franciscus Moronus.' Almost totally destroyed. St Roch was taken to be St John the Evangelist by Zannandreis and St Elizabeth by Crowe.

29 *Madonna with St James, St Roch and another Saint*. Façade fresco. Verona, Strada Porto Vescovo No. 320.

Destroyed or missing:
30 Vasari (V, p. 312–13) records: Frescoes in S. Bernardino, the chapel of Nicolò de'Medici: (1) *The Feeding of the Five Thousand*. (2) *St Louis and another figure*. (3) Ceiling frescoes – all these as Domenico Morone's assistant.
Frescoes in S. Maria in Organo, on the choir-screen:
(1) *Entry into Jerusalem*. (2) *Agony in the Garden*. (3) *The Deposition* in the cloister garth.
Portrait of Antonio Fumanelli.
Fresco: *Madonna*. Verona, Piazza Brà (Dal Persico I, p. 159. Crowe V, p. 524). *Virgin and Child with St John*. Formerly in the Moscardi Collection (Crowe V, p. 524, note 22).
Façade fresco: House near S. Jacopo di Galizia in via di Mezzo (Bernardini, *loc cit.*, p. 1377).

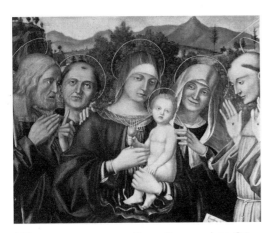

260 FRANCESCO MORONE. *Sacra Conversazione*, Cat. Wks, No. 25 (Bergamo, Accademia Carrara)

Façade fresco: Casa Scaramelli near Porto di Borsari (Bernardini and Simeoni p. 209).

Christ bearing the Cross: the centre portion of the altarpiece in the Cappella degli Emili in the cathedral. Side panels of this work discussed in No. 18.

Fresco at the Teatro Filarmonico (Simeoni p. 209): façade of the Palazzo Guglienzi, *Madonna*.

For payments shared with Girolamo dai Libri, see Girolamo's Cat. Wks, No. 22.

Doubtful works:

31 *St Sebastian*, Camerini Collection, Piazzola near Padua. Borenius (*The Painters of Vicenza*, p. 171/2) acquiesces to Frizzoni's attribution of the work to Francesco Morone because of similarities to No. 19 which he finds convincing. Earlier attributed to Buonconsiglio.

Erroneous attributions:

32 *Samson and Delilah*. Milan, Museo Poldi-Pezzoli No. 577. Molmenti, *Carpaccio*, p. 262, follows Morelli in attributing the painting to Michele da Verona. Cf. also v.d. Bercken, *Malerei der Renaissance in Oberitalien*, p. 141. Discussed and illustrated in Schübring, *Cassoni*, p. 374, Pl. 146. Berenson, p. 267: Morone. Likewise in *Dedalo* V, p. 634. Photo Anderson 11159.
I am unable to find the name of the real author of this valuable painting.

33 *Deposition*. Lunette on canvas. Verona, Museum No. 117. Cf. Trecca, p. 41. This painting has been associated with a wide variety of names. The grainy way in which the paint is applied as well as the overall impression of darkness seem to me to warrant placing it in the Montagna circle.

34 *Birth of John the Baptist*. Predella. Verona, Cathedral. Formerly part of the Maffei Altarpiece. The long tradition of calling this a Morone (Dal Persico, p. 39, still accepted by Simeoni, p. 92) is surely wrong. Cf. Avena, *Catalogo*, p. 22 . . . 'Mostra la mano d'un artista mediocre'.

35 *Frescoes in the nave of S. Maria in Organo*, Verona. Old Testament Stories. Given to Fran-

cesco Morone by Zannandreis, p. 85, by Milanesi, p. 311, note 3, and by Biermann. They are by Giolfino.

36 *Madonna and Child with St Roch and Joachim*. Church at Soave near Verona. Canvas $2 \cdot 12 \times 1 \cdot 75$. Above it, a lunette showing God the Father. Cf. Avena, *Catalogo*, p. 27. A work from the Francesco Morone school. The erection date of the altar is on the wall behind the painting: 24 March 1529. Cf. Biadego, *La Capella di S. Biagio*, p. 14, who considers this to be the last work by Francesco's own hand. Ill.: Biadego, p. 114.

37 *Descent of the Holy Spirit*. Lunette fresco in S. Anastasia, Verona. Third altar to the left. Last ascribed to Francesco by Simeoni, p. 63. More likely by Michele da Verona. The same holds true for the fresco of *The Virgin and St John* over the first altar to the left.

Bernasconi, p. 280ff. and later Bernardini, p. 1379 mention of a painting in Trento, by which they probably mean Caroto's *Madonna with Saints*. I can say nothing definite about a few other attributions, since neither the originals nor good photographs were available to me. I would mention one panel, a Camaldolese monk in monastic garb, with shepherd's staff and a book – Auction catalogue for the Grimaldi collection, R. Lepke, Berlin 1913, p. 23 (No. 236) Pl. 31.
A fresco of a *Madonna with Saints*, Venice, Laurenti Collection; there, too, a tondo of a Madonna and Child (most likely from the school).
Berenson, in *Dedalo* V, p. 634, also ascribes the Berlin *Betrothel* (No. 1175) to Francesco Morone, definitely an error.

Girolamo dai Libri

Girolamo dai Libri is recorded as being 18 years old in the register of 1492; so he was born in 1474 and not, as Vasari says, in 1472.[51] He married some time after 1501. Of his five children, his son Francesco especially dedicated himself to painting. According to Vasari,

Girolamo died on 2 July 1555. The close relationship between Girolamo and Francesco Morone has been dealt with above. Girolamo outlived his friend by twenty-six years, but his artistic work appears to cease more or less after the latter's death. Only the *Baptism* stems from the beginning of the 1530s. How Girolamo occupied himself during these many years remains unclear. Lotze[52] believed that he confined himself entirely to miniature painting after 1530. This assumption is supported by Vasari's words that in his old age Girolamo had to give up the 'minuto lavoro di decorare i libri, perché la mano e l'occhio non gli servivano più'; and it is also backed up by a passage in Valerini's *Bellezze di Verona* (1586), in which Girolamo is referred to as being 'sublime nella miniatura'. However, beyond these general remarks there is nothing to help us. On p. 110ff. Canossa published some payments for miniatures during the period in question, but as none of these miniatures can be definitely identified (cf. below) we must leave the last quarter century of his life out of our consideration.

In spite of their close association, Girolamo's artistic development does not run parallel with Francesco Morone's. While the latter's work after 1515 shows a noticeable decline, Girolamo does not reach his peak until the 1520s, three years before Francesco Morone's death. Trained in his father's school of illustration, he was soon attracted by the art of Domenico and Francesco. The impression made by Mantegna is crucial for his early works. His steady, unruffled development is in many ways similar to Francesco's, although his greater overall progress is evidence of a stronger personality. Particularly eventful are the years around 1515, when there are decisive changes in the relationship of the figures to the landscape, the types of heads, the flow of the drapery, and indeed the whole colouristic conception of the picture. Girolamo's strength and individuality lie in the way he attempted to incorporate landscape into the composition. For him the relationship of the figures to the space is a constantly new problem the solution of which he does not find until the end of his artistic life. He strives for an illuminatory colour effect through which he succeeds in achieving a much greater degree of 'aerial perspective' and depth than either Morone or Cavazzola.

Girolamo dai Libri: Catalogue of Works

1 *Pietà*. Malcesine. S. Stefano, first altar on the right. Canvas $2·75 \times 1·52$. Originally in the Lischi Chapel in S. Maria in Organo in Verona. Transferred to Malcesine in 1719. According to Vasari (V, 327) completed at the age of sixteen. Zannandreis, p. 88, laments the loss of the *Pietà*. Cf. Avena, *Catalogo*, p. 29–30. For this, and all the following items, see especially Canossa's treatise ('La famiglia dai Libri,' in: *Atti e Memorie dell'Accademia d'agricoltura scienze lettere arti e commercio in Verona*, Ser. IV, vol. XII, 1912, p. 85ff.) where almost all the pertinent literature has been collected. Ill.: Gerola, *Le antiche pale di S. Maria in Organo*, Pl. XIV.
The earliest possible date is the mid to late 1590s. Not only Mantegna's influence but also that of Gentile Bellini are to be seen in the heads of the two men around Christ. The extravagant masses of folds recall the late works of Domenico Morone. The miniature-like colours and the painstaking execution, point back to the book illuminations carried out in the workshop of Girolamo's father.

2 *Adoration*. Verona, Museum No. 290. Panel $2·18 \times 1·52$. From S. Maria in Organo to Museum 1812. Cf. Trecca, p. 29. In Gerola, *Le antiche pale*, p. 5–7, there is information on the painting's varied history. Ill. in Biermann, p. 123; Biadego p. 115 – Photo Alinari 13477, Anderson 12446.
According to Vasari (V, 329) this piece was not painted until after completion of the Marcellise organ panels of 1515. The style, however, indicates an earlier date. Some typical features (particularly the head of the Madonna), the often exaggerated style of drapery, the hard contours and the bright colouring, all are reminiscent of the *Pietà*. The figure of Mary, for instance, consists of a dark red dress, a light blue cloak and a yellow shawl, all directly next to each other. To the right, in the background, the landscape shows substantial progress. The evenly dark tones and less rigid outlines of the landscape indicate the direction this development is taking.

3 *St Peter* and *St John the Evangelist*. London, Mond Collection. Wood. Each one $0·75 \times 0·33$. 261, 262

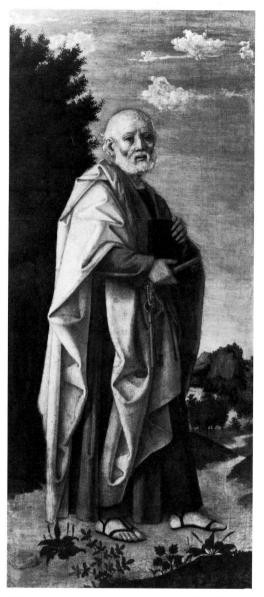

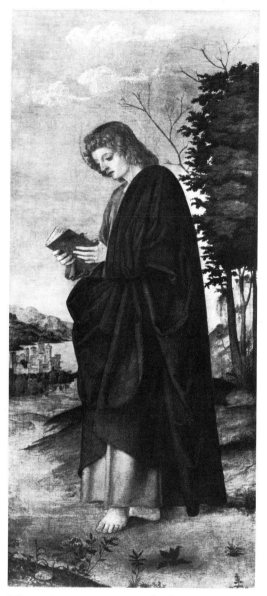

261 GIROLAMO DAI LIBRI. *St Peter*, Cat. Wks, No. 3 (formerly Mond Collection, now private collection)

262 GIROLAMO DAI LIBRI. *St John the Evangelist*, Cat. Wks, No. 3 (formerly Mond Collection, now private collection)

Cf. J. P. Richter. *The Mond Collection* 1, p. 268 and Plate XVI. The paintings are identical to those which Vasari (p. 311) calls Morone's, in S. Maria in Organo (Muletta Altar). In Gerola, *Le antiche pale*, p. 21–23, are records of payments, for gilding and framing the pictures, from 26 October 1501 to 29 January 1502. The new altar was erected in 1682; Girolamo's panels became

part of the Mond Collection in 1887. Ill.: Gerola, Pl. IX. Photo Braun 29497.

It is best to mention these early works in conjunction with the *Adoration*. The figure of St John is vividly reminiscent of the one in the *Pietà*; however, there is now an element of calm. The figure of St Peter cannot have been conceived long after that of St Joseph in the

220

Adoration. The grouping of the figures in the foreground, allowing on one side an unimpaired view into the landscape, and the composition of the landscape itself, are in perfect accord. 1501 is a plausible date for the painting's completion.

4 *Madonna and Child with St Thomas, St Augustine, a kneeling monk and donors.* Verona, S. Anastasia, right transept. Centrego altar. Panel 3·40 × 1·55. Berenson and Richter date it 1512, but a date is nowhere to be found. The Centrego altar had been built between 1488 and 1502. Earlier attributed to Morone. Hence, Dal Pozzo, p. 217, who is followed by all the older writers. Cf. Avena, p. 32. Ill.: Venturi, p. 511. Photo Alinari 13451, Anderson 12365. Judging by the type of figures, the painting belongs with the works discussed up to this point. It forms part of a consistent group with them. Its composition, and the un-Veronese style of architecture, can be traced to the influence of Giovanni Bellini himself, or to Montagna who worked from time to time in Verona. While the lower part of the picture has grown exceedingly dark, one can still find the old brightness in the upper part. The strong modelling, in the body of the Child for instance, is characteristic of the connection with Domenico's late works.

5 *St Roch, St Sebastian and Job.* Verona, S. Tomaso, fourth altar on the right. Canvas 2·15 × 1·62. Once generally attributed to Caroto. Cf. Maffei III, 327. Correctly attributed by Morelli. Ill.: Biermann, p. 119. Photo Anderson 19574.
The lines are still hard and tight, the forms angular, with bright colours still almost directly next to each other. In the facial expressions, especially that of St Roch, Girolamo has put as much tenderness as he is capable of. An early date is also indicated by the relationship of the figures in the foreground to the landscape which spreads out at the bottom left. Cf. the *Adoration.* Since the St Roch Altarpiece was erected in 1505, we do gain here a *terminus post quem.*

6 *St Roch in the Desert.* Bergamo. Privately owned: Sig. Giacomo Frizzoni. Panel. Predella. Mentioned only by Berenson and doubtless correctly attributed.

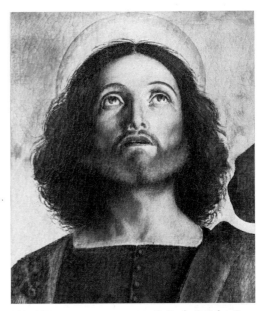

263, 264 GIROLAMO DAI LIBRI. *St Roch, St Sebastian and Job,* with (top) a detail of the head of St Roch, Cat. Wks, No. 5 (Verona, S. Tomaso)

221

From the style of the picture I suspect that we are dealing with part of the predella of the preceding work. The group made up of St Roch and the dog, to the left in front of the tree-covered rock, the road which winds into the background at the right with its smaller figures – all of this is conceived in the spirit of the *Adoration*.

7 *Adoration*. London, Mond Collection. Canvas 0·76 × 0·92. Cf. J. P. Richter, *loc. cit.*, p. 278. Pl. XVII. Richter suggests that we are dealing with a fragment of a taller and wider composition. The original was higher than it was broad. Photo Braun 29496.

Even without knowing the original I cannot help but challenge Richter's placing of the work at the beginning of the 1520s. The composition repeats a little more freely the well known type of the *Adoration* (No. 2). Likewise the heads belong to this early period. In the early works they all have a pointed and angular shape, while after 1515 the oval predominates. St Joseph's cloak reveals the hard, angular folds which are characteristic of the Marcellise organ panels. Because of this connection with the organ panels on the one hand, and with the early works on the other, this *Adoration* appears to me to have originated even before 1515.

257, 8 *Adoration, St Catherine*, and *St Dorothy* 1515.
258 Marcellise near Verona. Organ panels. Today in the Museum. Formerly in S. Maria in Organo. Cf. the corresponding pieces by Francesco Morone (Cat. Wks, No. 7), where further details are given. Cf. also Gerola, *Le antiche pale*, p. 23–28, 2 plates.

The old manner of organization is perceptible only in the *Adoration*. The foreground scenery has been dispensed with, allowing the figures to blend more closely with the landscape. Figure types are given new form. Heads of the Madonna and saints are oval in shape. The lines are still firm; the colours are particularly clear and bright. The modelling had been attractive in the earlier works (especially Nos 4 and 6) but here this three-dimensional quality gives way to more painterly tendencies. For this reason the panels bear the mark of less pleasing transitional works.

9 *Virgin and Child with St Anne*, 1518. London,

National Gallery No. 748. Canvas 1·57 × 0·94. Formerly in S. Maria della Scala in Verona, forming the centre part of an altarpiece, the side panels of which Cavazzola and Torbido painted in competition with each other. Cf. Sgulmero, *Il trino-tritico di S. Maria della Scala*. Verona 1905. From the dating of the side panels (cf. Cavazzola Cat. Wks, No. 15) we also obtain a date for the centre part. Signed: 'Hieronymus a Libris P.' In Cignaroli's possession in the middle of the 18th century; from 1854 Galleria Monga; 1874 London. Cf. *Catalogue* (1920), p. 116, Ill.: Venturi, p. 795. Photo Hanfstängl 32, Braun 30748. Cf. Comments made in No. 10.

10 *Virgin and Child with St Anne, Joachim and St Joseph*. Verona, S. Paolo. Canvas 2·68 × 1·51. Formerly on the main altar, now on third altar to the right. Ascribed variously to Domenico Brusasorci and Francesco Morone. Today there is general agreement with the attribution to Girolamo made by Vasari (V, 328). Cf. Gerola in *Madonna Verona* VIII (1914), p. 92 and Avena, *Catologo* 32–33. Photo Anderson 12395. Ill.: Biermann, p. 124, Biadego, p. 115.

This painting should be seen in conjunction with the one in London, because of the similarities of figure types and landscape. But it should be dated somewhat later, as it is better organized, clearer and more expressive. It is as if, in reworking the same subject, Girolamo had realized the shortcomings of the earlier work and tried to avoid them in this one (e.g. compare the way the two Marys are seated). The handling of colour clearly heralds Girolamo's development as a colourist. The chromatic scale is well balanced: the red and green garments of the saints, the pink of Mary's dress and the lilac of St Anne's mantle complement each other. Gone are the large, unmodified areas of colour. The shading on the bodies includes a viscous umber, a constant with Girolamo.

11 *Madonna and Child with St Bartholomew and S. Zeno*. Berlin, Kaiser-Friedrich-Museum No. 30. Canvas 2·09 × 1·43. Formerly in S. Maria in Organo in Verona, second chapel to the left. 1721, altar painted over then removed. Later in the Galleria Solly, and from there to Berlin in 1821. Cf. *Katalog* (1921) p. 244 and Gerola, *Le antiche pale*, p. 32/33. Ill. Pl. XIII. Photo Hanfstängl 247.

This altarpiece is close in date to the *St Anne* in S. Paolo, a view that is strengthened not only by the similarity of single figures (especially the Child) but also by the almost identical details of drapery. Compare the cloaks of St Bartholomew and S. Zeno with those of Joachim and St Joseph. Overpainting has rendered the colours less than pleasing.

12 *Madonna and Child with St Sebastian and St Roch* (Madonna Maffei). Verona, Museum No. 252. Canvas 1·85 × 1·45. From S. Giacomo alla Pigna. The Maffei coat of arms on the base of the throne. Cf. Trecca, p. 30. Photo Anderson 12443.

The picture is a good example of Girolamo's development. The heads have the long oval shape, tightly bound hair, parted in the middle, well-defined eyebrows and large pupils – all characteristic of the later period. There is less tension in the folds, which lose much of their plastic qualities as the pictorial effects are heightened. In this regard one should compare the transformation which has taken place between the Sebastian in S. Tomaso and the one in this altarpiece. The hard outlines, the skilful modelling of anatomical details, give way to a picturesque manner which has as its first aim the attainment of space and depth. The shading on the bodies becomes brighter and more transparent; colour contrasts disappear.

13 *Madonna and Child, with Lorenzo Giustiniani and S. Zeno*, 1526. Verona, S. Giorgio in Braida, fourth chapel to the left. Canvas 2·85 × 2·28. Above it a lunette depicting God the Father: 1·00 × 2·00. Signed: '1526 Men. Mar. 29 Hieronymus A Libris pinxit.' Read as '1529' in Lanzi, (Edition of 1823, p. 69), corrected by Persico II, 93. Nevertheless, has made its way into a great deal of the literature through Lanzi. Cf. Avena, *Catalogo*, p. 31/32. Ill.: Biermann, p. 121/22, Biadego p. 116. Photo Anderson 12380, 12384, Alinari 13458, 13459.

Girolamo's principal work, surpassing all his others in its careful execution – indeed so characteristic of Girolamo in every respect that we may regard it as his finest creation. If the *Madonna della Quercia* excels it in the strength of St Roch's expression or in the freedom of composition, this painting must be judged his masterpiece by virtue of its consistent quality and liveliness of detail (e.g. in the landscape). The well preserved freshness of the colours gives us our best example of Girolamo's palette during the 1520s. S. Zeno's purple vestments harmonize perfectly with Lorenzo's deep green. The Madonna's mantle is of a striking blue; the colour of her dress changes from pink into red tones. The landscape is a uniform bright green without deep shadows. The happy overall impression springs in no small measure from the sensitive handling of the colours.

14 *Christ and the Woman at the Well*. Verona, Museum. Canvas 1·50 × 1·80. Cf. Avena, *Catalogo . . .* p. 30/31.

A comparison with the small predella of St Roch gives a clear indication of the change in composition. The figures now stand in an airy and endless landscape – in contrast to the earlier stage-like foregrounds, which only allowed a view into the distance on one side. The landscape is closely related to that of 1526; but a few touches, such as the shape of the heads and the harder outline, suggest a somewhat earlier date.

15 *Predella with stories of saints: the miracle of S. Biagio, the martyrdoms of St Sebastian and of S. Giulianna*, 1526–29. Verona, S. Nazaro e Celso, Cappella S. Biagio. Predella for the Bonsignori altarpiece. Wood 0·31 × 1·86. Documented in Zannandreis, p. 89. Remaining literature in Gerola, *Madonna Verona* VIII (1914), p. 202. Biadego in *La Cappella di S. Biagio*, p. 124/25 records the precise payments made to Girolamo: first, four payments between 10 June 1524 and 4 February 1525 for gilding Bonsignori's altarpiece. On 20 December 1526, 22 ducats for 'li tri quadri sotto el pe' de l'anchona de S. Biasio'. Between 17 January and 5 February three payments 'per el peduzo de l'altar'. Ill.: Biermann, p. 126. Engraving by Zancon, *Raccolta di N.60 Stampe*, No. 50 (only partial). Photo Anderson.

This work belongs among the best of this genre done in Verona. The attempt to blend figures and landscape is even more pronounced than in the preceding piece. Again the figure of St Sebastian serves to demonstrate the progress made towards a painterly solution, in comparison with the Madonna Maffei.

223

245 16 *Madonna and Child with St Joseph, the Archangel Raphael and Tobias*, 1530. Verona, Museum No. 339. Canvas 3·38 × 1·80. From S. Maria della Vittoria. Signed: 'Hieronimus Alibris Veronesis pixit 1530.' A putto holds a parasol over the Madonna's throne. For this reason the picture has also been called the *Madonna dell'ombrello.* Cf. Trecca, p. 29. Photo Anderson 12442.

The head of the Madonna is in complete accord with those of the Madonna Maffei and the Madonna of 1526. Girolamo's typology changes little over a great many years, whereas his progress in painting technique is more substantial.

246 17 *Madonna on clouds with St Peter and St Paul.* Verona, Museum No. 333. Canvas 3·10 × 1·75. Known as the *Madonna della Quercia* because of the oak tree, in front of which St Peter stands. Cf. Trecca, p. 30 with ill. Pl. IV. Photo Anderson, engraving in Zancon *op. cit.,* No. 17. In composition and colouring this is Girolamo's most developed, but not his most perfect, creation. The free and easy rendering of the Madonna and the Child sacrifices much of the sensitivity of earlier works to technical accomplishment. The result ultimately is the opposite of what happens with Cavazzola. While the latter tries to achieve a harmony of colour and a *chiaroscuro* effect by first applying a brown underpaint, Girolamo strives for transparency in his tones, and by applying the paint thinly he lets the canvas shine through. This produces a fine and delicate airiness, which in this picture reaches a beautiful clearness. Particularly effective in this regard are the raised arm of St Peter and the Baptism in the far distance. Even here, however, Girolamo cannot quite give up his sticky, somewhat dirty umber in the skin shading, a weakness which he never overcomes despite all other changes.

253 18 *Baptism of Christ.* Verona, Museum No. 253. Canvas 1·85 × 1·42. From S. Maria alla Fratta. Cf. Trecca, p. 30. Photo Anderson 12445.

The attribution to Girolamo has been doubted, but without any good reason. The somewhat weary facial expressions, the still ungainly poses of the bodies, the landscape, brought to life down to the smallest detail – all point to Girolamo's own hand. Look for instance at the formation of the hands, in which the small finger is often spread in a characteristic manner. The mountainous landscape stretching into depth as in a fine haze, is highly accomplished. From this as well as from the faintly coloured, fleshy fullness of the body of Christ we can assume a late date, in the 1530s.

19 *Madonna with St Leonard, St Augustine (?), St Catherine and St Apollonia.* Hamilton Palace near Glasgow, Staircase hall. Canvas. Life-size figures. At one time at the main altar of the Church of S. Lionardo nel Monte near Verona (Vasari V, p. 328). Monastery secularized 1769. In the 19th century, accoording to Bernasconi, in a private Genoese collection. Compare especially for this picture Crowe-Jordan, p. 527 and Waagen, Treasures III, p. 196. Cf. further, Brinton, *Humanism and Art* (1900), p. 63. While Crowe emphasizes the discord in the colours, Waagen speaks of bright and warm colouring. I list this large and apparently very important altarpiece by Girolamo at this point, but am unable to say anything further about it.

20 *Fresco of the Madonna between St Joseph and John the Baptist.* Above this the four Evangelists. Verona, Piazza d' Erbe No. 23. Engraving in Nanin, *Disegni di varie dipinture a frescho che son in Verona* 1864. Pl. 56.

As far as the figure types, especially in the poorly preserved upper part, allow us to judge, we are dealing with a work from Girolamo's own hand. I am unable to say anything beyond that.

21 *Predella with scenes from the life of S. Lorenzo Giustiniani.* Three paintings on canvas, each 0·32 × 0·56.

(1) *Casting out devils.* (2) *Miracle of the mass and the saint appearing to a nun.* (3) *Death of the saint.* Formerly in the Eugen Schweitzer Collection, Berlin. Published in the auction catalogue (Cassirer—Helbing 1918, p. 19/20 Pls 14/16). I do not know their present location. Since it seems to be thanks to Frizzoni's discriminating eye that these pieces are today attributed to Girolamo, they can be listed among his certain works. There is nothing in any of the reproductions which would exclude his authorship.

Lost works

22 Altar frontal painted with Francesco Morone in S. Maria in Organo in Verona. Payment documented 1514. Cf. Gerola, *Madonna Verona* XI, p. 104.

23 Payments from the church and convent of S. Maria in Organo are documented for the years 1499/1501 and 1519/1520 – both times for miniatures – and from 1514, 1516, 1523. With regard to these lost paintings as well as an imperial coat of arms, completed in 1514, according to a contemporary report, see Gerola, *Madonna Verona* XI, p. 104.

24 *Altar panel with St Onofrius.* Listed in Vasari as being located in S. Maria della Vittoria, together with an altarpiece for the de'Zoccoli family, (cf. No. 16 above), the latter now in the museum.

25 Three small paintings for an altar in S. Maria in Organo. Mentioned by Vasari (V, 329/30). The *Deposition* in the centre, three martyrs on each side. In 1818 the side panels were still in the Galleria Albarelli in Verona. Drawn in Caliari, *Gabinetto di Quadri ... esistenti in Verona presso il sig. Giov. Albarelli* (Verona, 1815).

26 Predella from an altarpiece in S. Maria della Vittoria, (cf. No. 16); still in the church in 1814. 1815 Galleria Albarelli. Cf. Caliari, *op. cit.* XX.

27 *Madonna with Saints.* Church of Roncanova (province of Verona). Formerly main panel of an altarpiece. Cf. Persico II, p. 256. It must have represented the Madonna with St Philip and St James (a conclusion based on the name of the altar). Cf. Simeoni, p. 533, where there is a discussion of the various possibilities for its whereabouts at that time.

28 See Canossa regarding the attributions of various miniatures. Insofar as I was able to check, most lack convincing proof. (In Brescia, for example, I did not find one among all the miniatures which could justifiably be credited to Girolamo). To provide real evidence for an attribution means sifting through a great deal of material. J. P. Richter denies that Girolamo painted miniatures at all. The payment documents contradict that, but still it seems to me, too, that large-scale paintings must form the bulk of his oeuvre. Otherwise why has not one stylistically authentic or signed miniature been discovered?

Paintings erroneously attributed to Girolamo:

29 *Madonna and Child.* Verona Museum No. 138. Canvas 0·97 × 0·75. Cf. Trecca, p. 29. Without question a later imitation, based on the 1526 work. In the original, the low viewpoint was dictated by the elevated position; this has been misunderstood with the result that the proportions are seriously distorted. The landscape in the left half of the picture is taken from the Madonna Maffei.

30 *Madonna with St Paul and St Catherine.* The Church of Mezzano di Sotto near Verona. In older writers (Zannandreis, p. 90, Dal Persico II 126–27) attributed to Girolamo. Crowe, p. 530 note 36, already begins to doubt it. Today acknowledged to be the work of Giovanni Caroto.

31 *Madonna with Angels.* Paris, Louvre No. 1318. Complete details about this much discussed work in Seymour de Ricci, *Description raisonnée des peintures du Louvre*, 1913, p. 68–69. To complete the bibliography I may add *L'Arte* IV (1901), p. 315 and IX (1906), p. 414; and Lermolieff, *Kunstkritische Studien* II, 165. No matter how divided the opinions about its artistic origins, the painting must in any case be excluded from the work of Girolamo dai Libri. This is the view taken by most scholars.

32 *Madonna with St Bernard and John the Baptist.* Quinto near Verona. Panel 2·71 × 1·61. Cf. Avena, *Catalogo* p. 31. This is an able pupil's work, done under the direct influence of Girolamo.

33 *Seated woman playing a string instrument.* Initials. Formerly in the Schweitzer Collection, Berlin. In the catalogue (cf. No. 21 above) given to Girolamo dai Libri. Cf. remarks made regarding the miniatures. Here too I cannot find sufficient reason to recognize Girolamo's hand.

34 *St Sebastian*. Verona, Museum No. 115. Panel 0·70 × 0·90. Considered by Bernardini, p. 1389, to be a Girolamo. Cf. Trecca, p. 112. Of all the possibilities listed there, the attribution to Basaiti seems to me closest to the mark. In any case, the light and somewhat glassy treatment and the insipid forms point to the school of Giovanni Bellini.

G. Campori (*Raccolta di cataloghi ed inventarii inediti . . .* Modena 1870, p. 395) in his inventory of the Boscoli Collection in Parma mentions a painting by Girolamo. Such a work (*Madonna and Child on clouds, with Michael, Raphael and Tobias below*, 4·40 × 2·10) would certainly have come to light by now, unless it were in some gallery under another name.
Finally Berenson mentions a doubtful *Adoration* in Liverpool (Royal Institution No. 16) a *Musical Festival in a landscape* in Brussels (Errera Collection) and two miniatures in London (*David the musician*) and in Milan (*Madonna and Angels in landscape*, Trivulzio Collection.)

Cavazzola

As with all these masters, accounts of Cavazzola's life are scant indeed. Alcardi's[53] monograph of Cavazzola is important for its comprehensive material including engravings, but essentially adds little to Vasari's *Vita*. Zannandreis adds some new information. Gamba's essay in the *Rassegna d'Arte* (cf. No. 1) is useful for its stylistic analysis and chronology of a series of works, although he does not draw on all the available material.

Paolo Morando, known as Cavazzola, was younger than his comrades. He was born in 1486;[54] Vasari even calls him one of Francesco Morone's pupils, although he soon outgrew the latter in ability: 'e seppe molto più che il maestro'. Vasari declares that Cavazzola never left Verona. No other facts of the artist's life are known to us. Apparently Verona held high hopes of him but he died young (1522). Zannandreis includes the document about Cavazzola's death.[55] The question of whether Cavazzola was Francesco's or Domenico's pupil cannot be properly answered. He shows the marked influence of the Morones during his early period (at the beginning of the century), a time in which Francesco himself is most closely

identified with his father's art. In the years before about 1514, however, we can trace Cavazzola's rapid emancipation from Moronesque traditions. Different forces soon pull the young artist in different directions. Even by the turn of the first decade, the Morones' influence is in conflict with that of the young Caroto. A more personal note and greater artistic individuality are evident in the *Annunciation* fresco in the Capella di San Biagio of 1510–11. In the middle period, 1515–18, Mantegna's influence was particularly strong. The influence of Milan can be traced here and there in the painterly treatment. Common to all these pieces are the brightness of colour, the smoothness of the surface and the green tones of the skin shading. Mantegna's influence begins to weaken after 1517; in contrast to the highly animated works of the middle period, an inner calm now begins to show itself. Hand in hand with this, and in contrast to the earlier brightness of colour, goes a striving towards artistic unity, a striving that could never reach fruition because of the painter's early death. Green and blue tones give way progressively to an overall brown. In the same way the composition gains in unity and the forms take on the breadth of the Cinquecento.

Cavazzola: Catalogue of Works

1 *Madonna and Child*. Verona, Museum No. 11. Canvas 0·66 × 0·54. Signed: 'Paulus F. Taddei-Morandi.' Formerly in Galleria Bernasconi, No. 85. Cf. Trecca, p. 35. For this and the following works, references will be found in Gamba (*Rassegna d'Arte* V, 1905, p. 33–40) and Bernasconi (*Studi . . .* p. 274–79, 401–49) and also to the engravings in Aleardi (*Di Paolo Morando*, Verona 1853). Ill. in Biermann, p. 137 and Venturi p. 813.
The work bears all the marks of the Morone school, and shows the awkward and uncertain forms characteristic of youth.

2 *Madonna and Child*, 1508. Half-length. Gazzada, privately owned by Sig. Cagnola. 0·48 × 0·37. Identical to the panel in the possession of Conte Bandini da Lischa dated at 1509 in Bernasconi. Signed 'AD 1508 Paolo Morando F.' Cf. Aleardi, Plate III with the Ill. in Gamba.

Comparison to Giovanni Caroto's early work (1501), the *Madonna Sewing* in the Modena Gallery (Ill. Venturi, p. 815), proves that Morando, still uncertain of his style, is approaching Caroto's manner of painting, which is inspired by Bonsignori and Mantegna. On the other hand we recognize the legacy of Domenico Morone in the high forehead, the distinct hair-line, and the eyelids.

3 *Fresco of the Annunication with S. Biagio and St Benedict*, 1510–1511. Verona, above the inside arch of the chapel of S. Biagio in S. Nazaro e Celso. A document in Zannandreis, p. 96, indicates that Cavazzola worked on the frescoes from 16 June 1510 till 19 June 1511. Biadego, *La Cappella di S. Biagio*, p. 119, records five payments from 6 June 1510 to 29 December 1511; their purpose is not stated. But Zannandreis' document (reprinted in Biadego, p. 119–120) proves their connection with the *Annunciation*.

The fresco demonstrates well Cavazzola's vacillation in the choice of artistic direction. The Madonna and angels are reminiscent of Caroto, whereas the saints could be taken for the work of Francesco Morone. In the colouring Morando has already attained his own style. Predominant are a magical blue and violet toned red. The dark blue sky, with the yellow, reddish and violet lights on the horizon, and the shimmering grey clouds anticipate the mood of the *Pietà* of 1517.

4 *Christ carrying the Cross, with donor*. Half-length. Milan, Trivulzio Collection. Panel. Signed: 'P. Morandus p.' Ill.: Gamba, p. 37.

The early character of the painting finds expression in the parallel folds of the robe, in the type of the long, oval head of Christ, and its similarity to the head of Mary in the *Annunciation* fresco. The folds of the sleeve point towards the style of the middle period. All this suggests a date between 1511 and 1514.

9 5 *Madonna and Child with St John*, 1514. Half-length. Berlin, Kaiser-Friedrich-Museum. Signed:' AD 1514 MOC Paulus MP.'

The motif of the Madonna and the Child is already similar to that of the 1518 *Madonna* in the Poldi-Pezzoli, Milan: the little St John anticipates the one in the later group (Verona,

Museum). Nevertheless, the treatment of the background, the oval shape of the Madonna's head and certain hard lines in the rendering of the folds point back to the Gazzada painting.

6 *Madonna and Child with John the Baptist and St Benedict*, 1515 (?). Badia di Calavena near Verona (now in the Museum). Canvas 1·16 × 1·18. Tempera. Badly damaged. Cf. Avena, *Catalogo . . .* No. 37. Zannandreis, p. 98, speaks of a painting in the parish church in Selva di Progno (province of Verona) on which the Madonna and Child, St Andrew, etc. and the signature '1515 Paulus Veronensis' were to be found. Zannandreis reports severe damage even then. Perhaps that painting is the one we have here (an assumption already made by Gamba, p. 36). Stylistically there is no reason to object. Only, if Zannandreis really did see the picture, could the inscription 'S. Benedictus' have escaped his attention? Perhaps he took his report from Dal Persico II, 139. Cf. Gerola, 'Opere perdute' in *Madonna Verona* XI (1917), p. 97ff., who lists this work among the lost paintings.

The figure of St Benedict is a throwback to the figures of Morone and to Cavazzola's own in the *Annunciation*, in the Capella S. Biagio. John the Baptist, on the other hand, leads us in the direction of the 1518 *St Roch* in London and, in the head especially, of the Christ in the *Flagellation*. The angular, broken, and some-

265

265 CAVAZZOLA. *Madonna and Child with John the Baptist and St Benedict*, Cat. Wks, No. 6 (Verona, Museum)

266 CAVAZZOLA. *Christ Carrying the Cross*, Cat. Wks, No. 7 (Verona, Museum)

267 CAVAZZOLA. *Pietà*, Cat. Wks, No. 7 (Verona, Museum)

what wrinkled rendering of the folds on his cloak is indicative of Cavazzola's middle years, somewhere between 1514 and 1518. The pose and position of the child point to the *Gazzada Madonna*; however, the modelling, the more elegant movement and type of head used are closer to later works like the *Frankfurt Madonna*. Stylistically then there is no reason to doubt the traditional dating. The colouring, though almost totally spoiled, indicates an early period but can add little to our analysis.

7 *Five-panel altarpiece*, 1517. Verona, Museum No. 292–295, 303, 308, 390, 392, 394. From the chapel of S. Croce in S. Bernardino. Transferred to the museum in 1853. The five main parts are on canvas; the four predella panels on wood. *Pietà* 2·35 × 1·55. *Agony in the Garden* and *Carrying the Cross* 2·33 × 1·07. *Crowning with*

Thorns and *Flagellation* 1·75 × 1·10. Signatures: *Flagellation* – 'Paulus P.', *Carrying the Cross* – 'Paulus M.-P.', *Agony in the Garden* – 'Paulus Morandus – P.', *Pietà* – 'Paulus V.P. 1517.'
At one time the paintings were combined with Morone's *Crucifixion* of 1498 to form a whole. The arrangement was as follows: lower centre was occupied by the *Pietà*; above it and equal in width was Morone's *Crucifixion* which was higher than the panels on each side. In the lower left adjoining the *Pietà*, the *Agony in the Garden* and above it the *Flagellation*; lower right *Carrying the Cross* and above it the *Crowning with Thorns*. The predella paintings consist of four portraits representing saints (whose names we know from Vasari): S. Bonaventura and St Joseph under the *Agony in the Garden*; John the Baptist and S. Bernardino da Feltre under the *Carrying the Cross*. Cf. Trecca p. 36–38. A copy

268 CAVAZZOLA. *Flagellation*, Cat. Wks, No. 7
(Verona, Museum)

reach its greatest perfection in the *Pietà*. One
may therefore conclude, that since the *Pietà*
bears the date 1517, the work must have been
begun in 1516 at the very latest. The ragged and
angular style of the drapery is consistent with
this date, although in the *Pietà* this tends
already to be smoothed out. The development is
even more tangible in the choice of figure types
and above all in the colouring. The Christ in the
Carrying the Cross still approximates to that in
the Trivulzio Collection, while the Christ in the
Flagellation coincides with the figure of St Roch
in London. The Magdalen in the *Pietà* is to be
found again in the *Madonna* of the Museo Poldi-
Pezzoli. At first Cavazzola works with contrast-
ing colours. In the progression of the altar-
pieces, however, one notices a tendency, which
pictorially aims at excluding these contrasts. An
overall heavy, leaden tone predominates in the
Pietà, while in the *Carrying the Cross* reds,
greens and oranges still stand disconnectedly
and coldly next to each other. The use of flesh
tones changes with time from green and blue
tones to grey-green and brown. In the high-
lights there is initially that pink which is so
typical of Verona and especially Francesco
Morone. Dream-like deep blues and greens give
the *Pietà* a very special mood. The type of
priming used gives the surface of the whole
series a shiny and somewhat oily appearance.
The predella paintings are badly spoiled and
poorly restored.

of this altarpiece has been correctly recon-
structed except that the predella panel beneath
the *Pietà* was replaced by a makeshift *Death of
the Virgin* in the 17th century. To complete the
whole there was also a *Madonna and Child*, the
painter of which is unknown even to Dal
Persico, and St Bartholomew and St Francis of
Assisi (cf. Morone, Cat. Wks, No. 2). These
pieces originally filled the spaces between the
portrait heads in Cavazzola's predella. Cf. Dal
Persico I, 115. According to Vasari (V, 316), the
bearded Nicodemus of the *Pietà* is Morando
himself. Ill.: Engraving of the Deposition in
Zancon No. 33; Biermann p. 141, 142; Biadego,
Verona p. 119. Photo Anderson 14613, 12422,
14624, 124525, 14634.
The development proceeds from the *Agony in the
Garden* and the *Carrying the Cross*, through the
Crowning with Thorns and the *Flagellation* to

269
CAVAZZOLA.
*S. Bona-
ventura*,
Cat. Wks,
No. 7
(Verona,
Museum)

8 *St Peter and John the Baptist. Archangel Michael and St Paul.* Half-lengths. Verona, Museum No. 307 and 302. Canvas. Each of the two corresponding pieces 0·85 × 1·25. From the S. Chiara Convent. Cf. Trecca p. 40/41. According to Berenson by Michele da Verona. Morelli and Bernardini, p. 1384: collaboration between Michele and Cavazzola. Ill.: Biermann, p. 139. Photo Anderson 12429, 12430.

These pieces are connected with the altarpiece and, like it, clearly belong to the period of strong Mantegnesque influence. The treatment of the skin, with its grey-blue shading, the contrasting green and red, the motif of the cloak placed over the shoulder in the figure of St George (cf. the self-portrait in the *Pietà*), the freer lines – all of this points to the years 1516–17. One should also note the similarity between the head of St John and those of the Christs in the Passion.

9 *Frescoes of Michael and Raphael with Tobias.* Verona, S. Maria in Organo. Right transept. Over life-size.

The works date probably from the period around 1517, or possibly a few years earlier. We list them at this point because of the great similarity between the figure of St George here and that of the half-length painting. One can also find parallels with the angel of the London Madonna painting. The treatment of the skin with its faint shading and its dominant reddish tone would, however, push the frescoes back to an earlier period. No more definite conclusions can be drawn because of the vagueness of our knowledge of Cavazzola's fresco style and because the works are not very well preserved.

270 10 *Knight and attendant,* the so-called *Gattamelata.* Florence, formerly Uffizi No. 571, now Pitti. Canvas 0·90 × 0·73. At one time generally thought to be by Giorgione; later by Caroto. L. Justi, *Giorgione* I, 212 still believes in a close connection with Giorgione. Ill.: Justi II, Pl. 52. Photo Anderson 7549.

Gamba offers sufficient evidence that we are concerned here with a work by Cavazzola. In the series of two figure compositions, which occur frequently with Cavazzola, this painting is close to the early Christ in Milan. However, it surpasses it in its complexity of movement, despite the fourfold verticals and the parallelism

270 CAVAZZOLA. *Knight and attendant,* so-called *Gattamelata,* Cat. Wks, No. 10 (Florence, Pitti Palace)

in the arms of the knight and attendant. The next stage is the group around the man to the far right in the *Pietà*, with one of the women behind him in profile. (Notice, besides the general parallels in position and movement, the similarity of headgear in the woman and the attendant, the drawing of the ears, and the hairline.) The London and Frankfurt paintings demonstrate the further development of the secondary figure in profile. These features would point to a date between 1514 and 1517 but we can narrow the period still further by another observation: Morone's influence is entirely absent in both form and colour. This painting shows an unmistakable advance beyond No. 6 tentatively dated 1515, and belongs close to the major altarpiece. It must have been created in 1515/16. The position of the torso in three-quarter view, with arms crossed and head turned in the opposite direction are typical of Cavazzola. It clearly indicates the further development of the Christ figure in the *Carrying the Cross* (Trivulzio Collection). The type of head lies somewhere between the Christ and the man in the *Pietà*. The right hand, which holds the sword, comes up again in the figure of Christ. The left one, in this

position for the first time, can be pursued throughout Cavazzola's work: *Portrait of a Lady* (Milan), *St Roch* (London), *Doubting Thomas* (Verona), *Portrait* (Dresden); similarly, *Portrait of a Woman* (Bergamo).

0 11 *Madonna and Child with John the Baptist and an Angel*. Half-length. London, National Gallery No. 777. Canvas 0·76 × 0·66. Signed: 'Paulus V.P.' From the collection of Count Lodovico Portalupi, Verona. Acquired 1867.

Crowe is probably mistaken when he mentions two similar pictures, one in the Portalupi collection and one which came from the Bernasconi Collection to the National Gallery. Information from the London catalogue, when compared to Aleardi, Pl. XXI, proves that we are dealing here with the piece from the Portalupi Collection. But Zannandreis reports that Lorenzo Muttoni was believed to have prepared a copy of this work, so there is a possibility that the original and a copy are both in existence. Cf. *Catalogue* 1920, p. 193–194. Photo Anderson 18151.

This work too belongs to that series of paintings which is easy to connect with the large altarpiece. The Raphael repeats the type of the Angels (cf. Nos 8 and 9). In the left hand of the Madonna we recognize the left hand of Peter (cf. Nos 8 and 9). In the figure of Christ, the form of the arm and the cut of the shirt are to be found again a short time later in the *Milan Madonna*. The heads of the Magdalen in the *Pietà*, the Poldi-Pezzoli *Madonna* and in our painting here form a closely related trio. The relaxed forms point to the years 1517/18.

12 *Fresco of St Bernard*. Half-length, life-size. Verona, S. Bernardino, cloister to the left at the front of the church. Tondo in a lunette over a door. A small, very fresh *Madonna and Child* in half-length (diameter approx. 20 cm) is located in the decorative band which divides the lunette from the door. Cf. Vasari p. 315, later Dal Pozzo p. 34, who also mentions a fresco of St Francis (now lost). Berenson lists as a doubtful work a *Madonna* in a lunette in the cloisters. The fresco is not mentioned by any other author and I myself could not find it there. The style of the *Pietà* sets the tone for this grandly conceived but unfortunately damaged fresco.

271 CAVAZZOLA. *Portrait of a Lady*, Cat. Wks, No. 13 (Bergamo, formerly Galleria Morelli, now Accademia Carrara)

13 *Portrait of a Lady*. Half-length. Bergamo, 271 Galleria Morelli No. 566. Canvas 0·74 × 0·95. Cf. the Gamba-Frizzoni controversy in *Rassegna d'Arte* V (1905), p. 56. Photo Arti Grafiche-Bergamo No. 320.

The portrait undoubtedly belongs to Cavazzola's oeuvre, to the years around 1517 to be precise. The signs which point to this time are the characteristically wrinkled treatment of the sleeves, the subdued greenish shading in the skin, the cold reddish tone on the cheeks and eyelids and the smooth treatment of the surface. The shape and line of the hands alone allow for no other name but Cavazzola.

14 *Madonna and Child*, 1518. Half-length. Milan, Museum Poldi-Pezzoli No. 698. Panel 0·15 × 0·19. Signed: 'Paulus Veron. P. 1518.' From the Frizzoni Collection, 1912. Cf. Frizzoni in *Rassegna d'Arte* XII (1912), p. 121, with illustration. Photo Marcozzi 464, Brogi 15492.

Cavazzola's growing mastery displays itself in the broader arrangement of the mantle and the colours which range from greenish shades to umber and brown.

231

15 *St Roch*, 1518. London, National Gallery No. 735. Canvas 1·56 × 0·54. Signed: 'Paulus Morãdus V.P.' The year 1518 is no longer recognizable. Originally in S. Maria della Scala, first altar on the left, in Verona, it was a counterpart to a *St Sebastian* by Torbido. Removed from the altar in 1742. Later in the Caldana Collection and from there it went in 1853 into the Bernasconi Collection. 1864 National Gallery. Cf. *Catalogue* 1920, p. 201. Sgulmero, *Il trino-trittico di S. Maria della Scala in Verona* (Nozze Simeoni-Colpi) 1905. Photo Hanfstängl 359.

In the head and drapery there are echoes of Mantegna. In the hovering angel one sees Torbido's influence.

16 *Doubting Thomas*. Verona, Museum No. 298. Canvas 1·40 × 1·63. From the Convent of Santa Chiara. In the background to the left, the Ascension, to the right Pentecost. Cf. Trecca, p. 41. Photo Anderson, Stödtner.
Although the Christ here is posed in a very similar way to the Raphael in the fresco in S. Maria in Organo, the colouristic idiosyncrasies show marked progress. There is decided development towards an overall painterly conception: the group is held together by the mass of a brown wall. Against this background, red and white lose the vivid and contrasting character of earlier works. The niche anticipates an idea which will return in the *Madonna* No. 19. In Christ's robe there are the last reminiscences of Mantegna's late work.

251 17 *Madonna and Child with an Angel*, 1519. Half-length. Frankfurt, Städelsches Institut No. 49B. Canvas 0·71 × 0·59. Unclear signature preserved. 1890 – acquired by auction from the Ropp Collection in Cologne. Cf. *Katalog* 1900, p. 67. Photo Bruckmann.
Considering the style of the painting, 1519 is a correct reading of the meagre remnants of the inscription. One can see Cavazzola's later manner in the arrangement of colours: in Mary's red dress, in the orange coloured lining of the blue cloak, in the deep green of the Angel's garments, in the light blue cloth over the Child's legs – all this against a dark coloured background. In addition there is the predominantly reddish-brown shading of the skin

and the shadows around the eyes. The type of the Madonna is an extraordinary anticipation of the one of 1522. The character of the composition alone would permit a correct dating of this picture.

18 *Portrait of Giulia Trivulzio*. Half-length. Milan, privately owned by Marchesa Trotti-Belgioioso. Inscribed: 'Iulia Triwl. Theodori. Francie Marescal. unica. filia Frans. Triwl Marchis. viglevani Nicolai Co. Musochi. filjj. uxor.'
Unfortunately I did not get to see this painting, which is supposed to possess special tonal qualities in the treatment of the white silk dress. The broad application of paint seems to me to surpass that of the Frankfurt Madonna. Gamba's date of 1518 is possibly a little early.

19 *Madonna and Child with St John.* 2 Half-length. Verona, Museum No. 85. Canvas 0·72 × 0·60. Signed: 'Paulus-Morandus – V.P.' The authenticity of the signature has been doubted for no good reason. From the Bernasconi Collection. Cf. Trecca, p. 43. One finds an almost exact replica of this painting in the figure of Love from the surrounding Virtues in the next picture. Photo Anderson 12417.
The painting's connection with the one of 1522 gives a clue to its date. Both pictures probably go back to a common source, since neither that nor our *Madonna* looks like a copy, nor are they completely identical. All the characteristics are late: notice the type of head, with the pointed chin, the breadth of the folds and above all the overall brown tone. (At several points the brown ground is visible.) The deep shadows run to reddish browns; the surface has lost its glossiness entirely.

20 *Madonna on Clouds with Saints*, 1522. 2 Verona, Museum No. 335. Canvas 4·40 × 2·67. Inscribed: '1522.' Cf. Trecca, p. 38-40. Earlier called a Morone, but, since Dal Pozzo. p. 35, Cavazzola. According to tradition the work remained unfinished at Morando's death (Vasari, p. 317). Maffei reports that Morone completed it. Depicted are the Madonna with the Child in clouds between St Francis of Assisi (r.) and St Antony of Padua (l.). The three theological and four cardinal Virtues surround them. On the earth stand six saints of the

Franciscan order, two groups of three on each side. Left: St Elizabeth, S. Bonaventura, King Louis. Right: St Elzearus, Bishop Louis, S. Ivo. In the centre, a half-length of the donor, Catarina da Sacco. Ill.: Biadego, Verona, p. 117. Photo Anderson 12427.

The discrepancies in composition have been discussed above. The saints' heads in the lower half of the picture are especially fine. Here one finds the purest, most significant expression produced up to this time in Verona. There is a broadening out both in the size of the figures and the arrangement of the drapery. Here and there one still recognizes vestiges of the fussy style of the middle period. The principal contrast with the main work of the preceding period lies in the relinquishing of clashing colours, of stagey highlights and indeed of all striking effects. A brownish tone pervades the whole picture. Each group of three figures is bound together by the background, while the entire right half of the picture is set in a lighter tone. In only a few places does the old love of garish colours still break through. I will not dismiss out of hand the traditional belief that Cavazzola left the painting unfinished. There are glaring distortions to be found in the Virtues, which conflict with the saints below. Furthermore, there is a fiery red, which I have otherwise not noticed in Cavazzola's spectrum colours. (Only in the Angel of the Frankfurt painting can one see similar colours.)

272 21 *Portrait of a Man.* Half-length. Dresden No. 201. Canvas 0·93 × 0·75. Formerly in the possession of the degli Emili family in Verona; acquired in London 1875. It depicts Joanis Emilius, a member of the Megli family of Verona, jurist and *protonotarius apostolicus.* Details in Kohler, in *Monatshefte für Kunstwissenschaft,* 1916, p. 62. Cf. *Katalog* 1902, p. 98 (1912, p. 28). Ill.: Kohler and in the *Katalog* (1902), p. 86. Photo Braun 20232, Bruckmann 201, Hanfstängl.

This work may be regarded as the last and most mature statement of Cavazzola's art. Expression, movement and colour reveal the movement toward greater calm in the late years. In many respects the portrait surpasses the great altarpiece: compare the colouristic development in the brocade on the sleeve with that of King Louis (No. 20, third figure to the left).

272 CAVAZZOLA. *Portrait of a Man,* Cat. Wks, No. 21 (Dresden, Staatliche Kunstsammlungen, Gemäldegalerie Alte Meister)

Badly preserved works:

22 *Fresco of Raphael and Tobias,* 1520. Verona, S. Euphemia, exterior, above the Canons' portal in Via S. Euphemia. There remain only faint traces of the work. Cf. the engraving in Aleardi (Pl. XXII). Zannandreis (p. 96) was still able to read the date. According to Vasari (V, 315, note) inscribed: 'Societas Angeli Rafaeli Fecit Fieni 1520.'

23 *Fresco of the Sybil with Augustus.* Verona, No. 29 Via del Paradiso. Vasari reports: 'opera assai bella per della prime che fece Paolo'. Thereafter it was known as an early work, though this is questionable. Persico II, p. 36, adds to the same façade a *Sacrifice of Isaac,* which was also supposed to be Cavazzola's. Hence Milanesi p. 314, note III, and Berenson. Cf. Aleardi Plate VII. There are only a few recognizable fragments left.

Doubtful works

24 and 25 *St Francis preaching.* Two versions: (1) Verona, Museum No. 101. Panel 0·38 × 0·76. From Casa Emilei into the Bernasconi Collection and from there to the museum. (2) Budapest,

233

Gallery of Fine Art No. 164. Panel 0·42 × 0·77. Acquired in 1895 in Milan.

Trecca (p. 44) considers the Verona work to be by Domenico Morone; Térey, (p. 101) thinks the same of the one from Budapest. (According to the Budapest catalogue so does Bode.) Bernardini calls it a Francesco Morone. I concur with Berenson and Gamba, who do not mention Morone's name in this context. Berenson attributes the Budapest painting to Cavazzola; he does not mention the one in Verona. In Gamba's opinion one might have here a part of the lost predella from the large altarpiece of 1522. Without knowing the Budapest piece it is impossible for me to decide which of the two pictures is the original and whether this predella should be credited definitely to Cavazzola.

26 *Portrait of a Man.* Half-length. Vicenza, Museum No. 86. Canvas 0·50 × 0·60. This picture is seriously damaged and has been so vigorously cleaned that the colours have completely lost their original character. Gamba calls the work a pathetic Raphaelesque imitation. He was probably deceived by its state of preservation. (Fiocco attributes it erroneously to Torbido.)

Faced with such severe damage, one will never be able to make a completely accurate attribution. Nevertheless there seems to me something to be said for mentioning Cavazzola's name. There is a strong general similarity to the Dresden painting. As for details, I would point out the somewhat protruding mouth, which recurs often with Cavazzola, especially in the *Gattamelata*; also compare the right hand here, the right hand in the Dresden work and the left hand in the Bergamo painting. The crossing of the arms and the somewhat uncertain position of the head are characteristic of Cavazzola. A green which has been preserved on one sleeve fits his colour range.

27 *John the Baptist.* Budapest, Gallery of Fine Art, No. 135. Canvas 1·29 × 1·76. Acquired 1894 in Venice. Crowe mentions (p. 537, footnote) that it was in the collection of Dr G. Bresciani. Earlier Bernasconi: in the hands of the heirs of Sig. Malenza, a lawyer. Cf. *Catalogue*, p. 192 with ill. According to Frizzoni, Lederer and Bode, not by Cavazzola. Not mentioned in Berenson.

In the foreground stands St John, with donor; in the background, Baptism and Preaching in the desert. Cf. Aleardi Pl. II. Photo Bard, Hanfstängl. Without knowledge of the original one cannot make an accurate judgment.

Lost works

28 *The Betrothal of St Catherine.* In Dal Persico I, p. 227, this work is mentioned in the list of pictures which were to hang in the future pinacoteca. Likewise in 'Elenco dei pezzi di pittura e stampe' in *Madonna Verona* I (1907) p. 208.

29 *St Roch, St Antony, St Clare, St Bernard, Job, Martyrdom of St Sebastian, Baptism.* Seven panels from the Sambonifacio Gallery mentioned by Dal Persico (II, 33). If one assumes Dal Persico to be incorrect here, then the first six pieces might be identified with Verona Museum, No. 135: today recognized to be Morone's work (No. 17).

Works erroneously attributed to Cavazzola

30 *St Antony.* Milan, Museo Poldi-Pezzoli No. 579. Panel 0·95 × 0·59. Catalogue from 1911, p. 77. Berenson, *Rassegna d'Arte* IV (1904) names this painting along with the next (No. 31) as Cavazzola's, but in *North Italian Painters* he presents it as a Girolamo. Frizzoni, in *Rassegna d'Arte* V, p. 57, agrees with Gamba in declaring it not to be a Cavazzola. But then in *Rassegna d'Arte* XII, p. 121 he goes back again to thinking that it is.

31 *Saint*, Miserden Park, Cirencester, in the possession of W. A. Leatham. Counterpart to the *St Antony*. Recognized as such by Berenson (*Rassegna d'Arte* 1904, p. 185). In *North Italian Painters* as a Girolamo (cf. above). H. Cook, *Burlington Magazine* I, p. 186, attributes the work to Luini. Beltrami (*Luini*, 1911, p. 591) would allow this attribution but for the incompatibility of its counterpart, the *St Antony*. Ills. of both paintings in Beltrami p. 590; *Rassegna d'Arte* 1912, p. 121/22. The Saint, in *Burlington Magazine. St Antony*, photo Anderson 11178. For the time being the paintings of both St Antony and the other saint can only be attributed to the Verona School around 1520. I

can see no sign of Morando's, Girolamo's or Morone's hand.

32 *St Paul with Saints and Worshippers*. Verona, S. Anastasia. Right transept (earlier, vestry). Canvas 2·44 × 1·63. According to Berenson and Gamba: Francesco Morone. According to Morelli: Michele da Verona. However, most authors, especially the earlier ones, have plumped for Cavazzola. (Cf. the engraving in Aleardi, Pl. XI.)
I consider the painting to be a late imitation, made up of features from several masters. Even Crowe noticed the 'exceedingly fine and slender figures'.

33 *Fresco of Christ carrying the Cross, with a monk*. Verona, S. Bernardino. Fills a lunette above the small door to the right. Overpainted. According to Berenson: Cavazzola. But the fresco does not correspond either in expression or movement to Cavazzola's style. Judging by the colours especially, it could have been conceived a good half century later.

34 *St Giustina*. Budapest, Lederer Collection. Both Gamba and Bernardini (*L'Arte* IX, p. 98) were right in removing this from Cavazzola's oeuvre.

35 *Madonna and Child with two Saints*. Englewood (U.S.A.), Platt Collection. Breck, in *Rassegna d'Arte* 1910, p. 146, published it as a Cavazzola. A critique by Gamba in *Madonna Verona* V (1911), p. 57, banished it completely from the Verona School.

36 *Moses and the People*. Verona, Museum No. 132. Panel 0·18 × 0·30. Cf. Trecca p. 44. Berenson's attribution of this work to Caroto is correct, though it is often linked with Cavazzola. This can be confirmed by comparing it to Caroto's small paintings in Bergamo.

37 *Madonna and Child*. Half-length. Conte Murari of Verona owns a small panel depicting the Madonna and Child which may be mentioned in connection with Cavazzola.

There remain to be mentioned a few works ascribed to Cavazzola, about which I am unable to give any information:

1 *Madonna with St Francis* in Chartres (No. 86). Cf. Berenson p. 192.

2 *Madonna*. Count Serristori, Florence. Cf. Berenson, p. 192.

3 *Portrait of a Man* in the Rudolfinum in Prague (No. 486. In the Rudolfinum catalogue it is marked with a ?).

4 *Portrait of a Musician*. Mentioned by Reinach in *Tableaux inédits ou peu connus tirés de Collections Françaises* 1906, p. 52/53 (Pl. 42) and said to be part of the Richtenberger Collection. M. Duelberg feels the name Cavazzola is valid. Formerly attributed to Lorenzo Lotto and Sebastiano del Piombo.

5 *Death and Burial of the Virgin*. Two panels 0/68 × 0·70. (a) Mary dying surrounded by the Apostles. (b) The body on a bier borne away by the Apostles. Formerly Guggenheim Collection. Cf. *Catalogue de la Collection de M. le Comm. Guggenheim, Venise*. Munich, Helbing 1913, p. 45, No. 826, Pl. 26.

6 *The Astronomer*. Formerly Graham Collection (England). Auctioned in 1886. Cf. Redford, *Art Sales*, 1888, II, p. 241.

7 *Portrait of a Woman*. Formerly Meazza Collection. Auctioned 1884 in Milan. Cf. S. Reinach, *Répertoire de peintures* 1905, I, p. 56.

Foreword

1 *Art History as a Discipline*, Winterthur, Delaware, 1959

2 *Kunstchronik*, 1931

3 'On the Use of Critical Terms', *Modern Language Association*, Chicago, 1967

I Michelangelo's Biblioteca Laurenziana

1 For access to the documents I am indebted to Comm. Giovanni Poggi. Report of the work then in progress in a few general sentences in *Arte e Storia*, XXI (1902), p. 87.

2 *Michelagnolo Buonarroti als Architekt*, Munich, 1904, p. 26. At the time of publication the renovation was already completed. Geymüller nevertheless omits all reference to it, in spite of the fact that Castellucci, the architect who measured the Laurenziana for him, was at the same time directing the work of renovation. Geymüller's description of the unfinished façade has remained unnoticed.

3 No. 9411 (Pl. 4), view of the Vestibule façade. The plate no longer exists and the number has been transferred to the photograph of the new façade (Pl. 5). No. 8434 (Pl. 2), view of the whole west side of the cloister.

4 It is worth noticing that Geymüller – without knowing anything of the two building periods – must have observed a horizontal division in the wall, for he says (p. 26): 'An der unvollendeten oberen Mauer des Vestibüls, welche auf einer älteren Mauer aufgesetzt ist . . .' In fact on the photograph one can make out the two different kinds of bricks used: in the lower part, as far up as the cornice of the Library, a narrower kind than above.

5 This corner has been built over by the modern block erected at the end of last century at the south end of the Library (see p. 59). Above the roof of the new building the two top quoins can be seen; between the top one and the cornice there are seven layers of brick. Perhaps on this side too the quoining was discontinued when the heightening of the Vestibule was decided upon.

6 The effect Michelangelo intended is shown in Pl. 7.

7 Berenson, *Florentine Drawings*, no. 1423, connected the sheet wrongly with the Medici Chapel. Correct designation, Geymüller, *op. cit.*, p. 26, sheet 4, no. 5.

Subsequently Thode, *Kritische Untersuchungen*, II, p. 124; C. Frey, *Handzeichnungen des Michelangelo Buonarroti*, no. 234; Tolnay in *Münchner Jahrbuch*, 1928, p. 402, fig. 20.

8 Pilasters, not columns as Thode always maintains. This is shown on the plans on the same sheet, most clearly at the top left. The form of the corner shown in the upper middle is misleading; for if the drawing were completed pilasters would be marked next to the columns on either side. The crucial question about this drawing is the following: should the double column articulation of the wall be continued right into the corner (the final column completing the articulation of each wall) or should this final column be replaced by a pillar? This drawing clearly shows that Michelangelo had already decided in favour of the latter plan. Each wall thus forms a separate whole, not just a section of a continuous rhythmical sequence.

9 Tolnay, *loc. cit.*, p. 402, maintains that at this stage Michelangelo was considering two doors placed asymmetrically in the base. There is nothing in the building to justify the displacement of the right-hand door; behind the whole of the west wall lay a terrace above a Quattrocento loggia, leaving Michelangelo perfectly free in the placing of his doors.

10 Tolnay, *loc. cit.*, p. 402, thinks that the articulation of the main storey is continued in the attic. This is not so; for the alternating breadths of the projecting and receding bays can only have a horizontal effect.

11 Geymüller, *op. cit.*, p. 26, who alone seems to have considered this question, wrongly takes the circular recesses of the attic for windows. This is impossible, for the circular recesses on the east wall are backed on the outside by piers and in the south and north walls openings at these points are impossible.

12 C. Frey, *Briefe an Michelangiolo*, Berlin, 1899, pp. 268, 270f.

13 C. Frey, *Handzeichnungen*, p. 82, is thinking of the 'piccola libreria', which, in fact, was to be lit from the roof (see p. 45). Thode, *Krit. Unt.*, II, pp. 116, 119, does not take up a clear position.

14 'La presente è per farvi intendere come N.re alli giorni passati hebbe la vostra de 7 col disegno a piedi della libreria, gli mandasti. . . . Et dice, che li ochi disegnati per dare li lumi si pensa habbino ad essere una cosa bella; ma che

non sa, se la polvere, [che] riceveranno, sara maggiore che 'l lume rendere potteranno? Et che alzando el muro duo braccia per fare le finestre, come advisate, et essendo parte del tecto posta su, et haverlo hora a diffarlo et tramutare legnami, se 'l reggera el peso et fara danno alla fabrica?'

15 Michelangelo's letter of 2 December is clearly referred to. See C. Frey, *op. cit.*

16 In Frey's edition of the text it is *et*: the sense demands that this should be *o*.

17 Thode, *op. cit.*, p. 116, translates the wrong way round: that the skylight brings about the heightening.

18 See Milanesi, *Lettere di Michelangelo*, Firenze, 1875, p. 597.

19 'N. S. a preso grande piacere, quando lesse, che voi vi eri risoluto a fare il ricetto, siche sollecitatelo. Ora circa alle finestre sopra tetto con quelli ochi di vetro nel palco dice N. S., che gli pare cosa bella et nuova; niente di manco non ci risolve a fare, ma disse, che e'bisognierebe saldare dua frati delli Jesuati, che non attendessino ad altro che a nettare la polvere.'

20 From the comparatively summary accounts published by Gronau in *Jahrbuch der Preuss. Kunstsammlungen*, XXXII (1911), *Beiheft*, pp. 68ff., not much can be gathered regarding the progress of the work. See Appendix, I.

21 Frey, *Briefe . . .*, p. 274.

22 *La Libreria Mediceo Laurenziana*, Florence, 1739, p. VII: '. . . sarebbe la muraglia restata molto interrotta de' vani, e conseguentemente priva del suo bastevol sostegno.'

23 Frey, *Handzeichnungen*, Pl. 210; and Tolnay, *Münchner Jahrbuch*, 1928, fig. 40.

24 It is not impossible that the layers of rubble to be seen on the uncompleted façade are witness of the intermediate scheme. But this theory can only be offered tentatively as a possible explanation. It is to be supposed that Michelangelo, in order to relieve the burden of the upper part of the Vestibule façade in the first plan, had the compartments between the piers filled with rubble instead of having them bricked right over. This rubble filling was to go as far as the cornice – more than 2·00 m. The fact that the rubble in the uncompleted façade goes only to 0·55 m may again be due to the intermediate scheme. The

windows would have been placed exactly where the rubble of the right-hand and middle compartments leaves off. The rubble from the compartments filled to the height of the Library had begun to be removed. While this work was in progress the change to the last scheme took place, so that in the south compartment more rubble remains than in either of the others.

25 Woelfflin, *Renaissance und Barock*, newly revised by Hans Rose, 1926, p. 127, fig. 69. In the edition of 1908 this façade was not mentioned. Tolnay analyzed the façade as Michelangelo's work in *Repertorium für Kunstwissenschaft*, 1927, pp. 192ff., fig. 23, but corrected himself in *Münchner Jahrbuch*, 1928, p. 433. The modern completion of the façade is noticed neither by Tolnay in Thieme-Becker, XXIV, p. 520, nor by Marargoni, *La Basilica di S. Lorenzo in Firenze*, 1922, p. 79.

26 Gaye, *Carteggio*, III, p. 12.

27 *Krit. Untersuchungen*, II, p. 124; III, no. 173.

28 *Münchner Jahrbuch*, 1928, p. 402.

29 Drawn between January and April, 1524. Tolnay concludes on the ground of this plan that Michelangelo at first meant to make the Library similar to the Vestibule. He reverses the sequence of plans, of which there is documentary evidence.

30 On this indication of a third storey, the literature provides no comment.

31 Frey, *Briefe . . .*, p. 279: 'che come in tera sono tre vie, che mettono in mezo due ordini di banchi, cosi vorebe fussi nel palco.'

32 *Münchner Jahrbuch*, 1928, p. 402. Never questioned in previous literature. See Marquard, *Die Zeichnungen Michelangelos im Teyler-Museum zu Haarlem*, Pl. 12; and Woelfflin in *Repertorium für Kunstwissenschaft*, 1901, p. 320, who first connected the sketches of the sheet with the Vestibule. Further, Geymüller, p. 48; Thode, II, p. 122, 133, III, no. 260; Frey-Knapp, no. 315; Panofsky in *Repertorium für Kunstwissenschaft*, 1927, p. 37. The other side of the sheet with sketches of legs is not by Michelangelo. The left-hand half of the sheet concerns us most. On the verso is a small plan, and the elevation of a single division of the wall – belonging together and having, it seems, some connection with the drawing on the left.

33 The plan top right does not belong to the adjoining elevation. It was drawn later and shows the state actually con-structed. That in the elevation pilasters are intended on the outside and columns are intended on the inside is evident from the genesis of all Library and Vestibule plans. The pilasters are always brought forward of the columns. See also note 68.

34 In the much later design for the windows of the upper storey (Pl. 13), made after the intermediate stage, Michelangelo returned to the frame motif of this time. The question must at least be raised whether in the Haarlem drawing windows are planned only in the outer bays and niches in the central ones. This possibility seems to be supported by the straight moulding running across below the semicircular heading. It is, however, more likely that these lines represent pentimenti reducing the central windows to a size corresponding to that of the outer two. This alteration is not only in accord with subsequent development, but the Library can only in this phase be reconstructed with a close sequence of windows. The pope himself demanded as many windows as possible. See Fattucci's letter of 30 January 1524 (Frey, *Briefe . . .*, p. 209).

35 'Et circa alle scale gli piace assaj la salita di dua scale.'

36 Although there are indeed some remarkable coincidences between the measurements of S. Spirito and of this elevation (which Geymüller does not mention), yet the rectangular base below the double division of the centre actually makes any reference to S. Spirito impossible. On the scale of S. Spirito the base would be approximately 8·00 m high!

37 The height of the secondary base plus that of the main storey on the Haarlem sheet is approximately that of the giant storey of Casa Buonarroti 89.

38 Thode and Frey speak always of giant columns instead of giant pilasters. This must be a mistake. See the later use of the same motifs on the Capitoline buildings.

39 Frey believed, incorrectly, that on the Casa Buonarroti sheet the whole wall lies in one plane. Tolnay's analysis is intelligible only on the presumption that Made the same mistake (*Münchner Jahrbuch*, 1928, p. 402, fig. 19). See below, note 56.

40 Not windows, as Thode thought: these would be impossible here.

41 The base is slightly heightened in comparison with that of the Haarlem sheet. The tabernacle of the outer division is clearly marked as such by the lines completing it at the bottom – which have no counterpart on the doors.

42 A slight diminution of the height of the base later on left doors and tabernacle standing free on the surface of the wall.

43 Instead of the breathing space allowed to each column in the long hall, here they are packed closely together. Instead of the row of isolated projecting pilasters, here concentration is effected in the connection of pairs of pilasters by the projecting cornice above each tabernacle.

44 Compare the bases of columns in Casa Buonarroti 48 with only one small hollow moulding.

45 On the subject of this drawing see p. 29. Casa Buonarroti 92 (Pl. 21) with sketches for the stairs was reversed and to the sheet were added not only the two big moulding drawings on the left, but also a section of the base comprising a niche similar to British Museum 1895-9-15–508 (Pl. 17).

46 Sheet British Museum 1895-9-15-507, once thought to refer to the Vestibule, has been justifiably rejected by Popp in *Münchner Jahrbuch*, 1927, p. 405, note 9.

47 In *Monatshefte für Kunstwissenschaft*, 1922, pp. 262ff.

48 On the letter of 10 March see Appendix, III, 2d. This letter runs that the pope remains 'un poco di dubbio, e questo si è la scala per salire le sei braccia.' The differences in level between Vestibule and Library is in fact only a little more than 5 braccia.

49 See Frey, *Briefe . . .*, p. 226.

50 *Münchner Jahrbuch*, 1928, p. 400, fig. 17.

51 As Tolnay excludes the Haarlem drawing he overlooks the connection between plan and elevation.

52 Tolnay is here reminded of the steep single flight of stairs in the medieval courtyard (Bargello) and sees the novelty of Michelangelo's idea in its duplication. But it is not possible to regard the former as the genetic origin of the latter.

53 Frey, *Briefe . . .*, p. 250.

54 Frey, 71, regards the connection of the plan with the Vestibule as uncertain. Thode, *Krit. Unt.*, II, p. 121-2, III, no. 135, correctly dates the plan April 1525. Tolnay, *Münchner Jahrbuch*, 1928, p. 407, note 28, fig. 18, places this plan as well as that of Archivio Buonarroti (II) before 29 April 1524. Tolnay was the first to recognize the connection between plan Casa Buonarroti 89 and elevation Casa Buonarroti 92 (Pls 19 and 20, top). But he dates the drawings on the latter *en bloc*

'approximately 12 April 1525', and thus leaves a gap of nearly a year between plan and elevation. In his article in Thieme-Becker, on the other hand, he allows the elevation on Casa Buonarroti 92 (Pl. 20) to have been made together with the plan before 29 April 1524. He thus separates the elevation from the other sketches on the sheet which he attributes to April 1525.

55 See Tolnay, *loc. cit.*

56 What the stair that goes with the elevation shown in Pl. 16 looked like must remain an open question. Wrongly connecting plan (Pl. 19) and elevation (Pl. 16), Tolnay draws conclusions of outstanding importance as to the architectural conceptions of Michelangelo. According to Tolnay two central bays have the effect of a duplication of each side one, although, again according to him, the twofold bay of the centre is only one-third as wide again as each side bay. [In fact, elevation (Pl. 16) is articulated: *a*, *b*(*a* + *a*), *a*; in plan (Pl. 19) the relation of staircase to wall is: *a*, *b* (*a* + $\frac{1}{3}$*a*), *a*.] Tolnay further concludes that the staircase placed against the central bays will appear larger than it really is. The disguise of an objective form by such optical illusionism seems – apart from this particular case, which can be refuted on other grounds – to be in direct opposition to Michelangelo's architectural conceptions.
Another conclusion is drawn on p. 398 of the same article, also far-reaching in its consequence and also based on a false analysis of the facts.

57 This reference already in Tolnay, *loc. cit.*, p. 405, fig. 22. In Frey, fig. 164, 165, and Thode, *Krit. Unt.*, II, p. 129, and III, no. 138, the drawings are to some extent incorrectly described and wrongly arranged.

58 Tolnay, *loc. cit.*, p. 400, sees in the elevation, already correctly related to the plan by Panofsky in *Monatshefte f. Kunstwissenschaft*, 1922, pp. 262ff., a threefold free-standing stair which goes beyond the twofold stair of Stage 5. Against this stands the fact that the breadth of the side flights has almost the same relation to the central space as that shown on the plan, while after the planning of the free-standing stair the distance between the side flights was considerably diminished.

59 The solution must be similar to that of Buontalenti for S. Stefano.

60 These measurements approximately deduced from the *c.* 30 cm depth of each step.

61 The outer landings would have had the form of a trapeze, from which the stair to the middle landing would have cut off on each side an irregular triangle.

62 Two steps to equal the depth of the last steps of the central flight, and one to connect the last steps of the side flights.

63 *Krit. Unt.*, III, no. 138. Compare Frey's correct conclusions in *Handzeichnungen*, text p. 80. For the understanding of Michelangelo's sketch it is necessary to point out that during the drawing an enlargement of scale took place towards the middle. In consequence of this change the flight on the right was not completed, so that the whole staircase should not appear lopsided. Nor must we overlook the fact that only during the actual process of making this drawing were the architect's ideas clearly formulated, ideas which were quite new in the history of the stair. The detail of the connection between side and middle flights shown upper left is sufficient witness of the struggle Michelangelo had with this conception.

64 Only this sheet, no. 816, published by Geymüller, *Michelagnolo Buonarroti als Architekt*, p. 48, fig. 38; *ibid.*, sheet 1464. See Thode, *Krit. Unt.*, II, p. 129–30, III, no. 244a. Frey, *Handzeichnungen*, note p. 80 would use these sheets in reconstructing Michelangelo's plans only with strict reservations: he gives no reason for this opinion.

65 See Geymüller, *loc. cit.*; Thode, *loc. cit.*; Panofsky in *Monatshefte f. Kunstwissenschaft*, 1922, p. 265.

66 Under this plan is written 'pianta'. These two, as also the other plans, are always seen from the door. So also is the original plan by Michelangelo in Pl. 21.

67 Folio 65r. Published by L. H. Heydenreich in *Mitteilungen des Kunsthist. Instituts in Florenz*, III, July, 1931, p. 440, fig. 5. Note by Vannocci 'Scala di Michel Ango Buonarotti per la Libraria di San Lorenzo.'

68 The Lille drawing first published by Geymüller, *op. cit.*, p. 47, fig. 37. Here also Vannocci's sheet is referred to. See Thode, II, p. 122, III, no. 281. Vannocci's drawing in folio 30v of the sketchbook published by Heydenreich, *loc. cit.*, fig. 4. This stage of development is clearly illustrated in the plan on the Haarlem sheet, centre right (Pl. 15). Here is shown the oval stair placed against the Library wall, the articulation of the Vestibule wall in five bays and concentric circles which probably represent the ochio of the skylight. However, we insist on the originality neither of this ground-plan nor of the other plan of this sheet.

69 As in the preceding plan the relation of the middle to each side is 2:1. It is most likely that the junction of middle and side flights was to be effected here on the same principle of corner joints as in Stage 8. It is remarkable that on the middle flight $\frac{1}{3}$ is written and on the right-hand side flight $\frac{1}{4}$. But it does not seem necessary to conclude that the middle and side flights rise in different rhythms.

70 The oval scheme is not really so practicable as it appears in the copy. A feasible reconstruction (though possible) can be dispensed with as Michelangelo's exact intentions are not known.

71 So long as there was to be a passage between the two wings of the stair – as marked on Stages 3 and 5 – the outer parts of the landing must be about 2·00 m high. This height is arrived at also if we start from the fact that the central landing lies on the level of the cornice of the base, i.e. 2·60 m less three steps of about 20 cm each: 2·00 m. The number of steps drawn in these plans show that Michelangelo did not usually insert the exact number of steps, but contended himself with a summary indication of them.

72 Michelangelo omitted to show on the section of the stair the necessary continuation of the slope above the landing. This tallies with the fact that he separated to some degree in this thought the complicated lower threefold construction from the single flight above it.

73 Battista da Sangallo had been dead eight years († 1552) when Vannocci was born.

74 'nel modo, forma e misura, siccome è disegnato tutto non tanto in sul chiostro, ma per il modino fatto di terra dal nostro Michelagnolo, come ciascuno de' sopra detti maestri veduto apresso anno.' In che però si dichiara expresso che li scaglioni della scala anno a essere 14, tutti d'un pezzo l'uno e massime li primi 7 colle rivolte, senza che si dimostri alcun convento.' Milanesi, *Lettere di Michelangelo*, p. 707. This important contract has been curiously overlooked by Michelangelo scholars. We find it only quoted (not interpreted) in an obscure work by Gaetano Guasti, *Bibl. Medicea Laurenziana*, in *Raccolta delle migliori Fabbriche antiche e moderne di Firenze disegnate e descritte da R. ed E. Mazzanti e T. del Lungo*, Florence, 1876, pp. 22–3. 'Convento' is defined as 'Spazio tra due cose commesse come pietre, mattoni, legni.' See Tommaseo, *Dizionario della lingua italiana*, 1929, II, p. 619.

75 In the text of the contract no express mention is made of three flights; this would be superfluous. It is self-evident that the specific demands concern the middle flight.

76 'Notch-boards', Panofsky's interpretation of the word, correct in other connections, would here be senseless. *Monatshefte f. Kunstwissenschaft*, 1922, pp. 262ff.

77 'Rivolta' occurs several times in the 16th century in a similar sense. See Tommaseo, *op. cit.*, V, p. 429. Compare also 'rivolta' as the cuff of a sleeve or the toe-cap of a shoe.

78 Panofsky, *loc. cit.*, as others, takes this form of step for a conception of Ammanati's. Tolnay, on the other hand, rightly recognizes the connection of the final form of the step with Stage 6 and supports, therefore, its authenticity. But Tolnay thinks the form an invention of the last stage of the plan of 1559.

79 Stage 9 was discussed in an unpublished manuscript in *Festschrift für Adolph Goldschmidt*, 1933.

80 Ed. Milanesi, VII, p. 236.

81 *Ibid.*, VI, p. 92.

82 Milanesi, *Lettere . . .*, p. 550, note 2. See Thode II, p. 117, and Frey, *Der literarische Nachlass des Giorgio Vasari*, 1923, I, p. 416.

83 Letter from D. Giannotti to Lorenzo Ridolfi of 8 August: '. . . sono addosso a Michelagniolo, e . . . spero fargli fare un disegno per quella scala . . .' See Steinmann, *Michelangelo im Spiegel seiner Zeit*, 1930, p. 84, no. 181.

84 The date of this part of the building has hitherto been uncertain. Thode alone dates it correctly (II, p. 117): 1549. Frey, *Der literarische Nachlass . . .*, I, p. 402, note, dates Tribolo's journey to Rome about 1545 and Popp, *Medici-Kapelle*, p. 118, believes it to have been considerably earlier – between March and December 1538.

85 In recent literature reference is to be found to this condition of the wall only in Panofsky, *loc. cit.*, p. 272, and he cannot explain it.

86 However, in the photograph on Pl. V of Geymüller's work a big hole is to be seen at this point – at least on the illustrated left-hand side of the stair. Old people also affirm that on both sides the two upper marks of steps on the wall were made when big holes were filled in. The size and shape of the holes show that there must have been exactly two steps on each side.

87 Torelli was able to say in his letter of 1550 quoted above that Michelangelo's model for the steps was in the room where Andrea Sansovino died. As Sansovino died in 1529, this must refer to a model of 1525/6, not to the latest model of 1533.

88 *Vita di Michelagnolo Bonarroti.* Separately printed in 1759/60, p. 53, note.

89 *Continuazione delle mem. istoriche . . . di S. Lorenzo*, Florence, 1816, I, p. 252.

90 Michelangelo's letter in Vasari, ed. Milanesi, VII, p. 237, further Milanesi, *Lettere . . .*, pp. 548–9, with incorrect date, 1558. The fragment of the draft of this letter in Cod. Vat. 3211, folio 87v, first published by C. Frey in *Jahrbuch d. Preussischen Kunstsammlungen*, IV, 1883, p. 40. It was enclosed in a letter to Lionardo Buonarroti, who was to read it and pass it on. Printed in Milanesi, *Lettere . . .*, p. 312 (with the correct date, 1555), and in Frey, *Der literarische Nachlass . . .*, I, pp. 415–7, with exhaustive philological comments.

91 Panofsky, *Repertorium f. Kunstwissenschaft*, 1922, p. 262, for the comparison of the fragment and the letter itself. Also in Frey, *Der literarische Nachlass . . .*, 1923, I, pp. 419ff.

92 '. . . che l'imbasamento del Ricetto non sia occupato in luogo nessuno et resti libera . . .'

93 See also Panofsky, *loc. cit.*, p. 271.

94 Of the correspondence the following letters are preserved: *16. XII. 1558*, Michelangelo to Lionardo Buonarroti in Florence (Milanesi, *Lettere . . .*, p. 344). Concerns the making and despatching of the small terracotta model of the stair. A lost letter of Ammanati's is referred to. *23. XII. 1558*, Ammanati to Michelangelo (Frey, *Briefe . . .*, pp. 358–9) thanking for the model which Michelangelo is to send by Ammanati's father-in-law, G. A. Battiferro. *7. I. 1559*, Michelangelo to Lionardo Buonarroti (Milanesi, *op. cit.*, p. 348, with incorrect date). On the following Sunday Michelangelo will despatch the model from Rome. *13 (?) I. 1559*, Michelangelo to Ammanati (Milanesi, *op cit.*, p. 550, without date). Important explanatory letter accompanying the model. *14. I. 1559*, Michelangelo to Lionardo B. (Milanesi, *op. cit.*, p. 349, with incorrect date). The model left Rome the day before. *29. I. 1559*, Ammanati to Michelangelo (Frey, *Briefe . . .*, p. 359). Ammanati has received the model. *18. II. 1559*, Ammanati from Florence to Duke Cosimo (Gaye, *Carteggio* III, pp. 11–12, Panofsky, *op. cit.*, p. 268). Ammanati sends the model to Pisa with a request for Cosimo's placet. *19. II. 1559*, Francesco di Ser Jacopo from Florence to Cosimo (Gaye, *op. cit.*, III, pp. 12–13). Explains Ammanati's letter of the day before. *22. II. 1559*, Cosimo in Pisa sends an answer

to Ammanati (Gaye, III, p. 13). The stair is to be constructed according to the model. The same information goes on the same day to Francesco di Ser Jacopo (Gaye, III, p. 13–14). Michelangelo's proposal in his letter of 13 January to build the stair of walnut is rejected by Cosimo. See also C. Frey, *Der literarische Nachlass . . .*, I, p. 418.

95 Incorrect interpretation by Panofsky, *loc. cit.*, p. 270, as he did not know the stage of 1533.

96 Vasari, ed. Milanesi, VII, p. 236:'. . . scala, della quale Michelagnolo aveva fatto fare molte pietre'. Torelli's letter of 1550 runs: '. . . et intendo ch'erano lavorate tutte le pietre, excepto il primo scaglione.'

97 There must have been some changes in the project of 1533, analyzed above, because only seven steps with 'rivolte' were actually made at that time.

98 For this reason alone the identification of the sketch Casa Buonarroti 37Av (Tolnay in *Münchner Jahrbuch*, 1928, p. 433, fig. 39) with a newel post is not tenable.

99 'Rimandovi la pianta della Libreria che s'à a fare, ed in capo della Libreria v'è segniato dua studietti, che mettono in mezzo la finestra, che si risconta coll'entrata della Libreria; ed in quegli studietti vole mettere certi libri più secreti; e ancora vole adoperare quelli che mettono in mezo la porta.' Gotti, *Vita di Michelangiolo*, 1875, I, p. 165.

100 Fattucci to Michelangelo: '. . . et fate, che in testa della libreria venga una finestra in mezzo di due studioli di circa sei braccia l'uno, come è disegniato nell'autra, et dua altri che mettino in mezzo a porta' (Frey, *Briefe . . .*, p. 221).

101 See Fattucci's letter to Michelangelo of 13 April 1524 (Frey, *op. cit.*, p. 224).

102 'Perrora non vole, che voi faciate la crociera, ma lasciate in modo che quando [si] lavora, fare si possa.' (Frey, *op. cit.*, p. 234.)

103 'La croce facendo diciotto braccia per ogni verso e'l vano d'ogni lato vi va di muro della medesima altezza e grossezza.'

104 *Handzeichnungen*, text p. 81.

105 'Circa la capella in capo la libreria dice, non vi vole cappelle, ma vole, sia una libreria secreta per tenere certi libri piu pretiosi che gli altri.' Frey, *Briefe . . .*, p. 250.

106 Thode believes that this plan is the sketch for a part of the Library ceiling,

Frey that it is a plan for the Medici Chapel. These identifications are incorrect, as is that of A. E. Popp (*Medici-Kapelle*, p. 168), who thinks it is a side room for the Medici Chapel in which Michelangelo for some time intended to place the pope's tomb. Popp's opinion is based on Fattucci's letter of 7 June 1524 (Frey, *Briefe* . . ., p. 230): it is disproved by the fact alone that the plan of the 'side room' is bounded on the left by a wall which bounds at the same time the so-called Medici Chapel. See also Popp in *Münchner Jahrbuch*, IV, 1927, p. 391, note 3.

107 Before the north short wall indication of a few steps: the way up to the upper cloister, and still today the approach to the Laurenziana. The cloister is also indicated by lines on the right. Steps and cloister are again roughly indicated on the Vestibule plan.

108 'Io ebbi una di Giovanni Spina con certi disegni della pichola libreria, la quale mostrai a N. S., et dice, che vole, che la si facia, come avete disegniato.' Frey, *Briefe* . . ., p. 250. Frey, *Handzeichnungen*, text, gives already the correct date for this final plan.

109 The Library is actually more than one braccio wider. This mistake is not important since this is not a scale drawing but a free-hand sketch.

110 Frey recognizes correctly in Casa Buonarotti 79 (Pl. 40) the later stage, while Thode (II, pp. 120f., III nos. 141f.) pays no attention to the sequence of plans. A real analysis of the meaning of both sheets has not yet been undertaken. Sheet Casa Buonarotti 79 is engraved in G. I. Rossi, *La Libreria Mediceo Laurenziana*, 1739.

111 Frey, *Briefe* . . ., p. 279. Fattucci to Michelangelo, 3 April 1526: 'Et perche dice [the pope], che voi volevi la resolutione della pichola libreria per potere fare il tramezo fra il ricetto et la libreria, dice, che voi lo facciate come la picola fussi fatta, la quale vole si facia, come sara finito il ricetto.' Frey in the text to his *Handzeichnungen* rightly maintains that in order to build the wall separating Library and Vestibule Michelangelo must know the form of the opposite wall – that dividing Library and 'piccola libreria' – i.e. the character of the 'piccola libreria' itself.

112 See, Frey, *Briefe* . . ., pp. 287, 289, 290.

113 Inscribed between the lines of the surrounding wall on Casa Buonarotti 79 (Pl. 40) are the words: 'e l muro dilarion martelli.' Below: 'la chasa dilarion martelli.' And referring to the lighting of the

'piccola libreria': 'riducesi in tondo disopra e tucti e lumi si piglion dalla volta perche non si posson aver daltrove.' Near the east wall, still to be erected: 'di qua si puo fare quello che piace perche e de preti.' On this side there is no restriction as the ground belongs to the priests. On the purchase of the house of Ilarione Martelli see letters of 10 and 29 November, 1525: The pope has decided 'di comperare detta casa et di adoperare quello che se n'ara di bisogno et il resto apigionare.' On 30 December 1525, Ilarione Martelli had received a first payment of L. 42 for 'muro si è comperato da lui per conto della libreria.' See Gronau in *Jahrbuch der Preuss. Kunstslg.*, 1911, p. 73.

114 See above, note 111.

115 Letters from Fattucci to Michelangelo of 18 April and 6 June. See Frey, *Briefe* . . ., pp. 280–84; Thode, II, p. 116.

116 See Milanesi, *Lettere* . . ., p. 707.

117 Besides the mouldings for the doors the sheet contains one section of a step with the inscription: 'e modani degli scaglioni dati a cecchone.' This section is much richer than that of the step actually executed and agrees to a considerable extent with the two steps outside the Vestibule door.

118 Thode refers a part of these drawings to windows, principally Casa Buonarotti 98 on account of the mouldings below. But actually these mouldings are executed in correspondence with the drawing.

119 The agreement between scale drawing and the existing door was first recognized by Geymüller.

120 See Thode, III, no. 161. Thode is here thinking of the Tribunes in St Peter's. Otherwise the sheet has not hitherto been noticed.

121 The earliest representation of this kind of frame division is seen in the sketch for a window, Casa Buonarotti 3 (Pl. 13, February 1525). This sketch in its turn is preceded by the Haarlem sheet.

122 The date 1526 can be proved for sheet 95 by the fact that the drawing with door mouldings of 1526 contains also a section for the steps outside the Vestibule entrance door, which must have been considered together with the door itself. The steps in place today alone go back to Michelangelo. Sheet Casa Buonarotti 95 served as basis for the contract of 1533. First engraved by G. I. Rossi, *op. cit.*, Pl. XXI. Then published by Geymüller, *op. cit.*, p. 33, Pl. 4, fig. 1, and Thode, III, no. 150, and correctly interpreted. Popp,

Medici-Kapelle, pp. 45, 126, sees in this sheet an earlier stage of the tabernacles above the doors of the Medici Chapel. The connection of this drawing with the Vestibule entrance door is, however, evident.

123 The sheet (pen, 38·5 × 28·4 cm) is contained in a portfolio of Dosio drawings after the Vestibule. The plan makes the identification of the sheet certain. Dosio has here reconstructed the door frame from worked fragments found in the Vestibule. This reconstruction agrees exactly with drawing Casa Buonarroti 95 (Pl. 47). Only the whole cornice between door and pediment and the tablet for the inscription in the pediment are missing. These parts were evidently not yet worked.

124 Nelli's sheet 20 reproduces drawing Casa Buonarroti 95. His text affirms that the worked parts of the door were lying in the Vestibule: 'Porta cavata da alcuni pezzi di pietre, che sono in terra dentro il Ricetto, e da un disegno di Michelagnolo, che si trova appresso i Buonarruoti suoi Eredi, al quale si giudica esser quella, che fù da lui destinata per l'esterno di esso Ricetto, perchè, oltre al corrispondere coll'apertura della porta interna, conviene ancora colla Modanatura dell'esterno delle Finestre variata dalla Modanatura dell'altre porte conforme allo stile di Michelagnolo di non replicare gli stessi disegni, mostrando egli in ciò la ricchezza de'suoi concetti.'

125 The plates for this work were drawn in 1727. Here the text on the history of the door runs as follows: 'Questa porta, non ha gran tempo, fu messa sù per comandamento del Serenissimo Gran Duca Cosimo III, coll'assistenza di Pier Maria Baldi Architetto. e servitore in Corte di S. A. R. il quale non senza qualche grave ragione si sarà indotto a replicare una cosa già posta in opera, anzichè secondare il pensiero di Ma., perfezionandone un'altra da lui lasciata imperfetta; se pure vogliamo credere, che gli osservassela. E dal non essere stata fatta quella stima, che far si dovea giustamente d'alcuné cose, le quali mancato il Buonarruoti abbozzate rimasero in alcuni preziosi frammenti di pietre, le quali si conservano nel Ricetto. . . . Nella Tav. XX quella Porta si mostra, la quale si vede posta in opera nello stato presente, nella XXI poi quel Disegno, che da noi è citato; e finalmente nella XXII uno degli Stipiti, e l'Architrave. . . .' On Rossi's three plates the three conditions are shown together: the door executed by Baldi, the design of the Casa Buonarroti, and the worked fragments of the door lying in the Vestibule. In this last plate the segmental pediment reproduced by Dosio is not shown. Most likely in the course of time it had disappeared. The

correct state of affairs was forgotten soon after the completion of the door. In: Ruggieri, *Studio d'Architettura Civile*, Florence, 1722–8, I, pl. I, this door in elevation, section, and plan is shown as 'Architettura di Michel Angelo B.' Ruggieri's work is the standard book of engravings of Florentine architecture.

126 Baldi, the details of whose activity as an architect have not yet been investigated, worked in Florence at the end of the 17th century. See Thieme-Becker, II, p. 393.

127 Letter from Fattucci to Michelangelo of 10 March 1524 (Gotti, *op. cit.*, I, p. 165): 'A caro il palco, e vorrebbelo bello e non riquadrato, ma con qualche fantasia nuova, e che e' non vi fussi di sfondato più che dua o tre dita come voi saprete fare.'

128 Frey, *Briefe* . . ., p. 224: 'Ancora vide il disegnio del palcho, il quale gli piacque. Pargli, chè quegli andari si riscontrano con que di sotto, che l'a carissimo; solo gli pare, che quello andare dal lato venga a essere più largo che quello di sotto, che è tre quarti, secondo che v'è scritto. Et se per aventura non fussi in questo modo, come N. S. la 'ntende, fate, a ogni modo sia cosi come la 'ntende lui; et se voi vi potessi acomodare qualche sua fantasia overo livrea, come a fatto in quella camera che fe M.o Giovanni da Udine, credo, l'arebbe caro.'

129 Fattucci to Michelangelo of 12 April 1525 (Frey, *Briefe* . . ., p. 250): 'Ancora vole, faciate uno bellissimo palco alla libreria, come gia vi scrissi altra volta, con poco isfondato. Et mandatemi il disegnio, facesti l'autra volta; et se n'avete fatto nessuno altro o avessi altra fantasia mandategli, perche N. S. gli vole vedere.'

130 Frey, *Briefe* . . ., p. 279. The relevant passage has been exhaustively analyzed above, p. 22.

131 On the draft of Michelangelo's letter to Fattucci of 17 June see above. The passage referring to the ceiling misinterpreted by Thode, II, p. 117.

132 Fattucci to Michelangelo of 16 October 1526 (Frey, *Briefe* . . ., p. 289): 'Del palco della libreria per ora nonne vole fare niente.'

133 Letter to Michelangelo (Gotti, *op. cit.*, I, p. 225): '. . . et dice [Sua Santità] che alogate li banchi e palchi e figure e scale e quello pare a vui, che possino fare senza vui questa invernata, purchè si lavori, e che no si abandoni l'opera, e che si faci tutto quello si pol fare senza vui. . . .' Concerning the stair and the doors Michelangelo had already three

days previously, on 20 August 1533, concluded the contract which we have analyzed.

134 This idea first developed by Franceschini in *Nuovo osservatore fiorentino*, 1885/6, p. 412. See f. i. P. Frankl, *Die Entwicklungsphasen der neuren Baukunst*, 1914, p. 115. About the *imprese* of Cosimo see Gio. Ferro, *Teatro d'Imprese*, II, p. 176: 'Capricorno: Questo segno ascendente del Duca Cosimo, pose il Giovio per l'istesso Duca e gli diede motto: Fidem fati virtute sequemur.' P. 272: 'Delfino: Motto: Festina lente (Euripides).'

135 See above, note 127.

136 Ed. Milanesi, VII, p. 203; III, p. 351.

137 Working on the ceiling with Caroto and the famous Battista del Tasso (1500/55) was – as Baldinucci, *Notizie de Professori*, Milan, 1811, VII, p. 605, testifies – also the latter's son-in-law Antonio Crocini († 1577/8). Thode, II, p. 118, incorrectly thinks a share was also taken by Crocini's son-in-law, the painter Francesco Pagani (about 1531–61). Misunderstanding of the Baldinucci text.

138 Thode, II, p. 135, believed incorrectly that they were sketches for a central bay and two neighbouring side bays showing the arrangement of the whole as it was executed. Casa Buonaroti 126 is misleading as side and middle bays are shown separately and on different scales. Frey wrongly concludes in his text that according to this drawing the side bays were to run on without interruption.

139 The relation of the side divisions of the drawing to the middle, corresponds almost exactly to the relation of the side bays to the middle bay of the short walls of the Library.

140 Schottmüller in *Jahrbuch d. Kunsthist. Sammlungen (Wien)* II, 1928, pp. 226ff., makes important observations on the Library ceiling, without, however, arriving at the real idea of the ceiling plan as it was actually carried out.

141 Between 1534 and about 1549 no work was done in the Vestibule or the Library. Then, however, it began simultaneously on all parts of the building. The proposal of dating the ceiling so late was made only by Franceschini in *Nuovo osservatore fiorentino*, 1885/6, p. 412, and then without being remarked.

142 Vasari, ed. Milanesi, VII, p. 203.

143 Fattucci to Michelangelo (Frey, *Briefe* . . ., p. 234): '. . . quanti banchi vi va, colla distantia l'uno dallo altro, come

quelli di S.o Marco apunto. Et ancora m'avisate, quanti libri andra per banco.'

144 Fattucci to Michelangelo of 3 April 1526 (Frey, *Briefe* . . . p. 279): '. . . et dice che troviate o faciate trovare asse d'albero e di noce per e banchi.'

145 Fattucci to Michelangelo (Frey, *Briefe* . . ., p. 284).

146 Gotti, *op. cit.*, I, p. 171: 'Nostro Signore vuole che siano tutti di noce scielto [in Milanesi and Gotti: 'sculto.' Corrected from the original in the Archivio Buonarroti by Frey, *Handzeichnungen*, text p. 126]; non si cura di spendere 3 fiorini più, che non li importano, pure che siano alla cosimesca, ciò è si assimigliano le opere del magnifico Cosimo.'

147 Gotti, *op. cit.*, I, p. 225.

148 Casa Buonarroti 94; Frey, 269. See also Tolnay in *Münchner Jahrbuch*, 1928, p. 462, no. 13.

149 As Schottmüller rightly points out in *Jahrbuch d. Kunsthist. Sammlungen*, II, p. 228.

150 A. Marquand, *Benedetto and Santi Buglioni*, 1921, pp. 196 and 201ff.

151 Ed. Milanesi, VI, p. 88, note 1, and p. 92.

152 It does not seem right to conclude from this that on the severer and less adorned ceiling painting was planned, as Schottmüller, *op. cit.*, pp. 226ff., believes.

153 Window glass restored by De Matteis. See Franceschini, *op. cit.*, p. 415.

154 L. Biadi, *Notizie sulle antiche fabriche di Firenze non terminate*, Florence, 1824, pp. 134–6.

155 G. I. Rossi, *Libr. Laurenziana*, p. VII: 'Tralle cose, le quali Michelagniolo in questo Edifizio non solamente lasciò imperfetto, ma incognite ancora, e prive d'ogni memoria, una senza fallo, si è il Cornicione, il quale doveva servire di finimento, e quasi di corona a tutta la stanza.' See also p. XXIII.

156 *Op. cit.*, p. 26. Geymüller refers to Ruggieri, *Studio d'architettura civile*, IV, p. 31, who, however, refers to the parts of the outer door still to be worked. Thode believed (II, p. 127) that on sheet 62 of the Casa Buonarroti (published by Tolnay in *Münchner Jahrbuch*, 1928, fig. 82), of five sketches for the Library cornice two related to the modern Vestibule cornice, which he took to be old.

157 Ammanati to Cosimo I from Florence of 18 February 1559 (Gaye, *Carteggio*, III, pp. 11f.): '. . . se V. E. I. vorrà che per ordine suo io dimandi, quando le parrerà tempo, a lui [Michelangelo] del palco [after this word in Gaye's text is a comma, which must be a mistake] del ricetto e del modello della facciata, lo farò.' Hereupon Cosimo answers 22 February (Gaye, *op. cit.*, III, p. 13): 'Circa il palco del ricetto e del modello della facciata, che non saria fuor di proposito di cavare dal Bon. quel che si può.'

158 *Studio d'architettura civile*, IV, Pl. 14.

159 Uff. dis. arch. 1946. Pen, 36·6 × 25·6 cm.

160 See L. Biadi, *op. cit.*, pp. 134–6. Fullest report by Franceschini in *Nuovo osservatore fiorentino*, 1885/6, pp. 421ff., and in *Per l'arte fiorentina: Dialoghi critici*, Florence, 1895, pp. 225ff. Here also the material for the modern extension. To the significance of Pocciantis building and its effect on the Library, no reference is otherwise made in Michelangelo literature. Pocciantis building serves today as reading room – contrary to its original purpose – and after 1880 was fitted with windows and desks. The effect of its architecture is thus to some extent spoiled.

161 On this point compare Geymüller, *op. cit.*, pp. 26f.: 'Der Treppe gegenüber stehen die Wände öde und leer und wie über die eigne Form verlegen da.'

162 A. Riegl, *Die Entstehung der Barockkunst in Rom*, Vienna, 1908, p. 44. Also Geymüller, *op. cit.*, p. 26: 'Mauerpfeiler treten vor, nicht wie üblich die Säulen.'

163 The problem of masses is only one of quantity. A decision as to whether a work is still Renaissance or already Baroque can from this point of view never be convincing, for the arguments must depend on the personal reactions of individuals.

164 See also Tolnay in *Münchner Jahrbuch*, 1928, p. 408.

165 Conflict was first recognized as an integral part of Michelangelo's architecture by Woelfflin, *Renaissance und Barock*, ed. 1926, p. 50 ('Komposition nach Kontrasten'), considered in detail by Geymüller. pp. 49ff. ('Der Pleonasmus als Prinzip und Quelle von Gegensätzen.' 'Die Vermehrung künstlerischer Gegensätze'). Later interpretation chiefly by Riegl, *Entstehung der Barockkunst*, pp. 39, 97, 148f., etc.

166 The opinion of Popp in *Münchner Jahrbuch*, 1927, p. 401 (and also earlier writers), that these tabernacles were to contain statues is not supported by anything.

167 Although conflicts were seen in Michelangelo's architecture he was generally placed at the beginning of the group of Baroque architects.

168 Parts of this chapter first discussed in an unpublished manuscript in *Festschrift für Walter Friedländer*, 1933.

169 Woelfflin, *Renaissance und Barock*, p. 50, discovered that within the Vestibule 'unaufhörliche Bewegung entsteht.' Woelfflin did not see that this movement is essentially different from that of the Baroque.

170 For our purpose it is perfectly appropriate to draw a comparison between the articulation of a chapel wall, that of a palace façade, and later on that of a church façade. It would not be difficult to confront like with like. The Cappella Gondi has been chosen as it offers the earliest example known to us of double function. The examples from Renaissance and Baroque were chosen because they are particularly impressive.

171 W. Friedländer, *Das Casino Pius IV*, 1912, p. 127.

172 Vasari, ed. Milanesi, VII, p. 57.

173 The same kind of complications can be observed inside the Library if one compares the walls between the pilasters with the 'classical' simple row of columns.

174 *Permutation* in its mathematical sense: the reversal of given elements. In linguistics the word is used when parts of a sentence have a function other than that originally proper to them. Since the essence of that kind of interplay of wall planes consists in a reversal of functions, we have taken over the expression.

175 See Weisbach in *Zeitschrift f. bildende Kunst*, 1919, pp. 161ff.; Friedländer in *Repertorium für Kunstwissenschaft*, 1925, pp. 49ff.

176 Only in the 1920s were attempts made to define Mannerist architecture. Voss (*Die Malerei der Spätrenaissance in Rom und Florenz*, Berlin, 1920, pp. 10ff.) and Dvořák (*Geschichte der italienischen Kunst*, Munich, 1928, II, pp. 113ff., 197) emphasize the unity of style between Mannerist painting and architecture. Symptoms of Mannerist architecture were collected by Dagobert Frey in *Wiener Jahrbuch für Kunstgeschichte*, III (1924), p. 98, and Walter Friedländer in *Repertorium f. Kunstwissenschaft*, 1925, pp. 56f. The problem has now been treated from various points of view. The works of L. Hagelberg in *Münchner Jahrbuch*, 1931, pp. 264–80, and Michalski in *Zeitschrift für Kunstgeschichte*, 1933, pp. 88–109, do not go much beyond Riegl, who saw the conflict simply in relations of strength and stress. Two authors, Panofsky (in *Staedel-Jahrbuch*, 1930, pp. 65–72) and H. Sedlmayr (*Die Architektur Borrominis*, 1930, pp. 152ff.) see as we do the essential characteristic of Mannerist architecture in a dual structure (see Panofsky, *Idea*, 1924, p. 43).

177 See P. Frankl, *Entwicklungsphasen der neueren Baukunst*, p. 178: 'Die Laurenziana ist in den Körperformen barock, nicht aber in ihrer optischen Erscheinung, noch ist alles flächenhaft ausgebreitet, frontal gesehen. . .'

IV The Changing Concept of Proportion

1 André Fournier des Corats, *La Proportion égyptienne et les rapports de divine harmonie*. Paris, 1957.

2 Adolf Zeising, *Neue Lehre von den Proportionen des menschlichen Körpers*. Leipzig, 1854.

3 Miloutine Borissavliévitch, *The Golden Number and the Scientific Aesthetics of Architecture* (London, 1958; first French edn., Paris, 1952), pp. 37ff.

4 Gustav Theodor Fechner, *Vorschule der Aesthetik*. Leipzig, 1876.

5 Theodor Lipps, *Aesthetik, Psychologie des Schönen und der Kunst* (Hamburg and Leipzig, 1903), I, pp. 66ff.

6 F. X. Pfeifer, *Der goldene Schnitt und dessen Erscheinungsformen in Mathematik, Natur und Kunst*. Augsburg, 1885. For further material see R. C. Archibald, 'Notes on the Logarithmic Spiral, Golden Section and the Fibonacci Series' in Jay Hambidge, *Dynamic Symmetry: The Greek Vase* (New Haven, 1920), pp. 152ff.

7 E. Henszlmann, *Théorie des proportions*. . . . Paris, 1860.

8 Matila Ghyka, *Le Nombre d'or*. Paris, 1931.

9 F. M. Lund, *Ad Quadratum*. London, 1921.

10 Ernst Moessel, *Die Proportion in Antike und Mittelalter*. Munich, 1926.

11 Ch. Funck-Hellet, *De la proportion. L'équerre des maîtres d'oeuvre* (Paris, 1951), p. 13.

12 Hambidge demonstrates how the

curve of the logarithmic spiral can be transformed into a right-angle spiral.

13 Jay Hambidge, *op. cit.* (note 6), p. 142.

14 L. D. Caskey, *The Geometry of Greek Vases.* Boston, 1922.

15 Walter Dorwin Teague, *Design This Day.* New York, 1940.

16 Samuel Colman, *Nature's Harmonic Unity: A Treatise on Its Relation to Proportional Form,* edited by C. A. Coan. New York and London, 1912.

17 George Jouven, *Rythme et architecture: Les tracés harmoniques.* Paris, 1951.

18 How wayward the thinking of rational beings can become when they get involved in the mystique of proportion is shown by Jouven's belief that Dürer in his *Melancholia* engraving arranged that the sum of numbers of the magic square should be thirty-four, because this was *'l'âge où Dürer dut être initié à la Divine Proportion par Pacioli.'*

19 Cesare Bairati, *La simmetria dinamica. Scienza ed arte nell'architettura classica.* Milan, 1952.

20 Irma A. Richter, *Rhythmic Form in Art.* London, 1932.

21 W. B. Dinsmoor, in a carefully argued review of Jean Bousquet's *Le Trésor de Cyrène* (*American Journal of Archaeology,* 1957; *61*: 402–411) calls the author's method an offshoot of Hambidgian dynamic symmetry, and expresses the hope to have killed it 'before it becomes an integral part of our archaeological vocabulary.'

22 Theodore A. Cook, 'A New Disease in Architecture,' *The Nineteenth Century,* 1922, *91*: 521ff.

23 George D. Birkhoff, *Aesthetic Measure* (Cambridge, Mass., 1933), p. 72. For a criticism of Birkhoff's work, see H. J. Eysenck, *Sense and Nonsense in Psychology* (Harmondsworth, 1957), pp. 326ff.

24 Percy E. Nobbs, *Design: A Treatise on the Discovery of Form* (London, 1937), p. 123.

25 Eliel Saarinen, *Search for Form* (New York, 1948), p. 259.

26 See Katharine E. Gilbert and Helmut Kuhn, *A History of Aesthetics* (Bloomington, Indiana, 1953), pp. 531ff.

27 George Lansing Raymond, *Proportion and Harmony of Line and Colour in Painting, Sculpture, and Architecture* (New York and London, 1899), pp. 201 and *passim.*

28 C. J. Moe, *Numeri di Vitruvio.* Milan, 1945.

29 The papers read at the Congress were unfortunately not published together. A good report appeared in the *Neue Zürcher Zeitung,* 11 October 1951; for summaries of all the papers, see *Atti e Rassegna tecnica* (Società degli Ingegneri e degli Architetti in Torino), 1952, *6*: pp. 119–135.

30 The full report is in the *Journal of the Royal Institute of British Architects,* 1957, *64*: pp. 456–463. The motion was introduced by Nikolaus Pevsner, while Maxwell Fry, Misha Black, W. E. Tatton Brown, Peter D. Smithson, Sir John Summerson, and others shared in the discussion.

31 *L'Architettura,* 1957, *3*: pp. 508f.

32 Years ago the Parisian Jean Fautrier coined the motto for the whole trend when he said that art is *'un moyen fou sans règles ni calculs.'*

33 Sir John Summerson, 'The Case for a Theory of Modern Architecture,' *Journal RIBA,* 1957, *64*: pp. 307–313.

34 Saarinen, *op. cit.,* p. 261.

35 Ezra D. Ehrenkrantz, *The Modular Number Pattern: Flexibility through Standardisation.* London, 1956.

36 Ehrenkrantz does not mention *Modulor Coordination in Building. Project 174.* Paris, European Productivity Agency of the Organization for European Economic Cooperation, 1956.

37 Lancelot Law Whyte, 'The Growth of Ideas,' *Eranos Jahrbuch,* 1955, *23*: pp. 367–388.

38 Hermann Weyl, *Symmetry.* Princeton, 1951.

V Brunelleschi and 'Proportion in Perspective'.

I gratefully acknowledge my debt to Dr L. S. Bosanquet, Reader in Mathematics, University College, London, who has taken great pains in checking the results of this paper. His suggestions and emendations were most valuable.

1 *Journal of the Warburg and Courtauld Institutes,* Vol. IX, 1946, p. 103.

2 A few quotations may suffice to characterize the position. H. von Geymüller, *Die Architektur der Renaissance in Tos-* kana, Munich, 1885, I, p. 2, only states that Brunelleschi created the basis 'zu der für die Architektur so wichtigen Perspektive.' P. Frankl, *Die Renaissancearchitektur in Italien,* Leipzig, 1912, p. 5, believed that Brunelleschi needed perspective to clarify the effect of his designs. H. Willich, *Die Baukunst der Renaissance in Italien,* Berlin, 1914, p. 16f., seems to imply that Brunelleschi's invention was mainly aimed at assisting painters with their architectural backgrounds.

3 See, e.g., Dagobert Fry, *Architettura della Rinascenza,* Rome, 1924, p. 16f. and *id., Gotik und Renaissance,* Augsburg, 1929, p. 9ff., W. M. Ivins, *On the Rationalisation of Sight,* New York, 1938.

4 *The Codex Huygens and Leonardo da Vinci's Art Theory,* London, 1940, p. 160f. See also G. Nicco Fasola's edition of Piero della Francesca's *De prospectiva pingendi,* Florence, 1942, p. 23.

5 Antonio Manetti, *Vita di Filippo di Ser Brunellesco,* ed. Elena Toesca, Florence, 1927, p. 9. The crucial words 'porre bene e con ragione le diminuzioni . . .' were translated by E. G. Holt, *Literary Sources of Art History,* Princeton, 1947, p. 97, 'setting down well and rationally. . . .' Although in itself unobjectionable, this translation of the word 'ragione' does not do justice to the spirit of the whole passage, for as the rest of the sentence shows, Manetti is in fact talking about ratios; it is therefore almost certain that he here used the term 'ragione' in its mathematical meaning as 'proportion.'

6 Ed. G. Nicco Fasola, *op. cit.,* p. 63: 'intendo tractare solo de la commensuratione, quale diciamo prospectiva.'

7 *Ibid.,* p. 128f.

8 I followed Leoni in using this term.

9 Such a triangle cannot be constructed.

10 For the whole passage and also the following quotations see H. Janitschek, *Leone Battista Alberti's kleinere kunsttheoretische Schriften,* Vienna, 1877, p. 71ff.; also the 1950 edition of *Della Pittura* by Luigi Mallè, Florence, p. 66f. My translations are adapted from Leoni's edition.

11 In this context it may be recalled that in his *Vier Bücher von menschlicher Proportion* Dürer used numerical notations in the first two books, while in the third he applied similar triangles, for instance to enlarge or diminish figures in proportion.

12 Alberti's short paragraph about sur-

faces 'non-equidistant' to the picture plane need not be discussed in this context.

13 See Wittkower, *Architectural Principles in the Age of Humanism*, London, 1949, p. 120.

14 Janitschek, *op. cit.*, p. 179.

15 'Die Proportionen in der Architektur' (*Handbuch der Architektur*, IV, 1), Darmstadt, 1883, p. 39ff.

16 Important relations of the parts to each other remain constant from whatever point the building is viewed. In the present example, e.g., the diagonal laid through the left-hand aisle will always touch the apex of the door pediment or that laid through the nave will always be a tangent to the circular window however much foreshortened the view. Giuseppe Vaccaro, 'Principi di armonia nell'architettura,' *Atti della insigne Accademia nazionale di San Luca*, N.S., I, 1951–52, p. 8ff., makes some shrewd observations on this problem.

17 Janitschek, *op. cit.*, p. 81: '... l'altre [linee, i.e. not the first transversal which in this erroneous construction is not determined by the vanishing point, but chosen fortuitously] seguano a ragione.'
 Leonardo, in a note of 1492, seems, misled by observation ('truovo per isperienza'), to have made momentarily a mistake similar to that criticized by Alberti. The passage runs: 'If a second object is as far beyond the first as the first is from the eye, although they are of the same size, the second will seem half the size of the first, and if the third object is of the same size as the second, and the third is as far beyond the second as the second from the first [in the text: 'from the third,' which must be a lapse] it will appear of half the size of the second; and so on by degrees. ...' This passage, which was correctly transcribed by Richter (*The Literary Works of Leonardo da Vinci*, London, 1939, No. 99) from Cod. A, Inst. de France, folio 103r, baffled previous editors of Leonardo's *Book on Painting* who found it most convenient to correct it (see H. Ludwig, *Leonardo da Vinci. Das Buch von der Malerei*, Vienna, 1888, I, p. 451f., III, p. 276ff.).
 E. Panofsky, to whose fundamental studies on perspective I owe a debt of gratitude difficult to define, is therefore in good company when he believes that the diminishing progression follows the rule (rejected by Alberti), A:B=B:C=C:D (*Cod. Huygens, op. cit.*, pp. 96, 97, 106).

18 Bk. VIII, ch. 6; IX, ch. 3. See also W. A. Eden, 'Studies in Urban Theory,' *The Town Planning Review*, XIX, 1943, p. 22.

19 Ed. C. Bartoli, Florence, 1550, p. 36: the architect's designs 'sieno riputate non dalla apparente prospettiva ma da verissimi scompartimenti, fondati su la ragione'. Orthogonal projection remained the rule in architectural practice, and only from the 17th century onwards do perspective drawings begin to be more frequent.

20 Bk. IX, ch. 10. In *Della Pittura* he even calls painting the *maestra* of architecture (Janitschek, *op. cit.*, p. 91).

21 See Nicco Fasola, *op. cit.*, p. 68f. It is clear that a right-angled triangle with sides 6, 18, 21 cannot be drawn, but this does not, of course, invalidate the correctness of the relations noted by Piero; they are true for any two similar triangles.

22 It is unimportant in this connection that Piero begins with the product of quantities, for if $ad = bc$, then must $a:b = c:d$ and conversely.

23 'Per insine a qui a decto de la proportione de le linee et de le superficie non degradate. ... Et hora, perchè voglio dire de le linee et superficie degradate, è necessario essa proportione dimostrare. ...' Nicco Fasola, p. 73.

24 On this point see Panofsky, 'Die Perspektive als symbolische Form,' *Vorträge der Bibliothek Warburg 1924–25*, p. 264f.

25 See Piero's third demonstration, Fasola, p. 67.

26 'La quinta è uno termine nel quale l'ochio descrive co' suoi raggi le cose proportionalmente et posse in quello giudicare la loro mesura: se non ci fusse termine non se poria intendere quanto le cose degradassero, sì che non se porieno dimostrare.' (Nicco Fasola, p. 64f.) I have translated this passage rather freely in order to make its precise meaning easily intelligible.

27 See below, p. 131.

28 Nicco Fasola, p. 74. In pl. 160 similar triangles are formed by each vertical line (representing an object), its respective projection on the intersection and the apex, being the eye. In the present diagram the upper horizontal is the line of sight. The same applies to the following diagrams.

29 The editor, Mrs Nicco Fasola, has added three interesting explanatory notes to Piero's text, which are, however, not without misunderstandings. See below.

30 'Et sempre è quella proportione de la

seconda linea a la prima, che è da l'ochio al termine che è la prima, et da la seconda a l'ochio.'

31 For clarity's sake the diagram shows the projections of the first and second object on the intersection (6:5). The size of the images is inversely proportional to the distance of the objects from the eye (5:6).

32 In order to explain the proportions of the series 105, 84, 70, 60, Piero had to say that the second to the first term represents a sesquiquarta proportion, meaning 84 plus $\frac{1}{4}$ of 84, the third to the second a sesquiquinta proportion, i.e. 70 plus $\frac{1}{5}$ 70, and the fourth to the third a sesquisexta proportion, i.e. 60 plus $\frac{1}{6}$ of 60.

33 How difficult it seems to be to disentangle these relatively simple matters is shown by the misinterpretation of Nicco Fasola who, by the way, is the only author to have discussed this problem. Since she did not understand that Piero's and Leonardo's procedures were different, she thought that Piero's results were incorrect. Nothing could be further from the truth.

34 It is clear from this that the unit of measurement is the height of each object (in fig. 9 = height of the intersection). The way Leonardo states his progression makes it identical (with inverted fractions) to that of Piero. But this is only the case when the intersection is one unit from the eye. Richter, *The Literary Works, op. cit.*, p. 156, No. 100, missed the meaning of the whole passage since he translated 'diminivira J $\frac{3}{4}$' etc. as 'will diminish *to* $\frac{3}{4}$...' etc.

35 This almost sounds like a deliberate correction of the passage quoted above (note 26).

36 See, above all, Richter, *op. cit.*, pp. 78 (No. 34) and 157 (No. 102): 'Io do i gradi delle cose oposte a l'ochio come il musico da le voci oposte a l'orecchio' etc.

37 See H. Ludwig, *Das Buch von der Malerei, op. cit.*, III, p. 196.

38 Wittkower, *op. cit.*, pp. 90, 103 and *passim*. The series $\frac{1}{2}$ $\frac{1}{3}$ $\frac{1}{4}$ is, of course, a harmonic progression. Written as integers 6, 4, 3, four is the harmonic mean between the two extremes.

39 One reason surely is his professed difficulty of expressing the ratios arithmetically on the intersection; another that in his system the same images on the intersection take on different numerical values, thus 1 becomes 3 when related to 2, and 2 becomes 4 when related to 3, and so forth (see Pl. 163).

40 See p. 132

41 Of course, with the use of modern symbols Leonardo's progression can be generalized: $\frac{n}{n+1} \frac{n}{n+2} \frac{n}{n+3}$, etc.

42 Leonardo's series $\frac{1}{2} \frac{1}{3} \frac{1}{4} \frac{1}{5}$ if applied to a marble floor instead of vertical objects, would change into $\frac{1}{2} \frac{1}{6} \frac{1}{12} \frac{1}{20} \frac{1}{30}$, for $\frac{1}{2} - \frac{1}{3} = \frac{1}{6}$; $\frac{1}{3} - \frac{1}{4} = \frac{1}{12}$ etc.

43 'Ipotesi sulle conoscenze matematiche statiche e mecchaniche del Brunelleschi,' Belle Arti, 1951.

44 The Development of Perspective during the Renaissance Period (London University Thesis, 1952, available in MS.), pp. 176, 187, 197.

45 In Opere volgari di L. B. Alberti, ed. Amicio Bonucci, Florence, 1847, vol. IV. Alberti's treatise on perspective (Della prospettiva), which would probably also throw more light on Brunelleschi's contribution, has not yet been traced, see Paul-Henri Michel, La pensée de L. B. Alberti, Paris, 1930, p. 24.

46 This interpretation finds support in contemporary demonstrations, e.g., when Piero, in describing our Pl. 160, makes the intersection as high as the three objects behind it and expresses the ratio of projection of the first object by comparing it to the height of the intersection.

47 The present floor dates from 1886, but the design, no doubt, repeats the original one. The ceiling is essentially the old one, in spite of comprehensive restorations. See W. and E. Paatz, Die Kirchen von Florenz, II, 1941, pp. 471, 478.

48 Die Architektur der Renaissance in Toskana, Munich, 1885–93, I, p. 18.

49 It seems that Manetti, who executed the nave after Brunelleschi's death, followed essentially his master's design although he departed from it in the aisles.

50 It is unnecessary to go into details. On the traditions of empirical perspective see John White, 'Developments in Renaissance Perspective,' in the Journal of the Warburg and Courtauld Institutes XII, 1949, p. 58ff.

51 Dr Ugo Procacci's investigations make this evident. I wish to thank him for showing me the results of his work.

52 But see C. Baroni's enlightened remarks, Bramante, Bergamo, 1944, p. 24.

53 It is true that lack of space prevented the building of a real choir. But this negative argument does not explain why Bramante chose the present scheme.

He composed S. Maria presso S. Satiro as a centralized church with three arms equal at least in theory. It will now be understood that the feigned choir was for him as good as a real one.

Illusionist devices on a less spectacular scale were used in Bramante's circle, also when not warranted by practical motives; see Battagio's chapels in S. Maria dell'Incoronata at Lodi (1488ff.).

VI Desiderio's 'St Jerome in the Desert'

I am most grateful to Professor Ulrich Middeldorf for the invaluable help he gave me during my work on this paper at the Kunsthistorisches Institut, Florence.

1 Most of this material is now conveniently assembled in the monograph by I. Cardellini, Desiderio da Settignano, Milan, 1962.

2 Ibid., p. 286, figs. 368–74.

3 J. Pope-Hennessy, Catalogue of Italian Sculpture in the Victoria and Albert Museum, London, 1964, vol. I, p. 138ff., No. 114. The entry covers most fully the entire question. See also Cardellini, op. cit., pp. 260–63.

4 By far the best that has been said about the relief is the brief entry in Charles Seymour, Jr., Masterpieces of Sculpture from the National Gallery of Art, New York, 1949, pp. 17, 177–78, No. 29.

5 To suggest identification of the Washington St Jerome with an entry in the 1553 inventory of the Palazzo della Signoria in Florence can only be regarded as an unqualified case of wishful thinking. The inventory (published by C. Conti, La prima reggia di Cosimo I de' Medici nel Palazzo già della Signoria di Firenze, Florence, 1893) says on p. 141: 'Uno quadro di marmo di basso rilievo d'un S. Girolamo' (and not 'Uno quadro di marmo in rilievo schiacciato' as quoted by Cardellini, p. 244). This relief was in the 'Prima stanza della Guardaroba segreta' (p. 137ff.), where there were a great many important works of art, among them the Aretino portrait by Titian and works by Salviati and Bronzino and also 'Una Nostra Donna di marmo di mezzo rilievo di mano di Desiderio.' The fact that the Jerome relief was listed without the artist's name may mean that the name had been forgotten or, more likely, that the relief was by someone less highly regarded than Desiderio and therefore not worth recording.

6 Original letters by Baron Renaud of 11 and 14 November 1921 in the National Gallery.

7 Estonia had been Russian before the Revolution and is again Russian; the country's independence was of brief duration. The location 'Pietroburgo' in the caption of the photograph may be regarded as a generic term for Russian territory. In recent copies from the old negative the reference to Lelli has been omitted.

8 Ulrich Middeldorf discovered this rare item on the shelves of the Kunsthistorisches Institut in Florence. Its full title is: Catalogo dei Monumenti, Statue Bassorilievi e altre sculture di varie epoche che si trovano formate in gesso nel premiato stabilimento di Giuseppe Lelli (fu Oronzio), Firenze, Via Ghibellina 1A & Corso de' Tintori 95, Florence, 1899, p. 8, No. 205: 'S. Girolamo in orazione nel romitorio, basso-rilievo, 55×43 cm.' (The exact size of the Washington relief is 0.547×0.427 m). The Brogi photograph shows the number 205 incised into the cast in the top left-hand corner.

9 Munich, 1892–1905, vol. VII (published in 1899), pl. 305; text, p. 95.

10 A careful inspection of the illustration clearly reveals the joints in the piece-mould (one going practically through the centre of the relief) which someone had not taken the trouble to file away.

11 Milan, 1908, vol. VI, p. 428, n. 1.

12 A. Venturi, L'arte a San Girolamo, Milan, 1924, p. 165, fig. 133.

13 Donatello, Stuttgart, 1907 (second ed. 1909), p. 186. In his Die italienische Plastik des Quattrocento, Berlin-Neubabelsberg, 1919, p. 123, Schubring briefly refers to the relief as a Bode attribution.

14 L. Planiscig, Desiderio da Settignano, Vienna, 1942, fig. 4.

15 Charles Seymour, Jr., op. cit. Pls. 102–5.

16 F. Schottmüller, in Thieme-Becker, vol. IX, 1913, p. 132; Venturi, 1924 (see note 12); U. Middeldorf, in Art in America, vol. XXVIII, 1940, p. 29; Planiscig, 1942 (see note 14); G. Galassi, La scultura fiorentina del Quattrocento, Milan 1949, p. 164; J. Pope-Hennessy, Italian Renaissance Sculpture, London, 1958, pp. 37, 303, Cardellini, op. cit., 1962, p. 244.

17 Valentiner, in Art News, vol. XXVI, No. 28, 14 April, p. 15f.

18 Swarzenski, in Gazette des Beaux Arts, vol. II, 1943, p. 291.

19 Goldscheider, Donatello, London, 1944, p. 31. n. 20. For this work and its artist, see J. Pope-Hennessy, Catalogue, pp. 332–35, No. 363.

245

20 For both dates, see Cardellini, *op. cit.*, pp. 158ff., 217ff.

21 *Op. cit.*, p. 16.

22 See above, note 16. Bode (above, note 9) had spontaneously dated the relief in Desiderio's last years.

23 All the references to the relief I have been able to find will be given in their proper places.

24 For the iconography of St Jerome, see apart from useful manuals such as Künstle's and Réau's, G. Kaftal's *Iconography of the Saints in Tuscan Painting*, Florence, 1952, p. 522ff., No. 158, and the book by Venturi (quoted in note 12), the excellent paper by G. Ring, 'St Jerome extracting the Thorn from the Lion's Foot,' *Art Bulletin*, vol. XXVII, 1945, pp. 188–94, and P. Ansgar Pöllmann, 'Von der Entwicklung des Hieronymus-Typus in der älteren Kunst,' *Benediktinische Monatsschrift*, vol. II, 1920, pp. 438–522.

25 Not very common.

26 I have never found a second cross, but considering the many thousands of representations of St Jerome it may well be that it occurs in some works of art. Nothing will be said on the following pages about the figure of Christ on the Cross. The nearest parallel to it I could find is the cross with the Good Thief in the bronze relief of the Crucifixion of the Museo Nazionale, Florence, that used to be attributed to Donatello, but has now been recognized as the work of a successor (see H. W. Janson, *The Sculpture of Donatello*, Princeton, 1957, p. 242ff., Pls. 497–502). This relief, previously dated 'about 1450,' seems to belong to a slightly later period; according to Janson it dates between 1470 and 1480. One of the puzzling features of Desiderio's Christ is that the foreshortening into depth has not been fully mastered, although it must be said that the figure makes a visually convincing impression. But since Christ's body is turned three-quarters to the beholder, the left arm would have been wrenched out of its socket; in any case, it is invisible and would have to be imagined nailed to an immensely lengthened crossbream. One may compare the solution to the same problem in the pseudo-Donatello bronze relief.

27 F. Oswald, in *Wallraf-Richartz Jahrbuch*, vol. XXIII, 1961, pp. 342–46. I have once again to thank Ulrich Middeldorf for directing my attention to this important paper. Oswald also tentatively suggests a portrait of S. Antonino in the St Jerome of Piero della Francesca's altarpiece in the Brera, Milan. The most likely candidate for an Italian 15th-century St

Jerome intended as a portrait is the marble figure on the façade of the Palazzo dell'Annunziata at Sulmona (Abbruzzi) in elaborate cardinal's dress with extraordinarily individual features (beardless, bulging eyes, long pointed nose). (Photo Nuccetelli, Sulmona; the photograph in the Kunsthistorisches Institut, Florence, was produced by Ulrich Middeldorf.) Many years ago, E. Wind, in *Journal of the Warburg Institute*, vol. I, 1937, p. 153, discussed the appropriateness of Cardinal Albrecht von Brandenburg's appearance in the guise of St Jerome in pictures by Cranach.

28 Venturi, *op. cit.*, (see note 12), p. 21f., fig. 12.

29 See J. Lauts, in *Jahrbuch d. kunsthist. Slg. in Wien*, vol. VII, 1933, p. 22, and *id.*, *Antonello da Messina*, Vienna, 1940, p. 33. It is worth mentioning that in Antonello's *Penitent St Jerome in a Landscape* in the Museum at Reggio Calabria the saint is 'correctly' bearded.

30 M. Horster, in *Wallraf-Richartz Jahrbuch*, vol. XVII, 1955, p. 105ff.: E. Battisti, in *Dizionario biografico degli italiani*, vol. III, 1961, p. 77. It may be pointed out that Meinhof (see below, note 32), p. 108, stresses the fact that Castagno's head of St Jerome shows slight indications of a beard, but that it has been reduced in such a way that it supports the modelling of the structure of the head.

31 For attribution and date, see G. Passavant, *Andrea del Verrocchio als Maler*, Düsseldorf, 1959, p. 133ff. (also *id.*, *Verrocchio*, London, 1969, p. 195f., No. 20), who shows convincingly that this work which had been attributed to various artists is based on a design by Verrocchio and was probably partly executed by him. Pages 122–91 contain a valuable contribution to the beardless St Jerome type in Italy.

32 The fullest discussion of certain aspects of Leonardo's St Jerome of interest in the present context is by W. Meinhof, in *Repertorium für Kunstwissenschaft*, vol. LII, 1931, pp. 101–24.

33 R. Valentiner, 'Leonardo and Desiderio,' *Burlington Magazine*, vol. LXI, 1932, pp. 53–61, makes it likely that the early Leonardo in Florence took a special interest in Desiderio's work.

34 See Meinhof, *op. cit.*, where some of the material is conveniently assembled.

35 A. Busignani, *Pollaiolo*, Florence, 1969, p. CLXXII f. Here also (p. CLXXIV f.) the so-called head of St John in the Galleria Palatina of the Palazzo Pitti, showing the same Leonardesque type of head, but expressing elation and content-

ment; this painting has been variously attributed; according to Busignani it is a certain Piero Pollaiuolo dating after the *Coronation* of 1483. Reference may also be made to the Leonardesque head of St Jerome in the fresco by Bartolomeo della Gatta (1448–1502) in the sacristy of Arezzo Cathedral, datable about 1487; see U. Pasqui, *Di Bartolomeo della Gatta*, Arezzo, 1926, p. 24f.

36 A careful observer will notice that the piece of rock is not entirely omitted. Desiderio placed it on the ground between the Saint's right thigh and the skull.

37 Some of them are mentioned by R. van Marle, *The Development of the Italian School of Painting*, vol. XII, 1931, p. 374ff. The painting here illustrated was with Julius Böhler in Munich in 1927. Van Marle (p. 386) mentioned it as 'recently for sale in Rome;' see also *Dedalo*, vol. XII, 1932, p. 838. The present whereabouts of the painting is unknown.

38 First noted by Planiscig (see note 14), p. 16.

39 A. Warburg, *Gesammelte Schriften*, Leipzig-Berlin, 1932, vol. II, p. 449, recognized the close dependence of Castagno's *David* on the paedagogue of the Niobid group (here illustrated after the well-known marble in the Uffizi). Warburg's observation undoubtedly remains correct although the Florentine Niobids were not discovered until 1583 (*ibid.*, p. 625) and although the arms of the paedagogue are later (though correct) restorations. Similar figures were known in the 15th century from Roman sarcophagi; see, e.g., the sarcophagus drawing in the late 15th-century Codex Escurialensis (ed. H. Egger, Vienna, 1905–6, f. 65v, text p. 155f.). Seymour pointed to a similar figure in Meleager sarcophagi; it represents Oeneus, Meleager's father, heading the scene of the transportation of Meleager's body; see C. Robert, *Die antiken Sarkophag-Reliefs*, Berlin, 1904, vol. III, ii, Pl. LXXVIII.

40 The history of the picture and previous attributions (to Pesellino, and to Pesellino and Fra Filippo Lippi combined) are fully discussed by R. Oertel, *Frühe italienische Malerei in Altenburg. Beschreibender Katalog*, Berlin, 1961. p. 146f. Oertel convincingly advocates Fra Filippo Lippi's sole authorship. See also M. Pittaluga, *Filippo Lippi*, Florence, 1949, p. 196.

41 See Pöllmann (above, note 24), p. 473. As far as I can see, Pöllmann is the only author who refers to the motif in passing; he briefly mentions an Austrian 16th-century altar in Vienna on which three lions are represented.

42 *Op. cit.*, p. 176, and *id.*, *Fra Filippo Lippi*, Vienna, 1942, p. 72.

43 I owe to Ulrich Middeldorf the reference to *Property of Signor Stefano Bardini at the American Art Galleries New York*. Sale April 1918; the piece is illustrated as No. 420. The relief shows the beardless emaciated St Jerome resting with both knees on the rocky ground and clad in a hermit's habit. Size: 23 by 18 inches.

44 The relief is in the Casa Buonarroti, Florence. Photo Brogi 20908.

45 For both, see Meinhof, *op. cit.* (see note 32), figs. 2 and 3. Best discussion and illustration of the engraving in A. M. Hind, *Early Italian Engravings. A Critical Catalogue*, New York, 1938, vol. I, i, p. 48, No. 58, pl. 54. The anonymous engraving has much in common with the presumed work of Finiguerra.

46 According to Hind, the fighting lion and lioness might be explained as referring to the subjugation of Pisa by Florence.

47 In his *Sculpture in Italy 1400 to 1500*, Pelican History of Art, 1966, p. 240, n. 18.

48 The only similarities may be found in the bits of stratified clouds which may be compared to the clouds in Donatello's *Ascension* relief in the Victoria and Albert Museum (1428–30). There are also slight similarities between the little bush next to the second cross in Desiderio's relief and the background trees in Donatello's work.

49 The holm oak is an evergreen shrub-like plant that may grow to a height of eighty or ninety feet and attain great age.

50 I am not the first to point out Desiderio's reliance on Fra Filippo Lippi. My text was well advanced when I found that Meinhof, *op. cit.*, (see above, note 32), p. 108, n. 16, had recognized 'the dependence of Desiderio's relief on the Altenburg picture as far as the landscape is concerned.' A. Bertini, *Scultura fiorentina del'400 e del'500* (Corsi universitari), Turin, 1965, p. 65f., found that in Desiderio's relief 'il rapporto tra le figure e il fondo ha una marcata affinità con l'opera di Filippo Lippi tra il '50 e il '60.' He therefore suggested dating the relief between 1461 and 1464, as I do.

51 Including the 'frame' that encases the relief and makes part of the marble slab, the measurements of the National Gallery piece are 0.427×0.547 m while the Hall version measures 0.430×0.553 m. It should be mentioned that, like the National Gallery relief, the Hall relief has no pedigree.

52 It is not without interest that technically the backs are quite different from each other. The National Gallery's relief is roughly treated with a trimming hammer while the back of the Hall relief was much more carefully finished with a tooth chisel.

53 For this and the following, H. Janitschek, *Leon Battista Alberti's kleinere kunsttheoretische Schriften*, Vienna, 1877, particularly p. 176ff.; see also J. Schlosser, *La letteratura artistica*, Vienna, 1964, p. 126.

54 For Gauricus, see Schlosser, *op. cit.*, pp. 235ff., 248. The only pertinent remarks on the question of mechanical aid in Quattrocento sculpture are to be found in I. Lavin, 'Bozzetti and Modelli,' in *Stil und Überlieferung in der Kunst des Abendlandes*, vol. III. Theorien und Probleme, Berlin. 1967, p. 97ff. The author adduces valid reasons for the assumption that Agostino di Duccio employed a pointing method for his colossal statue which later served Michelangelo for his *David*. The year of Agostino's commission, 1464, is precisely the period to which Desiderio's marbles belong.

VII The Young Raphael

1 All the documents are conveniently printed in Vincenzo Golzio, *Raffaello*, Città del Vaticano, 1936, p. 1ff. (henceforth quoted as Golzio).

2 Fullest publication of the court documents by H. Grimm in *Jahrbuch der Preussischen Kunstsammlungen*, III (1882), p. 161ff. It is usually assumed and often categorically stated (cf. Golzio, p. 6) that 'pro Raphaele absente' means that Raphael had left Urbino. Grimm argued that no such interpretation is permissible.

3 Vasari, *Le vite de'più eccellenti architetti, pittori et scultori, etc.*, Florence, 1550, p. 636: '... Et facevasi aiutare da Raffaello, il quale, ancorchè, fanciuletto, lo faceva il più et il meglio che e' sapeva.'

4 Vasari, ed. G. Milanesi, IV, p. 317: 'Raffaello ancor fanciullo gli fu di grande ajuto in molte opere che Giovanni fece nello stato d'Urbino.'

5 *La spositione di M. Simone Fornari da Rheggio sopra l'Orlando Furioso di M. Ludovico Ariosto*, Florence, 1549, p. 513f. (cf. Golzio, p. 195). Fornari omitted all adornments later incorporated in Vasari's report. He wrote: 'Fu posto dal padre suo sotto la disciplina di Pietro Perugino: il quale in poco spatio di tempo Raphaello andò si bene imitando, che quasi nulla, o poca differenza era dalle sue alle pitture del suo maestro.'

6 M. de Chantelou, *Journal du voyage du Cav. Bernin en France* (ed. Lalanne), Paris, 1885, under 6 October 1665.

7 Golzio, p. 7.

8 For the identification of these fragments and the reconstruction of the altarpiece, see O. Fischel in *Jahrb. d. Preuss. Kunstslg.*, XXXIII (1912), p. 105ff., and XXXIV, 1913, p. 89ff.; W. Schoene in *Festschrift für Carl Georg Heise*, Berlin, 1950, p. 113ff., and *Raphael*, Berlin and Darmstadt, 1958, p. 45, with a reconstruction slightly different from that given by Fischel.

9 A. Alipi, *Nuova Rivista Misena*, April 1891, pp. 51–53; Lisa de Schlegel in *Rivista d'Arte*, XI (1911), p. 72ff. For further bibliography, A. Venturi, *Storia dell' arte italiana*, VII, 2, p. 188f.

10 Adolfo Venturi's reconstruction of his *oeuvre* (*L'Arte*, XIV [1911], p. 139ff., and *Storia, loc. cit.*) has not found acceptance.

11 *Kunstchronik*, XX (1908/9), pp. 45–50.

12 E.g., W. Bombe in *Repertorium für Kunstwissenschaft*, IV (1911), p. 296ff.

13 O. Fischel, *Raphael*, London, 1948, p. 20.

14 1955, No. 65, p. 11ff.

15 *Painting of the High Renaissance in Rome and Florence*, Cambridge, Mass., 1961, p. 62.

16 Golzio, p. 8.

17 Cecil Gould, *National Gallery Catalogues. The Sixteenth Century Italian Schools*, London, 1962, p. 158f., with full bibliography.

18 F. Canuti, *Il Perugino*, Siena, 1931, I, pp. 148ff., 153f., argues that Evangelista di Pian di Meleto and Timoteo Viti set up a common workshop in 1502. If this is true, as it may well be, it would indicate that after the St Nicholas altarpiece Raphael's and Evangelista's association came to an end and, implicitly, that the old Giovanni Santi Workshop was dissolved.

19 Vasari-Milanesi, IV, p. 318f.

20 *Ibid.*, p. 317f.

21 This dating has been universally accepted.

22 The Coronation shows particularly close connections with Perugino's *Ascension of Christ* (Pl. 200) painted between 1496 and 1498 for S. Pietro at Perugia

(now Museum, Lyons). Raphael's predella with the *Presentation in the Temple* cannot be dissociated from Perugino's for the altarpiece in S. Maria Nuova, Fano (1497), etc. See Venturi, *Storia dell' arte italiana*, VII, 2, p. 784. Nevertheless, it is possible that Raphael executed the three scenes of the predella some time after the altarpiece.

23 For Perugino's itinerary during these years, cf. Canuti, II, p. 21ff. It should also be noted that from October 1502 on and through most of 1503 Perugino was in Florence. Again, in 1504 and 1505 he was absent from Perugia for long periods. Canuti (I, p. 153f.) argued, to my mind inconclusively, that Perugino did not open school until January 1501. W. Bombe (*Perugino*, Klassiker der Kunst, 1914, p. xxiv), using arguments similar to ours, thought that Raphael joined Perugino's studio shortly before 1500, but believed that Raphael stayed there until 1504.

24 Golzio, pp. 8, 11. U. Gnoli, *Bollettino d'Arte* (1917), p. 133ff.

25 Venturi, *Storia*, IX, 2 p. 8. Canuti, I, p. 136, has no doubt that the Cambio was entirely finished in 1500. While the documents, so far as they survive, are somewhat ambiguous, they mention two *garzoni* but not Raphael as Perugino's assistants. U. Gnoli, *Pietro Perugino*, Spoleto, 1923, p. 35, calls Venturi's hypothesis absurd. Canuti (I, p. 140) takes a similarly determined stand against any contribution by Raphael. Bombe in *Repertorium für Kunstwissenschaft*, IV (1911), p. 300ff., Fischel, *Raphael*, I, p. 21, and others supplied their own list of Raphael contributions to Perugino's pictures.

26 But I have to admit that the question requires a careful re-examination.

27 The great and progressive artists whom Federigo da Montefeltre had drawn to his court – Justus van Ghent, Piero della Francesca, Mantegna, and Melozzo da Forlì – lived and worked in the refined atmosphere of the ducal palace. So far as we know, the more humble Giovanni Santi was not the recipient of ducal patronage. Nor does it seem that Federigo's son, Guidobaldo, who succeeded his father in 1489 at the age of fourteen and soon assembled the most splendid Renaissance society at his court, showed an interest in the young prodigy from Urbino before he had climbed to fame.

28 O. Fischel, *Raphaels Zeichnungen*, Berlin, 1913, nos 5–10, 15–32, 35, 36. The relation of three drawings to the National Gallery *Crucifixion* is problematical (Vienna, Albertina, Fischel, IV, no.

185; Oxford, Ashmolean 509, Parker, *Catalogue*, 1956, II, p. 259; Ottawa, National Gallery, A. E. Popham, *Old Master Drawings*, XIV, 1939–40, p. 50f. Cf. Cecil Gould's *Catalogue*, p. 158). The majority of the early drawings relate to the *Coronation*. While the metal point drawings would seem to support my early dating of the painting, three large chalk drawings (Fischel, *Zeichnungen*, nos. 23, 24, and A. E. Popham, *Old Master Drawings*, XII; 1937–38, p. 45) would seem rather advanced in style. But it should be remembered that these drawings formed part of the full sized cartoon and required a tecnhique different from the small preparatory studies.

29 The badly preserved procession banner with the Trinity and the Creation of Eve in Città di Castello is traditionally dated in 1499, and Fischel (*Zeichnungen*, no. 2, cf. also no. 11) has related a drawing to it. Roberto Longhi (*Paragone*, VI [1955], no. 65, p. 17) claims that the banner cannot have been painted before 1503.

30 K. T. Parker, *Catalogue of the Collection of Drawings in the Ashmolean Museum*, Oxford, 1956, II, no. 515.

31 Philip Pouncey and J. A. Gere, *Italian Drawings in the Department of Prints and Drawings. Raphael and his Circle*, London, 1962, no. 1 recto.

32 For the documents, cf. Milanesi in Vasari, III, p. 519ff. Here too a confrontation of Vasari's somewhat contradictory statements in his first and second editions. Pinturicchio's contract dates from 29 June 1502. The execution of the frescoes began about a year later, but was soon interrupted. The work may have been continued in the fall of 1504. It is possible that Raphael came to Siena at that moment and made 'some drawings and cartoons' as Vasari specifies in the second edition.

33 Now usually accepted, cf. Golzio, p. 9f. But see the doubts expressed in Vilhelm Wanscher's strange book, *Raffaello Santi*, London, 1926, p. 146.

34 By most recent authors dated 1506 rather than 1505 and this seems unobjectionable.

35 I have remarked on this problem in *Journal of the History of Ideas*, XXII (1961), p. 300.

36 Cennino Cennini, *The Craftsman's Handbook*, ed. Daniel V. Thompson, Jr., Yale University Press, 1933, pp. 2f., 15.

37 *Die klassische Kunst*, Munich, 1912, p. 74f. (first ed. 1898).

38 Raffaello Borghini, *Il Riposo*, Florence, 1584, p. 385. Cf. Golzio, p. 265.

39 Vasari, in Raphael's *Life*: Raphael 'fece una maniere una sola che fu poi sempre tenuta sua propria,' and in the *Proemio* to the Third Part of his work: Raphael 'studiando le fatiche de' maestri vecchi e quelle de' moderni, prese da tutti il meglio'. Cf. Golzio, pp. 227, 235.

40 So far as I can see, it first appeared in Paolo Pino, *Dialogo di Pittura*, Venice, 1548 (ed. Barocchi, *Trattati d'arte del cinquecento*, Bari, 1960, I, p. 127). Pini says that if the talents of Titian and Michelangelo would have appeared in one person, he would have been the 'god of painting'. Cf. also Schlosser, *Die Kunstliteratur*, Vienna, 1924, p. 210f.; Anthony Blunt, *Artistic Theory in Italy*, Oxford, 1940, p. 85; Denis Mahon, *Studies in Seicento Art and Theory*, London, 1947, p. 137.

41 Cf. Mahon, p. 212ff.

42 Cf. in particular Theodor Hetzer, *Gedanken um Raffaels Form*, Frankfurt, 1932, especially p. 18 and *passim*.

43 Letter of October 1542 (Golzio, p. 289). In this letter Michelangelo expressed the view that both Raphael and Bramante envied him to such an extent that they tried to ruin him. Nonetheless, Michelangelo was not a man given to let his judgment suffer by personal grievances.

44 Ascanio Condivi, *Vita di Michelangelo Buonarroti*, Rome, 1553; cf. Golzio, p. 294: 'gli [i.e. Michelangelo] ho sentito dire che Raffaello non hebbe quest' arte da natura, ma per lungo studio'.

IX Sacred Mountains

Instead of detailed notes, I give a list of the chief sources:

Samuel Butler, *Ex Voto: An Account of the Sacro Monte or New Jerusalem at Varallo Sesia*, London, 1888

C. del Frate, *S. Maria del Monte sopra Varese*, Varese, 1933

F. Galloni, *Il sacro monte di Varallo*, Varallo, 1909

P. Goldhardt, 'Die heiligen Berge Varallo, Orta und Varese' in: *Beiträge zur Bauwissenschaft*, 1908

A. Salsa, *Biografia del b. Bernardino Caimi fondatore del S. Monte Varallo Sesia*, Varallo, 1928

M. Trompetto, *Il santuario d'Oropa*, Milan, 1949

X The Painters of Verona

[This paper occupies a position slightly different from that of the other essays in

this volume, and a word of explanation is perhaps necessary. It was the result of trips to Italy by Rudolf Wittkower in 1921 and 1922, and served as the basis for a subsequent dissertation in Berlin. At that time it was more difficult to compile a comprehensive catalogue of works than it became later. The collections in France and England were not accessible, and even in Italy it was not possible to see every painting. He therefore regarded these essays as a first attempt to explore a previously uncharted area, and not as a definitive account. They are reprinted now because in the fifty years that have elapsed since they were published no definitive account has in fact appeared; taken as a whole they have not been superseded. It is nevertheless true that in many respects they are inevitably out of date, not only in their critical references but in such important details as the location of paintings. To have remedied this would have meant a major and quite impracticable revision, and it seemed best to let them stand virtually unchanged. Measurements throughout are given in metres. – Ed].

1 Kallab, *Vasaristudien*, p. 70, Reg. 100.

2 Vasari (ed. Milanesi) VII, p. 670.

3 Cf. Letters nos 191, 192, in Gaye's *Carteggio* III, p. 216 and Kallab p. 388f.

4 Bartolomeo dal Pozzo, *Le vite de' pittori, degli scultori, et architetti veronesi raccolte da varj Autori stampati, e manuscritti, e da altre particolari memorie*. Verona, G. Berno, 1718. On Pozzo cf. Comolli, *Bibliografia storico-critica dell'architettura civile* 1788, II, p. 283ff.

5 Cf. the Prefatione p. 1–2 and the quotations in the individual *Vite*.

6 See his wrong attribution in Domenico Morone, *Catalogue of Works*, No. 21.

7 Diego Zannandreis, *Le vite dei pittori scultori e architetti veronesi pubblicate e corredate di prefazione e di due indici da G. Biadego*, Verona 1891. On Zannandreis cf. Biadego in his 'Notizie preliminari' preceding the *Vite* and Schlosser, *Kunstliteratur*, 1924, p. 570.

8 *Nozze Coris-Benciolini*, Verona 1887.

9 He uses a copy kept in Verona which includes important notes by the painter Cignaroli. These were made accessible to the general public through Biadego's publication, *Di Giambettino Cignaroli pittore veronese notizie e documenti*. Venice 1890.

10 Bernasconi, *Studi sopra la storia della pittura italiana dei secoli XIV e XV e della scuola pittorica veronese*. Verona 1865. Cf.

Review by Unzer in Zahns *Jahrbüchern* II (1869) p. 195ff.

11 Aleardi-Muttoni, *Di Paolo Morando*. Verona 1853.

12 Simeoni, *Verona. Guida storico-artistica della città e provincia*, 1909. Cf. Bolognini in *Archivi storici italiani*, XLV, p. 224, and *Madonna Verona* V (1911) p. 55.

13 *Pittura insigni, che s'attrovano nelle chiese, e ne' luoghi publici di Verona*.

14 Maffei, *Compendio della Verona illustrata principalmente ad uso de'forestieri*, II, 1795. The *Compendio*'s guided tour is more thorough than that in Vol. III of the *Verona illustrata* of 1732.

15 Benassuti, *Verona colla sua provincia descritta al forestiere*. Verona 1842 (first ed. 1825).

16 Francesco Benaglio's Triptych in the chancel of S. Bernardino is a lifeless imitation of Mantegna's. See Venturi, *Storia dell'Arte* VII, 3, p. 444.

17 Michele da Verona stands in a direct pupil relationship to Domenico Morone and should therefore have been included in my section called 'Followers of Domenico Morone'. However, I was not able to form a reliable opinion of his work, as his most outstanding painting, the 1501 *Crucifixion* in the Brera, on which any stylistic criticism must be based, was inaccessible. According to the impression that I have formed, Michele seems to have been a shadow of his teacher. He is a minor master, who (on a smaller scale) stands to Domenico as Bissolo, Catena and others do to Giovanni Bellini. On the life of the artist, see A. Mazzi, *Appunti sulla vita e la fortuna del pittore Michele de Verona*, in *Madonna Verona* V (1911) p. 168ff. Most complete list of works: Berenson, *North Italian Painters*, p. 258ff. Other attributions in Schubring, *Cassoni* (p. 374ff).
An Antonio da Vendri is described by Bernasconi (p. 27) as a pupil of Cavazzola's. We have one of his works, complete with signature, in the Verona Museum (*Madonna and Child* 1518. Cf. Trecca, *Catalogo*, p. 27 No. 157). However, judging by this piece, Antonio can only be seen as a pupil of Liberale's. Cf. A. Mazzi, 'Per la biografia di Antonio da Vendri pittore', in *Madonna Verona* V (1911) p. 94–6.

18 On Mocetto cf. Baron in *Madonna Verona* III (1909), p. 61ff., IV (1910), p. 21ff. The picture in the sacristy of S. Maria in Organo shows a *Madonna with St Catherine and St Stephen*. See Venturi, VII, 4, p. 635.

19 Gerola, *Questioni storiche d'arte veronese*, in *Madonna Verona* III (1909), p. 104–13.

20 Gerola, in *Madonna Verona* III (1909), p. 33.

21 The Berlin picture seems to be related to a picture in the Galleria Tadini in Lovere which I have not been able to see. Frizzoni writes of this in *Emporium* XVII (1903), p. 351: 'Il vero si è che la medesima [tavola] come già ebbe ad oservare sagacemente il critico inglese R. Fry, offre sensible affinità con un dipinto di proporzioni poco difformi appartenente alla r. galleria di Berlino e legittimato col nome del veronese Domenico Morone'.

22 As we know, Perugino had finished his commission in Florence; in November 1504 he begins to paint the *Battle of Chastity against Sensuality* now in the Louvre.

23 Predella from the S. Zeno Altarpiece now in the Museum. The middle section of the predella (the *Crucifixion*) is in the Louvre, the sides (*Agony in the Garden* and *Resurrection*) are in the Museum of Tours.

24 It is easy to distinguish the earlier work on the main wall of the Library from the later on the side walls. On the whole the work of the master and that of the pupils can be differentiated. The main wall, with the exception of the figure on the extreme right, and a large part of the left side wall are the work of the master. Almost the whole right side comes primarily from pupils – particularly Francesco Morone.

25 Today the work is in the Trivulzio Collection in Milan. It was completed on 15 August 1497.

26 Cf. Kristeller, *Mantegna*, 1902, p. 410, Pl. XXIV.

27 Looking at this painting, one realizes that the S. Zeno Alterpiece could stimulate and encourage but could not create life where life was lacking.

28 Accademia, No. 614. Ill.: Venturi VII, 3 p. 446.

29 Cf. the painting in the Berlin Museum (Cat. Wks, No. 11) and the *Virgin and Child with St Anne* in the National Gallery, London. (Cat. Wks, No. 9).

30 Morone: *St Catherine with donor*, Verona Museum (Cat. Wks, No. 14) and *St James with donor*, Verona, Cathedral (Cat. Wks, No. 18). Cavazzola: altarpiece, 1522 (Cat. Wks, No. 20) and the *Carrying of the Cross* from the Trivulzio Collection (Cat. Wks, No. 4).

31 We find the marble parapet in Girolamo's *Madonna Maffei (Cat. Wks, No. 12)* and the *Madonna with Saints*, Berlin (Cat. Wks, No. 11). Hedges separate the foreground from the landscape of the *Virgin and Child with St Anne* in London (Cat. Wks, No. 9) and Verona (Cat. Wks, No. 10).

32 The *Madonna and Child*, London (Cat. Wks, No. 27) is almost an exact mirror image of the little *Madonna* in the Verona Museum (Cat. Wks, No. 26). Variations are visible only in the organization of the background.

33 One might compare them perhaps with Giovanni Caroto's *Madonna with two Saints* in S. Giovanni in Fonte (1513) today in Verona Cathedral, or Francesco Caroto's *Virgin and Child with St Anne and four Saints* in S. Fermo (1528): the one a work tending towards Venice; the other a painting totally influenced by Raphael.

34 This explains the curious opinion of Crowe and other authors who are always stressing the influences on Verona of the Perugia School – influences which in fact did not exist.

35 Cf. especially the depictions of the *Pietà* by Cavazzola (Cat. Wks, No. 7) and Girolamo (Cat. Wks, No. 1), Girolamo's *Adoration* in the Mond Collection (Cat. Wks, No. 3) and Morone's *Madonna with Saints* in S. Maria in Organo (Cat. Wks, No. 6).

36 Especially noteworthy are Girolamo's *St Roch with Saints* (Cat. Wks, No. 5), his *Madonna with St Peter and St Paul* (Cat. Wks, No. 17), and Morone's *Madonna* (Cat. Wks, No. 26).

37 For information on botanical precision in the drawing of local flora, see Forti, 'Studi su la flora della pittura classica Veronese'. In *Madonna Verona* XIV (1920) p. 57ff.

38 Especially characteristic of Girolamo.

39 A few small features bear the mark of Domenico's influence. The inorganic way in which certain limbs appear to be attached is often evident in the library frescoes. This essential characteristic can be found again in the Morone paintings of 1502 and 1503 (Cat. Wks, Nos 5 and 6) in the arms of St Nicholas or St Augustine, in the *St Catherine* in the Museum (Cat. Wks, No. 14) and in Girolamo's altarpiece in S. Giorgio (Cat. Wks, No. 13). The 'dangling' leg, which one encounters frequently in Domenico's figures, is again clearly visible in the Child in the Berlin *Madonna* of Francesco Morone (Cat. Wks, No. 9).

40 One finds this type most often with Girolamo, less frequently with Morone and Cavazzola. Girolamo: Altarpiece in S. Anastasia; the *Virgin and Child with St Anne* in S. Paolo; the *Adoration* in the Museum and the *St Peter* in the Mond Collection; St Peter in the *Madonna della Quercia*, and the *Pietà* in Malcesine. (Cat. Wks, Nos 1, 2, 3, 4, 7, 10, 17). Morone: *St Benedict*, in the organ panels from Marcellise (Cat. Wks, No. 7) and St Peter in the *Washing of the Feet* (Cat. Wks, No. 13). Cavazzola: *St Peter* in the half-length paintings (Cat. Wks, No. 8).

41 Cf. also John the Baptist in Mantegna's *Baptism* in S. Andrea in Mantua and the St John in Girolamo's *Baptism*.

42 Girolamo's *St Peter* in the Mond Collection is in every aspect borrowed from Mantegna. The same motif also with Girolamo: St Bartholomew of the Berlin work (Cat. Wks, No. 11), St Joseph in the *Nativity* (Cat. Wks, No. 2) and the *Virgin and Child with St Anne* (Cat. Wks, No. 10), St Peter in the *Madonna della Quercia* (Cat. Wks, No. 17), St John in the Altarpiece in Quinto (Cat. Wks, No. 32), and Morone in the St Joseph in the frescoes of 1515 (Cat. Wks, No. 8).

43 Compare Girolamo's works in S. Anastasia and in Berlin. Also very similar, the *Madonna Maffei* and the *Madonna* in S. Giorgio, as well as Morone's frescoes of 1515. The gesture of the *Madonna dell'Ombrello* repeats that of Mantegna's *Madonna della Vittoria* in the Louvre.

44 Compare especially the *Sacra Conversazione* in Bergamo (Cat. Wks, No. 25).

45 Compare the *Madonna* in the Verona Museum (Cat. Wks, No. 26), the Altarpiece in Berlin (Cat. Wks, No. 24), the London *Madonna* (Cat. Wks, No. 27) and the painting in Bergamo (Cat. Wks, No. 25) with, for instance, Bellini's painting in Turin. One finds parallels primarily in the depiction of the Madonna and Child.

46 Compare also Girolamo's *Madonna della Quercia* with Raphael's *Madonna di Foligno*. Although Girolamo's is an independent achievement, this work could never have been conceived without Raphael's example.

47 I can only partly agree with the points made by Hadeln in his essay: 'Veronese und Zelotti' (*Jahrbuch der preussischen Kunstsammlungen* XXXV, 1914, p. 173). Hadeln classifies Cavazzola as the 'classical representative of Raphaelism in Verona'. Earlier he claims that 'even the older painters like Girolamo dai Libri, the two Carotos, even the old Liberale, all products of the Mantegnesque school, were now trying to learn afresh'. The influence of Raphael on Girolamo is minimal. Granted, some aspects of Cavazzola do point to Raphael, but these are only in his last works and are scarcely noticeable. The true representative of Raphaelism is G. F. Caroto. What Hadeln calls 'the unexplained and rapid advance of Raphaelism to Verona' can be explained by the fact that Caroto brought it home with him from his journeys. Indeed, the two Carotos were the ones who maintained the Roman-Tuscan connection in every way. Giovanni Caroto gave the book *De origine e amplitudine civitatis Veronae* to Vasari, whom he knew personally. Printed in 1540, it concerned the antiquities of Verona and was richly illuminated by Caroto. By laying too much stress on Raphaelism Hadeln underestimates the Venetian influence. Even Giovanni Caroto, who was deeply involved with representatives of Mannerism, eventually succumbed to the tone set by Venice. A *Sacra conversazione* in the Galleria Colonna, Rome, attributed to Catena is certainly the work of Giovanni Caroto. It proves once again that the movement which reached its climax in Paolo Veronese was initiated from many sides.

48 Documents in Gerola, 'Questioni storiche' in *Madonna Verona* 1909, p. 110/11.

49 Vasari: 'amicissimo e come fratello di Girolamo dai Libri'. Shortly before his death Morone appointed his friend as the executor of his will. Cf. the last will and testament of Francesco Morone, dated 12 May 1529; published in excerpts by Cipolla in *Archivio Veneto* XXIII, I, (1882), pp. 213–16.

50 Vasari V, p. 310.

51 All documents published by Canossa, see Cat. Wks, No. 1.

52 Lotze, *Girolamo dai Libri e Francesco Morone*, Verona 1875, p. 22 (quoted from Canossa).

53 Aleardi-Muttoni, *Di Paolo Morando*, Verona 1853.

54 'Thadeus Cavazzola q.m. Jacobi: de Morando an. 54 Paulus filius an. 28. Register of 1514. Published by Bernasconi, later by Bernardini, p. 1381.

55 'Paulus pictor Morandus hic pictura praeclarus confrater melior obiit 13 Augusti 1522' – *Libro* of the Collegio SS. Siro e Libera, Zannandreis, p. 96.

PHOTOGRAPHIC ACKNOWLEDGMENTS

Thomas Agnew & Sons Ltd, London 261, 262; Alinari 13, 36, 43, 60, 64, 67, 68, 76, 155, 166, 171, 177, 178, 179, 180, 181, 182, 183, 185, 191, 199, 202, 204, 208, 212, 213, 214, 220, 222, 223, 224, 242, 243, 245, 247, 248, 252, 253, 267, 268, 269, 270; Anderson 66, 241, 244, 246, 254, 259, 263, 264; Birmingham Museums and Art Gallery 229, 230, 231; Blackstone Studios, New York 1; Brogi 2, 5, 35, 38, 40, 42, 45, 46, 47, 51, 52, 53, 54, 62, 63, 187, 190; Courtauld Institute of Art, London 120; Lauros-Giraudon 198; Mansell-Alinari 70, 271; Mansell-Anderson 197, 203, 234; Metropolitan Museum of Art, New York: Gift of Janos Scholz and Mrs Anne Bigelow Scholz, 1949, in memory of Flying Officer Walter Bigelow Rosen 84, 85, 86, 87, 89, 91; National Gallery of Art, Washington DC: Samuel H. Kress Collection 205, Widener Collection 169, 172, 173, 175, 184, 193; Reproduced by gracious permission of Her Majesty Queen Elizabeth II 217; Edwin Smith 219; Soprintendenza all'Arte Mediovale e Moderna, Florence 19, 20, 39, 55, 56, 57; Soprintendenza alle Gallerie, Florence 71, 81, 93; Soprintendenza alle Gallerie, Naples 196

INDEX